15TH–18TH CENTURY FRENCH DRAWINGS

IN THE METROPOLITAN MUSEUM OF ART

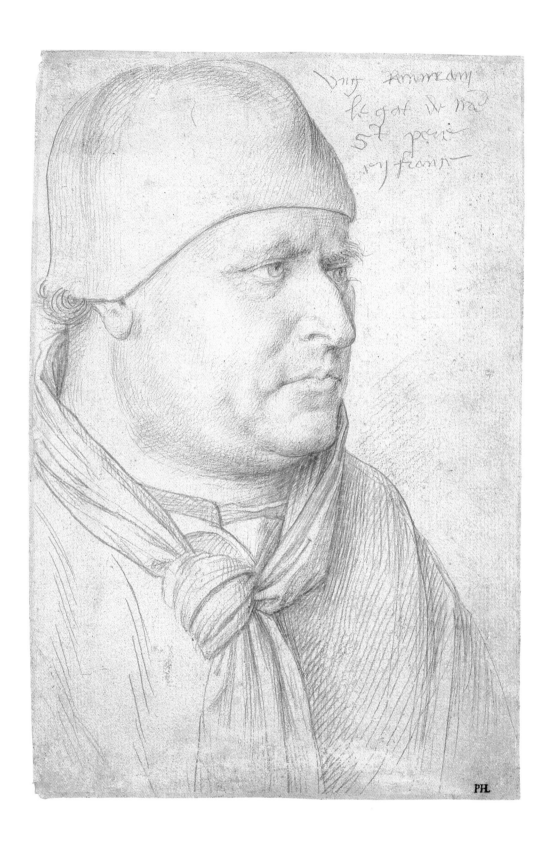

15TH–18TH CENTURY FRENCH DRAWINGS

IN THE METROPOLITAN MUSEUM OF ART

JACOB BEAN

with the assistance of LAWRENCE TURČIĆ

The Metropolitan Museum of Art
New York 1986

ON THE COVER/JACKET: Detail of
Charles de La Fosse, No. 140.

FRONTISPIECE: Jean Fouquet, No. 110.

PUBLISHED BY
The Metropolitan Museum of Art, New York

Bradford D. Kelleher, Publisher
John P. O'Neill, Editor in Chief
Polly Cone, Executive Editor
Anne M. Preuss, Editor
Heidi Haeuser, Production Assistant
Peter Oldenburg, Designer

LIBRARY OF CONGRESS CATALOGING-IN-PUBLICATION DATA

Metropolitan Museum of Art (New York, N.Y.)
 15th–18th century French drawings in the Metropolitan Museum
of Art.

 Bibliography: p.
 Includes index.
 1. Drawing, French—Catalogs. 2. Drawing—New York (N.Y.)
—Catalogs. 3. Metropolitan Museum of Art (New York, N.Y.)—
Catalogs. I. Bean, Jacob. II. Turčić, Lawrence. III. Title. IV. Title:
Fifteenth–eighteenth century French drawings in the Metropolitan
Museum of Art.

NC246.M48 1986 741.944'074'01471 85–31077
ISBN 0–87099–463–8
ISBN 0–87099–464–6 (pbk.)

Color photography by Malcolm Varon.
Black and white photography by the Photograph Studio,
The Metropolitan Museum of Art,
with special acknowledgment to Gene C. Herbert.

Type set by The Stinehour Press, Lunenburg, Vermont
Printed by The Meriden Gravure Company, Meriden, Connecticut
Bound by Publishers Book Bindery, Long Island City, New York

Contents

Preface

The earliest drawing in this catalogue—Fouquet's *Portrait of an Ecclesiastic*—dates from the middle of the fifteenth century, and though technically the chronological limit for this volume is the end of the *ancien régime* in 1789, a few drawings that date from the first two decades of the nineteenth century have been included. These are late works by artists such as Louis David or François-André Vincent, who had established their reputations before 1789.

The collection of French drawings of this period in the Metropolitan Museum has to a very large extent been formed over the last twenty-five years. Only seventy of the 358 drawings in this catalogue were in the collection when the Department of Drawings was established as a separate curatorial division of the museum in 1961; thus about four-fifths of the works included here have been acquired by purchase, gift, and bequest since then.

All drawings in our collection that I feel can be plausibly attributed to known artists of the period are described and reproduced. Old copies and sheets of (for me) dubious authenticity have been excluded. A question mark after an artist's name in a catalogue heading indicates that there are legitimate doubts concerning the attribution. Twenty-one still anonymous drawings of considerable interest are included at the end of the catalogue in the hope that their appearance will elicit new attributions. Prudence has dictated the abolition to anonymity of ten portrait drawings formerly given to "Clouet," "Dumonstier," or "Lagneau." Descriptive notices are intentionally brief to allow maximum space for reproduction. The entries offer essential bibliographical references and a record of provenance, with dealers indicated in brackets. Since many of the French drawings of this period in the Robert Lehman Collection at The Metropolitan Museum of Art have been reproduced and described in a very useful publication by George Szabo (1980), they are not illustrated here.

I am most grateful to Lawrence Turčić for his invaluable assistance in the compilation of this catalogue, of which he is in many ways co-author. I also wish to thank Helen B. Mules, Calvin Brown, and Henrietta Susser, members of the staff of the Department of Drawings, for their help. Helen K. Otis, Conservator and Administrator, Paper Conservation, has supplied valuable technical information. I am also grateful to the many scholars whose suggestions and attributions are recorded in the entries that follow; particular acknowledgment is due to Roseline Bacou, Jean-Pierre Cuzin, Jennifer Montagu, and Eunice Williams.

JACOB BEAN
Curator of Drawings

Works Cited in Abbreviated Form

Age of Revolution, 1975
French Painting 1774–1830: The Age of Revolution, exhibition catalogue, Grand Palais, Paris, The Detroit Institute of Arts, The Metropolitan Museum of Art, New York, 1975.

Allen, 1938
Josephine L. Allen, "Drawings from the Biron Collection," The Metropolitan Museum of Art Bulletin, March 1938, pp. 77–78.

Ames, 1975
Winslow Ames, "Bouchardon and Company," Master Drawings, XIII, 4, 1975, pp. 379–400, pls. 24a–43d.

Ananoff, 1961
Alexandre Ananoff, L'oeuvre dessiné de Jean-Honoré Fragonard (1732–1806). Catalogue raisonné, I, Paris, 1961.

Ananoff, 1963
Alexandre Ananoff, L'oeuvre dessiné de Jean-Honoré Fragonard (1732–1806). Catalogue raisonné, II, Paris, 1963.

Ananoff, 1966
Alexandre Ananoff, L'oeuvre dessiné de François Boucher (1703–1770). Catalogue raisonné, I, Paris, 1966.

Ananoff, 1968
Alexandre Ananoff, L'oeuvre dessiné de Jean-Honoré Fragonard (1732–1806). Catalogue raisonné, III, Paris, 1968.

Ananoff, 1970
Alexandre Ananoff, L'oeuvre dessiné de Jean-Honoré Fragonard (1732–1806). Catalogue raisonné, IV, Paris, 1970.

Ananoff, 1976
Alexandre Ananoff, with the collaboration of Daniel Wildenstein, François Boucher, 2 vols., Lausanne and Paris, 1976.

Ananoff, 1980
Alexandre Ananoff, with the collaboration of Daniel Wildenstein, L'opera completa di Boucher, Milan, 1980.

Annual Report
The Metropolitan Museum of Art. Annual Report of the Trustees, New York, from 1870 to the present.

Art Treasures of the Metropolitan, 1952
Art Treasures of the Metropolitan. A Selection from the European and Asiatic Collections of The Metropolitan Museum of Art Presented by the Curatorial Staff, New York, 1952.

Arts under Napoleon, 1978
The Arts under Napoleon, exhibition catalogue by James David Draper, The Metropolitan Museum of Art, New York, 1978.

Athens, 1979
Treasures from The Metropolitan Museum of Art, New York. Memories and Revivals of the Classical Spirit, exhibition catalogue by James David Draper and Joan R. Mertens, National Pinakothiki, Alexander Soutzos Museum, Athens, 1979.

Auquier
Philippe Auquier, Pierre Puget, décorateur naval et mariniste, Paris, n.d.

Bacou, 1971
Roseline Bacou, I disegni dei maestri. Il Settecento francese, Milan, 1971.

Baltimore, Boston, Minneapolis, 1984
Regency to Empire, French Printmaking 1715–1814, exhibition catalogue by Victor I. Carlson and John W. Ittmann, with contributions by David P. Becker, Richard Campbell, Jay McKean Fisher, George Levitine, and Mary L. Myers, The Baltimore Museum of Art, Museum of Fine Arts, Boston, The Minneapolis Institute of Arts, 1984–1985.

Barbault, 1974
Jean Barbault (1718–1762), exhibition catalogue by Nathalie Volle and Pierre Rosenberg, with a contribution on the Mascarade turque of 1748 by Thomas Gaethgens, Musée départemental de l'Oise, Beauvais, Musée des Beaux-Arts, Angers, Musée des Beaux-Arts, Valence, 1974–1975.

Bayonne, 1924
Les dessins de la collection Léon Bonnat au Musée de Bayonne. Première année, 1924, Paris, 1925.

Bayonne, 1926
Les dessins de la collection Léon Bonnat au Musée de Bayonne. Troisième année, 1926, Paris, 1926.

Bean, 1962
Jacob Bean, "The Drawings Collection," The Metropolitan Museum of Art Bulletin, January 1962, pp. 157–175.

Bean, 1964
Jacob Bean, 100 European Drawings in The Metropolitan Museum of Art, New York, 1964.

Bean, 1972
Drawings Recently Acquired, 1969–1971, exhibition catalogue by Jacob Bean, The Metropolitan Museum of Art, New York, 1972.

Bean, 1975
European Drawings Recently Acquired, 1972–1975, exhibition catalogue by Jacob Bean, The Metropolitan Museum of Art, New York, 1975.

Bean, 1983
Jacob Bean, "Four More Drawings by Charles de La Fosse," *Master Drawings*, XXI, 1, 1983, pp. 17–20, pls. 20–23.

Bean and Turčić, 1982
Jacob Bean, with the assistance of Lawrence Turčić, *15th and 16th Century Italian Drawings in The Metropolitan Museum of Art*, New York, 1982.

Beau, 1968
Marguerite Beau, *La collection des dessins d'Hubert Robert au Musée de Valence*, Lyon, 1968.

Bénard, 1810
M. Bénard, *Cabinet de M. Paignon-Dijonval. État détaillé et raisonné des dessins et estampes dont il est composé*, Paris, 1810, part I, drawings, part II, prints.

Benisovich, 1943
Michael Benisovich, "The French Drawings of the Metropolitan Museum," *Burlington Magazine*, LXXXII, 1943, pp. 70–76.

Berckenhagen, 1970
Ekhart Berckenhagen, *Staatliche Museen Preussischer Kulturbesitz. Die französischen Zeichnungen der Kunstbibliothek Berlin*, Berlin, 1970.

Bertini, 1958
Aldo Bertini, *I disegni italiani della Biblioteca Reale di Torino*, Rome, 1958.

Bjurström, 1976
Per Bjurström, *Drawings in Swedish Public Collections, 2. French Drawings, Sixteenth and Seventeenth Centuries*, Stockholm, 1976.

Bjurström, 1982
Per Bjurström, *Drawings in Swedish Public Collections, 4. French Drawings, Eighteenth Century*, Stockholm, 1982.

Blumenthal Collection Catalogue, V, 1930
Catalogue of the Collection of George and Florence Blumenthal, New York. Compiled by Stella Rubinstein-Bloch. V. Paintings, Drawings, Sculptures, XVIIIth Century, Paris, 1930.

Blunt, 1945
Anthony Blunt, *The French Drawings in the Collection of His Majesty the King at Windsor Castle*, Oxford and London, 1945.

Blunt Collection, 1964
The Sir Anthony Blunt Collection, exhibition catalogue, Courtauld Institute Galleries, London, 1964.

Blunt, 1979
Anthony Blunt, *The Drawings of Poussin*, New Haven and London, 1979.

Bocher, 1882
Emmanuel Bocher, *Jean-Michel Moreau, le jeune*, Paris, 1882.

Boisfleury, 1972
Sabine de Boisfleury, "Quelques dessins de Puget," *Puget et son temps. Actes du colloque tenu à l'Université de Provence, les 15, 16 et 17 octobre 1971. Provence historique*, XXII, 88, 1972.

Bollea, 1942
L. C. Bollea, *Lorenzo Pecheux, maestro di pittura nella R. Accademia delle belle arti di Torino*, Turin, 1936 [1942].

Bordeaux, 1974
Jean-Luc Bordeaux, "François Le Moyne's Painted Ceiling in the Salon d'Hercule at Versailles, a Long Overdue Study," *Gazette des Beaux-Arts*, LXXXIII, 1974, pp. 301–318.

Bordeaux, 1985
Jean-Luc Bordeaux, *François Le Moyne and His Generation, 1688–1737*, Neuilly-sur-Seine, 1985.

Borenius and Wittkower, 1937
Tancred Borenius and Rudolf Wittkower, *Catalogue of the Collection of Drawings by the Old Masters Formed by Sir Robert Mond. . . .* London [1937].

Bottineau, 1960
Yves Bottineau, *L'art de cour dans l'Espagne de Philippe V, 1700–1746*, Bordeaux, 1960.

Brookner, 1972
Anita Brookner, *Greuze. The Rise and Fall of an Eighteenth-Century Phenomenon*, London, 1972.

Brugerolles, 1981
De Michel-Ange à Géricault. Dessins de la donation Armand-Valton, exhibition catalogue by Emmanuelle Brugerolles, École nationale supérieure des Beaux-Arts, Paris, 1981.

Byam Shaw, 1970
J. Byam Shaw, "The Biron Collection of Venetian Eighteenth-Century Drawings at the Metropolitan Museum," *Metropolitan Museum Journal*, 3, 1970, pp. 235–258.

Carlson, 1978
Hubert Robert. Drawings and Watercolors, exhibition catalogue by Victor Carlson, National Gallery of Art, Washington, D.C., 1978.

Carnegie Institute, 1951
French Paintings, 1100–1900, exhibition catalogue, Department of Fine Arts, Carnegie Institute, Pittsburgh, 1951.

Cayeux, 1963
Jean de Cayeux, "Introduction au catalogue critique des *Griffonis* de Saint-Non et catalogue des *Griffonis*," *Bulletin de la Société de l'Histoire de l'Art français*, 1963 [1964], pp. 297–384.

Chennevières, 1880
Les dessins de maîtres anciens exposés à l'École des Beaux-Arts en 1879, étude par le marquis de Chennevières, Paris, 1880.

Chennevières, *L'Artiste*
Ph. de Chennevières, "Une collection de dessins d'artistes français," *L'Artiste*: VIII, 1894, pp. 81–98 (part I), pp. 177–191 (part II), pp. 252–273 (part III); IX, 1895, pp. 20–35 (part IV), pp. 177–183 (part V), pp. 259–265 (part VI), pp. 421–430 (part VII); X, 1895, pp. 22–29 (part VIII), pp. 91–101 (part IX), pp. 168–175 (part X), pp. 341–350 (part XI); XI, 1896, pp. 30–38 (part XII), pp. 91–102 (part XIII), pp. 250–263 (part XIV); XII, 1896, pp. 28–42 (part XV), pp. 172–183 (part XVI), pp. 413–425 (part XVII); XIII, 1897, pp. 14–26 (part XVIII), pp. 175–185 (part XIX); XIV, 1897, pp. 97–107 (part XX), pp. 262–276 (part XXI), pp. 410–425 (part XXII); II (nouvelle série), 1899, pp. 193–198 ("Dernières pages").

Clayton, 1923
Edward Clayton, *French Engravings of the Eighteenth Century in the Collection of Joseph Widener, Lynnewood Hall*, 4 vols., London, 1923.

Collection Hennin
Inventaire de la collection d'estampes relatives à l'histoire de France, léguée en 1863 à la Bibliothèque Nationale par M. Michel Hennin, rédigé par M. Georges Duplessis, 4 vols., Paris, 1877–1882.

Compiègne and Aix-en-Provence, 1977
Don Quichotte vu par un peintre du XVIIIe siècle: Natoire, exhibition catalogue by Odile Picard Sébastiani and Marie-Henriette Krotoff, Musée national du château de Compiègne, Musée des Tapisseries d'Aix-en-Provence, 1977.

Conisbee, 1976
Claude-Joseph Vernet, 1714–1789, exhibition catalogue by Philip Conisbee, Kenwood, London, 1976.

Constans, 1980
Claire Constans, *Musée national du château de Versailles. Catalogue des peintures*, Paris, 1980.

Crelly, 1962
William R. Crelly, *The Paintings of Simon Vouet*, New Haven and London, 1962.

Dacier, 1929–1931
Émile Dacier, *Gabriel de Saint-Aubin. Peintre, dessinateur et graveur (1724–1780)*, Paris and Brussels, I, 1929, II, 1931.

Dacier, Hérold, Vuaflart
Émile Dacier, Jacques Hérold, and Albert Vuaflart, *Jean de Jullienne et les graveurs de Watteau au XVIIIe siècle*. I, Hérold and Vuaflart, *Notices et documents biographiques*, Paris, 1929; II, Dacier and Vuaflart, *Historique*, Paris, 1922; III, Dacier and Vuaflart, *Catalogue*, Paris, 1922; IV, Dacier and Vuaflart, *Planches*, Paris, 1921.

Dandré-Bardon, 1765
Vie de Carle Vanloo, écuyer, chevalier de l'ordre de S. Michel, premier peintre du roi, directeur, recteur de l'Académie royale de peinture et de sculpture, et directeur des Élèves protégés par le roi. Lue par M. Dandré Bardon dans l'assemblée du 7 septembre 1765, Paris, 1765.

Davidson, 1975
Gail S. Davidson, "Some Genre Drawings by Jacques Stella: Notes on an Attribution," *Master Drawings*, XIII, 2, 1975, pp. 147–157, pls. 10–14.

Dayton, Ohio, 1971
French Artists in Italy, 1600–1900, exhibition catalogue by Jane van Nuis Cahill, Dayton Art Institute, Dayton, Ohio, 1971.

Dessins du Musée Atger, 1974
Dessins du Musée Atger conservés à la Bibliothèque de la Faculté de Médecine de Montpellier, exhibition catalogue by Yvonne Vidal with the assistance of Roseline Bacou and Lise Duclaux, Cabinet des Dessins, Musée du Louvre, Paris, 1974.

Dessins français du Metropolitan Museum, 1973
Dessins français du Metropolitan Museum of Art, New York. De David à Picasso, exhibition catalogue by Jacob Bean, Linda Gillies, and Cynthia Lambros, Musée du Louvre, Paris, 1973.

Dezallier d'Argenville, 1757
A.-J. Dezallier d'Argenville, *Voyage pittoresque de Paris ou indication de tout ce qu'il y a de plus beau dans cette grande ville en peinture, sculpture, et architecture*, third edition, Paris, 1757.

Diderot, 1984
Diderot et l'art de Boucher à David. Les Salons: 1759–1781, exhibition catalogue, Hôtel de la Monnaie, Paris, 1984.

Diderot, *Salons*, I
Jean Seznec and Jean Adhémar, eds., *Diderot Salons. Volume I. 1759, 1761, 1763*, second edition, Oxford, 1975.

Diderot, *Salons*, IV
Jean Seznec, ed., *Diderot Salons, Volume IV. 1769, 1771, 1775, 1781*, Oxford, 1967.

Dilke, 1902
Lady Dilke, *French Engravers and Draughtsmen of the XVIIIth Century*, London, 1902.

Dimier, 1928
Louis Dimier, ed., *Les peintres français du XVIIIe siècle. Histoire des vies et catalogue des oeuvres*, I, Paris and Brussels, 1928.

Dimier, 1930
Louis Dimier, ed., *Les peintres français du XVIIIe siècle. Histoire des vies et catalogue des oeuvres*, II, Paris and Brussels, 1930.

Drawings from Angers, 1977
The Finest Drawings from the Museums of Angers, exhibition catalogue, Heim Gallery, London, 1977.

Duclaux, 1975
Lise Duclaux, with the participation of Anne Prache, *Musée du Louvre. Cabinet des Dessins. Inventaire général des dessins. École française. XII. Nadar–Ozanne*, Paris, 1975.

Eidelberg, 1967
Martin P. Eidelberg, "Watteau's Use of Landscape Drawings," *Master Drawings*, V, 2, 1967, pp. 173–182, pls. 29–33.

Eisler, 1966
Colin Eisler, "Two Immortalized Landscapes—Watteau and the Recueil Jullienne," *The Metropolitan Museum of Art Bulletin*, January 1966, pp. 165–176.

Études, 1980
Études de la Revue du Louvre et des Musées de France, I. La donation Baderou au Musée de Rouen, Paris, 1980.

Fairfax Murray Publication, III
J. Pierpont Morgan Collection of Drawings by the Old Masters formed by C. Fairfax Murray, III, London, 1912.

Fenaille
Maurice Fenaille, *État général des tapisseries de la manufacture des Gobelins depuis son origine jusqu'à nos jours, 1600–1900*, 5 vols., Paris, 1903–1923.

Flemish Drawings and Prints, 1970
Flemish Drawings and Prints of the 17th Century, exhibition catalogue, The Metropolitan Museum of Art, New York, 1970.

Fogg Art Museum, 1980
French Drawings from a Private Collection: Louis XIII to Louis XVI, exhibition catalogue edited by Konrad Oberhuber and Beverly Schreiber Jacoby, Fogg Art Museum, Cambridge, Mass., 1980.

Franse tekenkunst, 1974
Franse tekenkunst van de 18de eeuw uit Nederlandse verzamelingen, exhibition catalogue, Rijksprentenkabinet, Amsterdam, 1974.

Friedlaender and Blunt, IV, 1963
The Drawings of Nicolas Poussin. Catalogue Raisonné. Edited by Walter Friedlaender and Anthony Blunt. Part Four. Studies for the Long Gallery. The Decorative Drawings. The Illustrations to Leonardo's Treatise. The Landscape Drawings. In Collaboration with John Shearman and Richard Hughes-Hallet, London, 1963.

Friedlaender and Blunt, V, 1974
The Drawings of Nicolas Poussin. Catalogue Raisonné. Edited by Walter Friedlaender and Anthony Blunt. Part Five. Drawings after the Antique. Miscellaneous Drawings. Addenda, London, 1974.

Gillies and Ives, 1972
French Drawings and Prints of the Eighteenth Century, exhibition catalogue by Linda Boyer Gillies and Colta Feller Ives, The Metropolitan Museum of Art, New York, 1972.

Goncourt, 1875
Edmond de Goncourt, Catalogue raisonné de l'oeuvre peint, dessiné et gravé d'Antoine Watteau, Paris, 1875.

Goncourt, 1880–1882
Edmond and Jules de Goncourt, L'art du dix-huitième siècle, third edition, Paris, I, 1880, II, 1882.

Goncourt, 1881
Edmond de Goncourt, La maison d'un artiste, 2 vols., Paris, 1881.

Grasselli and Rosenberg, Paris, 1984
Watteau, 1684–1721, exhibition catalogue by Margaret Morgan Grasselli and Pierre Rosenberg, with the assistance of Nicole Parmantier, Grand Palais, Paris, 1984–1985.

Grasselli and Rosenberg, Washington, 1984
Watteau, 1684–1721, exhibition catalogue by Margaret Morgan Grasselli and Pierre Rosenberg, with the assistance of Nicole Parmantier, National Gallery of Art, Washington, D.C., 1984.

Griseri, 1963
Mostra del barocco piemontese. II. Pittura, catalogue by Andreina Griseri, Turin, 1963.

Gruber, 1972
Alain-Charles Gruber, Les grandes fêtes et leurs décors à l'époque de Louis XVI, Geneva, 1972.

Guiffrey and Marcel
Jean Guiffrey and Pierre Marcel, Inventaire général des dessins du Musée du Louvre et du Musée de Versailles, 10 vols., Paris, 1907–1928. (The tenth volume brings the alphabetical inventory to Meissonier—Millet).

Guiraud, 1913
Lucien Guiraud, Dessins de l'école française du dix-huitième siècle provenant de la collection H[eseltine], Paris, 1913.

Hautecoeur, 1952
Louis Hautecoeur, Histoire de l'architecture classique en France. Tome IV. Seconde moitié du XVIIIe siècle, le style Louis XVI, 1750–1792, Paris, 1952.

Herding, 1970
Klaus Herding, Pierre Puget, das bildnerische Werk, Berlin, 1970.

Hérold, 1935
Jacques Hérold, Louis-Marin Bonnet (1756–1793). Catalogue de l'oeuvre gravé, Paris, 1935.

Heseltine, 1900
Drawings by François Boucher, Jean Honoré Fragonard, and Antoine Watteau in the Collection of J. P. H[eseltine], London, 1900.

d'Hulst, 1961
R.-A. d'Hulst, "Tekeningen van A. F. van der Meulen in het Metropolitan Museum te New York," Musées Royaux des Beaux-Arts, Bruxelles, Bulletin, X, no. 3–4, 1961, pp. 114–122.

Inventaire 17e siècle
Bibliothèque Nationale, Département des Estampes. Inventaire du fonds français, graveurs du XVIIe siècle, Paris, from 1939 onward.

Inventaire 18e siècle
Bibliothèque Nationale, Département des Estampes. Inventaire du fonds français, graveurs du XVIIIe siècle, Paris, from 1930 onward.

Jean-Richard, 1971
François Boucher, gravures et dessins provenant du Cabinet des Dessins et de la Collection Edmond de Rothschild au Musée du Louvre. Exposition organisée à l'occasion du bicentenaire de la mort de l'artiste, exhibition catalogue by Pierrette Jean-Richard, Musée du Louvre, Paris, 1971.

Jean-Richard, 1978
Pierrette Jean-Richard, Musée du Louvre. Cabinet des Dessins. Collection Edmond de Rothschild. Inventaire général des gravures. École française. I. L'oeuvre gravé de François Boucher dans la Collection Edmond de Rothschild, Paris, 1978.

Jean-Richard, 1985
Graveurs français de la seconde moitié du XVIIIe siècle. Collection Edmond de Rothschild, exhibition catalogue by Pierrette Jean-Richard, Musée du Louvre, Paris, 1985.

Kitson, 1980
Michael Kitson, "Further Unpublished Paintings by Claude," Burlington Magazine, CXXII, 1980, pp. 834–837.

Le Blanc
Ch. Le Blanc, Manuel de l'amateur d'estampes, 4 vols., Paris, 1854–1888.

Le Blanc, 1847
Charles Le Blanc, Catalogue de l'oeuvre de Jean Georges Wille, graveur . . ., Leipzig, 1847.

Le Brun, 1963
Charles Le Brun, 1619–1690, peintre et dessinateur, exhibition catalogue by Jacques Thuillier and Jennifer Montagu, château de Versailles, 1963.

Locquin, 1912
Jean Locquin, "Catalogue raisonné de l'oeuvre de Jean-Baptiste Oudry," *Archives de l'Art français*, VI, 1912, pp. i–viii, 1–209.

Locquin, 1978
Jean Locquin, *La peinture d'histoire en France de 1747 à 1785*, Paris, first edition, 1912, new edition, 1978.

London, Royal Academy, 1932
Exhibition of French Art, 1200–1900. Royal Academy of Arts, exhibition catalogue, London, 1932.

London, Royal Academy, 1933
Commemorative Catalogue of the Exhibition of French Art, 1200–1900. Royal Academy of Arts, London, January–March 1932, Oxford and London, 1933.

London, Royal Academy, 1968
France in the Eighteenth Century. Royal Academy of Arts, exhibition catalogue, London, 1968.

Lugt
Frits Lugt, *Les marques de collections de dessins et d'estampes . . . ,* Amsterdam, 1921.

Lugt Supp.
Frits Lugt, *Les marques de collections de dessins et d'estampes . . . Supplément,* The Hague, 1956.

Mallè, 1981
Luigi Mallè, *Stupinigi. Un capolavoro del Settecento europeo tra barocchetto e classicismo. Architettura, pittura, scultura, arredamento,* Turin, 1981.

Marseille, 1908
Philippe Auquier, *Ville de Marseille, Musée des Beaux-Arts. Catalogue des peintures, sculptures, pastels et dessins,* Marseille, 1908.

Marseille, 1978
La peinture en Provence au XVIIᵉ siècle, exhibition catalogue, Musée des Beaux-Arts, Palais Longchamp, Marseille, 1978.

Martin, 1908
Jean Martin, *Oeuvre de J.-B. Greuze. Catalogue raisonné, suivi de la liste des gravures exécutées d'après ses ouvrages,* Paris, 1908.

Méjanès and Vilain, 1973
Pierre-Charles Trémolières (Cholet, 1703–Paris, 1739), exhibition catalogue by Jean-François Méjanès and Jacques Vilain, with an introduction by Pierre Rosenberg, Musée de Cholet, 1973.

Metropolitan Museum, 1970
Masterpieces of Fifty Centuries. The Metropolitan Museum of Art, exhibition catalogue, The Metropolitan Museum of Art, New York, 1970.

Metropolitan Museum, European Drawings, 1943
European Drawings from the Collections of The Metropolitan Museum of Art, II, *Flemish, Dutch, German, Spanish, French, and British Drawings,* New York, 1943. (A portfolio of sixty-seven collotype reproductions.)

Metropolitan Museum, European Drawings, 1944
European Drawings from the Collections of The Metropolitan Museum of Art. Italian, Flemish, Dutch, German, Spanish, French, and British Drawings, new series, New York, 1944. (A portfolio of forty-eight collotype reproductions.)

Metropolitan Museum Handbook, 1895
The Metropolitan Museum of Art, Hand-Book No. 8. Drawings, Water-Color Paintings, Photographs and Etchings, Tapestries, etc., New York, 1895. (An unillustrated, summary checklist of the 882 European drawings then in the Museum's collection; they were all apparently at that time on exhibition. The introductory note warns that "the attributions of authorship are by former owners.")

Mongan, 1962
Agnes Mongan, *Great Drawings of All Time,* III, *French,* New York, 1962.

Munhall, 1976
Jean-Baptiste Greuze, 1725–1805, exhibition catalogue by Edgar Munhall, Wadsworth Atheneum, Hartford, California Palace of the Legion of Honor, San Francisco, Musée des Beaux-Arts, Dijon, 1976–1977.

Néo-Classicisme français, 1974
Le néo-classicisme français. Dessins des musées de province, exhibition catalogue, Grand Palais, Paris, 1974–1975.

Notable Acquisitions
The Metropolitan Museum of Art, Notable Acquisitions, New York, from 1975 to the present.

Opperman, 1977
Hal N. Opperman, *Jean-Baptiste Oudry,* 2 vols., New York and London, 1977.

Opperman, 1982
J.-B. Oudry, 1686–1755, exhibition catalogue by Hal Opperman, Grand Palais, Paris, 1982–1983.

Paris, 1900
Exposition universelle de 1900. Exposition rétrospective de la ville de Paris, exhibition catalogue, Paris, 1900.

Paris, 1984
Dessins français du XVIIᵉ siècle, exhibition catalogue, Cabinet des Dessins, Musée du Louvre, Paris, 1984–1985.

Paris, École des Beaux-Arts, 1879
Catalogue descriptif des dessins de maîtres anciens exposés à l'École des Beaux-Arts, mai–juin 1879, second edition, Paris, 1879.

Paris, Lille, Strasbourg, 1976
Cent dessins français du Fitzwilliam Museum, Cambridge, exhibition catalogue by Duncan Robinson, Galerie Heim, Paris, Palais des Beaux-Arts, Lille, Musée des Beaux-Arts, Strasbourg, 1976.

Parker, 1931
K. T. Parker, *The Drawings of Antoine Watteau,* London, 1931.

Parker and Mathey, 1957
K. T. Parker and J. Mathey, *Antoine Watteau. Catalogue complet de son oeuvre dessiné,* 2 vols., Paris, 1957.

Philadelphia, 1980
A Scholar Collects. Selections from the Anthony Morris Clark Bequest, exhibition catalogue edited by Ulrich W. Hiesinger and Ann Percy, Philadelphia Museum of Art, 1980.

Piranèse et les français, 1976
Académie de France à Rome. *Piranèse et les français, 1740–1790,* exhibition catalogue, Villa Medici, Rome, 1976.

Popham, 1935
A. E. Popham, *Catalogue of Drawings in the Collection Formed by Sir Thomas Phillipps, Bart., F.R.S., now in the Possession of His Grandson T. Fitzroy Phillipps Fenwick of Thirlestaine House,* Cheltenham, n.p., 1935.

Populus, 1930
Bernard Populus, *Claude Gillot (1673–1722). Catalogue de l'oeuvre gravé,* Paris, 1930.

Portalis, 1889
Baron Roger Portalis, *Honoré Fragonard, sa vie et son oeuvre,* Paris, 1889.

Réau, 1938
Louis Réau, "Carle Vanloo (1705–1765)," *Archives de l'Art français,* XIX, 1938, pp. 7–96.

Reinach, 1895
Salomon Reinach, *Pierres gravées des collections Marlborough et d'Orléans, des recueils d'Eckhel, Gori, Lévesque de Gravelle, Mariette, Millin, Stosch, réunies et rééditées avec un texte nouveau,* Paris, 1895.

Reynaud, 1981
Nicole Reynaud, *Jean Fouquet (Les dossiers du département des peintures,* 22), Musée du Louvre, Paris, 1981.

Roland Michel, 1979
Marianne Roland Michel, "Cochin illustrateur, et le missel de la chapelle royale," *Jahrbuch der Berliner Museen,* XXI, 1979, pp. 153–179.

Roli and Sestieri, 1981
Renato Roli and Giancarlo Sestieri, *I disegni italiani del Settecento. Scuole piemontese, lombarda, genovese, bolognese, toscana, romana e napoletana,* Treviso, 1981.

Rome in the 17th Century, 1976
Roman Artists of the 17th Century: Drawings and Prints, exhibition catalogue, The Metropolitan Museum of Art, New York, 1976.

Rome in the 18th Century, 1978
Artists in Rome in the 18th Century: Drawings and Prints, exhibition catalogue, The Metropolitan Museum of Art, New York, 1978.

Rosenberg, 1966
Pierre Rosenberg, *Inventaire des collections publiques françaises. 14. Rouen, Musée des Beaux-Arts. Tableaux français du XVII^ème siècle et italiens des XVII^ème et XVIII^ème siècles,* Paris, 1966.

Rosenberg, 1971
Pierre Rosenberg, *I disegni dei maestri. Il Seicento francese,* Milan, 1971.

Rosenberg, 1972
French Master Drawings of the 17th and 18th Centuries in North American Collections, introduction and catalogue by Pierre Rosenberg, Toronto, 1972. (No drawings from the Metropolitan Museum figured in this exhibition, but many are referred to in the catalogue entries.)

Rosenberg, 1979
Pierre Rosenberg, "Dieu as a Draughtsman," *Master Drawings,* XVII, 2, 1979, pp. 161–169, pls. 33–47.

Rosenberg and Bergot, 1981
French Master Drawings from the Rouen Museum, from Caron to Delacroix, exhibition catalogue by Pierre Rosenberg and François Bergot, National Gallery of Art, Washington, D.C., 1981.

Rosenberg, Reynaud, Compin, 1974
Pierre Rosenberg, Nicole Reynaud, Isabelle Compin, *Musée du Louvre. Catalogue illustré des peintures. École française XVII^e et XVIII^e siècles,* 2 vols., Paris, 1974.

Rosenberg and Schnapper, 1970
Jean Restout (1692–1768), exhibition catalogue by Pierre Rosenberg and Antoine Schnapper, Musée des Beaux-Arts, Rouen, 1970.

Rosenfeld, 1981
Largillierre and the Eighteenth-Century Portrait, exhibition catalogue by Myra Nan Rosenfeld, foreword by Pierre Rosenberg, with contributions by Inna S. Nemilova, Hal N. Opperman, and Antoine Schnapper, Montreal Museum of Fine Arts, 1981 [1982].

Roserot, 1910
Alphonse Roserot, *Edme Bouchardon,* Paris, 1910.

Röthlisberger, 1961
Marcel Röthlisberger, *Claude Lorrain. The Paintings,* 2 vols., New Haven, 1961.

Röthlisberger, *Art Quarterly,* 1961
Marcel Röthlisberger, "Drawings by Claude Lorrain in American Museums," *Art Quarterly,* XXIV, 4, 1961, pp. 346–355.

Röthlisberger, 1968
Marcel Roethlisberger, *Claude Lorrain. The Drawings,* 2 vols., Berkeley and Los Angeles, 1968.

Röthlisberger and Cecchi, 1975
Marcel Röthlisberger and Doretta Cecchi, *L'opera completa di Claude Lorrain,* Milan, 1975.

Rotterdam, Paris, New York, 1958–1959
French Drawings from American Collections, Clouet to Matisse, exhibition catalogue, Museum Boymans-van Beuningen, Rotterdam, Musée de l'Orangerie, Paris, The Metropolitan Museum of Art, New York, 1958–1959. (Catalogue numbers are the same in the Dutch, French, and American editions, but the plate numbers in the French edition differ from those cited here.)

Rouen, 1984
Choix de dessins français du XVII^e siècle. Collection du musée, exhibition catalogue by Marie-Pierre Foissy-Aufrère, Musée des Beaux-Arts, Rouen, 1984.

Rubin, 1977
Eighteenth-Century French Life-Drawing. Selections from the Collection of Mathias Polakovits, exhibition catalogue by James Henry Rubin in collaboration with David Levine, The Art Museum, Princeton University, 1977. (Two drawings from the Metropolitan Museum were reproduced in the introduction to this catalogue, but they were not exhibited.)

Russell, 1982
Claude Lorrain, 1600–1682, exhibition catalogue by H. D. Russell, National Gallery of Art, Washington, D.C., 1982–1983.

Russell, 1983
Claude Gellée dit Le Lorrain, 1600–1682, exhibition catalogue by H. D. Russell, Grand Palais, Paris, 1983.

Sahut, 1977
Carle Vanloo, premier peintre du roi (Nice, 1705–Paris, 1765), exhibition catalogue by Marie-Catherine Sahut, with an introduction by Pierre Rosenberg, Nice, Clermont-Ferrand, and Nancy, 1977. (This exemplary compilation constitutes a *catalogue raisonné* of Vanloo's production, though many works, including the drawings now in the Metropolitan, did not figure in the exhibition.)

Saint-Aubin, 1975
Prints and Drawings by Gabriel de Saint-Aubin, 1724–1780, exhibition catalogue by Victor Carlson, Ellen D'Oench, and Richard S. Field, Davison Art Center, Wesleyan University, Middletown, Connecticut, and Baltimore Museum of Art, 1975.

Saint-Paul—Saint-Louis, 1985
Saint-Paul—Saint-Louis. Les Jésuites à Paris, exhibition catalogue, Musée Carnavalet, Paris, 1985.

Sandoz, 1981
Marc Sandoz, *Gabriel Briard (1725–1777), avec des remarques liminaires sur Jean-Baptiste Alizard, Jean-François Amand, Jean Bardin, Jean-Simon Berthélemy, Nicolas-Guy Brenet, Jacques-Louis David, Philibert-Benoît De La Rue, Charles De La Traverse, Jean-Baptiste Deshays, Gabriel-François Doyen, Louis Durameau, Jean-Honoré Fragonard, Pierre-Charles Jombert, Simon Julien, Jean-Jacques Lagrenée (le jeune), Louis Lagrenée (l'aîné), Étienne Lavallée-Poussin, Anicet Lemonnier, Guillaume Ménageot, Charles Monnet, Jean-Pierre Norblin, Jean-François Peyron, Jean-Bernard Restout, Jean-Baptiste Suvée, François-André Vincent*, Paris, 1981.

Sandoz, 1983
Marc Sandoz, *Les Lagrenée. I. Louis (Jean, François) Lagrenée, 1725–1805, avec des remarques liminaires sur Jean-Baptiste Alizard, Jacques-François Amand, Jean-Simon Berthélemy, Nicolas-Guy Brenet, Gabriel Briard, Antoine-François Callet, Jacques-Louis David, Philibert-Benoît De La Rue, Jean-Baptiste Deshays, Gabriel Doyen, Louis-Jacques Durameau, Honoré Fragonard, Jean-Jacques Lagrenée, Étienne Lavallée-Poussin, Charles Monnet, Jean-Pierre Norblin, Jean-François Peyron, Joseph-Benoît Suvée, François-André Vincent*, Paris, 1983.

Schnapper, 1974
Antoine Schnapper, *Jean Jouvenet, 1644–1717, et la peinture d'histoire à Paris*, Paris, 1974.

Sheafer Collection, 1975
The Lesley and Emma Sheafer Collection. A Selective Presentation, exhibition catalogue by Yvonne Hackenbroch and James Parker, The Metropolitan Museum of Art, New York, 1975.

Shoolman and Slatkin, 1950
Regina Shoolman and Charles E. Slatkin, *Six Centuries of French Master Drawings in America*, New York, 1950.

Slatkin, 1973
François Boucher in North American Collections: 100 Drawings, exhibition catalogue by Regina Shoolman Slatkin, National Gallery of Art, Washington, D.C., Art Institute of Chicago, 1973–1974.

Souchal, 1977
François Souchal, *French Sculptors of the 17th and 18th Centuries. I. The Reign of Louis XIV. Illustrated Catalogue, A–F*, Oxford, 1977.

Souchal, 1981
François Souchal, *French Sculptors of the 17th and 18th Centuries. II. The Reign of Louis XIV. Illustrated Catalogue, G–L*, Oxford, 1981.

Sterling, 1955
Charles Sterling, *The Metropolitan Museum of Art. A Catalogue of French Paintings, XV–XVIII Centuries*, New York, 1955.

Stern, 1930
Jean Stern, *À l'ombre de Sophie Arnould. François-Joseph Belanger, architecte des Menus-Plaisirs, premier architecte du comte d'Artois*, 2 vols., Paris, 1930.

Storrs, 1973
The Academy of Europe. Rome in the 18th Century, exhibition catalogue by Frederick den Broeder, William Benton Museum of Art, University of Connecticut, Storrs, 1973.

Sutton, 1980
François Boucher, exhibition catalogue by Denys Sutton, Wildenstein, New York, 1980.

Thomas, 1961
The Eighteenth Century. One Hundred Drawings by One Hundred Artists, exhibition catalogue by Hylton Thomas, University Gallery, University of Minnesota, Minneapolis, 1961.

Thuillier, 1974
Jacques Thuillier, *L'opera completa di Poussin*, Milan, 1974.

Thuillier, 1981
Jacques Thuillier, "Charles Mellin 'très excellent peintre,'" *Les fondations nationales dans la Rome pontificale (Collection de l'École française de Rome, 52)*, Rome, 1981, pp. 583–684.

Thuillier, 1982
Claude Lorrain e i pittori lorenesi in Italia nel XVII secolo, exhibition catalogue by Jacques Thuillier, Académie de France, Rome, 1982.

Tietze, 1947
Hans Tietze, *European Master Drawings in the United States*, New York, 1947.

Van der Kemp, 1981
Gérald Van der Kemp, *Versailles*, New York, 1981.

Van Hasselt, 1961
150 Tekeningen uit vier eeuwen uit der verzameling van Sir Bruce en Lady Ingram, exhibition catalogue by Carlos van Hasselt, Museum Boymans-van Beuningen, Rotterdam, Rijksmuseum, Amsterdam, 1961–1962.

Venturi
Adolfo Venturi, *Storia dell'arte italiana*, 11 vols., from VI onward subdivided into parts, Milan, 1901–1939.

Verlet, 1961
Pierre Verlet, *Versailles*, Paris, 1961.

Virch, 1960
Claus Virch, "The Walter C. Baker Collection of Master Drawings," *The Metropolitan Museum of Art Bulletin*, June 1960, pp. 309–317.

Virch, 1962
Claus Virch, *Master Drawings in the Collection of Walter C. Baker*, New York, 1962.

Waterhouse, 1976
Ellis Waterhouse, *Roman Baroque Painting, a List of the Principal Painters and Their Works in and around Rome*, Oxford, 1976.

Wehle, 1924
H. B. W[ehle], "The Bequest of Anne D. Thomson," *The Metropolitan Museum of Art Bulletin*, March 1924, p. 64.

Wild, 1980
Doris Wild, *Nicolas Poussin*, 2 vols., Zurich, 1980.

Wildenstein, 1924
Georges Wildenstein, *Lancret*, Paris, 1924.

Williams, 1939
H. W. Williams, Jr., "Some French Drawings from the Biron Collection," *Art Quarterly*, II, 1, 1939, pp. 48–56.

Williams, 1978
Drawings by Fragonard in North American Collections, exhibition catalogue by Eunice Williams, National Gallery of Art, Washington, D.C., Fogg Art Museum, Cambridge, Massachusetts, 1978–1979.

Notices and Illustrations

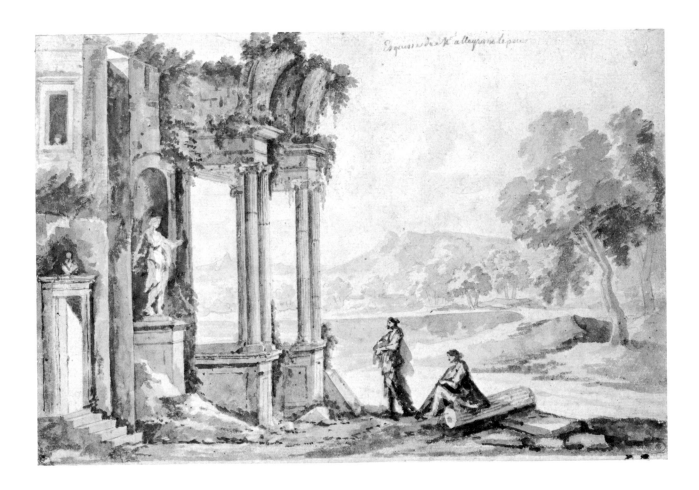

ÉTIENNE ALLEGRAIN

Paris 1644 – Paris 1736

1. *Ruins of a Temple by a Lake*

Brush and gray wash, over graphite. 19.1 x 29.5 cm. Repaired tears and losses. Lined.

Inscribed in pen and brown ink at upper right margin, *Esquisse de M^r allegrain le père*.

PROVENANCE: Charles Gasc (Lugt 543); Kaïeman (according to Chennevières); marquis de Chennevières (Lugt 2072); Chennevières sale, Paris, Hôtel Drouot, April 4–7, 1900, part of no. 6, "Ruines d'un temple antique au bord d'un lac"; Pierre Guéraud (according to vendor; mark, an interlaced PG, not in Lugt); [Paul Prouté]; [Galerie de Bayser]; purchased in Paris in 1981.

BIBLIOGRAPHY: Chennevières, *L'Artiste*, XII, 1896, part XV, p. 42, "Autre *Esquisse de M. Allegrain le père*, mots tracés de la même main que sur le dessin précédent: Ruines d'un temple antique au bord d'un lac; dans une niche est restée debout sur son piédestal la statue d'une Déesse que considèrent deux femmes, dont l'une est assise sur une colonne renversée. Au pinceau et à l'encre de Chine. Coll. Kaïeman"; *Catalogue "Domenico" 1980. Paul Prouté*, Paris, 1980, no. 25, repr.; *Exposition de dessins et sculptures de maîtres anciens, 1980. Galerie de Bayser*, Paris, 1980, no. 1, repr.; *Annual Report*, 1980–1981, p. 27.

Harry G. Sperling Fund, 1981
1981.15.1

The old inscription ascribes the drawing to Allegrain le père, in other words Étienne rather than his son Gabriel, who was also a specialist in landscape painting. The attribution seems very plausible; the broad pictorial treatment of the landscape and the elegant, rather elongated figures are similar to those in Étienne Allegrain's paintings.

The marquis de Chennevières possessed another brush drawing by Étienne Allegrain, "Paysage dans le goût du Poussin et du Guaspre." This erudite collector reported that the attribution to Allegrain le père was in the same hand as that on our drawing. Unfortunately, the present location of this second drawing is not known to us.

GILLES ALLOU

Paris 1670 – Paris 1751

2. *The Sculptor Antoine Coysevox*

Pen and brown ink, gray and brown wash, heightened with white, on blue paper faded to brown. 17.4 x 13.2 cm. Abrasions and losses at center right and lower left margins. Lined.

Inscribed in pen and brown ink on reverse of old mount, *Portrait du célèbre Antoine Coysevox, Sculpteur | natif de Lyon en 1640 et mort en 1720. à 80 ans | les jardins et la grande gallerie de versailles sont | ornés de ses ouvrages. | il a aussi exécuté les magnifiques groupes placés | à l'entré du jardin des thuilleries représentant l'un | la renomée sur un cheval ailé; l'autre Mercure | sur Pégase. | Ce grand homme relevoit l'éclat de son rare mérite, | par un dehors simple, une probité scrupuleuse, et | une modestie aimable. il fut élevé a la dignité de | Chancellier dans l'académie de Peinture et Sculpture | qui le recut dans son sein en 1676.*

PROVENANCE: [Cailleux]; [Michael Hall]; Mr. and Mrs. Charles Wrightsman.

BIBLIOGRAPHY: *Annual Report*, 1971–1972, p. 40; Bean, 1972, p. 26, no. 60.

Gift of Mr. and Mrs. Charles Wrightsman, 1971
1971.206.1

The drawing may well be a preparatory study for Allou's painted portrait of Coysevox, from which it differs in

several details. The painting, which was one of the three portraits submitted by Allou on his reception into the Academy in 1711, is now in the Musée de Versailles (Constans, 1980, no. 202). The sculpture in the background at right is a reduction of the figure of Fame, one of a pair of over-life-size equestrian groups by Coysevox, originally at Marly, but since 1719 at an entrance to the Tuileries gardens in Paris (Souchal, 1977, p. 210, figs. 77–78).

ANGO

? – Rome after 1773 ?

3. *Scene of Martyrdom, after Giovanni Angelo Canini*

Red chalk, over traces of black chalk. 38.0 x 30.5 cm. Lined.

Inscribed in red chalk at lower right in the artist's hand, *Maria Angeli | Caninius.*

PROVENANCE: [Jeudwine]; purchased in London in 1965.

BIBLIOGRAPHY: *Exhibition of Old Master Drawings. W. R. Jeudwine*, London, 1965, no. 28; *Annual Report*, 1965–1966, p. 75; *Rome in the 18th Century*, 1978, n.pag. [6].

Rogers Fund, 1965
65.112.6

Copy after one of two frescoes by Giovanni Angelo Canini in the apse of S. Francesca Romana, Rome, that represent the martyrdom of Sts. Nemesius, Olympius, Sempronius, Lucilla, Exuperia, and Theodulus (Waterhouse, 1976, p. 61). Ango has copied the fresco on the left (repr. *Arte Illustrata*, IV, 43–44, 1971, p. 12, fig. 4), and he has mistakenly situated the painting in *Maria Angeli* (S. Maria degli Angeli).

Jean-François Méjanès points out that in the Cabinet des Dessins of the Louvre there is a black chalk copy by Ango of the central kneeling female martyr in the Canini fresco (Inv. 23577; Guiffrey and Marcel, I, 1907, p. 12, no. 65, repr. p. 13).

4

3

4. *The Infant Moses before Pharaoh, after Giovanni Battista Ruggieri*

Black chalk. Framing lines in pen and brown ink. 13.7 x 21.5 cm. Lined.

Inscribed in black chalk at lower left, *le Poussin. Palais Justiniani.*

PROVENANCE: Eugene Victor Thaw.

BIBLIOGRAPHY: *Annual Report*, 1961–1962, p. 66, as Fragonard; Ananoff, 1968, no. 1876; Dayton, Ohio, 1971, no. 17, repr., as Fragonard; *Rome in the 18th Century*, 1978, n.pag. [10], as Fragonard.

Gift of Eugene Victor Thaw, 1961
61.234

Alexandre Ananoff was the first to point out that this is a typical copy by Ango, probably produced for the abbé de Saint-Non, though not reproduced in the *Griffonis*.

In the eighteenth century, the painting, now in the Neues Palais, Potsdam, hung in the Palazzo Giustiniani, Rome, and it was then mistakenly attributed to Poussin (L. Salerno, *Burlington Magazine*, CII, 1960, p. 139, fig. 3, p. 146).

PIERRE-ANTOINE BAUDOUIN

Paris 1723 – Paris 1769

5. *Le Matin*

Gouache, over traces of graphite. 26.0 x 20.0 cm. Paper pasted onto board. Surface abraded at margins.

PROVENANCE: George and Florence Blumenthal; Blumenthal sale, Paris, Hôtel Drouot, April 5–6, 1933, no. 6, "d'après Baudouin," presumably bought in; Ann Payne Blumenthal.

BIBLIOGRAPHY: *Blumenthal Collection Catalogue*, V, 1930, pl. X; Gillies and Ives, 1972, no. 1.

Gift of Ann Payne Blumenthal, 1943
43.163.19

Emmanuel de Ghendt etched four compositions by Baudouin representing the four parts of the day: *Matin*, *Midi*, *Soir*, and *Nuit* (E. Bocher, *Pierre-Antoine Baudouin*, Paris, 1875, nos. 32, 33, 46, and 35, respectively). This and the following gouache drawing (No. 6 below) may have been the models used for two of these reproductive prints; the latter are smaller, in reverse direction, and differ in detail from our gouache drawings.

5

6

PIERRE-ANTOINE BAUDOUIN (NO. 5)

The Goncourt brothers possessed a free pen and water-color sketch for *Le matin* (Goncourt sale, Paris, February 15–17, 1897, no. 7, repr.).

6. *La Nuit*

Gouache. 25.9 x 20.0 cm. Paper pasted onto board. Surface abraded at margins.

PROVENANCE: George and Florence Blumenthal; Blumenthal sale, Paris, Hôtel Drouot, April 5–6, 1933, no. 7, "d'après Baudouin," presumably bought in; Ann Payne Blumenthal.

BIBLIOGRAPHY: *Blumenthal Collection Catalogue*, V, 1930, pl. X; Gillies and Ives, 1972, no. 2.

Gift of Ann Payne Blumenthal, 1943
43.163.20

See No. 5 above.
The statue at upper left is Falconet's *Amour menaçant*.

FRANÇOIS-JOSEPH BELANGER

Paris 1744 – Paris 1818

7. *The Anointing of Louis XVI at His Coronation in Reims Cathedral, June 11, 1775*

Pen and black ink, gray wash, over light indications made with a stylus. 21.3 x 30.3 cm. Framing lines in pen and brown ink. Lined.

Inscribed in pen and gray ink in cartouche at lower margin of old mount, *Sacre de Louis XVI. | Cérémonie des Onctions*; in pen and black ink on a strip of blue paper pasted onto lower margin of old mount, *Mgr le Maréchal Duc de Duras, Pair de France, premier gentilhomme de la chambre de Sa Majesté, avait ordonné que l'Église Metropolitaine de Reims | fut disposée pour le cérémonial du Sacre de Louis XVI qui eut lieu le 11 Juin 1775 Belanger Architecte alors dessinateur breveté des menus plaisirs, | Dessinateur du cabinet de Monsieur et du Cabinet de Mgr Ch. Ph. d'Artois, fut chargé de fixer la représentation de cet auguste cérémonial par les dessins | qu'il a l'honneur d'offrir à Monseigneur le duc de Duras, Pair de France, premier gentilhomme de la chambre de Sa Majesté Louis XVIII. ce 11 Juin 1814.*

PROVENANCE: Duc de Duras; baron Edmond de Rothschild (according to Stern); [Cailleux]; purchased in Paris in 1984.

BIBLIOGRAPHY: Stern, 1930, I, p. 50, repr. opp. p. 48; Gruber, 1972, pp. 96, 196–197, fig. 60; *Annual Report*, 1983–1984, p. 24.

Van Day Truex Fund, 1984
1984.78

According to the dedicatory inscription, this drawing was executed by Belanger, *dessinateur breveté des Menus-Plaisirs*, for Emmanuel-Félicité, duc de Duras, who as *premier gentilhomme de la chambre du roi* supervised the coronation of Louis XVI that took place in Reims on June 11, 1775. The drawing, perhaps intended for engraving,

seems to have been retained by Belanger. In any case it was presented by him on June 11, 1814, to Amédée-Bretagne-Malo, duc de Duras, who was then *premier gentilhomme de la chambre du roi*, an office to which he had been appointed at the death of his grandfather Emmanuel-Félicité in 1789.

According to Jean Stern, the baron Edmond de Rothschild possessed two further drawings by Belanger representing the interior of Reims cathedral on the occasion of the coronation in 1775 (Stern, 1930, I, p. 50, note 2). One of these, *Vue de la cathédrale de Reims du côté du jubé*, is now in the Cabinet des Estampes, Bibliothèque Nationale, Paris (repr. *Catalogue "Dandré Bardon"* 1975. *Paul Prouté*, Paris, 1975, p. 18, no. 41).

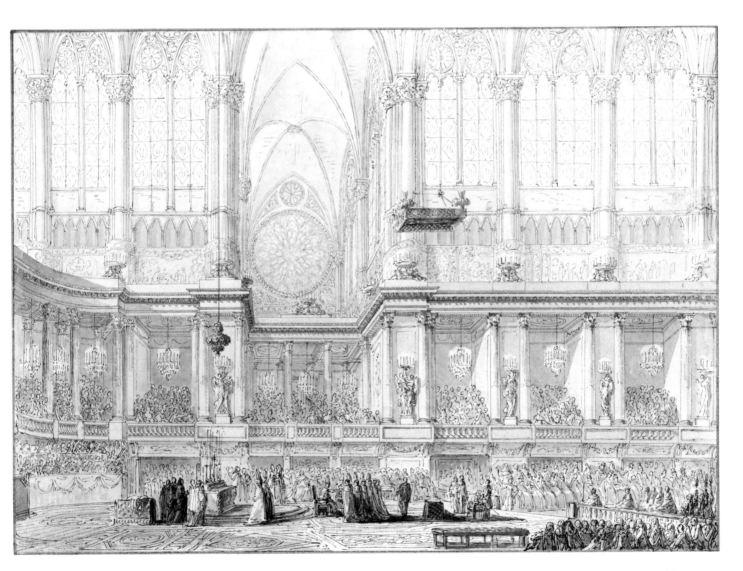

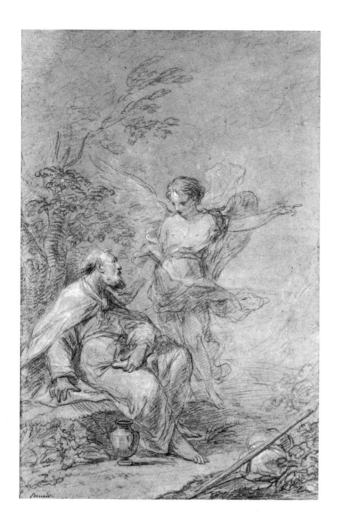

JOSEPH BERNARD,
called Bernard de Paris

Lunéville 1740 – Saint-Cloud 1809

9. *Portrait in the Calligraphic Manner: Mme Dugazon as Nina*

Pen and black ink, gray wash, some watercolor (the bust); pen and brown ink, faded green wash (the frame). 46.1 x 36.1 cm.

Inscribed in pen and brown ink at lower margin of frame, *M^{me} Dugazon dans Nina · / · Bernard. 1788.*

PROVENANCE: Augustin Fries; purchased in New York in 1967.

BIBLIOGRAPHY: *Annual Report*, 1967–1968, p. 87.

Rogers Fund, 1967
67.196

BENARD

18th century

8. *Elijah Visited by an Angel in the Wilderness* (I Kings 19:4–8)

Black chalk, heightened with white, on beige paper. 38.7 x 25.1 cm. Water stain at upper left corner. Lined.

Inscribed in pen and brown ink at lower left corner, *Benard.*

PROVENANCE: [Galerie de Bayser]; purchased in Paris in 1982.

BIBLIOGRAPHY: *Annual Report*, 1981–1982, p. 22.

Purchase, Mrs. Carl L. Selden Gift, in memory of Carl L. Selden, 1982
1982.61

We have been unable to identify *Benard*, whose refined drawing style reveals the influence of Jean Restout and François Lemoine.

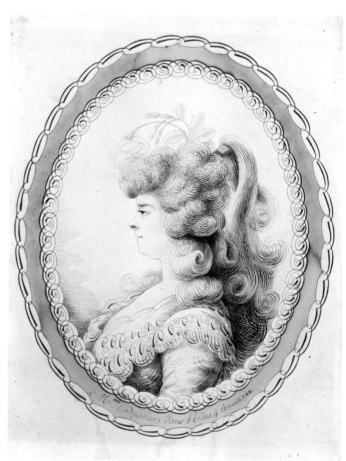

One of the most successful roles of Louise-Rose Lefèvre, *épouse* Dugazon, *actrice chantante* at the Théâtre italien in Paris, was that of *Nina ou la Folle par amour*, a prose comedy interspersed with songs that opened in 1786.

In that year Claude Hoin executed a gouache drawing of Mme Dugazon on stage as Nina; it was reproduced in a color print by Janinet published in 1787 (Jean-Richard, 1985, no. 122, repr.). Another gouache by Hoin portraying Mme Dugazon in the same role, dated 1789, was in the Goncourt collection (Goncourt sale, Paris, February 15–17, 1897, no. 125, repr.).

THOMAS BLANCHET

Paris 1614 ? – Lyon 1689

10. *Half Figure of a Woman Holding a Pair of Shears*

Red chalk, heightened with white, on brown paper. 27.0 x 16.0 cm. (overall). A strip of brown-washed paper about 3.0 cm. wide has been added at left margin. Lined.

Signed and dated in pen and brown ink at lower margin, *Thomas Blanchet in. Lugduni 1660.*

PROVENANCE: Pierre Crozat ? (2730 with paraph, Lugt 2951); [Feist]; purchased in New York in 1965.

BIBLIOGRAPHY: *Annual Report*, 1965–1966, p. 75.

Rogers Fund, 1965
65.159

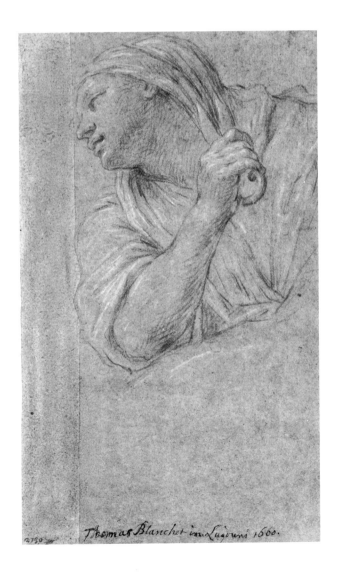

The figure may well represent one of the three Fates, Atropos with her shears. Jennifer Montagu points out that an old description of the now-destroyed paintings on the north wall of the staircase of the Hôtel de Ville in Lyon mentions a figure of Atropos cutting the thread she holds (letter of November 8, 1984). The contract for these decorations was signed in August 1661, while our drawing bears the date 1660.

Blanchet used a similar figure of Atropos, though reversed and with a number of variations, in the allegorical ceiling decoration in the Salle de la Nomination of the Hôtel de Ville, which was contracted for in 1675 (Chou Ling, *Thomas Blanchet*, Lyon, 1941, figs. 14–15).

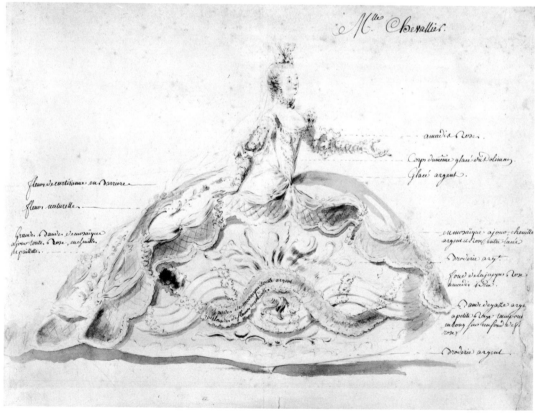

JEAN-JACQUES DE BOISSIEU

Lyon 1736 – Lyon 1810

11. *Farmyard*

Brush and brownish-gray washes, over traces of black chalk, on cream-colored paper. 27.5 x 36.9 cm.

PROVENANCE: French private collection (according to vendor); [Böhler]; purchased in Munich in 1978.

BIBLIOGRAPHY: *Julius Böhler. Ausstellung von Gemälden, Handzeichnungen, Plastiken in Holz, Terracotta und Bronze, Kunstgewerbe,* exhibition catalogue, Munich, 1978, no. 29, repr.; *Annual Report,* 1978–1979, p. 25.

Harry G. Sperling Fund, 1978
1978.411.1

LOUIS-RENÉ BOQUET

Paris 1717 – Paris 1814

12. *Costume for Mlle Chevalier*

Gray wash, yellow, blue, and a little red watercolor, over black chalk and a little graphite. 35.4 x 47.6 cm. Lower right margin replaced; scattered stains. Lined.

Inscribed in pen and brown ink at upper right, *M.^{lle} Chevallier.*; at left, *fleurs de cartisanne en Barriere | fleurs naturelles | Grandes Bandes de mosaïque | a jour toutes Rose | en chenilles et paillettes;* at lower center, *Bandes de mosaïque toute argent | guirlandes de fleurs naturelles;* at right, *amadis Roses | Corps du même glacé du Doliman. [?] | Glacé argent. | en mosaïque a jour, chenille | argent et Rose entre lacée | Broderie arg.^t | fond de la juppe Rose | amadis . . . | Bande de gaze arge . . . | a petite Raye tampon . . . | en long sur un fond de fl . . . | roses | Broderie argent.*

PROVENANCE: Charles-P. de Meurville; Meurville sale, Paris, Hôtel Drouot, salle 1, May 26–28, 1904, no. 64, "Boquet. Mademoiselle Chevalier en grand costume de danse pour le ballet du roi. Dessin colorié"; [Gahlin]; purchased in London in 1966.

BIBLIOGRAPHY: *Annual Report,* 1965–1966, p. 72; Y. Hackenbroch, *Connoisseur,* 196, September 1977, pp. 17–18, fig. 8.

Purchase, Mr. and Mrs. Charles Wrightsman Gift, 1966
66.91

Mlle Chevalier was a celebrated singer at the Paris Opéra, where she made her debut in 1741. Her career came to an abrupt conclusion in November 1755 when she sang out of tune; she is said to have been committed to an asylum in the following year.

The old attribution of the drawing to Boquet, who worked for the Menus-Plaisirs from 1748 as designer of

costumes for the Opéra, is quite plausible; this costume design is close in style to drawings by Boquet preserved in the Bibliothèque de l'Opéra, Paris (see M.-F. Christout in *Louis XV,* exhibition catalogue, Hôtel de la Monnaie, Paris, 1974, pp. 449–454).

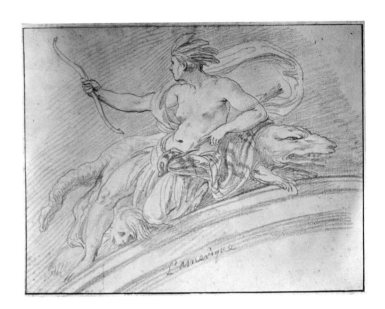

EDME BOUCHARDON

Chaumont (Haute-Marne) 1698 – Paris 1762

13. *Allegorical Figure of America*

Red chalk on beige paper. Framing lines in pen and brown ink. 25.7 x 34.5 cm. Repaired tear at lower left. Lined.

Inscribed in red chalk at lower center in the artist's hand, *L'amerique;* in pen and brown ink at lower left margin of old mount, *Bouchardon* —.

PROVENANCE: James Hazen Hyde.

BIBLIOGRAPHY: *Annual Report,* 1959–1960, p. 62.

Gift of Estate of James Hazen Hyde, 1959
59.208.91

Engraved in the same direction by Johann Justin Preissler as part of a set of the Four Continents after Bouchardon (Le Blanc, III, p. 245). The drawing and the engraving must date from Bouchardon's stay in Rome from 1723 to 1732; J. J. Preissler was in Italy from 1724 to 1731.

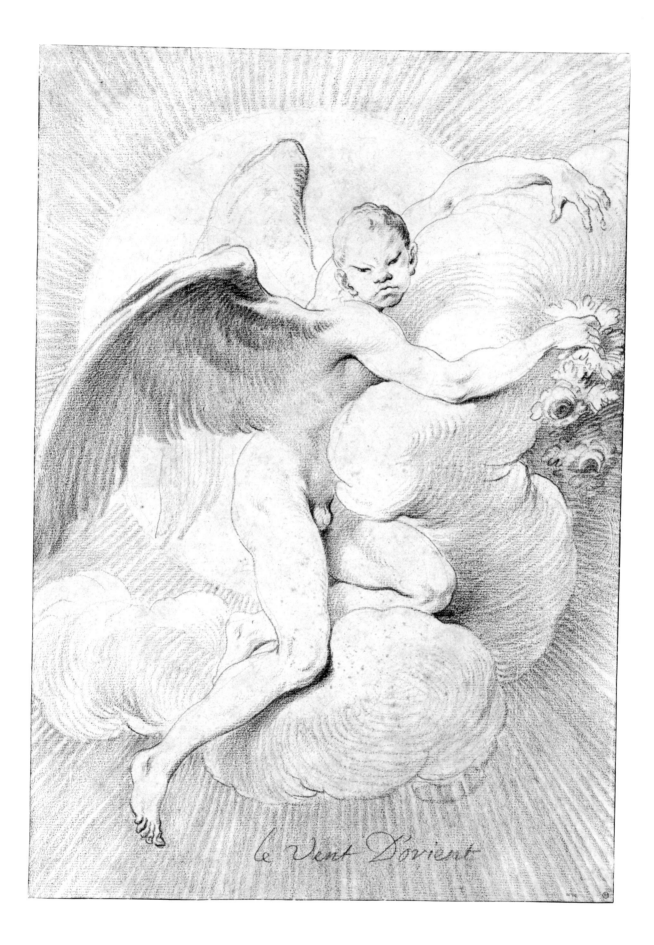

le Vent D'orient

EDME BOUCHARDON

14. *The East Wind*

Red chalk. Framing lines in pen and brown ink. 39.3 x 27.6 cm.
Scattered gray stains.

Inscribed in red chalk at lower center in the artist's hand, *le Vent
d'Orient*.

PROVENANCE: Pierre-Jean Mariette (Lugt 2097); Mariette sale,
Paris, 1775–1776, part of no. 1117, "Les quatre vents d'Orient,
d'Occident, etc. représentés par des Figures analogues à chaque Sujet";
Paul Gavarni (according to Goncourt); Edmond and Jules de Goncourt
(Lugt 1089); Goncourt sale, Paris, February 15–17, 1897, no. 18;
[Galerie de Bayser]; purchased in Paris in 1981.

BIBLIOGRAPHY: Goncourt, 1881, I, p. 50; *Exposition de dessins et
sculptures de maîtres anciens, 1980. Galerie de Bayser*, Paris, 1980, no. 4,
repr.; *Annual Report*, 1980–1981, p. 27; *Notable Acquisitions*, 1980–
1981, p. 49, repr.

Harry G. Sperling Fund, 1981
1981.15.2

P.-J. Mariette owned four drawings of personifications of
the winds by Bouchardon. To our knowledge, three have
survived; in addition to the present sheet with the *Vent
d'Orient*, there are red chalk representations of the *Vent de
Midy* and the *Vent d'Occident* from Mariette's collection in
the West Berlin Print Room (*Staatliche Museen, Preussi-
scher Kulturbesitz. Vom späten Mittelalter bis zu Jacques Louis
David. Neuerworbene und neubestimmte Zeichnungen im Ber-
liner Kupferstichkabinett*, exhibition catalogue, Berlin,
1973, nos. 169 and 170, repr.). The Winds in Berlin are
also represented as winged nude youths.

In the Nationalmuseum, Stockholm, there is a coun-
terproof of another representation of the *Vent d'Orient*
by Bouchardon. As here, the Wind is a cloud-borne,
winged, nude youth with an oriental cast of countenance;
but the pose of the figure is quite different (NM 64/1897,
as Larchevêque; *Nationalmuseum Bulletin*, V, 4, 1981, p.
159, fig. 9).

15. *The Sense of Smell*

Red chalk. Counterproof. Framing lines in pen and black ink. 38.5 x
28.7 cm. Horizontal crease at center. Lined.

Inscribed in pen and black ink in a cartouche at lower center of
Mariette mount, ODORATUS. / ED. BOUCHARDON / DELIN.

PROVENANCE: Pierre-Jean Mariette; Mariette sale, Paris, 1775–
1776, part of no. 1127, "Les contre-épreuves, à la sanguine, des cinq
sens de nature, représentés par des femmes debout sur un globe, avec
des attributs analogues; elles sont connues par les Estampes gravées

d'après par le C. de Caylus; les Dessins sont en Suede"; [Petit-Horry];
purchased in Paris in 1973.

BIBLIOGRAPHY: *Annual Report*, 1973–1974, p. 37; Bean, 1975, no.
34.

Harry G. Sperling Fund, 1973
1973.317.1

L'odorat is personified by a youth holding a flowering
plant (a rose with stylized leaves ?). At his feet, a dog
sniffs an acanthus-like plant for traces of an earlier canine
visitor.

The drawing was one of five counterproofs represent-
ing the Senses that figured in the Mariette sale in 1775–
1776, with the catalogue comment that the original
drawings were then in Sweden. Where these originals are
today is not known, and the four additional counterproofs
have disappeared as well.

Bouchardon's drawings were etched in the same direc-
tion as the originals by the comte de Caylus (*Inventaire 18ᵉ
siècle*, IV, pp. 63–64, no. 56). In the Mariette sale cata-
logue as well as in the Bibliothèque Nationale inventory,
the personifications of the five senses are all described as
female; in fact, both *L'odorat* and *La veuë* are represented
as boys, while *L'attouchement*, *Le goût*, and *L'oüye* are
young women.

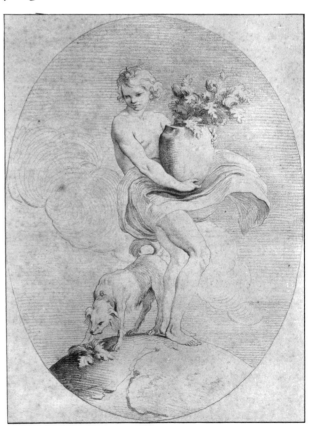

16. *Fountain Surmounted by Three Nymphs*

Red chalk on beige paper. 42.4 x 27.3 cm. A *pentimento* on white paper, measuring 14.2 x 18.2 cm., has been affixed at lower center, and includes the fountain base with dolphins. Creases at upper right and center left. Lined.

Inscribed in pen and brown ink on reverse of old mount, *Bouchardon*.

PROVENANCE: M.-G.-T. de Villenave; Villenave sale, Paris, Alliance des Arts, December 1, 1842, and following days, no. 617 (Lugt 61); [Galerie de Bayser]; [Ward-Jackson]; purchased in London in 1978.

BIBLIOGRAPHY: *Dessins de maîtres anciens, 1977. Galerie de Bayser*, Paris, 1977, no. 5, repr.; *Annual Report*, 1977–1978, p. 37.

Harry G. Sperling Fund, 1978
1978.27

There is a counterproof of this drawing in the Cabinet des Dessins, Musée du Louvre (Inv. 24270; Guiffrey and Marcel, II, 1908, no. 801, repr.; Roserot, 1910, pl. VII). Mary Myers points out that, on the Louvre counterproof, a hinged sheet at lower center records the design for the base of the fountain that figures in the pasted *pentimento* on our drawing. When the flap on the Louvre counterproof is lifted, an alternative design for the fountain base, with rearing dolphins about to swallow entwined snakes, is revealed.

An additional counterproof of our drawing is preserved in the James A. Rothschild collection at Waddesdon Manor (National Trust, Aylesbury, Bucks).

17. *Allegorical Figure of War*

Red chalk. 32.1 x 22.2 cm. Horizontal crease at center; scattered stains. Lined.

PROVENANCE: Marquis de Chennevières (Lugt 2073); Pierre Guéraud (according to vendor; mark, an interlaced PG, not in Lugt); [Galerie de Bayser]; purchased in Paris in 1979.

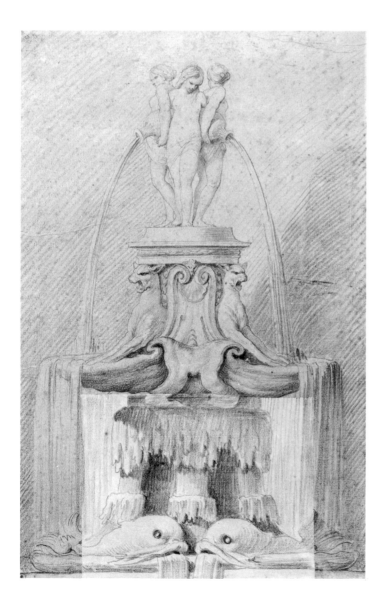

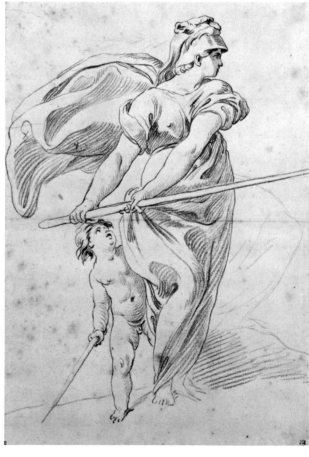

BIBLIOGRAPHY: Chennevières, *L'Artiste*, XIV, 1897, part XX, p. 99, "La Guerre représentée par une femme tenant une lance; derrière elle un enfant tenant une épée"; *Exposition de dessins de maîtres anciens et modernes*, 1978. *Galerie de Bayser*, Paris, 1978, no. 5, repr.; *Annual Report*, 1978–1979, p. 25.

Harry G. Sperling Fund, 1979
1979.10.1

18. *Sketch for a Token: Peace and Justice Triumphant over Discord*

Red chalk. Framing lines in pen and red ink; outside the circle the sheet is washed in red. 22.6 x 22.4 cm. Lined.

Faint red chalk inscription around border, SALUS REIPUBLICAE; in pen and black ink in a cartouche at lower center of Mariette mount, EDMUNDI / BOUCHARDON.

PROVENANCE: Pierre-Jean Mariette; Mariette sale, Paris, 1775–1776, part of no. 1143, "Douze Sujets de forme ronde, premières pensées de dessins, faits pour l'Académie des Inscriptions"; [Calmann]; purchased in London in 1961 with Nos. 19, 20, 21, 24, and 25 below.

BIBLIOGRAPHY: *Annual Report*, 1961–1962, p. 67; Ames, 1975, p. 382, fig. 3, pp. 383–384; J.-F. Méjanès in *Études*, 1980, p. 82.

Rogers Fund, 1961
61.165.2

Helmut Nickel points out that the arms on the altar are those of Geneva (parti per pale, on the dexter a halved eagle of the Empire, on the sinister a key). Above, the arms of Zurich on the left and Bern on the right flank the royal emblem of France with its three fleurs-de-lys. A more finished design for a similar composition—Peace, Justice, and Discord are present but not the Swiss and French arms—is in the Pierpont Morgan Library, New York (*Fairfax Murray Publication*, III, pl. 94; Ames, 1975, p. 382, fig. 4). The Morgan Library drawing bears the date 1738 in arabic numerals. Winslow Ames has suggested that both drawings are designs for a medal commemorating the Pacification of Geneva in 1738; however, the medal actually issued to commemorate this event is entirely different in subject and legend from the two drawings by Bouchardon (G.-R. Fleurimont, *Médailles du règne de Louis XV*, Paris [1749?], no. 56, the medal repr.).

19. *Sketch for a Token: Bâtiments du Roi, 1740*

Red chalk. Framing lines in pen and black ink; outside the circle the sheet is washed in red. 21.3 x 21.5 cm. Lined.

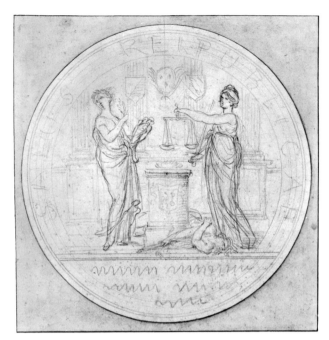

18

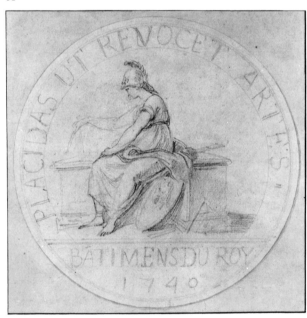

19

Inscribed in red chalk around border, PLACIDAS UT REVOCET ARTES / BÂTIMENS DU ROY / 1740; in pen and black ink in a cartouche at lower center of Mariette mount, EDMUNDUS / BOUCHARDON / SCULPT. REG.

PROVENANCE: See No. 18 above.

BIBLIOGRAPHY: *Annual Report*, 1961–1962, p. 67; J.-F. Méjanès in *Études*, 1980, p. 82.

Rogers Fund, 1961
61.165.3

Minerva is seated and holds a compass in her right hand.

There is a counterproof of Bouchardon's finished design for this *jeton* in the Cabinet des Estampes of the Bibliothèque Nationale, Paris (Pb 3 1 Rés, fol. 53).

20. *Sketch for a Token: Galères, 1740*

Red chalk. Framing lines in pen and black ink; outside the circle the sheet is washed in red. 21.4 x 21.6 cm. Lined.

Inscribed in red chalk around border, IRATIS PLACIDISQUE FRUUNTUR / GALERES / *1740*; in pen and black ink in a cartouche at lower center of Mariette mount, EDMUNDUS / BOUCHARDON.

PROVENANCE: See No. 18 above.

BIBLIOGRAPHY: *Annual Report*, 1961–1962, p. 67; J.-F. Méjanès in *Études*, 1980, p. 82.

Rogers Fund, 1961
61.165.5

Two tritons with conch shells are shown gamboling in the sea.

A counterproof of Bouchardon's finished design for this *jeton* is in the Cabinet des Estampes, Bibliothèque Nationale, Paris (Pb 3 1 Rés, fol. 54).

21. *Sketch for a Token: Maison de la Reine, 1740*

Red chalk. Framing lines in pen and black ink; outside the circle the sheet is washed in red. 21.4 x 21.5 cm. Lined.

Inscribed in red chalk around border, TOTO SPARGET IN ORBE / MAISON DE LA REINE / *1740*; in pen and black ink in a cartouche at lower center of Mariette mount, EDMUNDUS / BOUCHARDON.

PROVENANCE: See No. 18 above.

BIBLIOGRAPHY: *Annual Report*, 1961–1962, p. 67; J.-F. Méjanès in *Études*, 1980, p. 82.

Rogers Fund, 1961
61.165.4

A goddess (Ceres?) in a horse-drawn chariot scatters flowers to the winds.

A counterproof of Bouchardon's finished design for this *jeton* is in the Cabinet des Estampes, Bibliothèque Nationale, Paris (Pb 3 1 Rés, fol. 47).

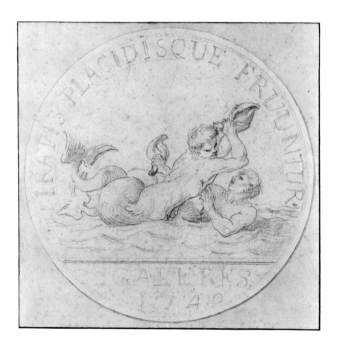

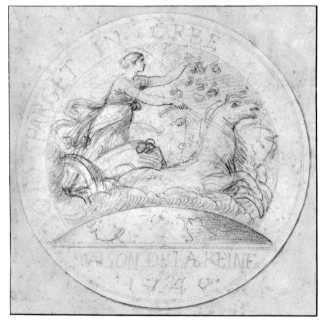

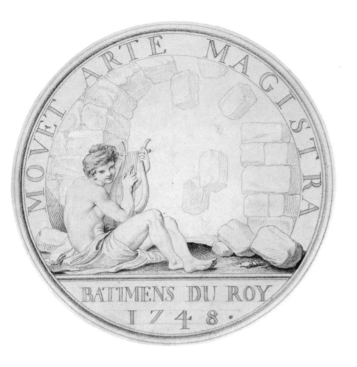 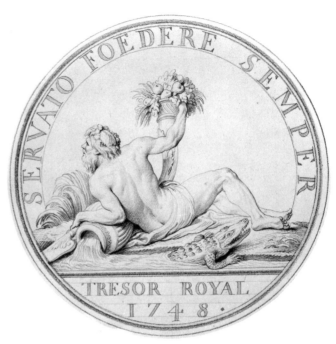

22. *Design for a Token: Bâtiments du Roi,* *1748*

Red chalk. Diameter 21.0 cm. Lined.

Inscribed in red chalk around border, MOVET ARTE MAGISTRA / BATIMENS DU ROY / *1748*.; in pen and brown ink at upper left corner of old blue mount, *le 28 octobre 1747 Bouchardon | remis le dessein a M Marteau.*

PROVENANCE: [Galerie de Bayser]; purchased in Paris in 1979.

BIBLIOGRAPHY: *Exposition de dessins de maîtres anciens et modernes, 1978. Galerie de Bayser*, Paris, 1978, no. 6B, repr.; *Annual Report,* 1978–1979, p. 25.

Harry G. Sperling Fund, 1979
1979.10.3

As the seated Amphion plays his lyre, the stones of the walls of Thebes move into place.

A counterproof of this drawing is preserved in the Cabinet des Estampes of the Bibliothèque Nationale, Paris (Pb 31 Rés, fol. 148).

23. *Design for a Token: Trésor Royal,* 1748

Red chalk. Diameter 21.0 cm. Lined.

Inscribed in red chalk around border, SERVATO FOEDERE SEMPER / TRESOR ROYAL / *1748*.; in pen and brown ink at upper left corner of old blue mount, *le 28 octobre 1747 Bouchardon | remis le dessein a | M. roitier.*

PROVENANCE: [Galerie de Bayser]; purchased in Paris in 1979.

BIBLIOGRAPHY: *Exposition de dessins de maîtres anciens et modernes, 1978. Galerie de Bayser*, Paris, 1978, no. 6A, repr.; *Annual Report,* 1978–1979, p. 25.

Harry G. Sperling Fund, 1979
1979.10.2

The crocodile probably identifies the river god as a personification of the Nile.

A counterproof of this drawing is preserved in the Cabinet des Estampes of the Bibliothèque Nationale, Paris (Pb 31 Rés, fol. 152).

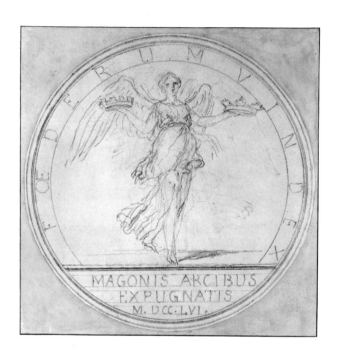

24. *Sketch for a Medal Commemorating the Capture of Port Mahon, 1756*

Red chalk. Framing lines in pen and black ink; outside the circle the sheet is washed in red. 23.2 x 23.1 cm. Lined.

Inscribed in red chalk around border, FOEDERUM VINDEX / MAGONIS ARCIBUS / EXPUGNATIS / M.DCC.LVI.; in pen and black ink in a cartouche at lower center of Mariette mount, EDMUNDI BOUCHARDON.

PROVENANCE: See No. 18 above.

BIBLIOGRAPHY: *Annual Report*, 1961–1962, p. 67; Ames, 1975, pp. 386–387, fig. 10; J.-F. Méjanès, in *Études*, 1980, p. 82.

Rogers Fund, 1961
61.165.6

The medal was intended to commemorate the capture from the English of Port Mahon, Minorca, by the duc de Richelieu in 1756 at the beginning of the Seven Years' War.

A counterproof of a somewhat different design by Bouchardon for this medal is preserved in the Cabinet des Estampes, Bibliothèque Nationale, Paris (Pb 31 Rés, fol. 228).

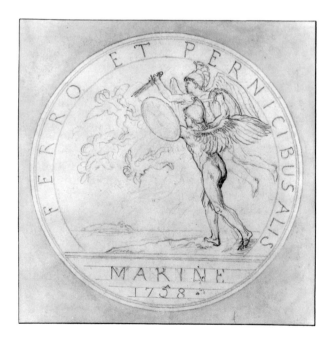

25. *Sketch for a Token: Marine, 1758*

Red chalk. Framing lines in pen and black ink; outside the circle the sheet is washed in red. 23.3 x 23.4 cm. Lined.

Inscribed in red chalk around border, FERRO ET PERNICIBUS ALIS / MARINE / *1758*.; in pen and black ink in a cartouche at lower center of Mariette mount, EDMUNDI / BOUCHARDON.

PROVENANCE: See No. 18 above.

BIBLIOGRAPHY: *Annual Report*, 1961–1962, p. 67; Ames, 1975, p. 386, fig. 9; J.-F. Méjanès in *Études*, 1980, p. 82.

Rogers Fund, 1961
61.165.1

Zetes and Calais are shown driving away the Harpies.

A more finished design by Bouchardon for this *jeton* is preserved in the Bibliothèque de l'Institut, Paris (repr. Ames, 1975, p. 386, fig. 8). There is a counterproof of this latter drawing in the Cabinet des Estampes, Bibliothèque Nationale, Paris (Pb 31 Rés, fol. 250).

FRANÇOIS BOUCHER

Paris 1703–Paris 1770

26. *The Element of Fire*

Red chalk. Faint ruled framing lines in black chalk. 35.0 x 28.8 cm. Horizontal crease at upper right margin. Lined.

PROVENANCE: Christian Humann; sale, New York, Sotheby's, January 21, 1983, no. 86, repr., as circle of François Boucher; [Day]; purchased in New York in 1984.

BIBLIOGRAPHY: *Exhibition of Fifty Old Master Drawings. Baskett and Day*, London and New York, 1983, no. 43, repr. in color; *Annual Report*, 1983–1984, p. 24; *Notable Acquisitions*, 1983–1984, p. 70, repr.

Van Day Truex Fund, 1984
1984.51.1

The drawing was engraved by Pierre Aveline as a part of a series representing the Four Elements published about 1740 by Huquier (Jean-Richard, 1978, nos. 230–234). All Four Elements are treated by Boucher in the mock-Chinese style so fashionable at the time. In a "Chinese" kitchen a kettle boils furiously on the stove as cook offers a cup of tea to a seated warrior. Presiding over the scene on a shelf above is a smiling *magot de la Chine*, a pot-bellied figure representing the Chinese god of happiness. Boucher may have owned such porcelain deities—in any case, similar figures appear in several of his paintings.

Fire seems to be the only original drawing for the Four Elements that has survived, though counterproofs of three of them—*Air, Earth,* and *Fire*—are preserved in the Cabinet des Dessins of the Musée du Louvre (the counterproof of *Fire* repr. Guiffrey and Marcel, II, 1908, no. 1415).

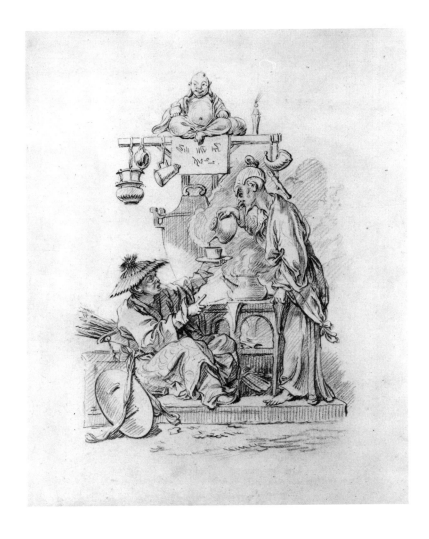

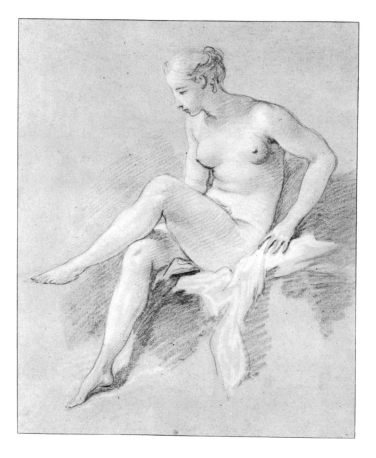

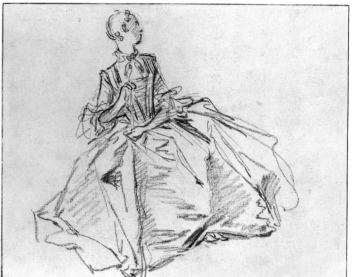

27. *Seated Female Nude*

Red chalk, heightened with white, on beige paper. Framing lines in pen and brown ink. 31.5 x 26.4 cm. Lined.

PROVENANCE: Walter C. Baker.

BIBLIOGRAPHY: *French Master Drawings*, catalogue of a loan exhibition, Charles E. Slatkin Galleries, New York, 1959, no. 44, repr.; Virch, 1962, no. 74; Ananoff, 1966, no. 709; Slatkin, 1973, no. 46, repr.; Ananoff, 1976, I, p. 329, fig. 657, p. 330, no. 215/1; *Annual Report*, 1979–1980, p. 27; Ananoff, 1980, p. 102, under no. 220.

Bequest of Walter C. Baker, 1971
1972.118.197

The drawing corresponds very closely to the seated figure of the goddess in *Diane sortant du bain*, a painting signed and dated 1742, now in the Musée du Louvre (Ananoff, 1976, no. 215, repr.).

28. *Seated Woman Holding a Fan*

Red chalk. Framing lines in pen and brown ink. 16.5 x 21.9 cm. Lined.

PROVENANCE: Niodot fils (Lugt Supp. 1944a); H. Pannier (according to inscription on reverse of old mount); Alexandrine Sinsheimer.

BIBLIOGRAPHY: *Annual Report*, 1958–1959, p. 56; Slatkin, 1973, no. 23, repr.

Bequest of Alexandrine Sinsheimer, 1958
59.23.39

This seated female figure appears in exactly the same pose in *La collation sur l'herbe*, a painting in a French private collection (*François Boucher*, exhibition catalogue, Galerie Cailleux, Paris, 1964, no. 33, repr., dated ca. 1745–1747). Drawn studies for other figures in this painting are in the Musée d'Orléans and in a Parisian private collection (Slatkin, 1973, figs. 11 and 12).

29. *Two Winged Putti*

Black chalk, gray wash, heightened with white, on beige paper. 21.1 x 23.7 cm. Lined.

Inscribed in pen and brown ink at lower left, *Boucher*.

PROVENANCE: Charles K. Lock.

BIBLIOGRAPHY: *Annual Report*, 1960–1961, p. 63; Ananoff, 1976, II, p. 58, no. 355/2, fig. 1047; Ananoff, 1980, p. 117, under no. 377.

Gift of Charles K. Lock, 1960
60.175.1

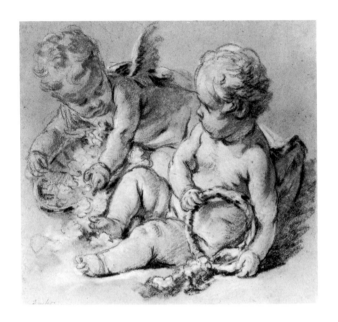

These two putti appear in the center foreground of Boucher's painting of 1750 *Apollon révélant sa divinité à la bergère Issé*, now in the Musée des Beaux-Arts, Tours (Ananoff, 1976, no. 355, repr.). In the painting, however, the basket held by the putto on the left is replaced by a large spray of flowers, and the form of the floral wreath held by the infant on the right is somewhat different.

30. *Woman's Left Hand and Forearm*

Black chalk, heightened with white, over traces of red chalk, on beige paper. Framing lines in pen and brown ink. 22.1 x 28.6 cm.

PROVENANCE: [Slatkin]; purchased in New York in 1955.

BIBLIOGRAPHY: *Annual Report*, 1955–1956, p. 42; Slatkin, 1973, no. 72, repr.; Ananoff, 1976, II, p. 148, fig. 1319, p. 150, no. 475/2; Ananoff, 1980, p. 126, under no. 500.

Rogers Fund, 1955
55.214

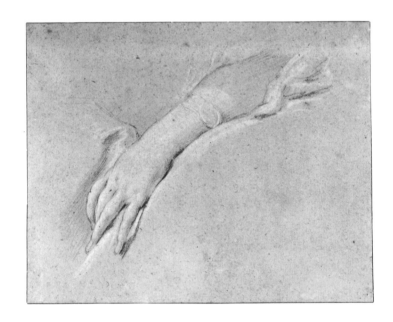

Study for the left hand of Mme de Pompadour in her portrait by Boucher, signed and dated 1756, now in the Alte Pinakothek, Munich (Ananoff, 1976, no. 475). A study for the right hand of the sitter is in an American private collection (Slatkin, 1973, no. 73, repr.).

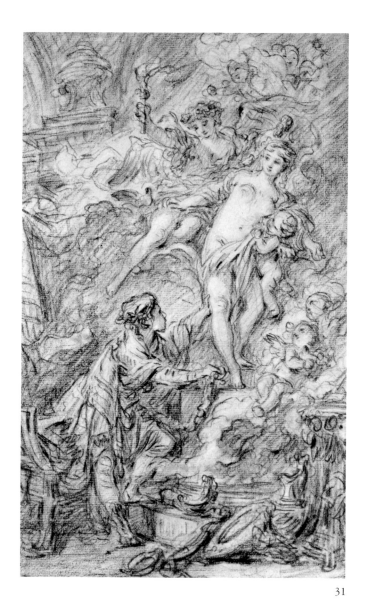

31 32

FRANÇOIS BOUCHER

31. *Pygmalion and Galatea*

Brown chalk. 35.2 x 22.2 cm. (sight).

PROVENANCE: Alphonse Trézel; Trézel sale, Paris, Galerie Jean Charpentier, May 17, 1935, no. 23, repr.; Mrs. O'Donnell Hoover.

BIBLIOGRAPHY: *Annual Report*, 1960–1961, p. 63; Ananoff, 1976, I, p. 355, no. 240/1, fig. 721, mistakenly said to be in the collection of Daniel Wildenstein.

Gift of Mrs. O'Donnell Hoover, subject to a life estate, 1960
60.176.1

The drawing is certainly related to, though it differs in many ways from, Boucher's illustration for *Les métamorphoses d'Ovide* of 1767–1771, engraved in reverse by Le Mire (the print repr. Ananoff, 1976, I, p. 355, fig. 719).

32. *Vertumnus and Pomona*

Brown chalk. 34.5 x 22.7 cm. (sight).

PROVENANCE: François Flameng; Flameng sale, Paris, Galerie Georges Petit, May 26–27, 1919, no. 95, repr. as "Cérès cherchant sa fille"; Alphonse Trézel; Trézel sale, Paris, Galerie Jean Charpentier, May 17, 1935, no. 24, repr.; Mrs. O'Donnell Hoover.

BIBLIOGRAPHY: *Annual Report*, 1960–1961, p. 63; T. C. Howe, *Bulletin. California Palace of the Legion of Honor*, I, 5, 1968, fig. 8; Slatkin, 1973, p. 110, fig. 44; Ananoff, 1976, II, p. 27, fig. 951, p. 89, no. 385/7, mistakenly said to be in the collection of Daniel Wildenstein.

Gift of Mrs. O'Donnell Hoover, subject to a life estate, 1960
60.176.2

Boucher drew and painted this subject on a number of occasions, in widely differing compositions. Our drawing comes close to, but differs from, both a Beauvais tapestry after Boucher (Ananoff, 1976, II, p. 88, fig. 1121) and one of the illustrations supplied by the artist for *Les métamorphoses d'Ovide* (Jean-Richard, 1978, no. 1564, repr.).

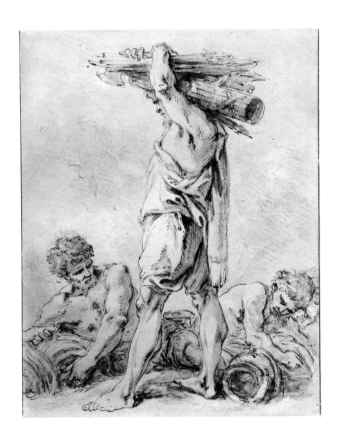

33. *Standing Man Carrying Fasces and Arms*

Pen and brown ink, brown wash, over black chalk. Framing lines in pen and black ink. 23.4 x 18.3 cm. Lined.

Inscribed in pen and brown ink on reverse of old mount, *Leprince*.

PROVENANCE: Jan Baptist de Graaf (Lugt 1120); [Cailleux]; purchased in Paris in 1961.

BIBLIOGRAPHY: *Annual Report*, 1960–1961, p. 63; Ananoff, 1966, no. 991a, fig. 162; R. S. Slatkin, *Master Drawings*, V, 1, 1967, p. 59.

Purchase, Joseph Pulitzer Bequest, 1961
61.1.3

In figure style and in composition the drawing is strikingly similar to an etching by Boucher that is signed and

dated 1751, *Homme, vu de dos, portant un trophée d'armes* (Jean-Richard, 1971, no. 6, pl. 1; Jean-Richard, 1978, no. 23, repr.). The standing figure in our drawing has the same vigorous, rather angular musculature as the trophy bearer in the print, and in both drawing and print the secondary figures in the middle ground stand or rest on a lower level surrounded by vases or arms.

The drawing is worked up in pen from a faint black chalk counterproof. A significant change in the head of the standing figure can be discerned; originally the bearer held his head upright and carried only the upper bundle of arms. The large fasces was added when his head was bent forward to the left. Minor alterations are also discernible in the poses of the figures below.

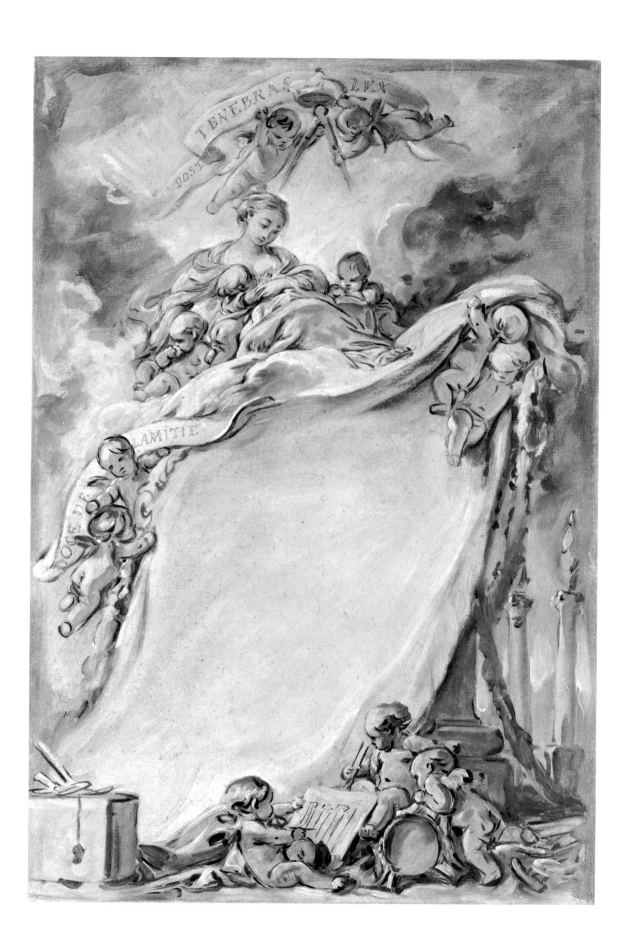

34. *Diploma for the Freemasons of Bordeaux*

Grisaille: black and white oil paint on brown paper, mounted on canvas. 38.8 x 26.7 cm.

Inscribed on banderole at upper margin, POST TENEBRAS LUX; on banderole at left, LOGE DE LAMITIÉ.

PROVENANCE: [Cailleux]; purchased in Paris in 1961.

BIBLIOGRAPHY: *Esquisses, maquettes, projets et ébauches de l'école française du XVIIIe siècle*, exhibition catalogue, Galerie Cailleux, Paris, 1934, no. 9; *Annual Report*, 1961–1962, p. 67; Bean, 1964, no. 58, repr.; A. H. Mayor, *Apollo*, LXXXII, September 1965, p. 246, fig. 9; Jean-Richard, 1971, p. 66, under no. 50; Gillies and Ives, 1972, no. 4; Slatkin, 1973, no. 85, repr.; Ananoff, 1976, II, p. 255, no. 614, fig. 1636; Jean-Richard, 1978, p. 151, under no. 507; Sutton, 1980, no. 30, fig. 29; Ananoff, 1980, p. 137, no. 649, repr.

Rogers Fund, 1961
61.127.1

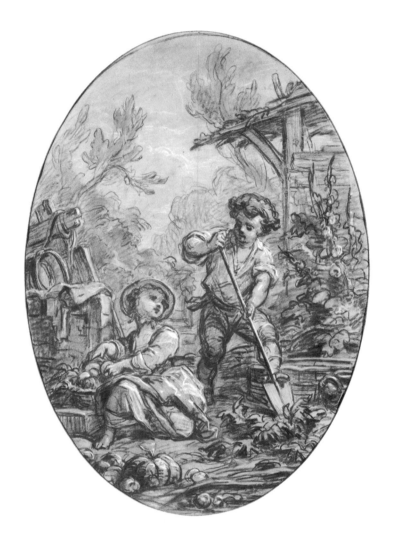

Etched by Pierre-Philippe Choffard in the same direction (Jean-Richard, 1978, no. 507, repr.). The print is signed and dated, *F. Boucher inv. 1765.* and *Ph. Choffard Sculp. 1766.*

35. *The Element of Earth: Two Children Gardening*

Charcoal, stumped, a little black chalk, heightened with white, on brown paper. 83.7 x 65.5 cm. (overall); 76.3 x 56.5 cm. (the oval).

Faint charcoal inscription at lower left, outside the oval, *Boucher* [?].

PROVENANCE: F. Bohler; Bohler sale, Paris, Hôtel Drouot, February 23, 1906, no. 7; [Wertheimer]; purchased in Paris in 1964.

BIBLIOGRAPHY: *Annual Report*, 1964–1965, p. 52; *Art Quarterly*, XXVIII, 3, 1965, p. 212, p. 220, fig. 1; Ananoff, 1966, p. 32, under no. 35; R. S. Slatkin, *Master Drawings*, V, 1, 1967, p. 59; Gillies and Ives, 1972, no. 6.

Louis V. Bell Fund, 1964
64.281.1

With No. 36 below, this vigorous and freely executed cartoon may have formed part of a series of oval representations of the *Four Elements*. If so, the drawings for *Fire* and *Water* have not survived.

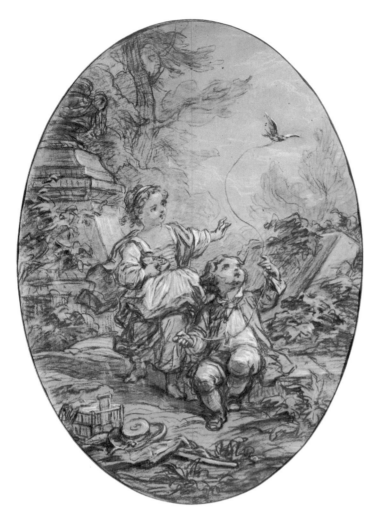

36. *The Element of Air: Two Children with a Bird on a String*

Charcoal, stumped, a little black chalk, heightened with white, on brown paper. 83.8 x 64.3 cm. (overall); 76.0 x 56.5 cm. (the oval).

Faint charcoal inscription at lower left, outside the oval, *Boucher*.

PROVENANCE: F. Bohler; Bohler sale, Paris, Hôtel Drouot, February 23, 1906, no. 6; [Wertheimer]; purchased in Paris in 1964.

BIBLIOGRAPHY: *Annual Report*, 1964–1965, pp. 51–52, repr.; *Art Quarterly*, XXVIII, 3, 1965, p. 212, p. 220, fig. 3; Ananoff, 1966, no. 35; R. S. Slatkin, *Master Drawings*, V, 1, 1967, p. 59; Gillies and Ives, 1972, no. 7.

Louis V. Bell Fund, 1964
64.281.2

See No. 35 above.

37. *Winged Female Figures in Spandrels above an Arch*

Black chalk, heightened with white, on dark blue paper. 19.5 x 34.9 cm.

Inscribed in pen and brown ink on verso, *F. Boucher*.

PROVENANCE: Marquis de Chennevières (Lugt 2073); Chennevières sale, Paris, Hôtel Drouot, April 4–7, 1900, part of no. 45, "Étude de deux génies ailés pour le couronnement d'un cintre"; baron Roger Portalis (Lugt 2232); Charles Mewes (according to vendor); [Jeudwine]; purchased in London in 1968.

BIBLIOGRAPHY: *Exhibition of Old Master Drawings Presented by W. R. Jeudwine and L'Art Ancien S.A.*, London, 1968, no. 16, pl. VI; *Annual Report*, 1968–1969, p. 67; Slatkin, 1973, no. 16, repr.

Rogers Fund, 1968
68.80.1

38. *The Continence of Scipio*

Brown chalk, brown wash. 48.4 x 28.5 cm. Arched top. Lined.

PROVENANCE: Georges Bourgarel; Bourgarel sale, Paris, Hôtel Drouot, salle 1, November 13–15, 1922, no. 61, as "Alexandre et la famille de Darius"; sale, Paris, Hôtel Drouot, salle 11, March 11, 1964, no. 41, pl. 1, as "La Famille de Darius aux pieds d'Alexandre"; sale, Paris, Hôtel Drouot, salle 1, March 16, 1966, no. 2, as "La Famille de Darius"; [Seiferheld]; purchased in New York in 1966.

BIBLIOGRAPHY: Ananoff, 1966, no. 1013, fig. 166, mistakenly as "La Famille de Darius aux pieds d'Alexandre"; *Annual Report*, 1966–1967, p. 60, repr.; R. S. Slatkin, *Master Drawings*, V, 1, 1967, p. 62; R. Bacou, *Revue de l'Art*, 14, 1971, p. 103, under no. 4; Gillies and Ives, 1972, no. 5; Rosenberg, 1972, p. 137, under no. 13; Slatkin, 1973, no. 89, repr.

Purchase, Joseph Pulitzer Bequest, 1966
66.106

Three further drawings by Boucher for a *Continence of Scipio* are known. One is the Musée des Beaux-Arts, Quimper, a second in the Detroit Institute of Arts, and the third is in an American private collection (repr. Slatkin, 1973, pp. 116 and 118). All four drawings are large, free and assured in execution, and each one proposes a somewhat different composition. No painting of this subject by Boucher has survived; thus it is tempting to associate these studies with a request for such a subject from the king of Poland in 1765. Ill health (and the meddling of Mme Geoffrin) apparently prevented Boucher from completing the painting, and the commission was passed on to Joseph-Marie Vien. The latter's *Continence of Scipio*, a more formal, static composition, signed and dated, *jo. m. vien. 1768*, is now in the National Museum, Warsaw (see M. Sandoz, *Bulletin du Musée National de Varsovie*, XVI, 4, 1975, pp. 103–121, the painting repr. p. 108). It should be noted that Vien's painting, like our drawing and that in Detroit, has an arched top.

FRANÇOIS BOUCHER

39. *Christ and the Woman Taken in Adultery*

Black chalk, gray wash, heightened with white, on faded gray-blue paper. Framing lines in pen and gray ink. 26.7 x 43.2 cm.

PROVENANCE: [Cailleux]; [Slatkin]; purchased in New York in 1957.

BIBLIOGRAPHY: *Annual Report*, 1957–1958, p. 58; R. S. Slatkin, *Master Drawings*, V, 1, 1967, p. 63; Slatkin, 1973, no. 7, repr.

Dodge Fund, 1957
57.139

The composition is probably of Italian inspiration, but we have not been able to identify the painting from which the drawing may have been copied. Luca Giordano is the artist that first comes to mind.

JEAN BOUCHER,
called Boucher de Bourges

Bourges 1568 – Bourges 1633

40. *A Kneeling King of France Holding the Scepters of Royal Authority*

Black chalk, heightened with white, on brown-washed paper. 25.2 x 17.5 cm. Lined.

Signed in pen and brown ink at lower left, *boucher*.

PROVENANCE: [Baderou]; purchased in Paris in 1960.

BIBLIOGRAPHY: *Annual Report*, 1960–1961, repr. p. 46, p. 63; J. Thuillier in *Études*, 1980, p. 25, p. 30, note 24; Rosenberg and Bergot, 1981, p. 7.

Rogers Fund, 1960
60.142.1

Jacques Thuillier has suggested that this drawing may be a study for the figure of St. Louis in a lost altarpiece by Jean Boucher, painted for the Dominican church in Bourges.

Drawings by Jean Boucher in the Cabinet des Dessins, Musée du Louvre, and in the Baderou Collection, Musée de Rouen, bear the same signature, *boucher*, that appears on our sheet (Paris, 1984, no. 12, repr.; J. Thuillier in *Études*, 1980, pp. 25–26, figs. 2–6).

LOUIS DE BOULLONGNE, le père

Paris 1609 – Paris 1674

41. *Sacrifice Offered before a Statue of Jupiter*

Pen and brown ink, brown and gray wash, heightened with white, over black chalk. Framing lines in pen and brown ink. 31.5 x 42.4 cm. A *pentimento* with the upper half of a seated nymph has been added at left margin. Surface somewhat abraded.

Inscribed in pen and brown ink at lower right corner, *Boulogne La* [the rest cut off].

PROVENANCE: Unidentified mark, J D (Lugt 1436); [Prouté]; [Baderou]; purchased in Paris in 1964.

BIBLIOGRAPHY: *Catalogue "Colmar" 1964. Paul Prouté et ses fils*, Paris, 1964, no. 19, repr.; *Annual Report*, 1964–1965, p. 51; Rosenberg, 1972, pp. 139–140, under no. 16; Bjurström, 1976, under no. 167.

Rogers Fund, 1964
64.196.2

The sheet may have been cut at the top and at the right margin, since only the lower part of the statue of Jupiter is included, and the inscription at lower right has clearly been trimmed.

Pierre Rosenberg accepted the presumably traditional attribution of this drawing to Boullongne the elder, and he associated it on stylistic grounds with a group of five drawn oval scenes of sacred history preserved at Evergreen House, Baltimore, Maryland (traditionally ascribed to S. Bourdon). He gave to the same artist a drawing in the Nationalmuseum, Stockholm (Bjurström, 1976, no. 167, repr.). Of these seven drawings, that in the Metropolitan Museum is by far the most vigorous, with idiosyncratic angular facial notations lacking in the other sheets.

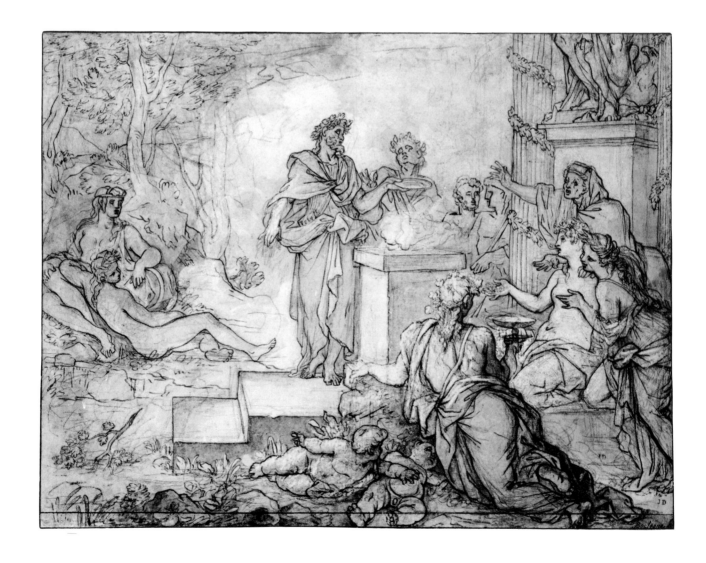

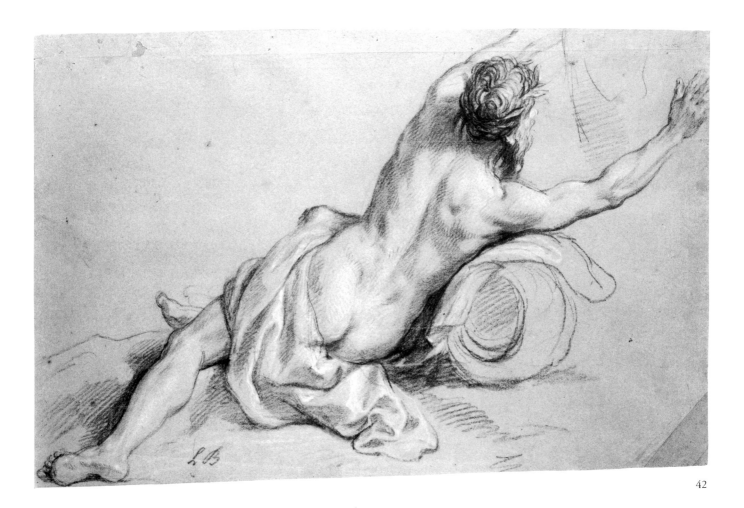

LOUIS DE BOULLONGNE, le jeune

Paris 1654 – Paris 1733

42. *Reclining River God*

Black chalk, heightened with white, on blue paper. 33.0 x 52.3 cm.
Horizontal crease below upper margin; lower right corner made up;
repaired tear and losses at upper left corner.

Initialed in black chalk at lower left, *L B*.

PROVENANCE: [Kleinberger]; purchased in New York in 1961.

BIBLIOGRAPHY: *Annual Report*, 1960–1961, p. 63; Rosenberg,
1972, p. 140, under no. 17.

Rogers Fund, 1961
61.28

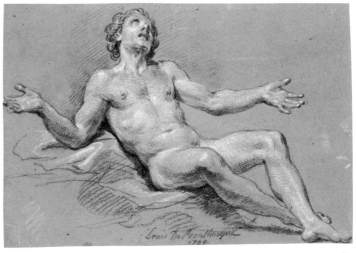

43

43. *Reclining Male Nude Looking Upward*

Black chalk, heightened with white, on blue paper. 30.6 x 46.4 cm.

Signed and dated in black chalk at center of lower margin, *Louis De
Boullongne* / 1704.

PROVENANCE: Harry G. Sperling.

BIBLIOGRAPHY: *Annual Report*, 1974–1975, p. 50.

Bequest of Harry G. Sperling, 1971
1975.131.91

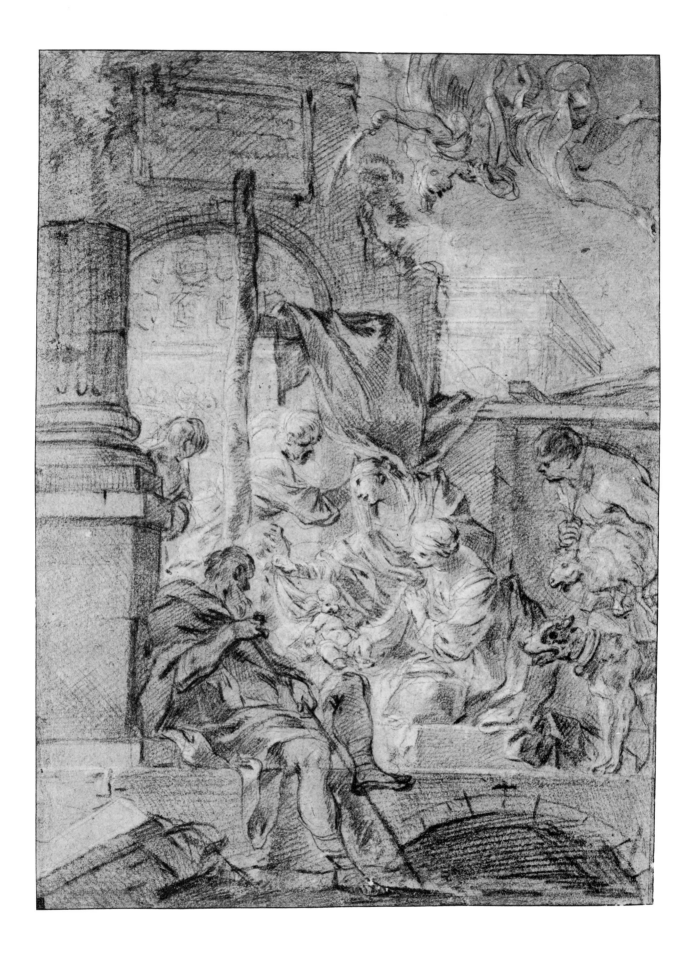

SÉBASTIEN BOURDON

Montpellier 1616 – Paris 1671

44. *The Adoration of the Shepherds*

Black chalk, heightened with white, on brown paper. Framing lines in pen and black ink. 36.4 x 27.0 cm. Slight losses and scattered stains.

PROVENANCE: Germain Seligman (his mark, interlaced GS, not in Lugt); [J. Seligmann]; purchased in New York in 1961.

BIBLIOGRAPHY: *Annual Report*, 1961–1962, p. 66; Rosenberg, 1972, p. 141, under no. 18.

Rogers Fund, 1961
61.166.1

45. *Christ and the Centurion*

(Matthew 8:5–13; Luke 7:2–10)

Pen and brown ink, brown wash, heightened with white, over red chalk. Verso: faint red chalk sketch of a procession with a chariot. 20.1 x 25.6 cm.

Inscribed in pen and brown ink at lower right, *P.L.*

PROVENANCE: Peter Sylvester (Lugt 2108, 2877); unidentified collector's mark (Lugt 2890).

BIBLIOGRAPHY: *Annual Report*, 1974–1975, p. 50.

Bequest of Harry G. Sperling, 1971
1975.131.92

A large painting of this subject by Bourdon, similar in composition but with many significant variations, has recently been on the art market (London, Christie's, December 17, 1981, no. 3, repr.; London, Sotheby's, April 4, 1984, no. 27, repr.).

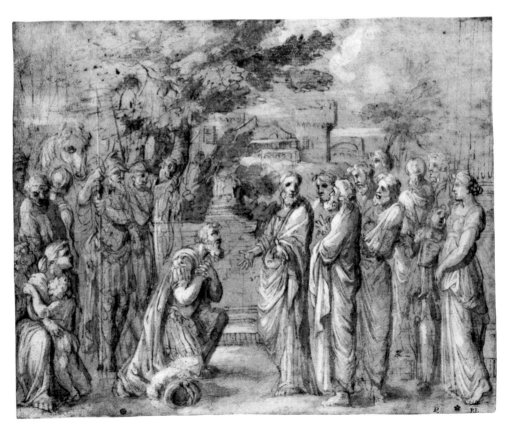

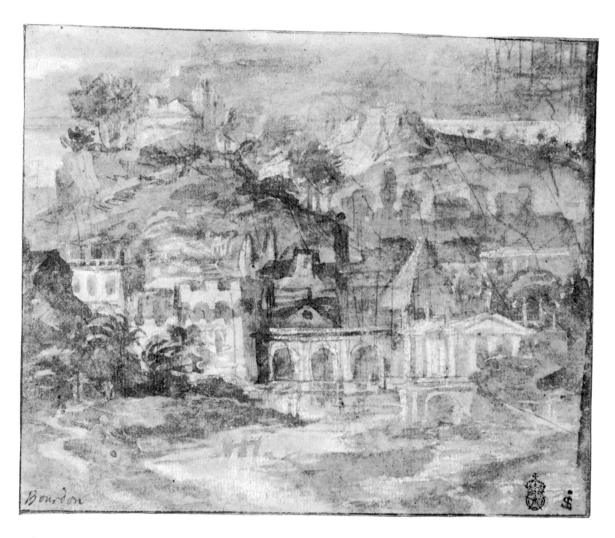

SÉBASTIEN BOURDON

46. *Landscape with Classical Buildings by a River*

Brush and brown wash, heightened with white, over red chalk. 14.9 x 18.7 cm. Lined.

Inscribed in pen and brown ink at lower left, *Bourdon*.

PROVENANCE: Earl Spencer (Lugt 1532); Spencer sale, London, T. Philipe, June 10–17, 1811, no. 98, "A classical landscape, in the great style of Nicolo Poussin—red chalk, bistre, and Indian ink, heightened"; A. G. B. Russell (Lugt Supp. 2770a); Russell sale, London, Sotheby's, May 22, 1928, no. 98; repurchased by 7th Earl Spencer; 8th Earl Spencer (according to vendor); [Day]; purchased in London in 1984.

BIBLIOGRAPHY: T. Borenius, *Connoisseur,* LXVI, May 1923, repr. p. 7, p. 10; *Le paysage français de Poussin à Corot*, exhibition catalogue, Petit Palais, Paris, 1925 [1926], p. 105, D. 382; *Exhibition of Fifty Old Master Drawings. Baskett and Day*, London and New York, 1983, no. 36; *Annual Report*, 1983–1984, p. 24.

Purchase, The Port Royal Foundation, Inc. Gift, 1984
1984.51.2

JACQUES CALLOT

Nancy 1592 ? – Nancy 1635

47. *Two Women Winding Yarn on Reels*

Red and a little black chalk. 8.9 x 11.4 cm. Lined.

Numbered in pen and brown ink over red chalk at upper right corner, *21*.

PROVENANCE: Jean-François Gigoux (Lugt 1164); purchased in London in 1906.

BIBLIOGRAPHY: *Metropolitan Museum of Art Bulletin*, December 1906, p. 162.

Rogers Fund, 1906
06.1042.19

The drawing, though an autograph work by Callot, was not utilized in an etching. However, a seated yarn winder seen in full profile to the right does occur in Callot's small

etching *La dévideuse et la fileuse* (J. Lieure, *Jacques Callot, catalogue de l'oeuvre gravé*, II, Paris, 1927, no. 536, repr.). In the Hermitage, Leningrad, there is a study in black chalk and brown wash for the *dévideuse* of the etching (D. Ternois, *Jacques Callot, catalogue complet de son oeuvre dessiné*, Paris, 1962, no. 501, repr.).

48. *Landscape with a Country Chapel*

Brush and brown wash, over black chalk. 12.2 x 23.6 cm. All four corners cut away. Lined.

Inscribed in pen and brown ink at lower margin, *Scuola Fiaminga*.

PROVENANCE: James Jackson Jarves; Cornelius Vanderbilt.

BIBLIOGRAPHY: *Metropolitan Museum Handbook*, 1895, no. 451, as Rembrandt; H. D. Russell, *Jacques Callot, Prints and Related Drawings*, Washington, D.C., 1975, p. 273, p. 307, no. 258, repr.

Gift of Cornelius Vanderbilt, 1880
80.3.451

Once assigned to the Flemish school, then to Rembrandt, the drawing was recognized as a typical example of Callot's work as a landscape draughtsman by Jacob Bean in 1961.

47

48

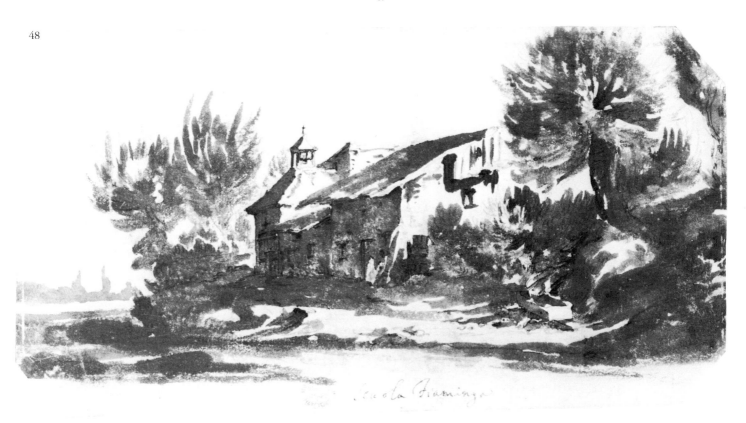

FRANÇOIS-JOSEPH CASANOVA

London 1727 – Brühl, near Vienna 1802

49. *Cavalry Skirmish with a Fallen Drummer at Left Foreground*

Brush and brown ink, brown and gray wash, heightened with white, on brown-washed paper. Framing lines in pen and brown ink. 17.7 x 23.7 cm. Lined.

Inscribed in pencil at lower left margin of Mariette mount, *Casanova. 1763.*

PROVENANCE: Pierre-Jean Mariette (Lugt 2097); Mariette sale, Paris, 1775–1776, no. 1186, with No. 50 below, "Deux Escarmouches de plusieurs cavaliers, le sabre et le pistolet en mains, d'un grand effet, sur papier brun, à l'encre de la Chine, rehaussée de blanc"; purchased in New York in 1983.

BIBLIOGRAPHY: *Annual Report*, 1983–1984, p. 24.

Harry G. Sperling Fund, 1983
1983.128.2

50. *Cavalry Skirmish with a Fallen Soldier at Right Foreground*

Brush and brown ink, brown and gray wash, heightened with white, on brown-washed paper. Framing lines in pen and brown ink. 17.6 x 23.7 cm. Repaired losses at upper right. Lined.

Inscribed in pencil at lower left margin of Mariette mount, *Casanova. 1763.*

PROVENANCE and BIBLIOGRAPHY: See No. 49 above.

Harry G. Sperling Fund, 1983
1983.128.3

Jrag's fait dans les écuries de monsieur a Tivoli 1773

54

LOUIS CHAIX

Marseille ca. 1740 – Paris 1811 ?

51. *The So-Called Stables of Maecenas at Tivoli*

Black chalk. Framing lines in pen and brown ink. 45.7 x 32.0 cm. Horizontal crease at center. Lined.

Inscribed in pen and brown ink at lower left of old mount in the artist's hand, *chaÿs feci dans les écurie de messene a tivolli 1773* [or 1775]; numbered in pen and brown ink at upper left of old mount, 20.

PROVENANCE: [Galerie de Bayser]; purchased in Paris in 1984.

BIBLIOGRAPHY: *Exposition de dessins anciens, 1984. Galerie de Bayser*, Paris, 1984, no. 6, repr.; *Annual Report*, 1984–1985, p. 25.

Van Day Truex Fund, 1984
1984.248

Observing it from the opposite end, Jean-Honoré Fragonard drew a red chalk view of the same ruined gallery in the so-called Villa of Maecenas at Tivoli; Fragonard's drawing is at the Musée de Besançon (M.-L. Cornillot, *Collection Pierre-Adrien Pâris, Besançon*, Paris, 1957, no. 40, repr.).

52. *Roman Ruins with Figures*

Black chalk. Framing lines in pen and brown ink. 32.4 x 46.1 cm. Lined.

Inscribed in pen and brown ink at lower left of old mount in the artist's hand, *chaÿs f. a rome 1776*.

PROVENANCE: F. A. den Broeder; [Colnaghi]; purchased in New York in 1982.

BIBLIOGRAPHY: Storrs, 1973, no. 108b; *Colnaghi in Association with F. A. den Broeder. Aspects of Neoclassicism, Drawings and Watercolors, 1760–1840*, exhibition catalogue, New York, 1982, no. 11, pl. VI; *Annual Report*, 1982–1983, p. 24.

Purchase, Richard and Trude Krautheimer and David L. Klein, Jr. Memorial Foundation, Inc. Gifts, 1982
1982.434

F. A. den Broeder very plausibly suggests that the drawing represents ruins on the Appian Way near the Villa of the Quintilii, just outside Rome.

CHARLES MICHEL-ANGE CHALLE

Paris 1718 – Paris 1778

53. *View within the Colosseum, Rome*

Black chalk, heightened with white, on gray-blue paper. Framing lines in pen and brown ink. Verso: faint black chalk sketch of an arch. 27.6 x 41.4 cm.

Signed in pen and black ink at lower left, *MA Challe* (partly effaced).

PROVENANCE: Freiherr M. von Heyl zu Herrnsheim (Lugt 2879); [le Claire]; purchased in New York in 1985.

BIBLIOGRAPHY: *Thomas le Claire Kunsthandel, II. Handzeichnungen und Aquarelle des 15.–19. Jahrhunderts*, exhibition catalogue, Hamburg, 1984, p. 38, no. 19, repr. p. 39; *Annual Report*, 1984–1985, p. 26.

Harry G. Sperling Fund, 1985
1985.43

Challe, who was *pensionnaire* at the French Academy in Rome from 1742 to 1749, drew a good many views of the Colosseum. Among these, a black and white chalk drawing in the Rijksprentenkabinet, Amsterdam, was made from almost exactly the same point of view, though the figures differ (repr. *Franse tekenkunst*, 1974, no. 22). Another closely related drawn view of the site by Challe is in the Musée Magnin, Dijon (repr. *Revue du Louvre et des Musées de France*, XXIX, 5–6, 1979, p. 456, fig. 2).

Lawrence Turčić points out that in the Museo Cerralbo, Madrid, there is what appears to be a counterproof of our drawing (C. Sanz Pastor y Fernandez de Pierola, *Museo Cerralbo. Catálogo de dibujos*, Madrid, 1976, p. 168, no. 151, repr., attributed to Salvator Rosa).

54. *Farmyard*

Black chalk, heightened with white, on beige paper. Framing lines in pen and black ink. 30.2 x 47.5 cm. Horizontal crease at center of right margin. Lined.

Signed in pen and brown ink at lower left, *MA Challe*.

PROVENANCE: [Baskett]; purchased in London in 1968.

BIBLIOGRAPHY: *Exhibition of Old Master and English Drawings. John Baskett*, London, 1968, no. 43; *Annual Report*, 1968–1969, p. 67.

Rogers Fund, 1968
68.105

Challe was a right-handed artist. Thus the presence on this sheet of an underdrawing in left-handed strokes sug-

gests that Challe took a counterproof from one of his own drawings and then worked up the surface in black and white chalk.

CLAUDE-LOUIS CHÂTELET

Paris 1753 – Paris 1795

55. *Road Leading to the Grotto of Posíllipo*

Pen and black ink, brown wash, watercolor, over faint traces of graphite. Framing lines in pen and brown ink. 21.5 x 14.8 cm.

PROVENANCE: Walter C. Baker.

BIBLIOGRAPHY: Virch, 1962, no. 84; *Annual Report*, 1979–1980, p. 27.

Bequest of Walter C. Baker, 1971
1972.118.200

The drawing was etched in the same direction by Desmoulins and finished by Quauvilliers as an illustration for *Voyage pittoresque ou description des royaumes de Naples et de Sicile* (I, part 1, 1781, pl. 37, opp. p. 82). The legend reads "Vue d'un chemin creux qui conduit à la Grotte du Pausilipe. Dessiné sur les lieux par Chastelet."

For other drawings reproduced in Saint-Non's *Voyage pittoresque*, see Nos. 99, 258, and 266 below.

56. *Distant View of Syracuse and Its Harbor*

Pen and brown ink, gray wash, over faint traces of graphite. Framing lines in pen and brown ink. 19.5 x 39.5 cm.

PROVENANCE: François Renaud (Lugt Supp. 1042); Albert Gallatin.

Gift of Albert Gallatin, 1920
20.166.4

A view of Syracuse by Châtelet, drawn from a different point of view, was utilized as an illustration for Saint-Non's *Voyage pittoresque* (IV, part 2, 1786, pl. 123, opp. p. 305).

FRANÇOIS CHAUVEAU
Paris 1613 – Paris 1676

57. *Allegory of History*

Pen and brown ink, gray wash, over traces of graphite. Framing lines in pen and brown ink. 16.4 x 18.5 cm. Contours indented with a stylus. Lined.

Inscribed in pen and brown ink at lower right, *françois chauveau fecit*.

PROVENANCE: Transferred from the Department of Prints and Photographs in 1985.

The Elisha Whittelsey Collection,
The Elisha Whittelsey Fund, 1949
49.168

History is represented as a winged female figure looking backward as she writes in a book held by Time.

History and Time are very close in style to the same allegorical figures as they appear in Chauveau's design in the Victoria and Albert Museum, London (D1076-1900) for the engraved frontispiece of *Familiae Romanae in antiquis numismatibus . . .* by Charles Patin, Paris, 1663 (*Inventaire 17ᵉ siècle*, II, pp. 484–485, no. 898).

The signature (?) at lower right is in the same hand as that on a drawing by Chauveau in the Royal Print Room, Copenhagen, representing two figures standing before the tomb of a king (Tu 25a, 31).

françois chauveau fecit

59

CLAUDE GELLÉE, called Le Lorrain

Chamagne 1600 – Rome 1682

58. *Landscape with the Rest on the Flight into Egypt*

VERSO. *The Rest on the Flight into Egypt*

Pen and brown ink, over traces of black chalk (recto); black chalk, pen and brown ink (verso; the figures are traced through from recto). 19.0 x 26.8 cm. The sheet has suffered from abrasion and water damage, particularly at lower left of recto.

Inscribed in pen and brown ink at lower left, *Claudio . . .* [?]; in pen and ink at upper margin of verso, *philip de flines | :f: | 39*; in black chalk, *2374 | Claude.*

PROVENANCE: Philip de Flines (inscription on verso); Jonathan Richardson, Sr. (Lugt 2184); sale, Amsterdam, Frederik Muller, November 20–21, 1882, no. 333; purchased in London in 1907.

BIBLIOGRAPHY: R. Fry, *Metropolitan Museum of Art Bulletin*, December 1907, p. 200; Röthlisberger, 1961, I, p. 498, under no. 229; Röthlisberger, *Art Quarterly*, 1961, p. 348, fig. 4 (recto), pp. 349–350, p. 354, note 10; Röthlisberger, 1968, I, no. 73, II, recto and verso repr.; Röthlisberger and Cecchi, 1975, p. 92, under no. 60; Kitson, 1980, p. 834; Russell, 1982, p. 130, under no. 21; Russell, 1983, p. 146, under no. 21.

Rogers Fund, 1907
07.282.1

58

58 v.

Marcel Röthlisberger suggested that the drawing on the recto is a study for *Landscape with a Rest on the Flight into Egypt*, a painting in a private collection that he dates 1638–1639 (Röthlisberger, 1961, no. 229, fig. 98). However, the figures and the landscape background come closer to a *Rest on the Flight* recently published by Michael Kitson, who dates the painting 1635–1636 (Kitson, 1980, fig. 24).

The sketches on the verso of the sheet must be studies for a vertical version of this composition.

59. *Coast View with Perseus and the Origin of Coral*

Pen and brown ink, brown, gray, and blue wash, heightened with white. 24.7 x 38.3 cm.

Signed and dated in pen and brown ink at lower left corner, *Claudio fecit / Rom / .1674.*

PROVENANCE: Grand Duke Nicholas Michailovitch; V. G. A. As-

sarsson (both according to vendor); [Neuman]; purchased in Stockholm in 1964.

BIBLIOGRAPHY: *Annual Report*, 1964–1965, p. 51; J. Bean, *Master Drawings*, III, 3, 1965, pp. 266–268, pls. 22–24; L. Boyer, *Metropolitan Museum of Art Bulletin*, May 1968, pp. 370–379, fig. 6, repr. in color; Röthlisberger, 1968, I, no. 1066, II, repr.; *The Art of Claude Lorrain*, exhibition catalogue, Hayward Gallery, London, 1969, no. 107, pl. 30; Metropolitan Museum, 1970, no. 296, repr.; Röthlisberger and Cecchi, 1975, p. 122, under no. 260; *Rome in the 17th Century*, 1976, n.pag. [8]; M. Kitson, *Claude Lorrain: Liber Veritatis*, London, 1978, pp. 167–168, under no. 184; Russell, 1982, p. 291, no. 71, repr.; Russell, 1983, repr. p. 288, p. 290, no. 71* (not exhibited in Paris).

Purchase, Mr. and Mrs. Arnold Whitridge Gift, 1964
64.253

This splendid drawing is one of the largest and most richly finished in all of Claude's abundant production. It differs in many details from the painting of the same subject, commissioned by Cardinal Massimi and now at Holkham Hall (Liber Veritatis 184, with the dates 1673 and 1674; Röthlisberger, 1961, no. 184, fig. 299). Claude may not have made the drawing in preparation for the painting, and it was perhaps intended as an independent work of art.

60. *Three Archers and a Figure with a Spear*

Pen and brown ink, brown wash, over traces of graphite. 15.9 x 24.7 cm. All four corners cut away.

Inscribed in black chalk at upper right, *Claudio*; in pen and brown ink on verso, *di Claudio Lorenese*.

PROVENANCE: [Matthiesen]; purchased in London in 1961.

BIBLIOGRAPHY: Röthlisberger, 1961, I, p. 426, no. 4; *Annual Report*, 1961–1962, p. 66; Röthlisberger, *Art Quarterly*, 1961, p. 354, note 10; Röthlisberger, 1968, I, no. 989, II, repr.; Röthlisberger and Cecchi, 1975, p. 121, under no. 256; Russell, 1982, pp. 272–273, no. 61, repr.; Russell, 1983, pp. 273–275, no. 61, repr.

Rogers Fund, 1961
61.125

Röthlisberger proposed that Claude made these studies in preparation for his painting of 1672, *Coast View with Aeneas Hunting*, now in the Musées Royaux des Beaux-Arts, Brussels (Röthlisberger, 1961, no. 180, fig. 294).

61. *Landscape with Apollo and the Muses*

Pen and brown ink, brown and gray wash, heightened with white, over traces of graphite, on blue-green paper. 24.0 x 32.2 cm. Diagonal crease at lower right.

Signed and dated in pen and brown ink at lower center, *Claudio fecit / ROM / 1674*; numbered in pen and brown ink on verso, *24*.

PROVENANCE: Henry Wellesley; Wellesley sale, London, Sotheby's, June 25–July 10, 1866, probably no. 302; [Schatzki]; purchased in New York in 1961.

BIBLIOGRAPHY: *Annual Report*, 1960–1961, p. 63; Röthlisberger, 1961, I, p. 453, no. 3, II, fig. 338; Röthlisberger, *Art Quarterly*, 1961, p. 354, note 10; Bean, 1962, p. 168, fig. 12; Röthlisberger, 1968, I, no. 1072, II, repr.; Röthlisberger and Cecchi, 1975, p. 124, under no. 271.

Rogers Fund, 1961
61.59

One of five drawings, all dated 1674, that treat the *Parnassus* theme. The related painting was executed six years later and is now in the Museum of Fine Arts, Boston (Röthlisberger, 1961, no. 193, fig. 314). Our drawing differs in a great many ways from the Boston painting, in which the composition is reversed.

CHARLES-LOUIS CLÉRISSEAU

Paris 1721 – Paris 1820

62. *Architectural Fantasy with Roman Ruins*

Pen and brown ink, brown and green wash. 25.5 x 35.6 cm.

Inscribed in brush and brown wash at lower right, *clerisse . . .*

PROVENANCE: [Franklyn]; Harry G. Sperling.

BIBLIOGRAPHY: *Annual Report*, 1974–1975, p. 50; *The Spirit of Antiquity. Giovanni Battista Piranesi, Robert Adam, and Charles-Louis Clérisseau*, exhibition catalogue, Washington University Gallery of Art, Saint Louis, Missouri, 1984, p. 24, fig. 15, p. 29, no. 16.

Bequest of Harry G. Sperling, 1971
1975.131.98

In a letter of March 3, 1977, Thomas McCormick kindly pointed out that on the verso of a drawing by Clérisseau at the Fitzwilliam Museum, Cambridge (Inv. 3641) there is an outline sketch for another version of this architectural fantasy.

CLODION (Claude Michel)

Nancy 1738 – Paris 1814

63. *Two Putti with Grapes and an Overturned Pitcher*

Black chalk, stumped, heightened with white, on beige paper. Framing lines in pen and brown ink. 23.3 x 29.2 cm.

PROVENANCE: Marius Paulme (Lugt 1910); Paulme sale, Paris, Galerie Georges Petit, May 13, 1929, no. 46, pl. 30; Irwin Laughlin; Mrs. Hubert Chanler; sale, London, Sotheby's, June 10, 1959, no. 13, repr. opp. p. 6, purchased by the Metropolitan Museum.

BIBLIOGRAPHY: *Annual Report*, 1958–1959, p. 56; Bean, 1964, no. 61, repr.; Gillies and Ives, 1972, no. 10.

The Elisha Whittelsey Collection,
The Elisha Whittelsey Fund, 1959
59.104

The group may have been studied for a sculpture representing Autumn, the vintage season. Comparable black chalk studies of putti are to be found at the Musée Bonnat in Bayonne (repr. Bayonne, 1924, no. 42, and Bayonne, 1926, no. 48), and at the Gulbenkian Foundation, Lisbon (repr. *Collection de la Fondation Calouste Gulbenkian. Arts plastiques français de Watteau à Renoir*, exhibition catalogue, Porto, 1964, no. 64).

CHARLES-NICOLAS COCHIN, le jeune

Paris 1715 – Paris 1790

64. *Allegory of the Life of the Dauphin*

Brownish-red chalk, over traces of black chalk. 29.8 x 19.7 cm. Lined.

Signed and dated in brownish-red chalk at lower margin, *C. N. Cochin filius delin. 176.* [last number effaced].

PROVENANCE: Lemoyne sale, Paris, August 10, 1778, no. 61 (according to C. Michel); Guyot de Villeneuve; Guyot de Villeneuve sale, Paris, Hôtel Drouot, May 28, 1900, no. 6; [Baderou]; purchased in Paris in 1961.

BIBLIOGRAPHY: *Annual Report*, 1961–1962, p. 67; Gillies and Ives, 1972, no. 11; C. Michel in *Diderot*, 1984, p. 499.

Rogers Fund, 1961
61.136.4

This drawing, which commemorates the death in 1765 (at the age of thirty-six) of the Dauphin Louis, son of Louis XV, was reproduced in reverse in the crayon manner by Gilles Demarteau (repr. *Diderot*, 1984, p. 500).

Demarteau's print was shown in the Salon of 1767, and the *livret* supplies a clear explanation of the iconography of Cochin's composition: "On voit en haut les Armes de Monseigneur le Dauphin, rayonnantes de gloire, et les restes d'un voile que la Mort a déchiré. En bas, la Mort entraîne les plis tombans de ce voile, dont la Modestie, qui est à côté, semble vouloir encore s'envelopper. Au-dessus . . . la Sagesse (sous l'emblême de Minerve), et la Justice, dirigent l'Étude, désignée par le coq et la lampe, vers l'Histoire, qui écrit, appuyée sur le temps. Derrière . . . sont la Bonté avec le Pélican, qui s'ouvre le sein; la tendresse conjugale, représentée par l'Hymen et l'Amour, liés de fleurs et s'embrassans: à côté d'eux est la Pureté, qui tient un lys. Dans le fond est un grouppe de Vertus chrétiennes et morales."

65. *Angels Adoring the Holy Trinity*

Brownish-red chalk, over traces of black chalk. Lightly squared in black chalk. 26.2 x 14.7 cm. Repaired tear at upper margin. Lined.

Signed and dated in brownish-red chalk at lower margin, *C. N. Cochin filius delin. 1772.*

PROVENANCE: Delbergue Cormont; sale, Paris, May 31, 1882, no. 12, mistakenly as "L'Assomption de la Sainte Vierge"; Hippolyte Destailleur; Destailleur sale, Paris, May 19–23, 1896, part of no. 734; sale, Paris, Hôtel Drouot, May 16–17, 1898, part of no. 63; [Cailleux]; purchased in Paris in 1983.

BIBLIOGRAPHY: Roland Michel, 1979, p. 176; *Annual Report*, 1983–1984, p. 24.

Harry G. Sperling Fund, 1983
1983.300

Marianne Roland Michel has identified this and the following five drawings (Nos. 66–70 below) as designs for illustrations in two lectionaries, an Epistolary and an Evangeliary, commissioned for the chapel royal of the château de Versailles. These two lectionaries, vellum manuscripts sumptuously ornamented with paintings in

gouache, are preserved in the Bibliothèque Nationale, Paris (M. Lat. 8896 and 8897).

Before his death in 1769 the miniaturist Pierre-Antoine Boudouin had supplied a number of illustrations for these lectionaries, especially for the Epistolary; some of these gouaches were shown in the Salons of 1767 and 1769. Soon after this, Cochin seems to have been called in to complete the project. He supplied drawings that were realized as gouache paintings, in large part by Nicolas-Louis Barbier, *peintre à gouache* and member of the Aca-

démie de Saint-Luc. The complex history of these lectionaries is discussed at length by Mme Roland Michel in the 1979 Berlin *Jahrbuch* and by Christian Michel in his as yet unpublished thesis, *Charles-Nicolas Cochin, illustrateur*.

This drawing is a study for the full-page gouache painting on fol. 42 verso of the Evangeliary, opposite fol. 43 recto, on which begins the text of the Gospel reading for the Feast of the Holy Trinity.

A number of Cochin's designs for the lectionaries have survived. Among these particular mention should be made of five drawings for full-page illustrations in the Evangeliary that were acquired not long ago by the West Berlin Print Room. They represent *Christ's Entry into Jerusalem*, the *Resurrection*, the *Ascension*, *Pentecost*, and the *Corpus Christi Procession* (the first four repr. Roland Michel, 1979, p. 154).

66. *The Company of Saints in Glory*

Brownish-red chalk, over traces of black chalk. Lightly squared in black chalk. 26.1 x 14.5 cm. Lined.

Signed and dated in brownish-red chalk at lower margin, *C. N. Cochin filius delin. 1772.*

PROVENANCE: Delbergue Cormont; sale, Paris, May 31, 1882, no. 12bis, mistakenly as "La Sainte Vierge dans les Cieux, adorée par les saints"; Hippolyte Destailleur; Destailleur sale, Paris, May 19–23, 1896, part of no. 734; sale, Paris, Hôtel Drouot, May 16–17, 1898, part of no. 63; [Cailleux]; purchased in Paris in 1983.

BIBLIOGRAPHY: Roland Michel, 1979, p. 176; *Annual Report*, 1983–1984, p. 24.

Harry G. Sperling Fund, 1983
1983.301

At the top of the composition the Virgin is seated beneath a luminous triangle representing the Holy Trinity. Immediately below her are Adam and Eve, and other Old Testament figures including Moses with the Tablets of the Law, and Aaron in his priestly costume. In the central register are the Apostles and Evangelists, identified by their attributes. Below at the left appear a pope, prelates, an emperor, and a king, while at the right St. Vincent de Paul stands at the center of a group of religious.

This drawing is a study for the full-page gouache painting on fol. 56 verso of the Evangeliary, opposite fol. 57 recto, on which begins the text of the Gospel reading for the Feast of All Saints.

See No. 65 above.

67. *The Risen Christ Appearing to Souls in Purgatory*

Brownish-red chalk, over traces of black chalk. 13.0 x 15.9 cm. Lined.

Signed and dated in red chalk at lower margin, *C. N. Cochin .f. delin. 1782.*

PROVENANCE: Guyot de Villeneuve; Guyot de Villeneuve sale, Paris, Hôtel Drouot, May 28, 1900, part of no. 11; [Shickman]; Christian Humann; sale, New York, Sotheby's, January 21, 1983, part of no. 76, purchased by the Metropolitan Museum.

BIBLIOGRAPHY: Roland Michel, 1979, p. 176; *Annual Report*, 1982–1983, p. 24.

Purchase, David L. Klein, Jr. Memorial Foundation, Inc. Gift, 1983
1983.29.5

Design for a cul-de-lampe on fol. 55 verso of the Evangeliary, at the end of the Gospel reading for the Feast of the Holy Martyrs Dionysius, Rusticus, and Eleutherius.
 See No. 65 above.

68. *Christ Falling under the Cross*

Brownish-red chalk. Framing lines in pen and brown ink. 11.8 x 21.8 cm.

Signed and dated in red chalk at lower left margin, *C. N. Cochin .f. delin. 1782*; numbered in pencil at lower right, 2.

PROVENANCE: Guyot de Villeneuve; Guyot de Villeneuve sale, Paris, Hôtel Drouot, May 28, 1900, part of no. 11; [Shickman]; Christian Humann; sale, New York, Sotheby's, January 21, 1983, part of no. 76, repr., purchased by the Metropolitan Museum.

BIBLIOGRAPHY: Roland Michel, 1979, p. 175; *Annual Report*, 1982–1983, p. 24.

Purchase, David L. Klein, Jr. Memorial Foundation, Inc. Gift, 1983
1983.29.2

Design for the border at the top of fol. 14 verso of the Epistolary, a page bearing the opening lines of the Epistle reading for Palm Sunday. The image was reversed in the gouache painting.
 See No. 65 above.

69

CHARLES-NICOLAS COCHIN

69. *The Coming of the Holy Spirit at Pentecost*

Brownish-red chalk, over traces of black chalk. 7.6 x 16.3 cm. Lined.

Signed in red chalk at lower left margin, *C. N. Cochin.*

PROVENANCE: Guyot de Villeneuve; Guyot de Villeneuve sale, Paris, Hôtel Drouot, May 28, 1900, part of no. 11; [Shickman]; Christian Humann; sale, New York, Sotheby's, January 21, 1983, part of no. 76, purchased by the Metropolitan Museum.

BIBLIOGRAPHY: Roland Michel, 1979, p. 175; *Annual Report*, 1982–1983, p. 24.

Purchase, David L. Klein, Jr. Memorial Foundation, Inc. Gift, 1983 1983.29.3

Design for the border at the top of fol. 22 recto of the Epistolary, a page bearing the opening lines of the reading from *Acts* for the Feast of Pentecost.

See No. 65 above.

70

70

70. *The Cross Triumphant over Worldly Powers*

Brownish-red chalk. 12.4 x 16.4 cm. Black stain at lower right.

Signed and dated in brownish-red chalk at lower center, *C. N. Cochin f. delin. 1782.*; numbered in pencil at lower left and right, *2.*

PROVENANCE: Guyot de Villeneuve; Guyot de Villeneuve sale, Paris, Hôtel Drouot, May 28, 1900, part of no. 11; [Shickman]; Christian Humann; sale, New York, Sotheby's, January 21, 1983, part of no. 76, purchased by the Metropolitan Museum.

BIBLIOGRAPHY: Roland Michel, 1979, p. 175; *Annual Report*, 1982–1983, p. 24.

Purchase, David L. Klein, Jr. Memorial Foundation, Inc. Gift, 1983 1983.29.4

Design for a cul-de-lampe on fol. 27 verso of the Epistolary, at the end of the Epistle reading for the Feast of St. Vincent de Paul. In the gouache painting the image was reversed, and the winged putto at uppermost left in the drawing was omitted.

See No. 65 above.

71. *The Rape of the Sabine Women*

Red chalk, over traces of black chalk. Lightly squared in black chalk. 25.8 x 37.9 cm.

PROVENANCE: Pierre-François Basan; Basan sale, Paris, December 1–19, 1798, no. 85, "L'Enlèvement des Sabines, composition de plus de cent figures; à la sanguine sur papier blanc. Pièce encadrée"; [Wildenstein]; [Drey]; purchased in New York in 1975.

BIBLIOGRAPHY: Salon of 1781, no. 286; Goncourt, 1880–1882, II, p. 115; Dilke, 1902, p. 185; *Annual Report*, 1975–1976, p. 36.

71

Harry G. Sperling Fund, 1975
1975.308

The drawing, exhibited in the Salon of 1781, was etched
in the crayon manner by Thérèse-Éléonore Hémery Lingée
(Le Blanc, II, p. 554, no. 3).

72. *Bust of a Man, in Profile to Left*

Graphite. Diameter 11.5 cm. Water stains at lower margin.

Signed and dated in pencil at lower margin, *C. N. Cochin f. delin.
1776.*

PROVENANCE: [Shickman]; purchased in New York in 1970.

BIBLIOGRAPHY: *Annual Report*, 1970–1971, p. 16; Bean, 1972, no.
63.

Rogers Fund, 1970
1970.41.2

JEAN-BAPTISTE CORNEILLE

Paris 1649 – Paris 1695

73. *The Nurture of Jupiter*

Pen and brown ink, brown wash, over traces of graphite. Squared in black chalk. 21.9 x 29.9 cm.

PROVENANCE: [Galerie de Bayser]; purchased in Paris in 1984.

BIBLIOGRAPHY: *Exposition de dessins anciens, 1984. Galerie de Bayser*, Paris, 1984, no. 7, repr.; *Annual Report*, 1984–1985, p. 25.

Purchase, David L. Klein, Jr. Memorial Foundation, Inc. Gift, 1984
1984.236

74. *Figure Studies for a Judgment Scene*

Pen and brown ink. 24.4 x 18.5 cm. Upper corners cut away. Lined.

Inscribed in pen and brown ink at lower margin of old mount in Richardson's hand, *Pietro de' Petri.*

PROVENANCE: Jonathan Richardson, Jr. (Lugt 2170, 2997); Sir Joshua Reynolds (Lugt 2364); sale, Paris, Nouveau Drouot, salle 6, February 15, 1984, no. 105, repr., as Pietro de' Pietri, purchased by the Metropolitan Museum.

BIBLIOGRAPHY: *Annual Report*, 1984–1985, p. 25.

Harry G. Sperling Fund, 1984
1984.247

The name of the Italian master Pietro de' Pietri (1663–
1716) is inscribed on the old mount in what appears to be
the hand of Jonathan Richardson, Jr. Notwithstanding
the venerability of this attribution, Lawrence Turčić con-
vincingly proposes that the nervous, idiosyncratic pen
work is typical of Jean-Baptiste Corneille. The facial
types, the fashion in which hands are drawn, and even the
architectural features of the background can be found in
J.-B. Corneille's signed drawing, the *Return of the Prodi-
gal Son*, in the British Museum, London (1897–11–
17–2; Rosenberg, 1971, fig. 45), as well as in No. 73
above.

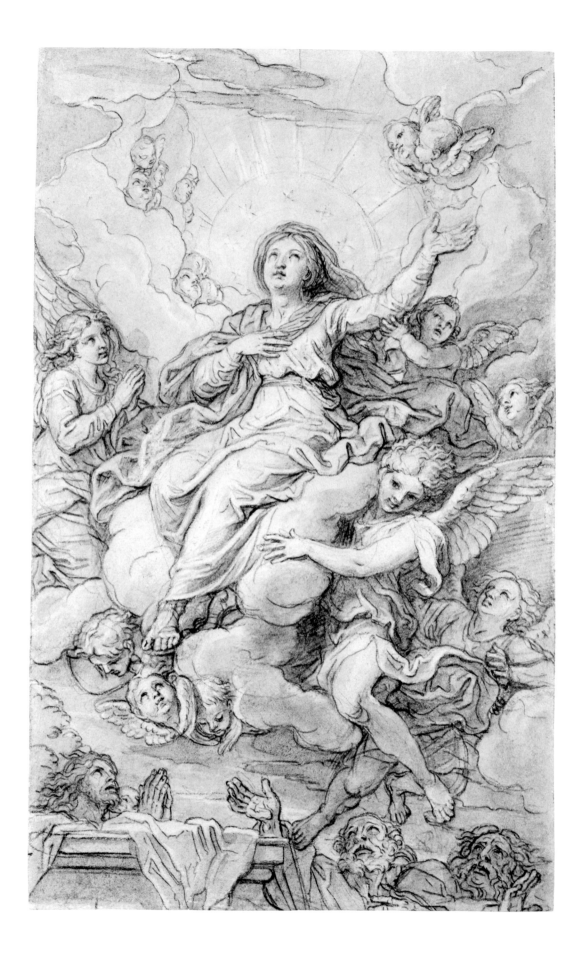

74

MICHEL CORNEILLE

Paris 1642 – Paris 1708

75. *The Assumption of the Virgin*

Pen and brown ink, brown wash, heightened with white, over black chalk. 31.5 x 19.5 cm.

Inscribed in black chalk on verso, *M^{el} Corneille*.

PROVENANCE: [Baderou]; purchased in Paris in 1973.

BIBLIOGRAPHY: *Annual Report*, 1972–1973, p. 33.

Rogers Fund, 1973
1973.15

76. *The Martyrdom of St. Andrew*

Pen and brown ink, a little brown wash, heightened with white, over black chalk, on blue-green paper faded to brown. 31.1 x 20.5 cm.

PROVENANCE: J.-A. Duval Le Camus (Lugt 1441); purchased in New York in 1982.

BIBLIOGRAPHY: *Annual Report*, 1981–1982, p. 23.

Harry G. Sperling Fund, 1982
1982.93.1

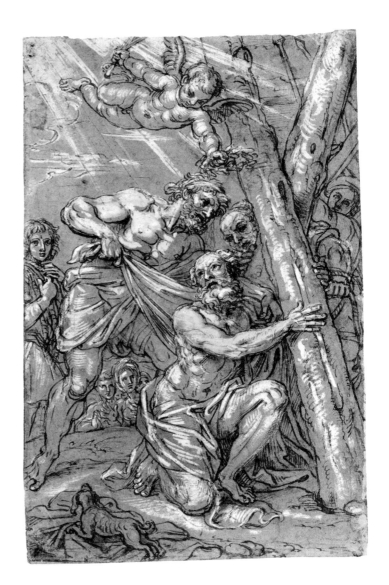

In the Graphische Sammlung, Munich, there is a double-faced sheet (Inv. 5289) by Michel Corneille with studies for a *Martyrdom of St. Andrew* that are close in composition to our drawing.

Another study by the artist representing the same subject, but with many variations in composition, is in the Cabinet des Dessins, Musée du Louvre (Guiffrey and Marcel, III, 1909, no. 2563, repr., wrongly as "d'après Louis Carrache"). The Louvre drawing was engraved in reverse by Corneille himself (*Inventaire 17^e siècle*, III, p. 149, no. 20).

GUILLAUME COURTOIS

Saint-Hippolyte 1628 – Rome 1679

77. *Study for a Portrait of a Man*

Red chalk. 33.2 x 25.4 cm.

Inscribed in red chalk on verso, *Baroccio*.

PROVENANCE: [Lowe]; purchased in London in 1975.

BIBLIOGRAPHY: *Old Master Drawings Presented by Lorna Lowe*, London, 1974, no. 15, pl. 5; *Annual Report*, 1974–1975, p. 51; Bean, 1975, no. 37; S. Prosperi Valenti Rodinò, *Disegni di Guglielmo Cortese (Guillaume Courtois) detto Il Borgognone nelle collezioni del Gabinetto Nazionale delle Stampe*, Rome, 1979, p. 87, under no. 198.

Harry G. Sperling Fund, 1975
1975.60

The convincing attribution to Guillaume Courtois is due to Ann Sutherland Harris.

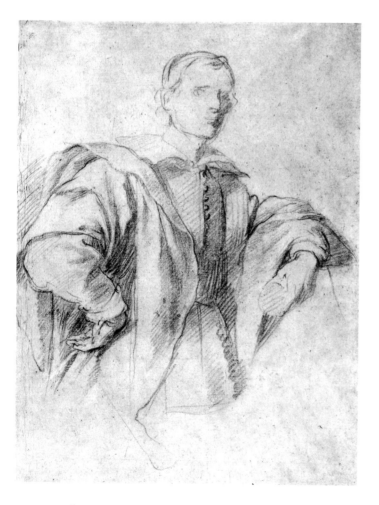

JEAN COUSIN, le père

Sens ca. 1490 – Sens ca. 1560

78. *Judgment Scene*

Pen and brown ink, brown wash, heightened with white, over slight traces of black chalk. 9.0 x 35.2 cm. A number of repaired losses. Lined.

Inscribed in pen and dark brown ink at lower left, DV. VICENTINO., at lower right, DU *Vicentino.*; at lower margin of old mount, *Domenico Vicentino. | École vénitienne.*; on reverse of old mount, *École Vénitienne | Sujet de Théagène et Cariclea au moment qu'il sont reconnu | dessiné à la plume lavé d'encre de la chine et reausé de blanc*; in pencil, *Giov.! Bat.ª Stefaneschi | Florence ob.! 1659-ae 77.*

PROVENANCE: Harry G. Friedman.

BIBLIOGRAPHY: *Annual Report*, 1963–1964, p. 60, as unknown artist, school of Fontainebleau; S. Béguin in *Per A. E. Popham*, Parma, 1981, pp. 55–61, repr.

Gift of Harry G. Friedman, 1963
63.117

This unfortunately rather damaged drawing was acquired as the work of an unidentified artist of the school of Fontainebleau. It was Mme Béguin who in 1973 proposed the name of Jean Cousin, le père, and she published and reproduced the drawing in 1981 with a carefully argued commentary on her attribution.

JEAN COUSIN, le père

Sens ca. 1490 – Sens ca. 1560
or

JEAN COUSIN, le fils

Sens ca. 1522 – Paris ca. 1594

79. *The Adoration of the Shepherds*

Pen and brown ink, brown wash, heightened with white, over black chalk. 25.3 x 39.0 cm. Lined.

Inscribed in pen and brown ink on old mount (now detached), *Frans Floris (de Vriendt) | Antwerpen* ᶜª *1520/1570 Antwerpen.*

PROVENANCE: Gerard Leembruggen Jzn.; Leembruggen sale, Amsterdam, March 5–8, 1866, no. 243, as Frans Floris; J. F. Ellinckhuysen; Ellinckhuysen sale, Amsterdam, November 19–20, 1878, no. 125, as Frans Floris; [Wallach]; purchased in New York in 1961.

BIBLIOGRAPHY: *Annual Report*, 1960–1961, p. 63, as Flemish (Antwerp); Bean, 1964, no. 52, repr.; S. Béguin in *L'école de Fontainebleau*, exhibition catalogue, Grand Palais, Paris, 1972, no. 69, repr., as

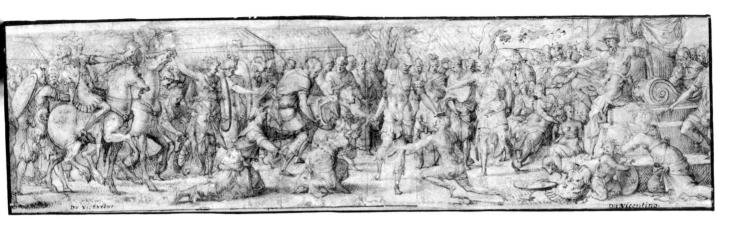

Cousin le fils (with additional bibliography); S. Béguin in *Fontaine-bleau, Art in France, 1528–1610*, exhibition catalogue, National Gallery of Canada, Ottawa, 1973, I, pl. 153, II, p. 41, no. 69 (as Cousin the Younger ?).

Rogers Fund, 1961
61.24

A clear distinction between the draughtsmanship of the Cousin, father and son, is a matter of controversy and uncertainty. The facial types, the architectural back-ground, and the calligraphic flourishes in this drawing are very close to those in *Infants Playing in Classical Ruins*, a large sheet in the Cabinet des Dessins, Musée du Louvre, that is generally accepted as the work of Cousin le père (S. Béguin, *Il Cinquecento francese*, Milan, 1970, pl. XIX). However, it has been argued that our drawing is some-what coarser in execution, and thus *might* be attributed to Cousin le fils, using the hypothesis that he was less talented than his father.

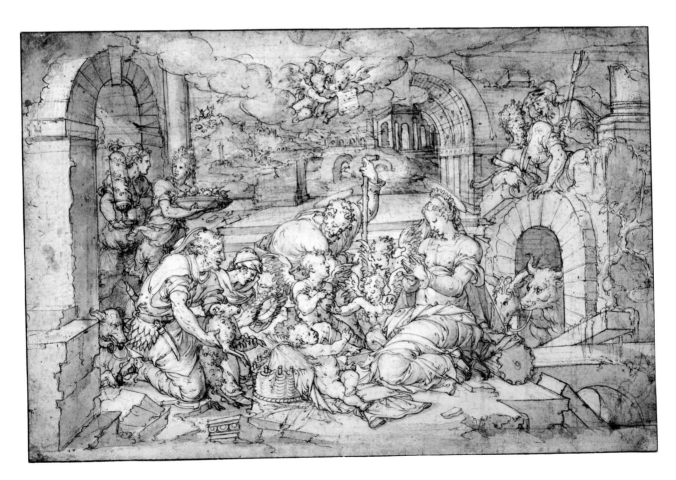

ANTOINE COYPEL

Paris 1661 – Paris 1722

80. *Zephyr and Flora*

Red chalk over traces of graphite. Squared in black chalk. 16.3 x 14.5 cm. Lined.

PROVENANCE: Sale, New York, Sotheby Parke Bernet, Arcade Auctions, January 20, 1983, no. 609, as Charles-Antoine Coypel, "Cupid and Psyche"; [P. Gordon]; purchased in New York in 1983.

BIBLIOGRAPHY: *Annual Report*, 1983–1984, p. 24.

Van Day Truex Fund, 1983
1983.432

Pamela Gordon identified this drawing as a study, with a number of variations, for a painting by Antoine Coypel executed for the Grand Trianon at Versailles. Payment for the picture is recorded on February 26, 1702 (A. Schnapper, *Tableaux pour le Trianon de marbre, 1688–1714*, Paris, 1967, p. 94, the painting repr. fig. 53).

81. *Seated Old Man Holding a Staff*

Red and black chalk, stumped, heightened with white, on beige paper. Squared in black chalk. 47.6 x 37.5 cm. Horizontal crease at center; several repaired tears. Lined.

Inscribed in pencil at lower right, *A. Coypel*.

PROVENANCE: Jacques Petit-Horry (his mark, JPH in a triangle, not in Lugt); purchased in Paris in 1972.

BIBLIOGRAPHY: *Annual Report*, 1972–1973, p. 33; Bean, 1975, no. 39.

Harris Brisbane Dick Fund, 1972
1972.224.1

Study for a seated shepherd who watches *La danse des chèvres*, one of twenty-eight paintings representing the story of Daphnis and Chloe executed by Antoine Coypel (with the assistance of the Regent, according to tradition)

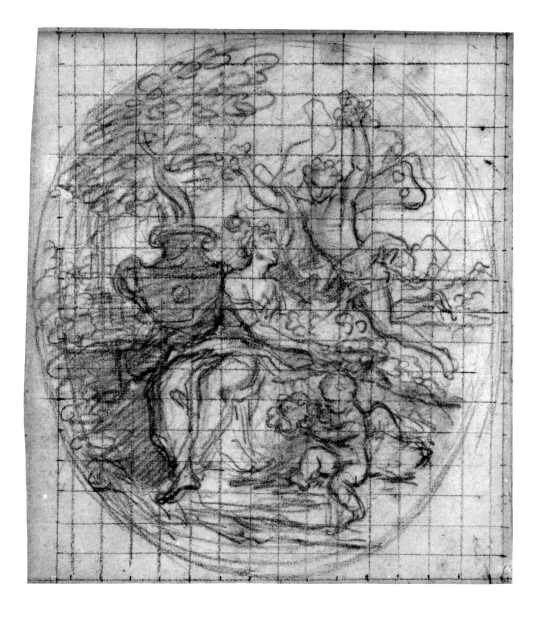

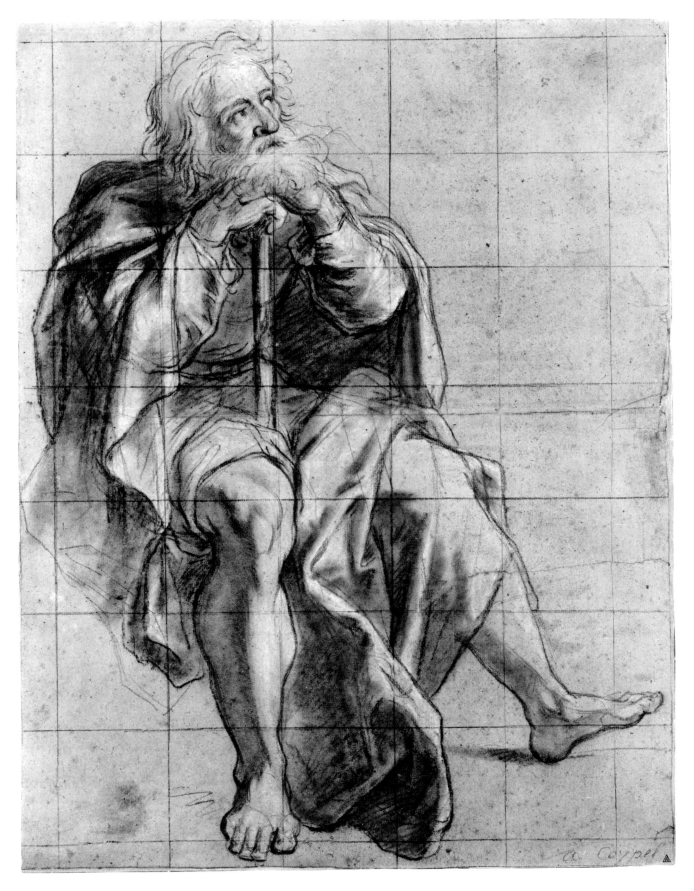

for the château de Bagnolet. The paintings, like the château, have disappeared, but the compositions are recorded in B. Audran's engraved illustrations for a *Daphnis et Chloé*, published in 1718 though the plates are dated 1714. Twenty of the subjects, including *La danse des chèvres*, were reproduced in a series of Gobelins tapestries datable ca. 1715 (Fenaille, III, 1904, pp. 283–292, repr. opp. p. 288).

82

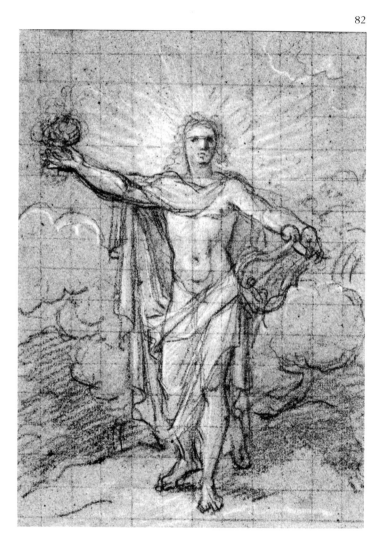

82. *Standing Figure of Apollo*

Black chalk, heightened with white, on blue paper. Squared in black chalk. 21.3 x 15.8 cm. Lined.

Inscribed in pen and brown ink on verso, *25 Coypel*.

PROVENANCE: Sale, London, Sotheby's, June 25, 1970, no. 94; Harry G. Sperling.

BIBLIOGRAPHY: *Annual Report*, 1974–1975, p. 50.

Bequest of Harry G. Sperling, 1971
1975.131.103

Apollo, his head surrounded with beams of light, holds a lyre with his left hand; the identity of the barely indicated object he holds in his extended right hand is uncertain.

CHARLES-ANTOINE COYPEL

Paris 1694 – Paris 1752

83. *River God and Another Male Figure*

Black chalk, stumped, touches of red chalk, heightened with white. Squared in black chalk. Framing lines in pen and brown ink. 36.7 x 27.3 cm. Lined.

PROVENANCE: Jacques Petit-Horry (his mark, JPH in a triangle, not in Lugt); purchased in Paris in 1972.

BIBLIOGRAPHY: A. Schnapper, *Revue du Louvre et des Musées de France*, XVIII, 4–5, 1968, pp. 259–260, note 39; *Annual Report*, 1972–1973, p. 34; Bean, 1975, no. 40, repr. on cover; *Notable Acquisitions*, 1965–1975, p. 63, repr.

Fletcher Fund, 1972
1972.224.2

This river god, holding a rudder in his right hand, his left raised in a gesture of defiance, is studied for the figure of the Scamandros that appears at the lower left in Charles-Antoine Coypel's painting of 1737, *Achilles Pursuing the Trojans into the River Scamandros*, now in Leningrad (*Musée de l'Ermitage. Département de l'art occidental. Catalogue des peintures*, Leningrad and Moscow, 1958, I, p. 289, p. 290, fig. 213). The nude figure at the lower left is a study for one of the drowning Trojans. The connection between this drawing and the painting in the Hermitage was first noted by Antoine Schnapper.

CHARLES-ANTOINE COYPEL

84. *Allegorical Figure of Painting*

Black chalk, stumped, heightened with red and white chalk, on blue paper. Lightly squared in black chalk. 35.6 x 31.0 cm.

PROVENANCE: [Schatzki]; purchased in New York in 1962.

BIBLIOGRAPHY: *Annual Report*, 1961–1962, p. 67, as anonymous French XVIII century; Rosenberg, 1972, p. 150, under no. 36; Gillies and Ives, 1972, no. 13; Fogg Art Museum, 1980, p. 96, under no. 28.

The Elisha Whittelsey Collection,
The Elisha Whittelsey Fund, 1962
62.19

This drawing entered the collection as an anonymous work of the eighteenth century. The convincing attribution to Charles-Antoine Coypel is due to Pierre Rosenberg (letter of February 21, 1972). He pointed out that our figure was utilized in an *Allegory of Painting Appearing to a Winged Youth on a Bed*, a picture by Charles-Antoine in a private collection in Paris. A chalk drawing for the whole composition is in the collection of Emile Wolf, New York (Fogg Art Museum, 1980, no. 28, repr.).

NOËL COYPEL

Paris 1628 – Paris 1707

85. *The Assumption of the Virgin*

Black chalk, heightened with white, on gray paper. 26.1 x 20.3 cm.
Lined.

PROVENANCE: Guichardot; Guichardot sale, Paris, July 7–10, 12–20, 1875, lot no. uncertain; marquis de Chennevières (Lugt 2073); [Galerie de Bayser]; purchased in Paris in 1981.

BIBLIOGRAPHY: Chennevières, *L'Artiste*, XII, 1896, part XVII, p. 416, "Noël Coypel . . . Assomption de la Vierge. À la pierre noire, rehaussé de blanc sur papier gris. Vente Guichardot"; *Exposition de dessins et sculptures de maîtres anciens, 1980. Galerie de Bayser*, Paris, 1980, no. 10, repr.; *Annual Report*, 1980–1981, p. 27.

Harry G. Sperling Fund, 1981
1981.15.3

JEAN DARET

Brussels 1613 or 1615 – Aix-en-Provence 1668

86. *The Risen Christ between the Virgin and St. Joseph, Appearing to St. Peter and the Other Apostles*

Brush and brown wash, over graphite. 16.9 x 12.3 cm. A number of vertical creases. Lined.

Inscribed in pen and brown ink at lower left, *Daret*; at lower center in another hand, *Daret*, over an illegible pencil inscription beginning with, *8*; numbered in pen and brown ink on verso, *12P / 12R*; inscribed in pen and black ink at lower right of Chennevières mount, J. DARET; blind stamp at lower right of mount, *96*.

PROVENANCE: Portes (according to Chennevières); marquis de Chennevières (Lugt 2072); Chennevières sale, Paris, Hôtel Drouot, April 4–7, 1900, part of no. 99; [Baderou]; purchased in Paris in 1961.

BIBLIOGRAPHY: Chennevières, *L'Artiste*, IX, 1895, part IV, p. 21, part VI, p. 264, "Le Christ assis sur des nues entre la Vierge et saint Joseph, et adoré par les disciples les uns debout, les autres agenouillés, sur terre. Au crayon lavé de bistre. Provient de la collection de M. Portes (d'Aix)"; *Annual Report*, 1961–1962, p. 66; P. Rosenberg in Marseille, 1978, p. 42.

Rogers Fund, 1961
61.136.3

87. *Study for Christ as Mediator*

Graphite. 17.3 x 17.3 cm. Lined.

Inscribed in pen and black ink at lower right of Chennevières mount, J. DARET; blind stamp at lower left of mount, 95.

PROVENANCE: Portes (according to Chennevières); marquis de Chennevières (Lugt 2072); Chennevières sale, Paris, Hôtel Drouot, April 4–7, 1900, part of no. 99; Jean-Pierre Selz and Seiferheld and Company.

BIBLIOGRAPHY: Chennevières, *L'Artiste*, IX, 1895, part IV, p. 21, part VI, p. 264, "De la collection Portes d'Aix: études . . . pour un Sauveur assis sur des nues"; *Annual Report*, 1966–1967, p. 59; P. Rosenberg in Marseille, 1978, p. 42.

Gift of Jean-Pierre Selz and Seiferheld and Company, 1967
67.39

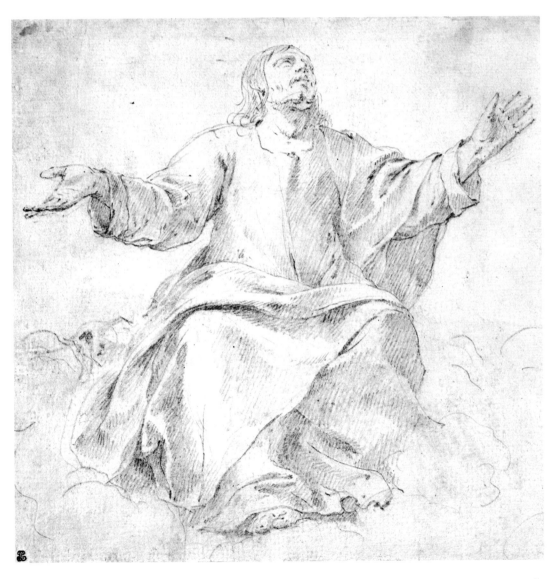

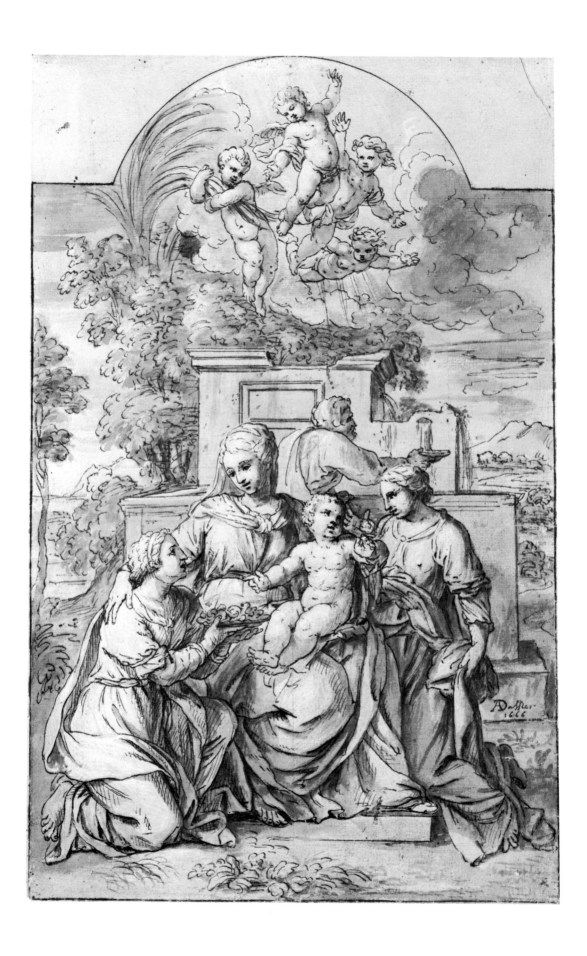

ADRIEN DASSIER

Lyon 1630 – Lyon 1690

88. *The Rest on the Flight into Egypt*

Pen and brown ink, gray-brown wash, heightened with white, over
traces of black chalk, on beige paper. Faintly squared in black chalk.
41.7 x 26.5 cm. Crease at upper right corner; scattered pigment
stains. Lined.

Signed and dated in pen and brown ink at lower right, *ADassier /
1666*.

PROVENANCE: [Rockman]; Harry G. Friedman.

BIBLIOGRAPHY: *Annual Report* 1959–1960, p. 57.

Gift of Harry G. Friedman, 1960
60.66.2

LOUIS DAVID

Paris 1748 – Brussels 1825

89. *Flying Figure Holding a Crown, Reclining River God*

Black chalk. 16.3 x 13.6 cm. All four corners cut away.

Inscribed in black chalk at lower margin, *Comp . . .*; initialed in pen
and brown ink at lower right by the artist's sons Jules and Eugène
(Lugt 1437 and 839), *J.D.* and *ED*.

PROVENANCE: David studio sale, Paris, April 17, 1826, lot no.
uncertain; [Galerie de Bayser et Strolin]; purchased in Paris in 1963.

BIBLIOGRAPHY: *Annual Report*, 1963–1964, p. 62; Dayton, Ohio,
1971, no. 35, repr.

Rogers Fund, 1963
63.92.1

This early drawing probably copies an Italian ceiling fres-
co of the seventeenth or eighteenth century, but it has not
been possible to identify the original.

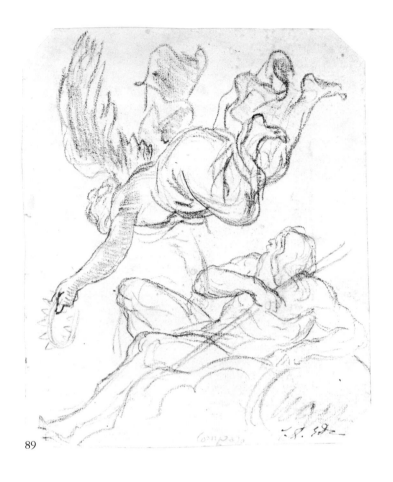

89

90. *Seated Draped Male Figure*

Black chalk, stumped, heightened with white, on beige paper.
Squared in black chalk. 53.6 x 41.5 cm. Lined.

Inscribed in pencil at lower right in the artist's hand, *David à son ami
chaudet*.

PROVENANCE: The sculptor Antoine-Denis Chaudet (according to
inscription); [Wildenstein]; purchased in London in 1961.

BIBLIOGRAPHY: Bean, 1962, pp. 170–171, fig. 16; *Annual Report*,
1961–1962, p. 67; Bean, 1964, no. 62, repr.; London, Royal Acad-
emy, 1968, p. 64, no. 182, fig. 330; *Dessins français du Metropolitan
Museum*, 1973, no. 23, repr.; A. Sérullaz in *Néo-Classicisme français*,
1974, p. 36, under no. 18; A. Schnapper in *Age of Revolution*, 1975, p.
368, under no. 32.

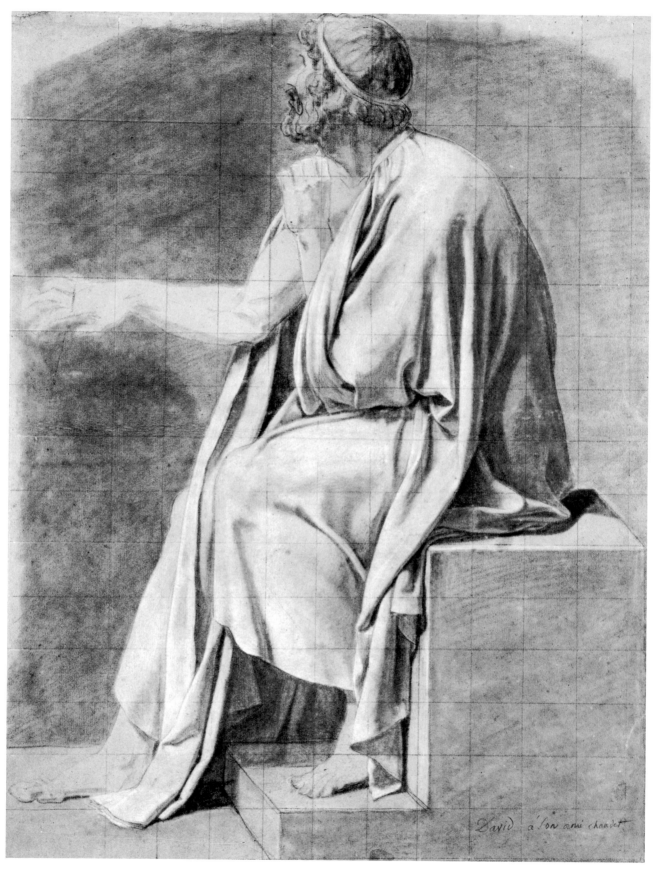

David à son ami chaudet

90

Rogers Fund, 1961
61.161.1

Full-scale squared study for the drapery of the seated
figure of Crito in the *Death of Socrates*; the painting,
signed and dated 1787 and shown in the Salon that year,
has been in the Metropolitan Museum since 1931. Simi-
lar large studies for the drapery of other figures in the
composition are preserved in French public collections:
three are in the Musée Bonnat, Bayonne, one in the Mu-
sée des Beaux-Arts, Tours, and one in the Musée Magnin,
Dijon (for these drawings see A. Sérullaz in *Néo-Classi-
cisme français*, 1974, p. 36).

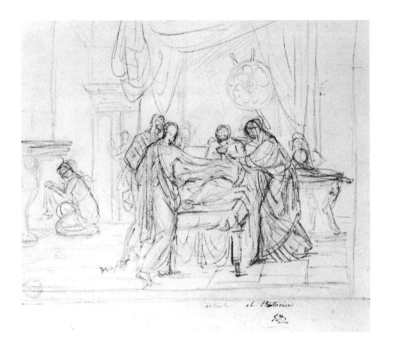

91. *Scene from Ancient History: Cup Offered to an Invalid*

Black chalk. 24.3 x 28.7 cm. Repaired loss at lower left. Lined.

Inscribed in pen and brown ink at lower right, *Antiochus*; in another
darker ink, *et Stratonice / ED* (initials of Eugène David, Lugt 839).

PROVENANCE: L.-J.-A. Coutan (Lugt 464); Coutan-Hauguet sale,
Paris, December 16–17, 1889, no. 93; [Wildenstein]; purchased in
New York in 1961.

BIBLIOGRAPHY: *Annual Report*, 1960–1961, p. 64.

Rogers Fund, 1961
61.54.2

The composition is entitled (by David himself?) simply
Antiochus. It may represent the poisoning of Antiochus II
Theos by his first wife Laodice, who was concerned for the
future of her two sons. Eugène David has mistakenly
added the words *et Stratonice*. The composition certainly
does not represent that celebrated story, which had been
the subject of David's *prix de Rome* of 1774.

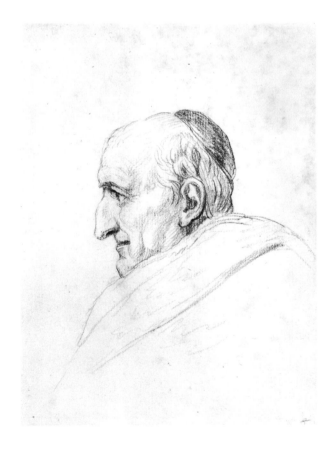

92. *Bust of a Prelate*

Black chalk. 17.5 x 13.0 cm.

Numbered in black chalk at lower right, *8*.

PROVENANCE: Prince Napoléon; Hippolyte Destailleur; Destailleur
sale, May 26–27, 1893, part of no. 29, "Album de croquis"; Walter
C. Baker.

BIBLIOGRAPHY: Virch, 1962, no. 89, as portrait of Cardinal Fesch;
Arts under Napoleon, 1978, no. 46, fig. 9, as portrait of Cardinal Fesch;
Annual Report, 1979–1980, p. 27.

LOUIS DAVID (NO. 92)

Bequest of Walter C. Baker, 1971
1972.118.204

The drawing comes from a now dismembered album of forty-two sketches, the better part of which were portrait studies utilized in David's *Sacre de l'Empereur Napoléon I^er*.

When the drawing was in the collection of Walter C. Baker, it was thought to be a study for Cardinal Fesch, as he is represented in the painting. However, Gérard Hubert has pointed out that this figure appears to the left of Cardinal Fesch. Charles Sterling and Hélène Adhémar tentatively identified the prelate as Étienne-Hubert Cambacérès, Cardinal Archbishop of Rouen (*Musée national du Louvre. Peintures. École française, XIX^e siècle*, II, Paris, 1959, p. 6).

The painting, which represents the coronation that took place on December 2, 1804, was commissioned by Napoleon himself. It was signed and dated by David, *1806 & 1807*.

93. *Leonidas at Thermopylae*

Black chalk. Squared in black chalk. 40.6 x 55.0 cm. Scattered stains; repaired tear at lower left.

Initialed in pen and brown ink at lower right by the artist's sons Eugène and Jules (Lugt 839 and 1437), *ED* and *J.D.*

PROVENANCE: David studio sale, Paris, April 17, 1826, part of no. 92; Jean Oberlé (according to vendor); [Baderou]; [Wildenstein]; purchased in New York in 1963.

BIBLIOGRAPHY: *Annual Report*, 1962–1963, p. 64; J. Bean, *Revue du Louvre et des Musées de France*, XIV, 6, 1964, pp. 327–329, fig. 1; D. von Bothmer, *Revue du Louvre et des Musées de France*, XIV, 6, 1964, pp. 330–332; *Dessins français de 1750 à 1825 dans les collections du Musée du Louvre, le néo-classicisme*, exhibition catalogue by A. Sérullaz, Cabinet des Dessins, Musée du Louvre, Paris, 1972, pp. 24–25, under no. 56; A. Sérullaz in *The Age of Neo-Classicism*, exhibition catalogue, Royal Academy and Victoria and Albert Museum, London, 1972, no. 556, pl. 82; *Dessins français du Metropolitan Museum*, 1973, no. 24, repr.; S. A. Nash, *Metropolitan Museum Journal*, 13, 1978, pp. 101–112, fig. 2; Athens, 1979, no. 75, repr.; A. Schnapper, *David, témoin de son temps*, Fribourg, 1980, p. 272, fig. 175.

Rogers Fund, 1963
63.1

93

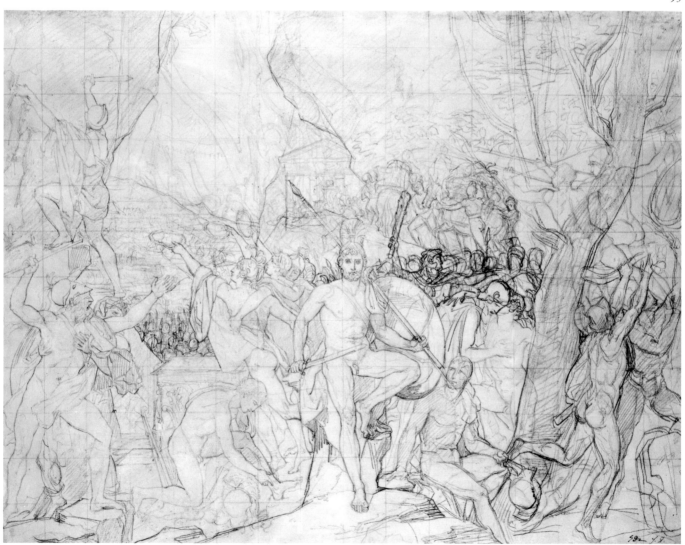

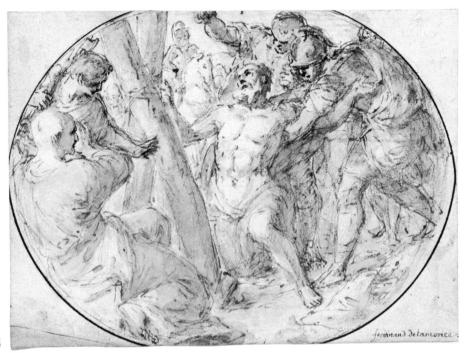

94

Study for *Léonidas aux Thermopyles*, signed and dated 1814 and since 1819 in the Musée du Louvre. Work on the painting was begun in the first years of the century, then abandoned for a decade and taken up again after 1811. Steven A. Nash has observed that our drawing was executed in two quite distinct stages; a faint underdrawing records the original, rather cluttered, composition of which he supplies a tracing (Nash, *op. cit.*, p. 103, fig. 3). The drawing was later reworked with decisive accents in black chalk; important changes were made in the arrangement of the figures and most of all in the landscape background.

FERDINAND DELAMONCE

Munich 1678 – Lyon 1753

94. *The Martyrdom of St. Andrew*

Pen and brown ink, brown wash, over black chalk. 13.1 x 18.7 cm. Lower left corner replaced. Lined.

Inscribed in pen and brown ink at lower right, *ferdinand delamonce*.

PROVENANCE: Sale, London, Sotheby's, December 7, 1978, no. 245, repr. p. 122; [Collins]; purchased in New York in 1979.

BIBLIOGRAPHY: *Annual Report*, 1978–1979, p. 25.

Purchase, Mr. and Mrs. Carl L. Selden Gift, 1979
1979.18

Stylistically comparable drawings by Ferdinand Delamonce are in the Rijksprentenkabinet, Amsterdam (Inv. 1952.33 and 1952.34, the latter repr. *Franse tekenkunst*, 1974, no. 29), and in the Baderou Collection, Musée de Rouen (*Études*, 1980, pp. 140–141, figs. 6 and 7).

PIERRE-ANTOINE DEMACHY

Paris 1723 – Paris 1807

95. *Architectural Fantasy, with the Demolition of the Old Vestibule of the Palais-Royal, Paris*

Gouache over traces of graphite. 24.4 x 28.6 cm. (overall). The original sheet, measuring 23.6 x 28.6 cm., is affixed to an old mount on which the drawing is continued in the artist's hand for 8 mm. at the lower margin.

Inscribed in pen and brown ink at lower left corner of old mount, *Demachy.*; in pencil on reverse of new mount, *Demolition of the Queen's Stables, Palace of the Louvre / Exhibited at the Salon 1759. / P. A. Demachy. 1723–1807*.

PROVENANCE: English private collection; [Morton Morris]; purchased in London in 1984.

BIBLIOGRAPHY: *Annual Report*, 1984–1985, p. 26.

Van Day Truex Fund, 1984
1984.357

Judging from a plate in J.-F. Blondel's *Architecture fran-çoise* that reproduces the old vestibule or "passage pour les équipages" of the Palais-Royal in Paris (III, 1754, no. 335), Demachy gives us quite an accurate view of the passageway in the course of demolition. The coupled Tuscan pilasters and the three arched niches were features of the old vestibule, which was demolished in the almost total reconstruction of the palace undertaken in the 1750s by Contant d'Ivry, architect of Louis-Philippe, duc d'Orléans, then proprietor of the Palais-Royal.

The element of fantasy in this drawing is the façade surmounted by a balustrade that is seen in the right background. This imaginary architecture was probably inspired by Perrault's south façade of the Palais du Louvre.

The modern inscription on the reverse of the mount wrongly identifies this gouache by Demachy with one shown in the Salon of 1759 that represented the demolition of the queen's stables near the Louvre. It was Jean-Marie Bruson of the Cabinet des Estampes at the Musée Carnavalet, Paris, who identified the building in the foreground. The demolition of the old vestibule of the Palais-Royal was the subject of a painting exhibited by Demachy in the Salon of 1767.

The Musée Carnavalet possesses a somewhat smaller drawing by Demachy representing the demolition at the Palais-Royal (Carnavalet D 5197, pen and brown ink, heightened with white, on tracing paper, varnished, 24.0 x 26.4 cm.; the composition is reversed).

JEAN-BAPTISTE DESHAYS

Rouen 1729 – Paris 1756

96. *Shepherds Dreaming of the Flight into Egypt*

Oil paint over black chalk on paper, mounted on canvas. Varnished. 33.4 x 30.8 cm.

PROVENANCE: [Cailleux]; purchased in Paris in 1983.

BIBLIOGRAPHY: *Annual Report*, 1982–1983, p. 24; *Notable Acquisitions*, 1983–1984, p. 72, repr. in color.

Harry G. Sperling Fund, 1983
1983.66

An oil sketch by Deshays in the Cabinet des Dessins, Musée du Louvre, representing the Rest on the Flight, may well be the pendant to our sketch; it is, in any case, exactly comparable in dimensions, style, and technique (Inv. 26 199, from the collection of P.-J. Mariette; repr. in color, Bacou, 1971, pl. XX).

97. *Phryne before the Areopagus*

Pen and brown ink, brown wash, heightened with white, over black chalk and charcoal, on beige paper. 47.4 x 60.2 cm. Horizontal creases at right margin; vertical crease at lower center. Lined.

Inscribed in pen and brown ink at lower margin right of center, *Deshays. f.*

PROVENANCE: Posthumous Deshays sale, Paris, March 26, 1765, and following days, no. 12, "Phryné, Courtisane d'Athènes, accusée d'impiété, et défendue par l'Orateur Hypéride. Ce Dessein capital, fait à la plume, au bistre rehaussé de blanc, est composé de plus de vingt figures dans le style des plus grands Maîtres."; Randon de Boisset; Randon de Boisset sale, Paris, February 27 – March 25, 1777, no. 372, "Phrinée devant l'Aréopage"; Vassal de Saint-Hubert; Vassal de Saint-Hubert sale, Paris, March 29 – April 13, 1779, no. 150, "Phrinée devant l'Aréopage" (the dimensions given, 10 pouces 9 lignes x 22 pouces, are somewhat different); sale, Paris, June 26, 1950, no. 52 (according to Sandoz); [Duits]; purchased in London in 1961.

BIBLIOGRAPHY: M. Sandoz, *Bulletin de la Société de l'Histoire de l'Art français*, 1958, p. 19; Bean, 1962, p. 170, fig. 15; *Annual Report*, 1961–1962, p. 67; Gillies and Ives, 1972, no. 16; M. Sandoz, *Jean-Baptiste Deshays 1729–1765*, Paris, 1977, p. 101, no. 136, pp. 102–103, no. 155, pl. IV, the subject mistakenly called "Suzanne devant ses juges."

Rogers Fund, 1961
61.126

The traditional (and we believe correct) title of this noble composition is *Phryné, courtisane d'Athènes, accusée d'impiété, défendu par l'orateur Hypéride*. Deshays's brother-in-law, P.-A. Baudouin, treated this rather unusual subject in a miniature he submitted as his *morceau de réception* in 1763; Baudouin's work is close in composition to and may have derived from the present wash drawing by Deshays (the miniature, now in the Cabinet des Dessins, Musée du Louvre, repr. Diderot, *Salons*, 1, fig. 118).

98. *Half Figure of a Man, Nude to the Waist*

Red and black chalk, heightened with white, on beige paper. 29.1 x 31.6 cm. Horizontal crease at bottom.

Unidentified initials in pen and brown ink at lower right, *c d'E* with a paraph.

PROVENANCE: Sale, London, Sotheby's, November 18, 1982, no. 17, as French School, early 18th century; [Colnaghi]; purchased in London in 1985.

BIBLIOGRAPHY: *Annual Report*, 1984–1985, p. 26.

Harry G. Sperling Fund, 1985
1985.47

The drawing was identified by Jean-François Baroni in 1984 as a study for one of the executioners in the *Martyrdom of St. Andrew* by Deshays, now in the Musée de Rouen. There are studies for another of the executioners in the Baderou Collection, Musée de Rouen, and in the Musée de Besançon, while a drawing for the whole composition is in the Albertina, Vienna (for these three draw-

ings and the painting, see Rosenberg and Bergot, 1981, pp. 26–28, and pl. 73).

LOUIS-JEAN DESPREZ

Auxerre 1743 – Stockholm 1804

99. *The Archbishop of Palermo Entering His Cathedral on the Feast of St. Rosalia*

Pen and black ink, gray wash and watercolor, over traces of graphite. Framing lines in pen and brown ink. 34.3 x 20.9 cm.

PROVENANCE: David-Weill (according to Wollin); [Colnaghi]; Harry G. Sperling.

BIBLIOGRAPHY: N. G. Wollin, *Gravures originales de Desprez ou exécutées d'après ses dessins*, Malmö, 1933, p. 29, the print repr. p. 153, pl. 31; N. G. Wollin, *Desprez en Italie*, Malmö, 1935, p. 84, pl. 116; *Exhibition of Old Master Drawings. P. and D. Colnaghi and Co.*, London, 1960, no. 47, pl. XIII; Dayton, Ohio, 1971, p. 19, no. 30, repr.; J. Bean, *Master Drawings*, x, 2, 1972, p. 165, identified as an illustration for Saint-Non's *Voyage pittoresque*; Rosenberg, 1972, p. 155, under no. 42; *Annual Report*, 1974–1975, p. 50; Bean, 1975, no. 45.

Bequest of Harry G. Sperling, 1971
1975.131.107

The drawing was etched in the same direction by Quau-villiers as an illustration for *Voyage pittoresque ou description des royaumes de Naples et de Sicile* (IV, part 1, 1785, pl. 57, opp. p. 139). The legend reads "Vuë du Portail et de l'Entrée principale de l'Église Cathédrale de Palerme. Dessinée par Despréz."

For other drawings reproduced in Saint-Non's *Voyage pittoresque*, see Nos. 55, 258, and 266.

ANTOINE DIEU

Paris ca. 1662 – Paris 1727

100. *Allegorical Homage to the Duc du Maine, Grand Maître de l'Artillerie*

Pen and black ink, gray wash, over traces of red chalk. 20.9 x 15.6 cm. Contours indented for transfer.

Inscribed in pen and brown ink at lower left margin, *Ant. Dieu. Invenit.*

PROVENANCE: Heinrich Wilhelm Campe (Lugt 1391); [L'Art Ancien]; purchased in Zurich in 1964.

BIBLIOGRAPHY: *Annual Report*, 1964–1965, p. 52, as Allegory of the Military Might of Louis XIV; Rosenberg, 1979, p. 167, pl. 37, as Allegory of the Military Glory of Louis XIV.

Rogers Fund, 1964
64.193.2

In April 1985 Mary O'Neill very kindly pointed out that this drawing by Dieu was engraved in reverse by Le Pautre and utilized as the frontispiece to the *Mémoires d'artillerie* by Pierre Surirey de Saint Remy, first published in Paris in 1697 (*Inventaire 17e siècle*, IV, p. 44, no. 176). The engraving is inscribed *Ant. Dieu inv. delin. / le Pautre sculp.* Around the frame of the portrait of the duc du Maine runs an inscription, LOUIS AUGUS . . . DE BOURBON DUC DU MAINE GD MTRE DE L'ARTILL. . . . Under the portrait is the inscription, *Edelinck effigie Sculp.*

Surirey de Saint Remy, Lieutenant du Grand Maître de l'Artillerie de France, dedicated the treatise to his superior, the duc du Maine. The drawing represents Fame and Victory holding up a portrait of the young duke, while in the foreground a helmeted female rests one hand on a shield with the duke's arms (which are correctly reversed in the engraving) and with the other indicates a wide variety of artillery produced for the royal army and navy.

Ant. Dieu. Inventit.

97

101. *The Nine Pierides Transformed into Magpies after Their Unsuccessful Competition with the Muses* (Ovid, *Metamorphoses*, V, 294–678)

Red chalk, red and gray wash. Framing lines in pen and brown ink. 27.1 x 22.2 cm. Lined.

Inscribed in pen and brown ink at lower left, *A dieu*.

PROVENANCE: Herbert List; purchased in Zurich in 1969.

BIBLIOGRAPHY: *Annual Report*, 1969–1970, p. 72; Bean, 1972, no. 67, mistakenly as the Daughters of Minyas Transformed into Bats; Rosenberg, 1979, p. 167, pl. 38.

Rogers Fund, 1969
69.122.1

Jennifer Montagu supplied the correct identification of the subject of the drawing in 1972.

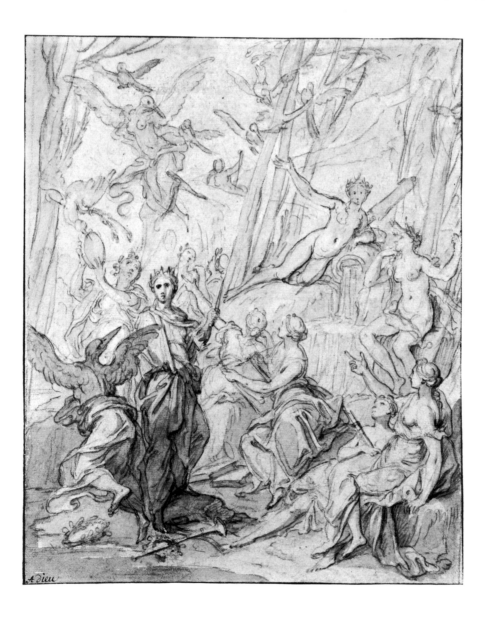

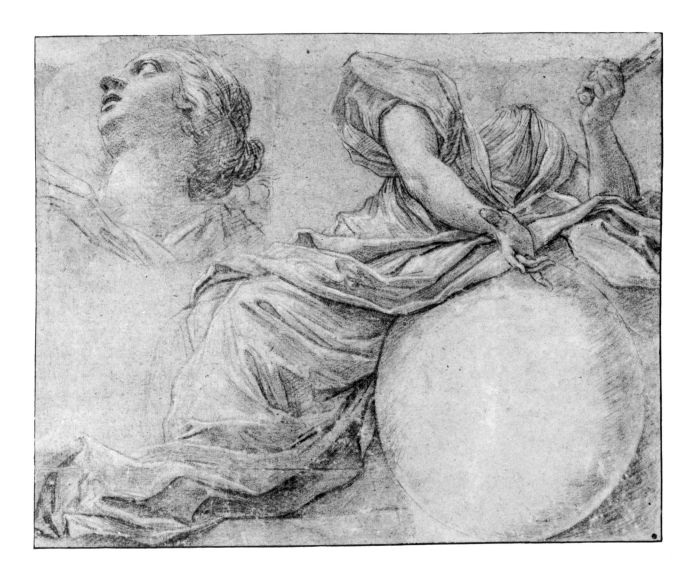

MICHEL DORIGNY

Saint-Quentin 1617 – Paris 1665

102. *Study for the Muse Urania*

Black chalk, heightened with white, on brownish paper. 29.3 x 37.8 cm. Upper margin irregular and made up; lower right quarter made up and the globe continued in another hand; the head study on a piece of paper pasted down to the larger sheet at upper left; surface somewhat abraded. Lined.

Inscribed in pen and black ink within a cartouche on the Mariette mount, FRANCISCUS / SOLIMENA.

PROVENANCE: Pierre-Jean Mariette (Lugt 2097); not identifiable in catalogue of 1775–1776 Mariette sale; [Colnaghi]; purchased in London in 1970.

BIBLIOGRAPHY: *Annual Report*, 1970–1971, p. 16, as Solimena; J. Bean, *17th Century Italian Drawings in The Metropolitan Museum of Art*, New York, 1979, no. 359, repr., as Solimena ?, but possibly French

and close to Vouet; B. Brejon de Lavergnée, *Master Drawings*, XIX, 4, 1981, pp. 453–455, fig. 13 (the painting), pl. 38 (our drawing).

Rogers Fund, 1970
1970.242.1

Barbara Brejon de Lavergnée identified the drawing as a study for the figure of Urania, who appeared with her globe, compasses, and crown of stars at the right in a *Parnassus*, a ceiling decoration for the pavillon de la Reine, château de Vincennes, that was destroyed in World War II. The composition is known through an old photograph.

GABRIEL-FRANÇOIS DOYEN

Paris 1726 – Saint Petersburg 1806

103. *Allegory of Fishery: Neptune and Amphitrite*

Pen and brown ink, brown wash, touches of white wash, over graphite. 28.8 x 21.7 cm.

PROVENANCE: Lagrenée (according to vendor); sale, Paris, Nouveau Drouot, salle 5, October 29, 1980, no. 172, repr. on cover; [Day]; purchased in London in 1981.

BIBLIOGRAPHY: *Exhibition of Fifty Old Master Drawings. Baskett and Day*, London, 1981, no. 36, repr.; *Annual Report*, 1980–1981, p. 27; *Notable Acquisitions*, 1981–1982, p. 44, repr.; Sandoz, 1983, pp. 34–35, repr.

Harry G. Sperling Fund, 1981
1981.129

Study for a painting commissioned by the marquis de Marigny in 1768 for the dining room of the Petit Trianon at Versailles (Locquin, 1978, p. 27, repr. fig. 109). In the painting the central group of Neptune and Amphitrite is reversed and they face to the left, as they do in the preparatory drawing that follows, No. 104.

104. *Allegory of Fishery: Neptune and Amphitrite*

Charcoal, stumped, black chalk, heightened with white. 48.0 x 37.5 cm. Darker areas, 3 cm. wide at top margin and 2.5 cm. wide at right margin, may indicate the artist's intention to reduce the height and width of the composition. Spot of rose pigment at center of left margin.

Inscribed in pencil on verso, *Boucher (?)*.

PROVENANCE: Jacques Petit-Horry (his mark, JPH in a triangle, not in Lugt); [Day]; purchased in London in 1981.

BIBLIOGRAPHY: *Annual Report*, 1981–1982, p. 22.

Purchase, Mr. and Mrs. David T. Schiff Gift, 1981
1981.286

A study for the *Allegory of Fishery* in the Petit Trianon that comes closer in composition to the painting than the drawing above, No. 103. In style and technique this black chalk drawing, in which considerable use is made of stumping, comes close to a study in the Kunsthaus Heylshof, Worms (W 144), for Doyen's *Last Communion of St. Louis*, a painting commissioned for the high altar of the chapel of the École Militaire in Paris and exhibited in the Salon of 1773.

JEAN-DÉMOSTHÈNE DUGOURC

Versailles 1749 – Paris 1825

105. *The Garden Façade of Bagatelle*

Pen and black ink, watercolor, over traces of black chalk. 28.3 x 40.2 cm. Lined.

Signed and dated in pen and black ink at lower left, *J. D. Dugourc, del.* *1779.*

PROVENANCE: Susan Dwight Bliss.

BIBLIOGRAPHY: *Annual Report*, 1966–1967, p. 59; Gillies and Ives, 1972, no. 18.

Bequest of Susan Dwight Bliss, 1966
67.55.17

Dugourc was brother-in-law of François-Joseph Belanger, the architect of Bagatelle, which was built in sixty-four days in 1777 for the comte d'Artois to win a wager with his sister-in-law, Marie-Antoinette.

Bagatelle, in the Bois de Boulogne, has survived, but the nineteenth-century addition of an attic story with an

excessively high cupola has distorted the proportions of the exterior.

The Metropolitan Museum possesses six landscape paintings by Hubert Robert commissioned for a boudoir on the ground floor at Bagatelle (Sterling, 1955, pp. 163–167).

106. *Figures in a Garden*

Gouache. 31.7 x 43.8 cm. Lined.

Signed in pen and brown ink on pedestal at center of lower margin, I. D. DUGOURC. PINXIT / M.D.CC.LXXXIIII.

PROVENANCE: [Wildenstein]; Peter Gregory (according to Sutton); Ann Phillips (according to Parke-Bernet); sale, New York, Parke-Bernet, May 6–7, 1964, no. 285, repr.; [Bier]; purchased in London in 1966.

BIBLIOGRAPHY: D. Sutton, *French Drawings of the Eighteenth Century*, London, 1949, repr. in color as frontispiece, p. 49; *Annual Report*, 1966–1967, p. 60; Gillies and Ives, 1972, no. 17; S. Hartmann-Nussbaum, *Bulletin de la Société de l'Histoire de l'Art français*, 1980 [1982], pp. 212–214, fig. 6.

Rogers Fund, 1966
66.54.1

In 1977 Mary L. Myers discovered in the Tassinari et Chatel collection in Lyon a black chalk study for this composition (repr. Hartmann-Nussbaum, *op. cit.*, fig. 5). Mme Hartmann-Nussbaum has suggested that both drawings are views in the garden of D.-R.-J. Papillon de la Ferté's estate on the Île-Saint-Denis. However, we cannot find the rustic garden house, the curious "roundabout" (a pump?) in the center of the circular court, nor the windmill, in the large and extremely detailed panoramic view of Papillon de la Ferté's property by the chevalier de Lespinasse, a drawing belonging to the Musée Carnavalet that is now on deposit at the Musée de l'Île-de-France at Sceaux (Photographie Giraudon LA 48204).

LOUIS DURAMEAU

Paris 1733 – Versailles 1796

107. *The Last Communion of St. Mary Magdalene, after Benedetto Luti*

Red chalk, heightened with white, on brown paper. Framing lines in pen and brown ink. 33.0 x 23.9 cm. Lined.

Inscribed in pen and brown ink at lower left margin of old mount, *du Rameaux.*

PROVENANCE: Pierre-Jean Mariette (Lugt 2097); Mariette sale, Paris, 1775–1776, part of no. 1231, "Onze autres Sujets divers, dessinés à Rome d'après les plus célèbres tableaux de différents grands Maîtres qui ne sont point encore connus par aucune Estampe, et que feu M. Mariette avoit prié cet Artiste de lui dessiner, pour lui en rappeller la mémoire, d'après B. Luti, Trevisani, Imperiali, Passeri, Mola, etc. faits à la sanguine"; unidentified collector's mark (HL with-in a heart, in red); sale, London, Sotheby's, October 22, 1984, no. 385, repr. pl. 9, purchased by the Metropolitan Museum.

BIBLIOGRAPHY: *Annual Report*, 1984–1985, p. 25.

Purchase, David L. Klein, Jr. Memorial Foundation, Inc. Gift, 1984
1984.352

Luti's painting is in S. Caterina da Siena a Magnanapoli, Rome (repr. *Pantheon*, XXIII, 1, 1965, p. 50, fig. 5). It was also copied by both Bouchardon and Natoire in red chalk drawings now in the Cabinet des Dessins, Musée du Louvre (Guiffrey and Marcel, I, 1907, no. 631, repr., and Duclaux, 1975, no. 81, repr., respectively).

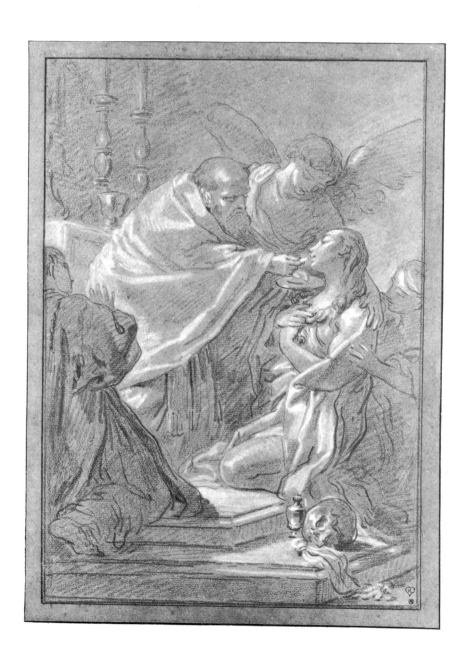

108. *St. Michael Casting Down Lucifer, after Pier Francesco Mola*

Red chalk, on beige paper. 26.4 x 15.4 cm.

Inscribed in pen and black ink on Mariette mount, *Pinxit in aede S. Marci Romae, Petrus Franc. Mola.*, in cartouche, LUDOVICUS / DURA-MEAU / DELINEABAT

PROVENANCE: Pierre-Jean Mariette; Mariette sale, Paris, 1775–1776, part of no. 1231 (see No. 107 above); [Schatzki]; purchased in New York in 1966.

BIBLIOGRAPHY: *Annual Report*, 1966–1967, p. 60; Dayton, Ohio, 1971, no. 28, repr.; Rosenberg, 1972, p. 158, under no. 47; *Rome in the 18th Century*, 1978, n.pag. [9]; M. Sandoz, *Louis-Jacques Durameau, 1733–1796*, Paris, 1980, p. 54, fig. 29, p. 75, no. 13c.

Rogers Fund, 1966
66.219

As Mariette's inscription indicates, the painting by P. F.

Mola is in S. Marco, Rome (repr. R. Cocke, *Pier Francesco Mola*, Oxford, 1972, pl. 100).

CHARLES EISEN

Valenciennes 1720 – Brussels 1778

109. *Standing Soldier: Garde Française*

Red chalk, over traces of graphite. 23.9 x 16.0 cm.

PROVENANCE: Harry G. Sperling.

BIBLIOGRAPHY: *Annual Report*, 1974–1975, p. 50.

Bequest of Harry G. Sperling, 1971
1975.131.132

The drawing was certified as the work of Antoine Watteau in 1964 by Jacques Mathey before it came to the

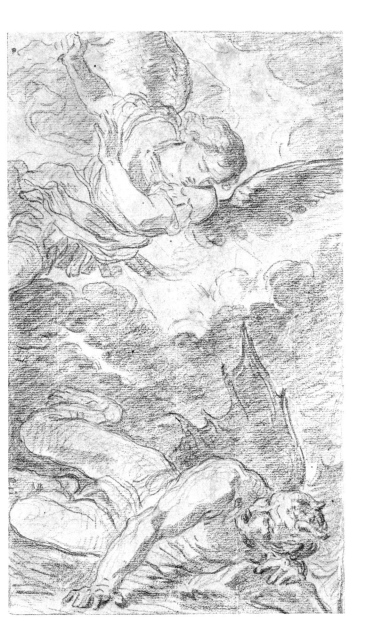

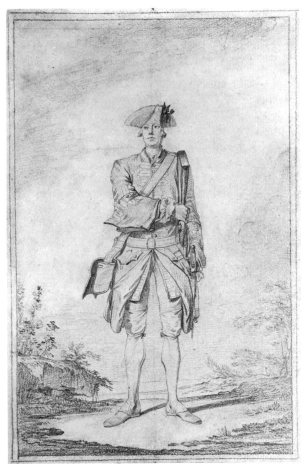

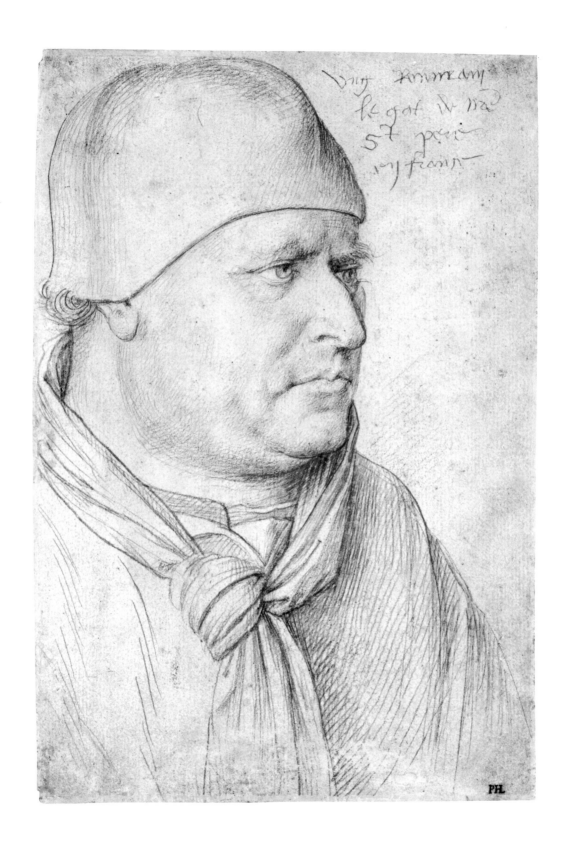

Museum; but in 1983 Lawrence Turčić recognized the draughtsman as Charles Eisen.

In the Royal Print Room, Copenhagen, there are two similar studies of *gardes françaises* by Eisen, signed and dated 1751, and twelve other sheets are in the Anne S. K. Brown Military Collection at Brown University (one repr. Rotterdam, Paris, New York, 1958–1959, pl. 84).

Some of these drawings, including ours, were engraved by N. Le Mire as illustrations for a rare publication, *Positions des soldats de l'infanterie pendant la manoeuvre du fusil*, Paris, 1751–1752 (V. Salomons, *Charles Eisen*, London, 1914, pp. 97–98).

JEAN FOUQUET

Tours ca. 1415/1420 – Tours 1478/1481

110. *Portrait of an Ecclesiastic*

Metalpoint, a little black chalk, on white prepared paper. 19.8 x 13.6 cm.

Inscribed in metalpoint at upper right, *Ung Roumain | legat de nō | S^t pere | en france*; in pen and brown ink on verso, *37 | BAC no. 31*; in pencil, *P. H. | Prosper Henry Lankrinck | Page to King Charles I. | Collector.*; on reverse of old mount, *Holben*.

PROVENANCE: Prosper Henry Lankrink (Lugt 2090); J. P. Heseltine (Lugt 1507); Henry Oppenheimer; Oppenheimer sale, London, Christie's, July 10, 13–14, 1936, no. 428, repr. as frontispiece; [Duveen]; purchased in New York in 1949.

BIBLIOGRAPHY: *Exposition des primitifs français*, Palais du Louvre and Bibliothèque Nationale, Paris, 1904, no. 44; H. Bouchot, *L'exposition des primitifs français. La peinture en France sous les Valois*, Paris, n.d. [1904], pl. XXXVIII; G. Lafenestre, *Jehan Fouquet*, Paris, 1905, repr. p. 27, p. 71; M. J. Friedländer, *Jahrbuch der Königlich Preuszischen Kunstsammlungen*, XXXI, 1910, pp. 227–230, fig. 2; *Drawings of the French School from the Collection of J.P.H.*, London, 1911, no. 9, repr.; S. Colvin, *Vasari Society*, part IX, 1913–1914, no. 25, repr.; P. Lavallée, *Le dessin français du XIII^e au XVI^e siècle*, Paris, 1930, p. 19, p. 70, no. 31, pl. XIX, "anonyme, 2^{me} moitié du XV^{me} siècle"; T. Cox, *Jehan Foucquet, Native of Tours*, London, 1931, p. 55, pl. L, opp. p. 129, p. 133; London, Royal Academy, 1932, no. 626; London, Royal Academy, 1933, no. 541, pl. 149; K. G. Perls, *Jean Fouquet*, Paris, 1940, p. 22, pl. 282, the attribution to Fouquet rejected; Charles Jacques [Sterling], *La peinture française. Les peintres du moyen âge*, Paris, 1941, *répertoire*, p. 18, no. 6, pl. 54; Blunt, 1945, p. 15, under no. 1; C. Sterling, *Art Bulletin*, XXVIII, 1946, pp. 125–131; Tietze, 1947, no. 5, repr.; G. Ring, *A Century of French Painting, 1400–1500*, London, 1949, p. 214, no. 139, pl. 92, attributed to Fouquet; *Annual Report*, 1949, repr. p. 27, p. 28; A. Mongan, *One Hundred Master Drawings*, Cambridge, Mass., 1949, p. 12, repr. p. 13; Shoolman and Slatkin, 1950, p. 4, pl. 2; *Art Treasures of the Metropolitan*, 1952, p. 68, fig. 61, p. 222, no. 61; *Metropolitan Museum of Art Bulletin*,

February 1959, p. 164, repr.; Mongan, 1962, no. 639, repr.; Bean, 1964, no. 51, repr. (with additional bibliography); C. Schaefer, *Gazette des Beaux-Arts*, LXX, 1967, pp. 189–212, fig. 6; *Treasures from Medieval France*, exhibition catalogue by W. D. Wixom, Cleveland Museum of Art, 1967, p. 308, no. VII 8, repr.; Metropolitan Museum, 1970, p. 189, no. 168, repr.; Reynaud, 1981, pp. 27–28, no. 7*, repr.; G. Szabo, *Drawing*, V, 1, 1983, pp. 5–6, fig. 1; S. Lombardi, *Jean Fouquet*, Florence, 1983, pp. 194–196, pl. 293.

Rogers Fund and Gift of Mrs. Benjamin Knower, Bequest of Ogden Mills, and Bequest of Collis P. Huntington, by exchange, 1949
49.38

Prosper Henry Lankrink, a seventeenth-century owner of this powerful drawing, thought it to be the work of Holbein. The attribution to Fouquet seems to have been first proposed by Georges Hulin, and the drawing was shown under this name in the great *Exposition des primitifs français*, held in Paris in 1904. This attribution has met with general approval—notable exceptions have been Pierre Lavallée, Grete Ring, and Klaus Perls. In recent years, Charles Sterling has been the most eloquent and convincing advocate of Fouquet's authorship of this sheet, which is surely one of the finest surviving portrait drawings of the fifteenth century.

The modeling of the head may be compared with that in Fouquet's chalk drawing of the head of Guillaume Jouvenel des Ursins in the West Berlin Print Room and with that in the painted portrait of Jouvenel in the Musée du Louvre, Paris (Reynaud, 1981, figs. 8–9, respectively).

This "Roman, legate of our Holy Father in France" has never been satisfactorily identified with an Italian prelate of the fifteenth century.

JEAN-HONORÉ FRAGONARD

Grasse 1732 – Paris 1806

111. *Hercules and Cacus, after Annibale Carracci; Destruction of Enceladus, after Agostino Carracci*

Black chalk. Framing lines in pen and brown ink. 20.2 x 29.1 cm. Horizontal crease at right margin; scattered stains. Lined.

Inscribed in black chalk at bottom of sheet, *augustin Carrache. | Palais Sampieri | Bologna | Annibal Carrache*.

PROVENANCE: Mrs. Paul Moore.

BIBLIOGRAPHY: *Annual Report*, 1959–1960, repr. p. 35, p. 58; Ananoff, 1963, no. 1052, fig. 281; Cayeux, 1963, p. 352, no. 187a; Dayton, Ohio, 1971, no. 16, repr.; Williams, 1978, no. 11, repr.

Gift of Mrs. Paul Moore, 1960
60.53

Fragonard copied frescoes painted by Annibale and Agostino Carracci over fireplaces in adjacent rooms in the Palazzo Sampieri-Talon, Bologna. The two compositions were etched in reverse in 1772 by the abbé de Saint-Non for his *Griffonis*.

The *Hercules and Cacus* group was attributed to Agostino Carracci by Fragonard and the *Destruction of Enceladus* to Annibale. Modern scholarship has reversed the attributions, as we have in the title of the drawing (see D. Posner, *Annibale Carracci*, London, 1971, II, p. 33).

112. *Seated Man Reading*

Red chalk. Framing lines in pen and brown ink. 34.0 x 23.3 cm. Repaired tear left of center; brown wash stain at lower right. Lined.

Faint pencil inscription at lower right, *Fragonard*.

PROVENANCE: F. Abott (Lugt 970); Camille Groult (according to Ananoff); sale, Paris, Galerie Georges Petit, June 21–22, 1920, no. 153; [Wildenstein]; Edith Sachs.

BIBLIOGRAPHY: Ananoff, 1961, no. 226, fig. 86; *Annual Report*, 1978–1979, p. 24.

Gift of Mrs. Howard J. Sachs and Peter G. Sachs, in memory of Miss Edith L. Sachs, 1978
1978.516.1

There is a counterproof of this drawing in the École des Beaux-Arts, Paris (Inv. 911).

111

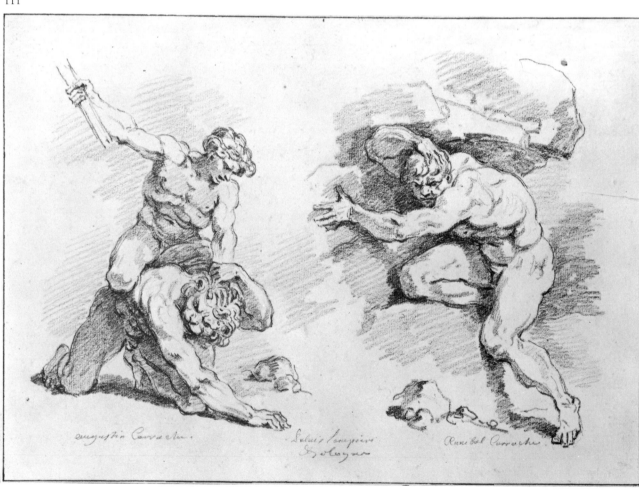

JEAN-HONORÉ FRAGONARD

113. *Le Mari Confesseur* (La Fontaine, *Contes*, I, 4)

Pale brown wash, over black chalk. 20.6 x 14.1 cm. The sheet has suffered from overexposure to light.

PROVENANCE: Jacques Doucet; Doucet sale, Paris, May 16–17, 1906, no. 25; Albert Lehmann; Lehmann sale, part II, Paris, Galerie Georges Petit, June 8, 1925, no. 154, repr.; Marcel Razsovich; [Ball]; Lesley and Emma Sheafer.

BIBLIOGRAPHY: *Exposition de dessins de Fragonard*, exhibition catalogue by Louis Réau, Jacques Seligmann et fils, Paris, 1931, no. 113; L. Réau, *Fragonard, sa vie et son oeuvre*, Brussels, 1956, p. 226; Ananoff, 1970, no. 2717; M. Roland Michel, *Burlington Magazine*, CXII, October 1970, advertisement supplement, p. vi; *Annual Report*, 1974–1975, p. 48; Williams, 1978, no. 53, repr.

The Lesley and Emma Sheafer Collection,
Bequest of Emma A. Sheafer, 1973
1974.356.44

The drawing was etched in reverse by J.-B. Tilliard as an illustration for the 1795 Didot edition of La Fontaine's *Contes et nouvelles* (F.-C. Lonchamp, *Manuel du bibliophile français 1470–1920*, Paris, 1927, I, p. 298, fig. 156). The scene represents the chevalier Artus returning from the wars in Italy to find his wife surrounded by admirers.

114. *Riverside Village Dominated by a Fortified Tower*

Black chalk, pen and brown ink, brown wash. 35.0 x 47.8 cm. Lined.

PROVENANCE: Baron Roger Portalis (Lugt 2232); Portalis sale, Paris, Hôtel Drouot, March 14, 1887, no. 88; Portalis sale, Paris, Hôtel Drouot, February 2–3, 1911, no. 98, repr. p. 13, attributed to Fragonard; J. P. Heseltine; Heseltine and Richter sale, Amsterdam, Frederik Muller, May 27–28, 1913, no. 297, pl. 46; Alfred Strolin; sale, Paris, June 30, 1922, no. 53, pl. 16 (according to Virch); Countess Wachtmeister (according to Sotheby's); sale, London, Sotheby's, December 15, 1954, no. 94; [Cailleux]; Walter C. Baker.

BIBLIOGRAPHY: Portalis, 1889, p. 307, repr. opp. p. 166; *Chardin et Fragonard*, exhibition catalogue, Galeries Georges Petit, Paris, 1907, no. 192; *Oeuvres de Fragonard*, exhibition catalogue by J. Wilhelm and A. Ananoff, Musée Fragonard, Grasse, 1957, no. 51, pl. XII; Virch, 1962, no. 78, repr.; Ananoff, 1963, no. 958, fig. 259; *Annual Report*, 1979–1980, p. 27.

Bequest of Walter C. Baker, 1971
1972.118.212

115. *View of a Park*

Black chalk, gray wash, touches of black and brown wash. Framing lines in pen and black ink. 27.8 x 39.7 cm.

PROVENANCE: Comte de Montesquiou (according to vendor); [Wertheimer]; [Knoedler]; purchased in New York in 1952.

BIBLIOGRAPHY: *Annual Report*, 1952, p. 18; Ananoff, 1970, no. 2215; Williams, 1978, no. 6, repr.; J. Massengale, *Burlington Magazine*, CXXI, 1979, pp. 271–272; *Three Masters of Landscape. Fragonard, Robert, and Boucher*, exhibition catalogue by P. L. Near, Virginia Museum of Fine Arts, Richmond, 1981, no. 8, repr.

Harris Brisbane Dick Fund, 1952
52.14

Alexandre Ananoff and Mrs. Massengale have suggested that the gray wash is a later addition to this black chalk drawing; we agree with Eunice Williams that the wash seems to be an integral part of the work.

III

JACQUES GAMELIN

Carcassonne 1738 – Carcassonne 1803

116. *The Rape of the Sabines*

Brush and blue-gray gouache, heightened with white, on beige paper. Ruled framing lines in graphite; margins washed in blue. 14.4 x 76.5 cm. The support consists of two sheets joined vertically at left of center. Water stains at center and right. Lined with canvas.

Inscribed in brush and brown paint on reverse of canvas lining, *Enlèvement des Sabines / Dessin par Jacques Gamelin / Directeur de l'académie de S^{t.} Luc / né à Carcassone le 3 octobre 1738 / mort dans la même ville le 12 oct 1803.*

PROVENANCE: Albert Sarraut; [Paul Prouté]; [Goldschmidt]; purchased in New York in 1966.

BIBLIOGRAPHY: *J. Gamelin 1738–1803*, exhibition catalogue by S. Mouton, Musée Municipal, Carcassonne, 1938, p. 195, no. 148; *Catalogue "Grand Siècle." Paul Prouté et ses fils*, Paris, 1965, no. 29, repr.; *Annual Report*, 1966–1967, p. 60; Gillies and Ives, 1972, no. 22; Rosenberg, 1972, p. 161, under no. 52.

Rogers Fund, 1966
66.128

Gamelin lived and worked in Rome from 1765 to 1774; this frieze, in which motifs borrowed from Polidoro da Caravaggio are reinterpreted with gusto, must date from this period.

CLAUDE GILLOT

Langres 1673 – Paris 1722

117. *Satyrs Preparing for a Festival*

Pen, black and brown ink, pink wash, over black chalk. Framing lines in pen and brown ink. 16.0 x 21.6 cm.

Inscribed in pen and brown ink on verso, *n 7*.

PROVENANCE: Jacques Mathey; [Cailleux]; purchased in Paris in 1961.

BIBLIOGRAPHY: J. Mathey, *Burlington Magazine*, CII, 1960, p. 358, no. 11, p. 359, fig. 29; *Annual Report*, 1961–1962, p. 67; Rosenberg, 1972, p. 163, under no. 56.

Rogers Fund, 1961
61.127.2

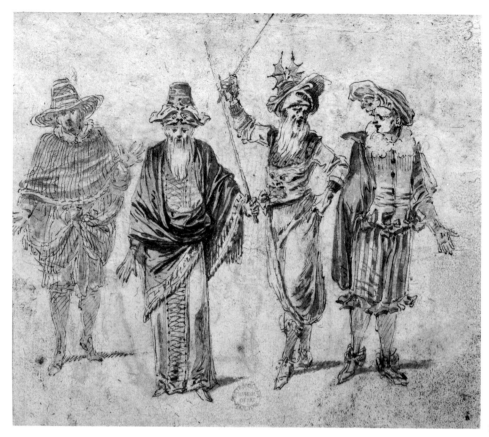

118

118 v.

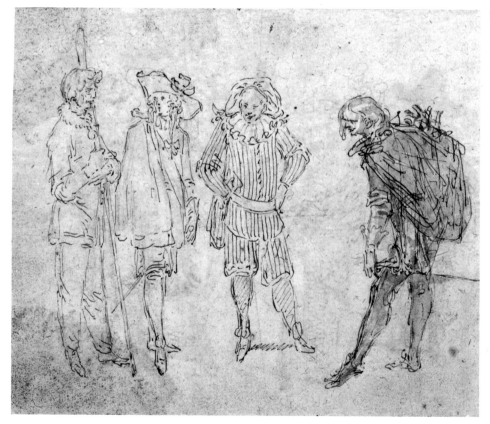

114

118. *Figures in Theatrical Costumes* VERSO. *Figures in Theatrical Costumes*

Pen and brown ink, red wash, over red chalk. 15.5 x 18.6 cm. Light stain of brown pigment at lower right.

Numbered in red chalk at upper right corner, *3*.

PROVENANCE: Jonathan Richardson, Jr. (Lugt 2170); purchased in London in 1906.

BIBLIOGRAPHY: *Metropolitan Museum of Art Bulletin*, December 1906, p. 162, as Watteau; Bean, 1964, under no. 55; Gillies and Ives, 1972, no. 24; Rosenberg, 1972, p. 163, under no. 56.

Rogers Fund, 1906
06.1042.7

This drawing and No. 119 below belonged to Jonathan Richardson, Jr.; his attribution for the sheets is not recorded, but they were acquired by the Museum, in 1906 and 1910, as the work of Watteau. The correct name, Gillot, was supplied in 1937.

These costume studies by Gillot come close in style to those etched by Joullain with the title *Nouveaux desseins*

d'habillements à l'usage des balets opéras et comédies (Populus, 1930, nos. 394–478).

A similar double-faced sheet of costume studies, with four figures to each side, was in the collection of Marius Paulme (sale, Paris, Galerie Georges Petit, May 13, 1929, no. 93, recto and verso repr.). The figures on the recto of our sheet and those on both the recto and verso of the Paulme drawing were copied in a larger sheet attributed to Gillot in the Thévenin collection (sale, Paris, Hôtel Drouot, April 28, 1906, no. 17, repr.).

119. *Figures in Theatrical Costumes*

Pen and brown ink, red wash, over red chalk. 13.8 x 20.1 cm. Lined.

PROVENANCE: Jonathan Richardson, Jr. (Lugt 2170); purchased in London in 1910.

BIBLIOGRAPHY: Bean, 1964, no. 55, repr.; *Apollo*, LXXXII, September 1965, p. 248, fig. 4; Gillies and Ives, 1972, no. 23; Rosenberg, 1972, p. 163, under no. 56.

Rogers Fund, 1910
10.45.15

See No. 118 above.

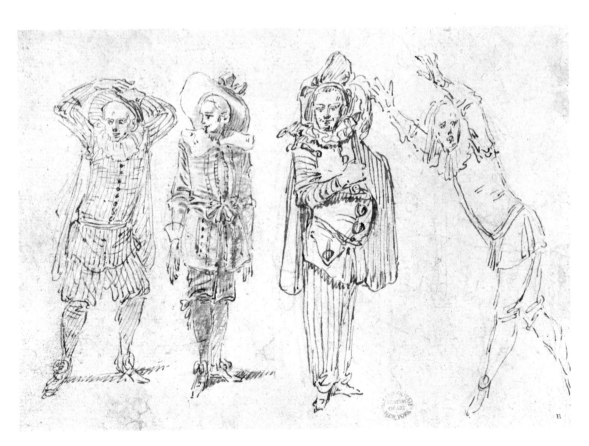

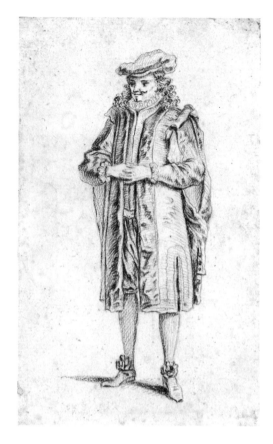

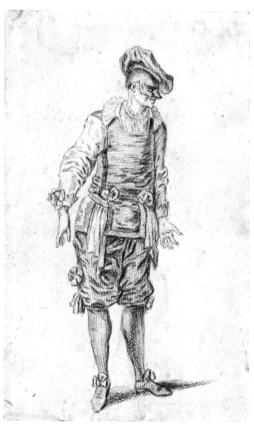

120. *Crepin's Master*

Red chalk, black chalk for hair and moustache. 12.4 x 7.8 cm. Verso blackened for transfer.

PROVENANCE: Alvin Beaumont; [Jeudwine]; Harry G. Sperling.

BIBLIOGRAPHY: Populus, 1930, p. 96, under no. 21; *Exhibition of Old Master Drawings Presented by W. R. Jeudwine*, London, 1958, no. 18; *Annual Report*, 1974–1975, p. 50.

Bequest of Harry G. Sperling, 1971
1975.131.113

This figure was used in the same direction by Gillot for one of the two actors in the first plate of a series of etchings known as *Les portraits d'acteurs* (Populus, 1930, nos. 21–30). The title of this first plate is *Crepin dans son habit de Gilles parlant à son maître*.

See No. 121 below.

121. *Fabio Costumed as a Doctor*

Red chalk, black chalk for the mask. 12.4 x 7.9 cm. Verso blackened for transfer.

PROVENANCE: Alvin Beaumont; [Jeudwine]; Harry G. Sperling.

BIBLIOGRAPHY: Populus, 1930, pp. 96–97, under no. 23; *Exhibition of Old Master Drawings Presented by W. R. Jeudwine*, London, 1958, no. 17; *Annual Report*, 1974–1975, p. 50.

Bequest of Harry G. Sperling, 1971
1975.131.112

Etched in the same direction by Gillot for the third plate in *Les portraits d'acteurs*. The title is *Fabio de la Comédie italienne dans son habit de médecin*.

See No. 120 above.

GRAVELOT (Hubert-François Bourguignon)

Paris 1699 – Paris 1773

122. *Design for an English Political Satire*

Pen and brown ink, brown wash. 21.9 x 30.7 cm. Contours indented for transfer. Repaired vertical tear at center; horizontal crease at center; scattered stains. Lined.

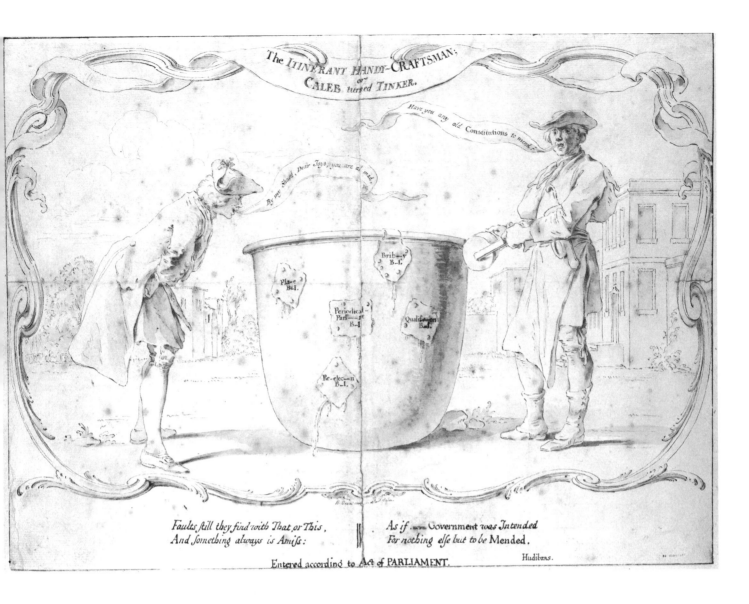

The ITINERANT HANDY-CRAFTSMAN;
or
CALEB turned TINKER.

Have you any old Constitutions to mend?

By my Shoul, Dear Joys, you are all mad.

Faults still they find with That, or This,
And something always is Amiss:

As if — Government was Intended
For nothing else but to be Mended.

Hudibras.

Entered according to Act of PARLIAMENT.

Signed in pen and brown ink at lower center, *H. Grav. delin.*; inscribed in pen and brown ink on banderole above, *The* ITINERANT HANDY-CRAFTSMAN; | *or* | CALEB *turned* TINKER; from the mouth of the figure at right, *Have you any old Constitutions to mend?*; from the mouth of the figure at left, *By my Shoul, Dear Joys, you are all mad.*; on the cauldron, *Brib—y | B—l., Pla—e | B—l., Periodical | Parl—nt | B—l, Qualif—on | B—l, Re-elec—n | B—l*; at lower margin, *Faults still they find with That or This, | And something always is Amiss: | As if . — . Government was Intended | For nothing else but to be Mended. | Hudibras. | Entered according to Act of* PARLIAMENT.

PROVENANCE: Général comte Antoine-François Andreossy (according to Goncourt); Andreossy sale, Paris, April 13–16, 1864, possibly no. 787; Edmond and Jules de Goncourt (Lugt 1089); Goncourt sale, Paris, February 15–17, 1897, no. 113; [Calmann]; purchased in London in 1963.

BIBLIOGRAPHY: Goncourt, 1881, I, p. 87; Goncourt, 1880–1882, II, pp. 32–33, repr. opp. p. 32, "C'est un dessin satirique composé, pendant le séjour en Angleterre de Gravelot, en faveur du ministre Walpole contre Caleb d'Anvers"; Paris, École des Beaux-Arts, 1879, no. 504; *Annual Report*, 1963–1964, p. 62; London, Royal Academy, 1968, p. 78, no. 299.

Rogers Fund, 1963
63.91.1

The satire is directed against Nicholas Amhurst who, as editor of *The Craftsman*, took the pseudonym Caleb D'Anvers. He is represented here as a tinker standing by a patched but leaking cauldron crying, "Have you any old Constitutions to mend?" Caleb D'Anvers was a vigorous opponent of the administration of Sir Robert Walpole, whose supporters no doubt commissioned this satire. The publication of the print based on this drawing was announced on June 6, 1740 (*Catalogue of Prints and Drawings in the British Museum. Division I. Political and Personal Satires*, III, Part 1, London, 1877, no. 2448).

The Department of Prints and Photographs at the Metropolitan Museum possesses a large group of ornament designs by Gravelot.

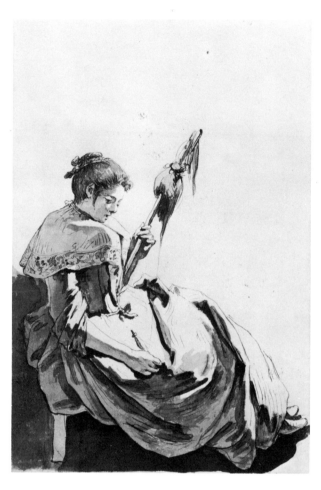

JEAN-BAPTISTE GREUZE

Tournus 1725 – Paris 1805

123. *Bolognese Peasant Girl with a Distaff*

Pen and black ink, gray wash, over traces of graphite. 20.2 x 13.6 cm. Lined.

Inscribed in pen and brown ink at lower margin of old mount, *Greuze f. 1755. | Contadina Bolognese.*

PROVENANCE: Randon de Boisset; Randon de Boisset sale, Paris, February 27–March 25, 1777, part of no. 376; Vassal de Saint-Hubert; Vassal de Saint-Hubert sale, Paris, March 29–April 13, 1779, part of no. 164; sale, Paris, April 24–May 5, 1783, part of no. 159; Georges Bourgarel; Bourgarel sale, Paris, Hôtel Drouot, June 15–16, 1922, part of no. 98; sale, Paris, Nouveau Drouot, salle 6, June 2, 1981, no. 38, with No. 124 below, mistakenly attributed to Charles-Joseph Flipart; purchased in New York in 1982.

BIBLIOGRAPHY: Martin, 1908, p. 28, no. 410/10; *Annual Report*, 1981–1982, p. 23; *Notable Acquisitions*, 1982–1983, p. 48.

Harry G. Sperling Fund, 1982
1982.93.2

In the course of his travels in Italy in 1755 with Louis Gougenot, abbé de Chezal-Benoît, Greuze made a good many drawings of costumes in the different regions and cities they visited. With the addition of landscape backgrounds or interior settings by Jean-Baptiste Lallemand, twenty-four of these figures were engraved in reverse by various members of the Moitte family, as a suite called *Divers habillements suivant le costume d'Italie* (see Munhall, 1976, pp. 38–39). This drawing and No. 124 below figure as numbers 10 and 13 in the series.

124. *Florentine Woman Wearing a Butterfly Cap and Holding a Hand Warmer*

Pen and black ink, gray wash, over traces of graphite. 20.1 x 13.6 cm. Lined.

Inscribed in pen and brown ink at lower margin of old mount, *Greuze. f. 1755. | fiorentina con cuffia da farfalla.*

PROVENANCE: See No. 123 above.

BIBLIOGRAPHY: Martin, 1908, p. 28, no. 410/13; *Annual Report*, 1981–1982, p. 23; *Notable Acquisitions*, 1982–1983, p. 48, repr.

Harry G. Sperling Fund, 1982
1982.93.3

See No. 123 above.

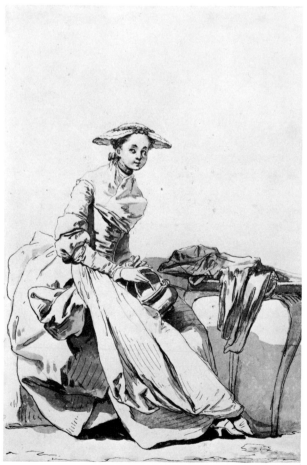

125. *The Angry Wife*

Brush, black and gray wash, heightened with white, over traces of graphite. Framing lines in pen and brown ink. 51.5 x 63.4 cm. Lined.

PROVENANCE: Joseph Joubert (inscription on old mount: "Dessin original de Greuze. Acheté dans son cabinet après sa mort par Monsieur Joseph Joubert, auteur des Pensée et Maximes"); Hesme de Villeneuve; Hesme de Villeneuve sale, Paris, March 3–4, 1856, no. 89; sale, Paris, Hôtel Drouot, March 9, 1950, no. 16; [Cailleux]; purchased in Paris in 1961.

BIBLIOGRAPHY: Martin, 1908, p. 11, no. 143; *Annual Report*, 1960–1961, p. 64; Bean, 1964, no. 59, repr.; London, Royal Academy, 1968, p. 82, no. 326, fig. 236; P. Hulton, *Master Drawings*, VI, 2, 1968, p. 167; Gillies and Ives, 1972, no. 25; Munhall, 1976, no. 96, repr.; M. Amaya, *Art in America*, November–December 1976, p. 84, repr.

Purchase, Joseph Pulitzer Bequest, 1961
61.1.1

This highly finished drawing was engraved in reverse by Robert Gaillard with the title *La femme colère* (Martin, 1908, p. 107).

Edgar Munhall has suggested that the scene is an incident in the artist's own household, so often disrupted by the furious temper of his overbearing wife.

126. *Domestic Scene*

Pen and brown ink, brown and gray wash, over traces of black chalk. 33.0 x 50.8 cm. Lined.

PROVENANCE: Jacques Petit-Horry (his mark, JPH in a triangle, not in Lugt); purchased in Paris in 1972.

BIBLIOGRAPHY: *Annual Report*, 1972–1973, p. 34; Bean, 1975, no. 47, repr.; *Notable Acquisitions*, 1965–1975, p. 63, repr.; Munhall, 1976, p. 164, under no. 81.

Harris Brisbane Dick Fund, 1972
1972.224.3

An exceptionally free and spirited example of Greuze's draughtsmanship. It is not related to a surviving painting, and the exact moralizing message of the subject is not clear.

127. *Head of an Old Woman Looking Up*

Red chalk. Framing lines in pen and brown ink. 41.0 x 32.5 cm.

PROVENANCE: [Schab]; purchased in New York in 1949.

BIBLIOGRAPHY: *Annual Report*, 1949, p. 28; Munhall, 1976, no. 27, repr.

Rogers Fund, 1949
49.131.1

Edgar Munhall has identified this drawing as a study for the head of the grandmother in a lost painting by Greuze, *La belle-mère*, known through engravings and through a composition study that was recently sold in Paris (Nouveau Drouot, salle 5–6, December 17, 1983, repr. *Calendrier—Décembre 1983*, fig. L).

126

127

128. *Head of a Girl Looking Up*

Red chalk. Framing lines in pen and brown ink. 35.3 x 28.4 cm.

PROVENANCE: [Schab]; purchased in New York in 1949.

BIBLIOGRAPHY: *Annual Report*, 1949, p. 28; *Metropolitan Museum of Art Bulletin*, February 1959, p. 166, repr.

Rogers Fund, 1949
49.131.2

Edgar Munhall has kindly pointed out that this drawing was engraved in reverse by Pierre-Charles Ingouf l'aîné (Martin, 1908, p. 82, no. 1353).

129. *Head of a Young Boy*

Red chalk. Framing lines in pen and brown ink. 30.0 x 24.2 cm.

PROVENANCE: [Schab]; purchased in New York in 1949.

BIBLIOGRAPHY: *Annual Report*, 1949, p. 28.

Rogers Fund, 1949
49.131.3

128

129

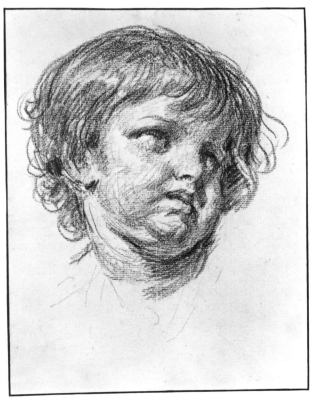

130. *Reclining River God*

Red chalk. Framing lines in pen and brown ink. 47.0 x 63.4 cm. Losses at upper corners; repaired tear at lower left. Lined.

PROVENANCE: [Cailleux]; purchased in Paris in 1961.

BIBLIOGRAPHY: *Annual Report*, 1960–1961, p. 47, repr., pp. 63–64; London, Royal Academy, 1968, p. 82, no. 319; Gillies and Ives, 1972, no. 26; Munhall, 1976, no. 56, repr. (with additional bibliography); Rubin, 1977, p. 33, fig. 9.

Purchase, Joseph Pulitzer Bequest, 1961
61.1.2

A similar reclining river god appears on the altar bas-relief in *Une jeune fille qui fait sa prière au pied de l'autel de l'Amour*, a painting by Greuze shown in the Salon of 1769, and now in the Wallace Collection, London (repr. Brookner, 1972, pl. 47).

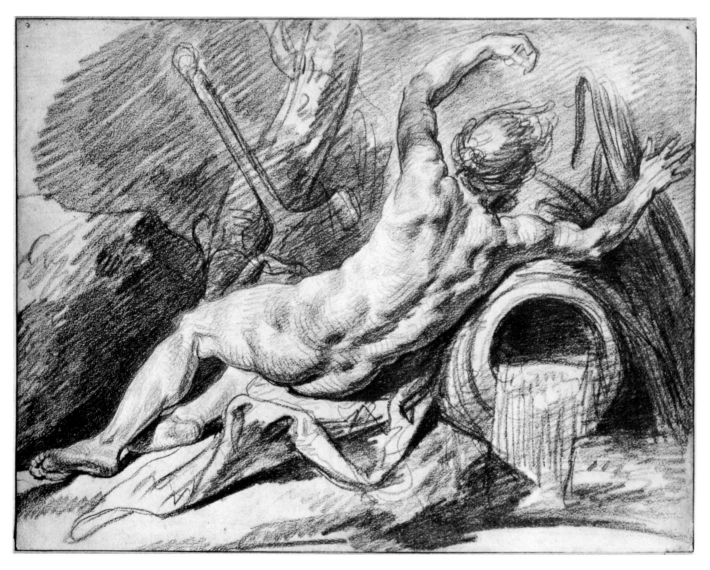

131. *A Farmer Entrusting the Plow to His Son*

Brush and gray wash, over graphite. Framing lines in pen and brown ink. Faintly squared in graphite. 39.3 x 49.5 cm. Lined. Study by Greuze of a child in brush and gray wash on reverse of old mount.

Signed in brush and gray wash at lower right, *Greuze*.

PROVENANCE: French private collection; [Galerie de Bayser]; purchased in Paris in 1983.

BIBLIOGRAPHY: Brookner, 1972, p. 133, mistakenly said to be in the Cailleux collection; *Annual Report*, 1983–1984, p. 24.

Van Day Truex Fund, 1983
1983.427

Study, with many variations, for a very late painting by Greuze exhibited in the Salon of 1801 with the title *Un cultivateur remettant la charrue à son fils, en présence de sa famille*. The painting was purchased by one of the artist's Russian patrons, Count Shuvalov, and is now in the Pushkin Museum in Moscow (repr. Brookner, 1972, pl. 95). Edgar Munhall points out that there is a smaller and more summary composition study for the picture at the Musée Greuze, Tournus (no. 35).

Le premier sillon, as the picture is sometimes called, is an exercise in a patriotic vein unusual for Greuze; for both subject and composition the artist seems to have borrowed from François-André Vincent's painting *L'agriculture*, shown at the Salon of 1798 (see R. Rosenblum, *Transformations in Late Eighteenth Century Art*, Princeton, 1974, pp. 93–94, fig. 95).

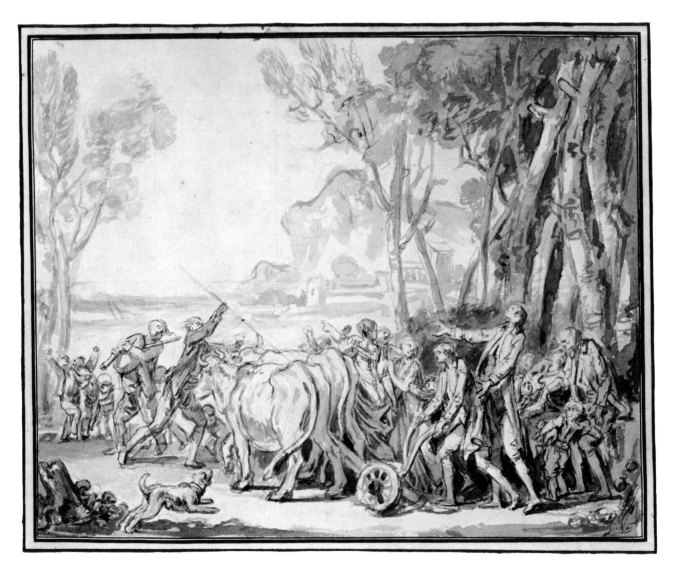

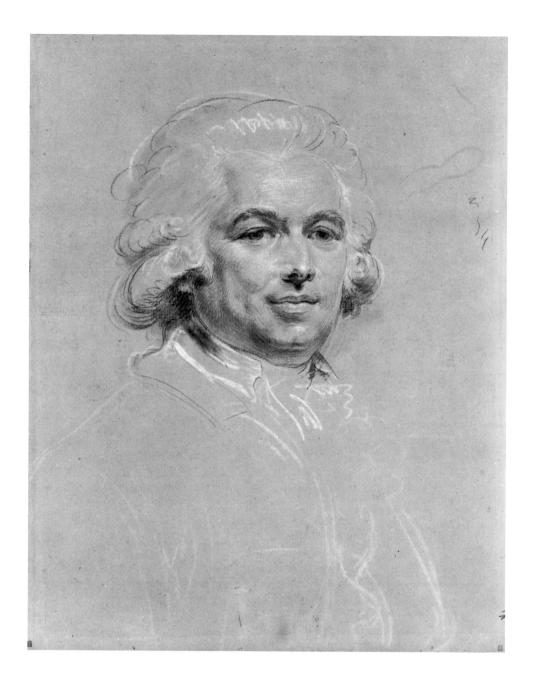

CLAUDE HOIN

Dijon 1750 – Dijon 1817

132. *Head of a Man*

Charcoal, stumped, black chalk, heightened with white, on beige paper. 51.5 x 41.5 cm.

PROVENANCE: Germain Seligman (his mark, interlaced GS, not in Lugt); Mrs. Vincent Astor.

BIBLIOGRAPHY: *Annual Report*, 1984–1985, pp. 24–25.

Gift of Mrs. Vincent Astor, 1985
1985.115

JEAN-PIERRE HOÜEL

Rouen 1735 – Paris 1813

133. *Visitors with Torches inside a Circular Building*

Pen and brown ink, gray-brown wash, heightened with touches of white, over traces of black chalk. 26.8 x 39.3 cm.

Signed and dated in pen and brown ink at lower right, *J. hoüel. f. 17..* [the last two numbers cut off].

PROVENANCE: Sale, London, Christie's, June 27, 1967, no. 132; S. Kaufman; [Jeudwine]; purchased in London in 1971; transferred from the Department of Prints and Photographs in 1985.

BIBLIOGRAPHY: *Fantastic and Ornamental Drawings. A Selection of Drawings from the Kaufman Collection*, exhibition catalogue by S. Kaufman and G. Knox, Portsmouth College of Art and Design, Portsmouth, England, 1969, no. 107, repr.; *Annual Report*, 1970–1971, p. 21.

Purchase, Harris Brisbane Dick Fund and Joseph Pulitzer Bequest, 1971
1971.280

The building represented is the church of S. Maria Maggiore at Nocera Superiore, south of Naples. In the eighteenth century this building was thought to have once been a pagan temple, but scholars today consider it an early Christian baptistery built with classical spoils.

This circular construction attracted the attention of eighteenth-century travelers, and a rather less dramatic view of it by Desprez figures in volume III of Saint-Non's *Voyage pittoresque* (1783, no. 93, opp. p. 170).

JEAN-BAPTISTE HUET

Paris 1745 – Paris 1811

134. *Black and White Dog, Head Turned to the Left*

Black chalk, heightened with white, touches of red chalk, brown ink (the pupil of the eye), on beige paper. Framing lines in black and red ink. 12.3 x 15.9 cm.

Signed and dated in pen and brown ink at upper left, *J. B. hüet an 3.*

PROVENANCE: Walter C. Baker.

BIBLIOGRAPHY: *Annual Report*, 1964–1965, p. 50; J. Wilhelm, *Bulletin du Musée Carnavalet*, XXVIII, 1, 1975, pp. 6–20, fig. 6 (our drawing), fig. 7 (the painting).

Gift of Walter C. Baker, 1964
64.244

Pascal de La Vaissière was the first to notice that this dog appears in one of the garden views painted for a room in the house of the engraver, Gilles Demarteau. This "garden room," now preserved in the Musée Carnavalet, Paris, was the collaborative work of Boucher and Fragonard, with Huet supplying the animals and birds in the paintings, which were probably executed about 1764–1765.

The considerably later date on our drawing, *L'an* III (1794–1795), no doubt indicates that this is an autograph replica of Huet's original sketch of the dog, made for sale at this later date.

PIERRE-CHARLES JOMBERT

Paris 1748 or 1749 – Paris 1825 ?

135. *The Punishment of the Arrogant Niobe by Diana and Apollo*

Oil paint on fine canvas, mounted on cardboard. 35.8 x 28.1 cm.

Inscribed in pen and brown ink on a large label pasted to the reverse of the cardboard mount, *Jombert (Charles Pierre) fils de Charles Antoine, libraire du Roi (célèbre éditeur, grand amateur des Beaux-Arts) a remporté le grand prix de peinture en 1772, sur le programme: La punition de l'orgueilleuse Niobé par Diane et Apollon.*

Jombert, mon ami, mon camarade d'étude dans la même école, m'a légué l'esquisse faite en loge, de son tableau, qui en est aujourd'hui l'archétype.

L'approbation générale qui a relevé l'éclat de sa couronne de lauréat, du grand prix de peinture, m'entraîne d'offrir à l'académie des Beaux-Arts son esquisse pour remplir une lacune qui interrompt l'arrangement périodique des monumens solennels de l'émulation. (1)

Son tableau manque dans cet arrangement, ainsi que quelques autres. Des inscriptions ou des esquisses autographes compléteroient une série monumentale que réclament l'histoire des beaux-arts en France, et les noms des familles honorablement proclamées par le tribunal académique.

Gault de Saint Germain

(1) *Les productions de cet artiste sont peu nombreuses, car sa longévité ne fut pour ainsi dire qu'une longue agonie. Dans son éloge que j'ai prononcée à l'hôtel de Ville (11 décembre 1825) je ne cite du développement de ses bonnes études, dans l'école de Rome, que son tableau (ordonné par le Roi en 1774 [or 9]) placé dans une des chapelles de l'église paroissiale de Saint-Sulpice, et le beau plafond qu'il a éxécuté à l'hôtel d'Orsay (rue de Varenne).*

PROVENANCE: P.-M. Gault de Saint-Germain; [Galerie de Bayser]; purchased in Paris in 1983.

BIBLIOGRAPHY: *Annual Report*, 1983–1984, p. 24.

Van Day Truex Fund, 1983
1983.426

Oil sketch, *faite en loge* as Gault de Saint-Germain tells us, for the painting *Les enfants de Niobé tues par Apollon et Diane* that won for Jombert the *premier prix de Rome* of 1772. Except in the positions of the cloud-borne figures of Apollo and Diana, there is a fairly close correspondence between the oil sketch and the finished painting, which is preserved in the École des Beaux-Arts, Paris (repr. *David et Rome*, exhibition catalogue, Académie de France, Rome, 1981, p. 30, fig. 4, as Lemonnier).

In the same year, 1772, Anicet-Charles-Gabriel Lemonnier won a first prize (carried over from 1770) for a painting of the same subject. Lemonnier's prize picture, quite different in composition from Jombert's, is in the Musée de Rouen, where it was sent as early as *L'an* XI (1802–1803). At some point in the nineteenth century,

Jombert's prize painting was thought to be that of Lemonnier, and the latter's name was painted in small letters at the upper left corner of the canvas.

Jombert's beginnings were extremely promising. Pierre, then director of the Academy, said of Jombert's *Niobé*: "Il y a longtemps qu'il n'y a eu un si bon prix. L'élève est honnête et bien né" (he was the son of the publisher and art-historian Charles-Antoine Jombert). Nothing has up to now been known of Jombert's life or art after his return from Rome in 1776. However, Gault de Saint-Germain's long inscription on the reverse of the mount of this sketch tells us that Jombert lived on until 1825, but that "sa longévité ne fut pour ainsi dire qu'une longue agonie."

For portrait drawings of the young Jombert by Vincent, see Nos. 310 and 311 below.

136. *View of Rome from the Palatine*

Black chalk, some accents in pen and black ink. 16.4 x 35.0 cm. Upper right corner missing. Lined.

Inscribed in pen and brown ink on reverse of old mount, *Ce dessin est le pendant de la marine oblongue*; in pencil, *Vue de Rome / prise du mont Palatin*; *Jombert*; *C. P. J. vers 1775 —*.

PROVENANCE: [Galerie de Bayser]; purchased in Paris in 1984.

BIBLIOGRAPHY: *Annual Report*, 1984–1985, p. 26.

Purchase, David L. Klein, Jr. Memorial Foundation, Inc. Gift, and The Howard Bayne Fund Gift, 1985
1985.6.3

The draughtsman must have been stationed on the northern slope of the Palatine. In the foreground is the via di S. Bonaventura, in the right middle ground there is a side view of the façade of S. Francesca Romana, its pediment crowned with statues. Beyond are the imposing vaults of the Basilica of Constantine, while just left of center appears the Torre delle Milizie. The domed church at the extreme left is SS. Nome di Maria.

A view drawn by Jombert of the Palatine with the entrance to the Farnese gardens, of the same size, style, and technique as our drawing, is in a private collection in Paris; it is signed and dated at lower left, *Jombert. Ro. 1775 (Exposition de dessins anciens, 1984. Galerie de Bayser*, Paris, 1984, no. 22).

JEAN JOUVENET
Rouen 1644 – Paris 1717

137. *St. Peter Healing the Sick with His Shadow* (Acts 5:15–16)

Red chalk. Squared in black chalk. Contours indented with a stylus. 52.6 x 34.8 cm. A sheet measuring 39.1 x 28.8 cm. has been affixed to the center of the larger sheet. Verso of the larger sheet blackened for transfer. Scattered stains and creases.

Inscribed faintly in red chalk at lower left, *J. Jouvenet*; numbered in pen and brown ink at lower right, *499*.

PROVENANCE: Étienne-Barthélemy Garnier; Garnier sale, Paris, February 27–28, 1850, possibly part of no. 41 (according to Schnapper); sale, Paris, Hôtel Drouot, salle 10, May 5, 1971, no. 34; [Baderou]; purchased in Paris in 1971.

BIBLIOGRAPHY: *Annual Report*, 1971–1972, p. 40; Gillies and Ives, 1972, no. 28; Rosenberg, 1972, p. 167, under no. 64; Schnapper, 1974, p. 224, no. 147, fig. 7, the Frankfurt drawing repr. fig. 8, the painting fig. 6; Bean, 1975, no. 48.

The Mr. and Mrs. Henry Ittleson, Jr. Purchase Fund, 1971
1971.238.1

Sketch for an early painting by Jouvenet that is now in the chapel of the Hôpital Laënnec in Paris. A highly finished drawing of this subject in the Städelsches Kunstinstitut, Frankfurt am Main, comes closer to the painting (A. Schnapper, *Master Drawings*, v, 2, 1967, pl. 1, p. 137, fig. 1).

138

RAYMOND LA FAGE

Lisle-sur-Tarn 1656 – Lyon 1684

138. *Nymphs and a Satyr Dancing*

Pen and brown ink on beige paper. 29.9 x 21.0 cm. Loss at upper right. Lined.

Inscribed in pen and brown ink at lower margin of old mount in Richardson's hand, *La Fage*; on reverse of old mount in Esdaile's hand, *Formerly in the collections of Jonⁿ Richardson and S^r Joshua Reynolds. / 1817 WE Lambert's coll.ⁿ P41 N79*; in another hand, *the 4th night / Lot 49*.

PROVENANCE: Jonathan Richardson, Sr. (Lugt 2183, 2984, 2995); Sir Joshua Reynolds (Lugt 2364); Charles Lambert (according to Esdaile); William Esdaile (Lugt 2617); Harry G. Friedman.

BIBLIOGRAPHY: *Annual Report*, 1956–1957, p. 63.

Gift of Harry G. Friedman, 1956
56.225.4

CHARLES DE LA FOSSE

Paris 1636 – Paris 1716

139. *The Sacrifice of Iphigenia*

Black and a little red chalk, heightened with white, on gray-brown paper. 34.2 x 29.5 cm. Scattered losses; surface abraded. Lined.

Inscribed in pen and brown ink at lower right, *La fosse*.

PROVENANCE: Sale, New York, Sotheby Parke Bernet, November 21, 1980, no. 38, repr.; [Goldschmidt]; purchased in New York in 1981.

BIBLIOGRAPHY: *Annual Report*, 1981–1982, p. 22; Bean, 1983, p. 17, pl. 20 (our drawing), fig. 1 (the painting).

Harry G. Sperling Fund, 1981
1981.220

Study for La Fosse's painting over the fireplace in the salon de Diane, château de Versailles. The dramatic diagonal composition of this preparatory study is replaced in the painting by a somewhat ponderous triangular scheme, perhaps more suitable for the over-chimney decoration, which was finished in 1680 (M. Stuffmann, *Gazette des Beaux-Arts*, LXIV, 1964, pp. 100–101).

140. *Head of a Young Girl and Studies of Her Hands and of Her Right Foot*

Red, black, and white chalk, touches of yellow and pink pastel, on beige paper. Framing lines in pen and black ink. 36.7 x 26.5 cm. Lined.

PROVENANCE: Kathryn Bache Miller; sale, London, Christie's, April 15, 1980, no. 171, repr.; [Tan Bunzl]; purchased in London in 1980.

BIBLIOGRAPHY: *Annual Report*, 1980–1981, p. 27; *Notable Acquisitions*, 1980–1981, pp. 48–49, repr. in color; Bean, 1983, pp. 17–18, pl. 21 (our drawing), fig. 2 (the painting).

Harry G. Sperling Fund, 1980
1980.321

Study for the head, the hands, and the bare right foot of the young Virgin Mary, who mounts the steps of the Temple in the *Presentation of the Virgin*, a painting by La Fosse signed and dated 1682. Formerly in the chapel of Our Lady of Mount Carmel in the principal Carmelite church in Toulouse, it is now in the Musée des Augustins of the same city. The drawing is executed in colored chalks; face, hands, and foot are modeled in red and white, while the Virgin's blonde hair is indicated by alternate strokes of yellow and black chalk.

In the Nationalmuseum, Stockholm, there is a reversed composition design for this painting, as well as a study in colored chalk of the head of the same model used in our drawing (Bjurström, 1976, nos. 441 and 458).

141. *The Vision of St. John of the Cross*

Black chalk, over red chalk, heightened with touches of white, on gray paper. 33.5 x 24.3 cm.

Inscribed in pen and brown ink at lower right, *Murillo*.

PROVENANCE: Private collection, Nice (according to vendor); [Aldega]; [Weiner]; purchased in New York in 1981.

BIBLIOGRAPHY: *Annual Report*, 1981–1982, p. 22; Bean, 1983, pp. 18–19, pl. 22.

Purchase, David L. Klein, Jr. Memorial Foundation, Inc. Gift, 1981
1981.277

The drawing appeared on the New York market in 1981 with a very tentative attribution to Antonio Pereda. The subject is Spanish, to be sure, but not the drawing; it is a typical example of the work of Charles de La Fosse, as comparison with the study for the *Sacrifice of Iphigenia* (No. 139 above) should make clear.

The brown habit and scapular of the Discalced Carmelite John of the Cross are indicated by a mixture of red and black chalk, while his white mantle is suggested by white chalk highlights. John of the Cross kneels in wonder before a vision of Christ carrying His Cross; Jesus asks, "John, what do you wish for your labors," and the answer is, "Lord, to suffer and to be despised for you."

No such painting by La Fosse is recorded, but that he may have received a commission for such a Carmelite subject is quite possible. John of the Cross (1542–1591) was not canonized until 1726, but had been beatified in 1675. Throughout the seventeenth century he was often represented in paintings and prints by Spanish, Flemish, and French artists, usually working on commissions from the Reformed Carmelites. In 1638, for example, a print after a design by Claude Mellan representing the Vision of St. John of the Cross was published in Rome, and later in the century Jean-Baptiste Corneille painted an altarpiece for the Parisian church of the *Carmes déchaussés* depicting Christ appearing to St. John of the Cross and St. Teresa of

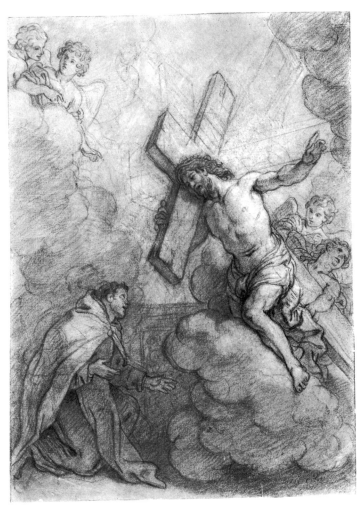

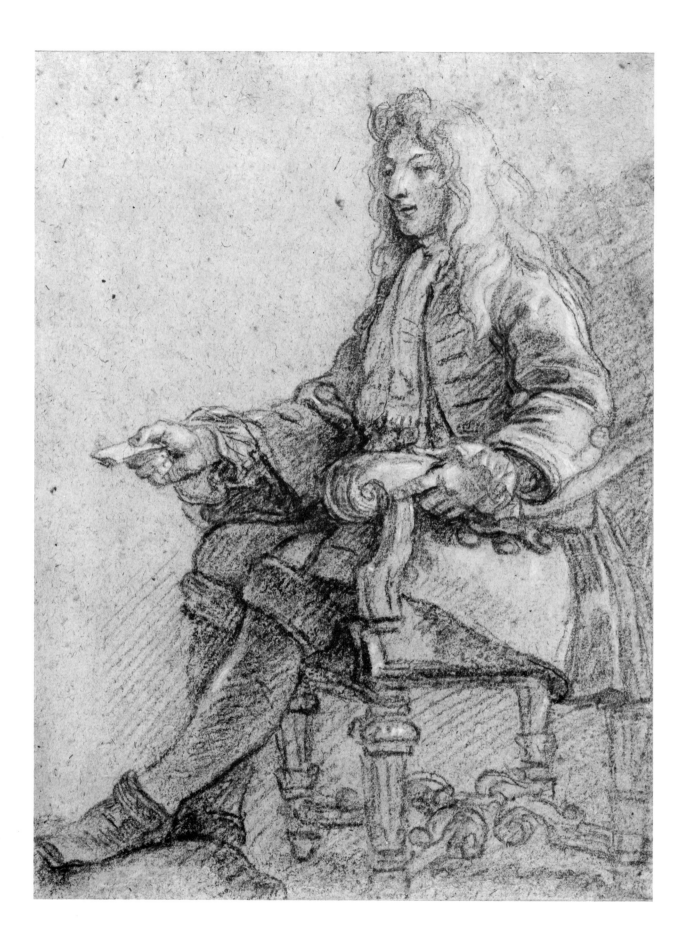

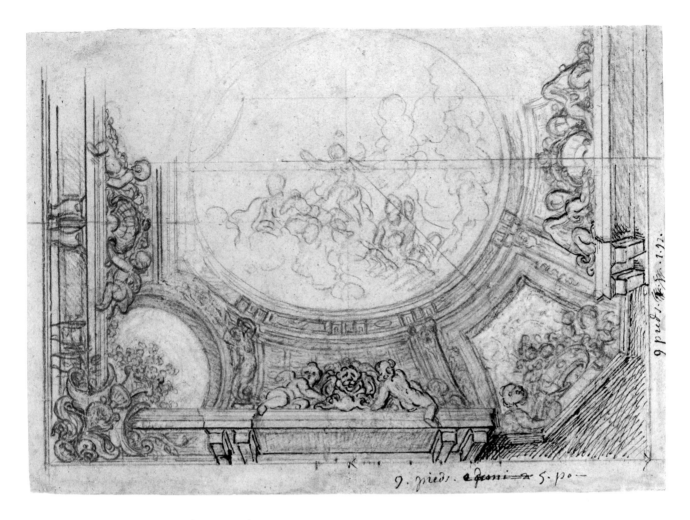

CHARLES DE LA FOSSE (NO. 141)

Jesus, co-reformers of the Carmelite order. As for La Fosse, we should recall that his *Presentation of the Virgin* in Toulouse was painted for the Carmelites (see No. 140 above).

142. *Gentleman Seated in an Armchair*

Red and black chalk, heightened with white, on beige paper. 30.8 x 23.2 cm.

Numbered in pen and brown ink on verso, *212*; modern pencil inscription, *Lafosse*.

PROVENANCE: Germain Seligman (on verso his mark, interlaced GS, not in Lugt); [Shickman]; purchased in New York in 1970.

BIBLIOGRAPHY: *Annual Report*, 1970–1971, p. 16; Bean, 1972, no. 68; Bean, 1983, p. 19, pl. 23.

Rogers Fund, 1970
1970.41.1

143. *Design for a Ceiling Decoration with a Central Oval Field*

Red and black chalk, pen and brown ink, faintly heightened with white. Contours indented with a stylus. 26.5 x 38.5 cm. Verso blackened for transfer. Scattered losses and creases.

Inscribed in pen and brown ink at lower right in the artist's hand, *9. pieds. . . . 5. po —*; at right margin, *9 pieds. 1.p.*

PROVENANCE: Marquis de Chennevières (the sheet does not bear his mark, but the drawing formed part of a group of three sold in 1984, one of which bore the mark); Alexandre Benois; sale, Paris, Nouveau Drouot, salle 5, November 16, 1984, no. 58 (nos. 56 and 57 were also ceiling designs by La Fosse).

BIBLIOGRAPHY: Chennevières, *L'Artiste*, XII, 1896, part XVII, p. 418, "Et trois ou quatre autres groupes pour parties de plafonds"; *Annual Report*, 1984–1985, pp. 24–25.

Anonymous Gift, 1985
1985.37

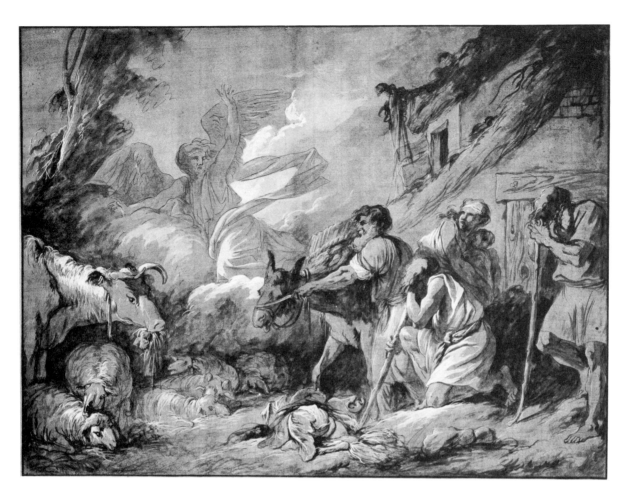

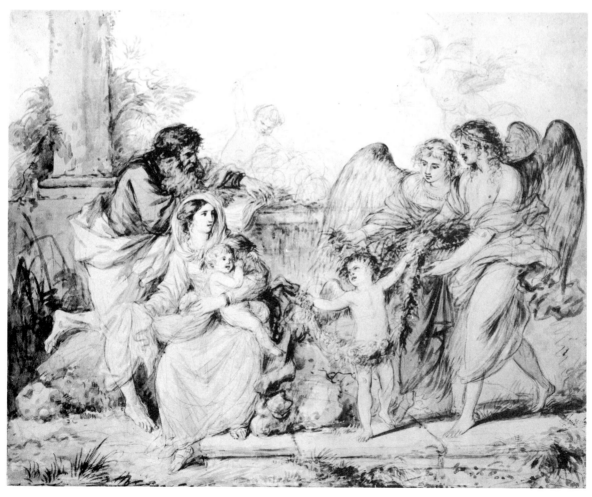

JEAN-JACQUES LAGRENÉE

Paris 1739 – Paris 1821

144. *Annunciation to the Shepherds*

Pen and brown ink, brown wash, heightened with white, on blue-washed paper. 40.2 x 55.4 cm. Lined.

PROVENANCE: [Galerie de Bayser]; purchased in Paris in 1983.

BIBLIOGRAPHY: *Annual Report*, 1983–1984, p. 24.

Purchase, Mrs. Carl L. Selden Gift, in memory of Carl L. Selden, 1983
1983.302

One of the seven drawings exhibited by J.-J. Lagrenée in the Salon of 1775; it was number 138: "L'Ange annonce aux Bergers la venue du Messie."

In Diderot's account of the Salon of 1775, his interlocutor, the young artist J.-P.-J. de Saint-Quentin, severely criticizes two of Lagrenée's paintings on view, but allows that "ses esquisses sur papier bleu rehaussées de blanc sont fort bien" (Diderot, *Salons*, IV, p. 290).

145. *Rest on the Flight into Egypt*

Brush and brown wash over black chalk. 46.4 x 59.7 cm. Lined.

Signed in pen and brown ink at lower right, *J. J. Lagrenée*; inscribed in pen and black ink on reverse of old mount, *fuite en egipte*.

PROVENANCE: [Komor]; purchased in New York in 1961.

BIBLIOGRAPHY: *Annual Report*, 1960–1961, p. 64; Rosenberg, 1972, p. 170, under no. 69; *Drawings from Angers*, 1977, under no. 63.

Rogers Fund, 1961
61.58

This drawing is very probably that exhibited by J.-J. Lagrenée in the Salon of 1785: "15. Une fuite en Egypte au bistre sur papier blanc. 2 pieds de large, sur 1 pied et demi de haut." The dimensions supplied in the *livret* are no doubt rounded off; our drawing actually measures 1 pied, 10 pouces de large, sur 1 pied, 5 pouces, 1 ligne de haut. The old inscription, *fuite en egipte*, on the reverse of the original mount, offers further confirmation that ours is the drawing exhibited in 1785 with the same title.

A drawing by J.-J. Lagrenée of similar dimensions in the Fogg Museum of Art, Cambridge, Mass., representing the Holy Family with many attendants and pyramids in the background, is possibly the drawing exhibited in the Salon of 1779 with the title *Repos en Egypte* (Anonymous Gift in memory of William A. Jackson, 1965.12; repr. Rosenberg, 1972, no. 69, pl. 127).

146. *Still Life: Vases, a Cassolette on a Pedestal, and an Overturned Basket of Fruit*

Pen and brown ink, gray wash, over graphite. 15.0 x 23.2 cm. Lined.

Inscribed in pen and black ink at lower right of Chennevières mount, LAGRÉNÉE; blind stamp at lower left of mount, *81*.

PROVENANCE: Marquis de Chennevières (Lugt 2073); Chennevières sale, Paris, April 4–7, 1900, part of no. 260, "Modèles de vases"; [Galerie de Bayser]; purchased in Paris in 1984.

BIBLIOGRAPHY: *Exposition de dessins anciens, 1984. Galerie de Bayser*, Paris, 1984, no. 25, repr.; *Annual Report*, 1984–1985, p. 25.

Van Day Truex Fund, 1984
1984.250

Possibly a design for a painted porcelain plaque; J.-J. Lagrenée was artistic director of the manufacture de Sèvres from 1785 to 1800. The drawing is probably later, and less strictly archaeological in spirit, than the studies in the Berlin Kunstbibliothek for Lagrenée's *Recueil de Compositions* of 1782 (Berckenhagen, 1970, pp. 366–367; P. Arizzoli in *Piranèse et les français*, 1976, pp. 160–161).

LOUIS LAGRENÉE

Paris 1725 – Paris 1805

147. *Seated Male Nude*

Red chalk. 39.7 x 50.6 cm. Lined.

Signed in red chalk at lower left, *Lagrenée*.

PROVENANCE: [Colnaghi]; purchased in London in 1985.

BIBLIOGRAPHY: *Annual Report*, 1984–1985, p. 26.

Harry G. Sperling Fund, 1985
1985.112.1

This academy was engraved *en manière de sanguine* in the same direction by Louis-Marin Bonnet. The legend on the print reads: *Tiré du Cabinet de Mr Lagrenée Peintre du Roy / Professeur en son Académie de Pture et Scture / L. Lagrenée delin. À Paris chez Bonnet rue St Jacques. / Dix neuvième Figure. / L. Bonnet Sculp.* (Hérold, 1935, p. 106, no. 123; Sandoz, 1983, p. 108, fig. 25, pp. 220–221). Bonnet reproduced twenty-nine red chalk drawings of male and female nudes by Louis Lagrenée, one of which is signed and dated 1770.

LAURENT DE LA HYRE

Paris 1606 – Paris 1656

148. *St. Roch Interceding before the Holy Trinity for Plague Victims*

Black chalk, gray wash. 22.5 x 14.8 cm. Scattered brown stains.

PROVENANCE: J. Fitchett Marsh (Lugt 1455 on old mount, now lost); [Colnaghi]; purchased in London in 1983.

BIBLIOGRAPHY: *An Exhibition of Old Master Drawings. P. and D. Colnaghi and Co.*, London, 1983, no. 23, repr.; *Annual Report*, 1983–1984, p. 24.

Harry G. Sperling Fund, 1983
1983.360

When the drawing was on the London market it was recognized as the work of La Hyre by Barbara Brejon de Lavergnée.

The somewhat tentative quality of the draughtsmanship suggests a relatively early date in the artist's career.

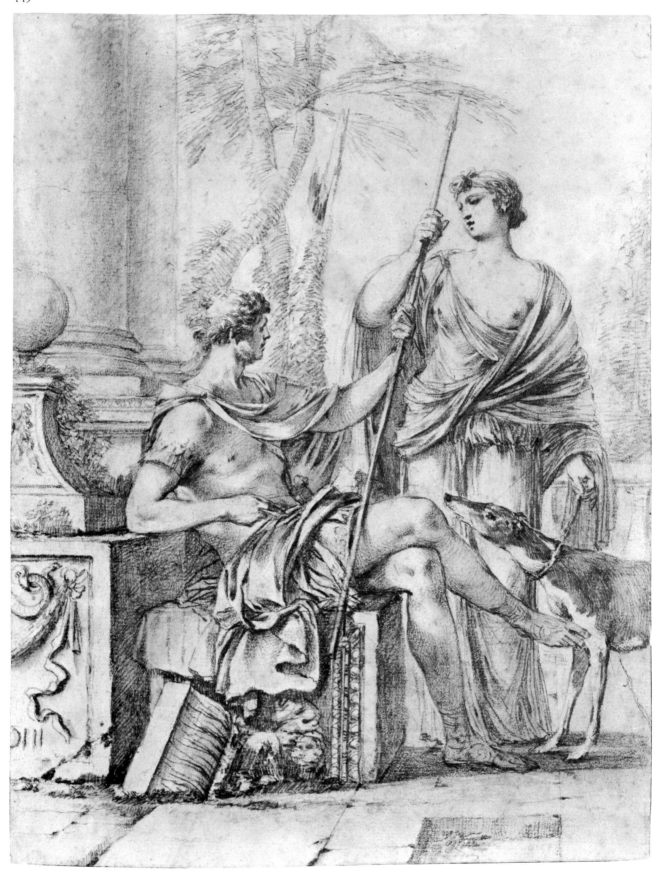

149. *Cephalus Receiving the Spear and Hound from Procris*

Black chalk, gray wash. 28.1 x 21.8 cm. Pink stain at upper center.

PROVENANCE: Jacques Petit-Horry (his mark, JPH in a triangle, not in Lugt); purchased in Paris in 1972.

BIBLIOGRAPHY: *Annual Report*, 1972–1973, p. 33; E. Standen, *The Museum of Fine Arts, Houston, Bulletin*, IV, 1, 1973, pp. 10–20, drawing and tapestry repr. p. 14; Bean, 1975, no. 49; E. Standen, *Apollo*, CXIII, July 1981, pp. 30–31; P. Rosenberg and J. Thuillier, *Laurent de La Hyre 1606–1656 (Cahiers du dessin français, 1)*, Paris, 1985, no. 26, repr.

Fletcher Fund, 1972
1972.224.4

Design for a cartoon used in a set of six tapestries reproducing mythological subjects by La Hyre. Edith Standen points out that the tapestries were probably woven in the Paris workshop of Hippolyte de Comans; two of La Hyre's paintings used for the series are signed and dated 1644.

NICOLAS LANCRET

Paris 1690 – Paris 1743

150. *Standing Hunter Holding a Rifle*

Black chalk, heightened with white, on brownish paper. 23.0 x 12.5 cm.

PROVENANCE: Eustace Cecil, Lord Rockley; Evelyn Cecil, Lord Rockley (according to Thomas); Harry G. Sperling.

BIBLIOGRAPHY: Thomas, 1961, no. 50; *Annual Report*, 1974–1975, p. 50.

Bequest of Harry G. Sperling, 1971
1975.131.118

Hylton Thomas pointed out that the drawing is a study for the hunter who appears at left of center in *Le déjeuner dans la forêt*, a painting now in Sanssouci, Potsdam (Wildenstein, 1924, no. 444, fig. 110).

151. *Woman Seated on the Ground*

Black chalk, heightened with white, on brownish paper. 14.1 x 17.7 cm. Lined.

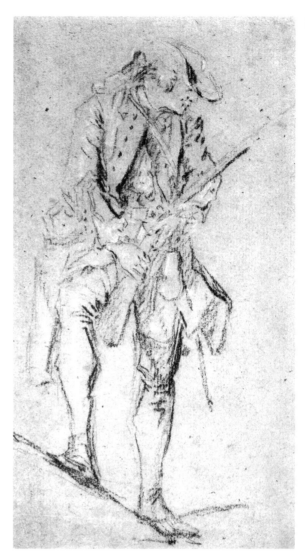

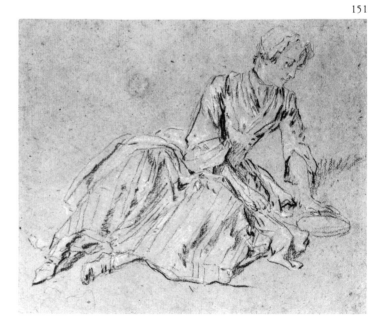

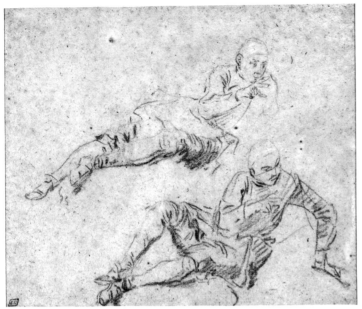

152

153

PROVENANCE: Henry Oppenheimer; Oppenheimer sale, London, Christie's, July 10, 13–14, 1936, no. 438, purchased by the Metropolitan Museum.

BIBLIOGRAPHY: H. B. Wehle, *Metropolitan Museum of Art Bulletin*, January 1937, pp. 6, 8–9; Benisovich, 1943, p. 70; *Metropolitan Museum, European Drawings*, 1943, no. 32, repr.

Harris Brisbane Dick Fund, 1936
36.101.4

In the catalogue of the Oppenheimer sale K. T. Parker identified the drawing as a study for the woman who reclines on the ground at left of center in the country picnic represented in *L'automne*, a work painted in 1738 for the château de La Muette, and now in the Musée du Louvre (Wildenstein, 1924, no. 13, fig. 12).

152. *Two Studies of a Reclining Youth*

Red chalk, heightened with a little white, on beige paper. 19.7 x 15.9 cm. (sight).

PROVENANCE: E. Calando (Lugt 837); Mrs. O'Donnell Hoover.

BIBLIOGRAPHY: *Annual Report*, 1959–1960, p. 57.

Gift of Mrs. O'Donnell Hoover, subject to a life estate, 1959
59.205

Margaret Morgan Grasselli, in a letter of April 7, 1975, connected the youth studied twice on this sheet with the boy who appears at the left in *Le jeu de pied-de-boeuf*, a painting now in the Neues Palais, Potsdam (Wildenstein, 1924, no. 248, fig. 62).

153. *Standing Woman Facing Right*

Red chalk. Verso: faint red chalk sketch of an arm and hand holding a fan. 21.4 x 11.6 cm. Stain at lower left.

Inscribed in pen and red ink at lower center of old mount, *Antoine Watteau*.

PROVENANCE: Lawrence Barnett Phillips (Lugt 1716); purchased in London in 1907.

Rogers Fund, 1907
07.283.11

The drawing was acquired by the Museum in 1907 as the work of Watteau; at an uncertain date this attribution

was rectified and the work correctly catalogued as Lancret. Margaret Morgan Grasselli points out that this figure with left hand extended to a fortune-teller appears in Lancret's painting *La diseuse de bonne aventure*, formerly in the Harland-Peck collection (Wildenstein, 1924, no. 524, fig. 200).

SIMON-MATHURIN LANTARA

Oncy 1729 – Paris 1778

154. *The Château of Chambord Seen from the Southwest*

Pen and gray ink, watercolor, over traces of graphite. 23.4 x 36.5 cm.

Signed in pen and brown ink at lower left, *Lantara f.*

PROVENANCE: [Morton Morris]; purchased in London in 1985.

BIBLIOGRAPHY: *Annual Report*, 1984–1985, p. 26.

Harry G. Sperling Fund, 1985
1985.104.3

This eighteenth-century view of Chambord, which has the air of a painstakingly accurate representation, reveals how extensive were the additions made to the château by the duchesse de Berry in the first half of the nineteenth century. The shrubbery in front of the castle and the field in the foreground were replaced by a grand court surrounded on three sides by low buildings.

NICOLAS DE LARGILLIERRE

Paris 1656 – Paris 1746

155. *Two Nude Male Figures Struggling Together*

Charcoal, stumped, black chalk, heightened with white, on brown paper. 42.2 x 55.0 cm. Vertical crease at center; water stains at upper margin; a number of repaired losses.

Signed and dated in black chalk at lower left, *N. de Largillierre Julliet / 1709 Et 1710.*

PROVENANCE: [Baderou]; purchased in Paris in 1969.

BIBLIOGRAPHY: *Annual Report*, 1968–1969, p. 67; Rosenberg, 1971, p. 86, under no. XXXIV; Bean, 1972, no. 69; *Notable Acquisitions*, 1965–1975, p. 59, repr.; Rubin, 1977, pp. 22–23, fig. 4; Rosenfeld, 1981, p. 195, no. 38, repr.

Rogers Fund, 1969
69.10

Seven comparable large *académies* by Largillierre are preserved in the École des Beaux-Arts in Paris (P. Lavallée, *Bulletin de la Société de l'Histoire de l'Art français*, 1921 [1922], pp. 107–113; Rosenfeld, 1981, pp. 187–194, all repr.).

All eight drawings must have been executed while Largillierre was *professeur* at the Academy between 1699 and 1715; three of the drawings in the École des Beaux-Arts bear dates: 1701, 1706, and 1707 (or 1709), while our drawing bears both the dates 1709 and 1710.

CHARLES DE LA TRAVERSE

Paris ca. 1727 – Paris ca. 1787

156. *Allegorical Figure of Melancholy*

Pen and brown ink, brown wash, over black chalk. 30.5 x 20.1 cm.

Inscribed in pen and brown ink at upper right, *la Mélancolie / la Traverse a Madrid / 1763*; and on book at lower right (upside down) *. . . ocalipse / Giovan . . . / Patmos.*

PROVENANCE: [P. Gordon]; purchased in New York in 1983.

BIBLIOGRAPHY: *Annual Report*, 1983–1984, p. 24.

Van Day Truex Fund, 1983
1983.431

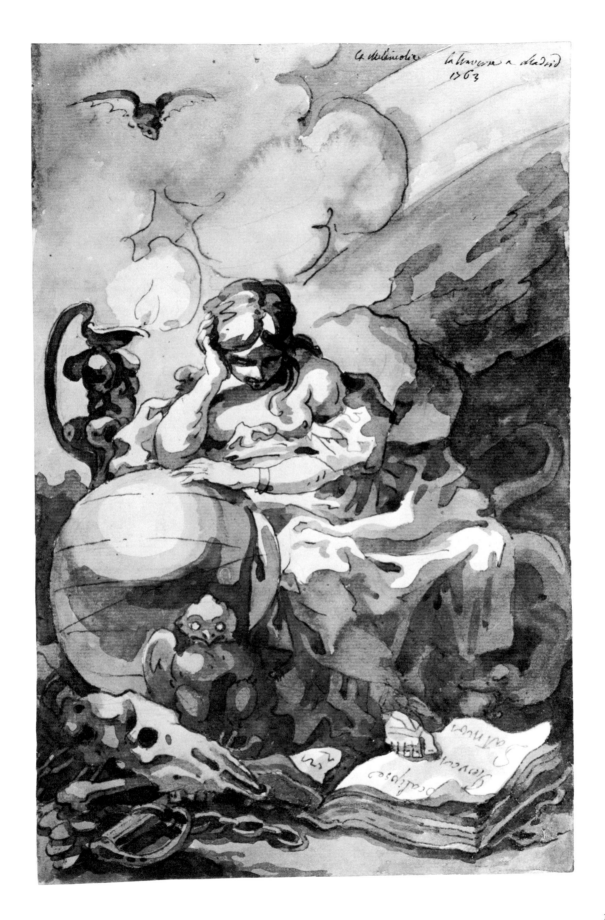

157

158

CHARLES LE BRUN

Paris 1619 – Paris 1690

157. *Allegory in Honor of Cardinal Richelieu*

Black chalk, black and gray wash, traces of red chalk. Contours incised for transfer. 37.3 x 74.9 cm. Vertical crease at center; a number of repaired tears and losses.

Inscribed in pen and brown ink at lower left of verso, *de M͏ͬ Le Brun.*

PROVENANCE: Anthony Blunt; [Colnaghi]; purchased in London in 1974.

BIBLIOGRAPHY: A. Blunt, *Burlington Magazine*, LXXXV, 1944, p. 169, pl. IIIA; J. Montagu in *Le Brun*, 1963, repr. p. 160, p. 161, no. 59; *Blunt Collection*, 1964, no. 66; *Gazette des Beaux-Arts*, LXVI, 1965, p. 53, under no. 284; *Annual Report*, 1973–1974, p. 37; Bean, 1975, no. 50.

Harry G. Sperling Fund, 1974
1974.106

Design for the lower part of the thesis of Jean Ruzé d'Effiat, dedicated to cardinal-duc de Richelieu in 1642. Le Brun's design was engraved in reverse by Michel Lasne (the lower part repr. V. Champier and G.-R. Sandoz, *Le Palais-Royal*, Paris, 1900, I, p. 3; the whole composition repr. *Gazette des Beaux-Arts*, LXVI, 1965, p. 53, no. 284).

Mars and Apollo with their attributes are seated to the left and right of the prow of a ship, above which appears a shield surmounted by a ducal crown and a cardinal's hat. Jennifer Montagu pointed out that the naval attributes refer to Richelieu's role as grand-amiral de France, while the figures of Mars and Apollo allude to his eminence in the arts of war and peace.

158. *The Relief of Candia in Crete*

Gray and pale blue wash over black chalk (the oval design), pale rose wash (surrounding the oval). Framing lines in pen and brown ink. 29.8 x 22.1 cm. Lined.

Inscribed in pen and gray ink at lower center, *Le Brun.*; in pen and brown ink, *Secours de Candie.*

PROVENANCE: Sir Joshua Reynolds (Lugt 2364); Anthony Blunt; purchased in London in 1975.

BIBLIOGRAPHY: *Blunt Collection*, 1964, p. 16, no. 55; W. Vitzthum, *Master Drawings*, III, 4, 1965, p. 406, pl. 33; *Annual Report*, 1975–1976, p. 36.

Harry G. Sperling Fund, 1975
1975.439

Anthony Blunt convincingly suggested that this drawing is an unused study for one of the oval fields in the galerie des Glaces of the château de Versailles.

159. *St. Charles Borromeo Distributing Communion to Plague Victims*

Black chalk. 15.0 x 41.8 cm.

Inscribed in pen and brown ink at lower right, *esquisse de m͏ͬ Le Brun / u I* [?]; in pen and brown ink on reverse of old mount (now detached) in Esdaile's hand, *. . . d Spencer's coll. 1811 WE P20 N82.*

PROVENANCE: Earl Spencer (Lugt 1531); Spencer sale, London, T. Philipe, June 10–17, 1811, no. 433, the subject described as "Monks administ[e]ring the sacrament to the wounded in battle—masterly

159

black chalk"; William Esdaile (Lugt 2617); Esdaile sale, London, Christie's, June 18–25, 1840, part of no. 1205, the subject described as "St. Ambrose visiting the sick at Milan, black chalk . . ."; C. R. Rudolf (Lugt Supp. 2811b); sale, London, Sotheby's, May 29, 1975, no. 2, pl. 11; [Colnaghi]; purchased in London in 1975.

BIBLIOGRAPHY: J. Montagu, *Burlington Magazine*, CXVIII, 1976, pp. 88–95, fig. 44 (the Girardon relief), fig. 45 (our drawing), fig. 46 (the Madrid drawing); *Annual Report*, 1975–1976, p. 36; Souchal, 1981, repr. p. 59, p. 60, under no. 73; J.-C. Boyer, *Revue de l'Art*, 64, 1984, p. 30, p. 34, fig. 16.

Harry G. Sperling Fund, 1975
1975.361

Jennifer Montagu identified the drawing as Le Brun's composition study for a bronze relief executed by François Girardon for the predella of the altar in a chapel Le Brun had acquired in Saint-Nicolas-du-Chardonnet, Paris, in 1667. Le Brun erected the tomb of his mother there and painted, for the chapel, an altarpiece representing his patron saint, Charles Borromeo, in prayer. The tomb and the altar remain in the church, but the cut-out bronze relief, intended to be seen against a white marble backing, found its way to the Musée des Beaux-Arts, Troyes.

A detail study by Le Brun for the kneeling man supporting the dying communicant in the relief was discovered by Miss Montagu among the anonymous eighteenth-century French drawings at the Biblioteca Nacional, Madrid.

CHARLES LE BRUN ?

160. *Allegory of Earth*

Gray wash, over red chalk. Framing lines in pen and brown ink. 30.2 x 20.9 cm. Pin hole at lower center. Lined.

PROVENANCE: [Baderou]; purchased in Paris in 1964.

BIBLIOGRAPHY: *Annual Report*, 1963–1964, p. 62; Rosenberg, 1972, p. 174, under no. 75.

Rogers Fund, 1964
64.33

Cybele and Bacchus stand flanking a cornucopia-crowned pedestal that is supported by a lion and a bear. The drawing may be a studio production, and Jennifer Montagu has suggested a date about 1660 (letters of August 20 and October 18, 1964). She kindly pointed out connections in style, design, and subject with a drawing in the

Cronstedt Collection in Stockholm representing Water (CC. 1770), and a drawing in the Cabinet des Estampes of the Bibliothèque Nationale, Paris, representing the element of Air (B 6a Rés, Le Brun).

CHARLES LE BRUN ?

161. *Apollo Bathing, Attended by the Nymphs of Thetis*

Gray wash, over red and black chalk. Squared in black chalk. Framing lines in pen and brown ink. 29.3 x 40.1 cm. Lined.

Inscribed in black chalk at left of lower center, *B*; at right of lower center, *bien* and *A*.

PROVENANCE: Baron de Triqueti (Lugt 1304); [Baderou]; purchased in Paris in 1965.

BIBLIOGRAPHY: *Annual Report*, 1965–1966, p. 75; Rosenberg, 1972, p. 174, under no. 75.

Rogers Fund, 1965
65.125.1

It seems very probable that Charles Le Brun supplied designs for the sculptured group *Apollo Bathing, Attended by the Nymphs of Thetis*, executed by François Girardon (Apollo and three of the nymphs) and Thomas Regnaudin (three nymphs) for the grotte de Thétis at Versailles (Souchal, 1981, pp. 25–28).

The style and technique of this drawing come close to that of Le Brun, and it may be the work of a studio assistant. The function of the drawing is not at all clear, though it is squared, bears the capital letters *B* and *A*, and the comment *bien*. It does not correspond in detail to, nor is it a preparation for, the contemporary engravings by Edelinck and Thomassin that show the group in its original setting.

SÉBASTIEN LECLERC

Metz 1637 – Paris 1714

162. *Alexander Entering Babylon*

Pen and brown ink, gray wash, over red chalk. 22.3 x 36.4 cm. The sheet is made up of more than thirty-five pieces of irregularly shaped paper; most of these are drawn *pentimenti* that have been moved from one place to another on the support.

PROVENANCE: [Colnaghi]; purchased in London in 1961.

BIBLIOGRAPHY: *Annual Report*, 1961–1962, p. 66.

Rogers Fund, 1961
61.130.3

Study for Leclerc's engraving, *L'entrée d'Alexandre dans Babylone* (*Inventaire 17ᵉ siècle*, VIII, 1980, no. 457, 4th and 5th states repr. p. 126). There are further preparatory studies for this engraving in the British Museum, London (1886-1-11-17), and in the Städelsches Kunstinstitut, Frankfurt am Main (Inv. 1106). It is the study in the British Museum that comes closest to the first states of the print.

PIERRE LÉLU

Paris 1741 – Paris 1810

163. *Church of São Martinho in Sintra, Portugal*

Pen and brown ink, gray and brown wash, over traces of graphite.
26.8 x 39.5 cm. Red pigment stain at upper left.

Inscribed in pen and brown ink at lower right in the artist's hand, *vue de L Eglise de Sinnetra / en Portugal*; at lower left what remains of an inscription lost when the sheet was trimmed, . . . *Sinnetra* [?].

PROVENANCE: Dargent, Rouen (mark, *Collection* HD, not in Lugt); purchased in New York in 1983.

BIBLIOGRAPHY: *Annual Report*, 1983–1984, p. 24.

Purchase, Lois Swan Junkin Gift, in memory of Nathalie Swan Rahv, 1983
1983.265

Hellmut Wohl kindly informed us that this view of Sintra is an exact one. The church of São Martinho, of Gothic origin, was rebuilt after the earthquake of 1755. "The stone cross in front of the church still exists. The tower at the left belongs to a building that is currently the local post-office. The hills in the background are part of the Serra de Sintra. The view is from the west" (letter of July 12, 1984).

Lélu seems to have visited Portugal around 1775. The Rijksprentenkabinet, Amsterdam, recently acquired in Paris a signed view of the Quinta de Penha Verde, Sintra, that is very similar in style to our drawing (*Rome 1760–1770. Fragonard, Hubert Robert et leurs amis*, exhibition catalogue, Galerie Cailleux, Paris, 1983, no. 42, repr.).

The Department of Prints and Photographs possesses a design by Lélu for the decoration of the corner of a coved ceiling (68.635; Gernsheim photograph 61738).

FRANÇOIS LEMOINE

Paris 1688 – Paris 1737

164. *The Adoration of the Shepherds*

Black chalk, heightened with white, on gray-green paper. 42.5 x 20.3 cm. Lined.

Inscribed in pen and black ink at lower left margin of old mount, *F. Le Moine.*

PROVENANCE: Jacques-Augustin de Silvestre ?; Silvestre sale, Paris, February 28–March 25, 1811, possibly part of no. 338, "L'Adoration des bergers . . . crayons noir et blanc, sur papier bleu"; unidentified collector's mark, interlaced GC (Lugt 1143); Iolo Williams (according to vendor); [Colnaghi]; purchased in London in 1961.

BIBLIOGRAPHY: *Annual Report*, 1961–1962, p. 66; Rosenberg, 1972, p. 176, under no. 79; Bordeaux, 1985, pp. 85, 149, no. D.39, fig. 167.

Rogers Fund, 1961
61.130.5

Jean-Luc Bordeaux identified the drawing as a composition study for a large altarpiece by Lemoine, the *Adoration of the Shepherds*, signed and dated 1721 (Bordeaux, 1985, p. 85, no. P.29, fig. 25). Until the Revolution the painting hung in the third chapel on the left in Saint-Roch, Paris (Dezallier d'Argenville, 1757, p. 110). It was presented to the Hospice du Mont-Cenis by Napoleon in 1813, and in 1855 it was sent to the parish church in Novalesa, near Susa in northwest Italy, where it is today.

165. *The Flight into Egypt*

Black chalk, heightened with white, on blue paper. Framing lines in pen and brown ink. 21.3 x 31.0 cm. Lined.

Inscribed in pen and brown ink at lower center of old mount, *F. Lemoine.*; on reverse of old mount in an imprinted cartouche (Lugt 3000), *françois le Moine / Cab^t joubert.*

PROVENANCE: Joubert (according to inscription on reverse of old mount); unidentified collector's mark, interlaced GC (Lugt 1143); sale, London, Christie's, July 6, 1982, no. 84, repr.; purchased in Lausanne in 1983.

BIBLIOGRAPHY: *Annual Report*, 1982–1983, p. 24; Bordeaux, 1985, pp. 104, 150, no. D.43, fig. 171, "present location unknown."

Harry G. Sperling Fund, 1983
1983.128.1

Here the free, rather loose handling of black and white chalk on blue paper is close to that found in two pastoral scenes by François Lemoine in the Pierpont Morgan Library, New York (Bordeaux, 1985, p. 148, nos. D.32–D.33, figs. 159–160). The Morgan drawings are studies for paintings dated 1721.

166. *Studies of a Valet Pouring Wine*

Red chalk. 25.6 x 16.7 cm.

PROVENANCE: Léon Decloux; Léon Decloux sale, Paris, Hôtel Drouot, February 14–15, 1898, no. 167, repr., as Watteau; George and Florence Blumenthal; Ann Payne Blumenthal.

BIBLIOGRAPHY: *Blumenthal Collection Catalogue*, V, 1930, pl. XXIII, as Watteau; J. Wilhelm, *Art Quarterly*, XIV, 1951, pp. 216–230, fig. 6; Gillies and Ives, 1972, no. 30; *Pantheon*, XXX, 6, 1972, p. 513, repr.; Rosenberg, 1972, p. 176, under no. 79; Bjurström, 1982, under no. 1054; Bordeaux, 1985, pp. 89, 152, no. D.55, fig. 183.

Gift of Ann Payne Blumenthal, 1943
43.163.22

In 1951 Jacques Wilhelm identified this drawing, formerly attributed to Antoine Watteau, as a study for a valet pouring wine in the left foreground of François Lemoine's painting the *Hunt Breakfast* in the Alte Pinakothek, Munich (repr. Wilhelm, *op. cit.*, p. 218, fig. 3). There are other studies for the same figure in Stockholm (Bjurström, 1982, no. 1054, repr.), and in a private collection in Paris (repr. Wilhelm, *op. cit.*, p. 219, fig. 4).

Jean-Luc Bordeaux proposes that the painting in Munich, though signed, is "most likely a studio copy." For him, the prime version of the *Hunt Breakfast* is that in the Museu de Arte, São Paulo, Brazil, which is said to be signed and dated 1723 (Bordeaux, 1985, pp. 88–89, no. P.38, fig. 34).

167. *Standing Male Nude Seen from Below*

Black chalk, stumped and heightened with white, on beige paper. Framing lines in pen and brown ink. 37.1 x 21.4 cm. Lined. The drawing is affixed to a mount similar to that of No. 168 below; however, a gold strip has been added around the white band.

Inscribed in pen and brown ink at lower left of old mount, *504m̃os* [?]; at lower right, *2H. . . .* [?].

PROVENANCE: Sale, London, Sotheby's, July 2, 1984, no. 141, purchased by the Metropolitan Museum.

BIBLIOGRAPHY: *Annual Report*, 1984–1985, p. 25.

Purchase, David L. Klein, Jr. Memorial Foundation, Inc. Gift, 1984
1984.238

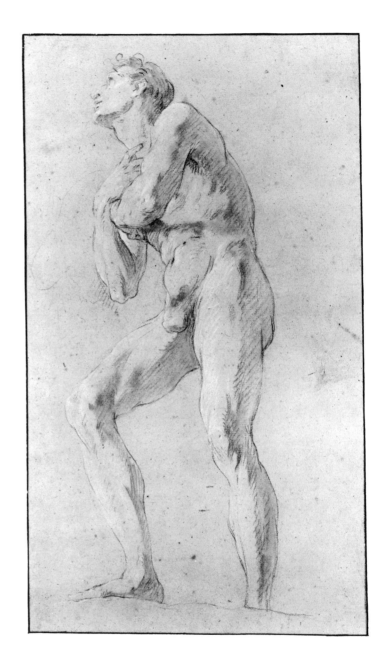

Study from the nude for a figure that appears wearing a heavy cloak in the foreground of Lemoine's fresco in the cupola of the Lady Chapel, Saint-Sulpice, Paris. The figure is one of a group of parishioners, of all ages and conditions, recommended to the Blessed Virgin by Monsieur Olier, curé of the parish church of Saint-Sulpice from 1642 to 1652. The Virgin in glory figures at the center of the cupola as mediatrix and advocate for sinful humanity; she is identified on a banderole as *Refugium peccatorum*. The fresco was commissioned at the end of 1730, work was begun in 1731, and it was finished in October of 1732. Damaged and repainted, the fresco itself is hardly legible today, but its original appearance can be reconstructed from contemporary descriptions and surviving oil sketches for the composition (Bordeaux, 1985, pp. 119–121, no. P.91, fig. 84; as in some old guides and modern texts, the subject is mistakenly described as the Assumption of the Virgin).

Fourteen figure studies for this work are preserved in the Cabinet des Dessins, Musée du Louvre. Some of these were identified by Jacques Wilhelm, others by Roseline Bacou and Jean-Luc Bordeaux. It is interesting to note that Lemoine used the same male model represented here in two studies from the nude for the figure of St. Sulpicius, who appears dressed in a rich chasuble as one of the patron saints of the church (Inv. 30529 and Inv. 30556; Bordeaux, 1985, figs. 254–255). Like ours, all the figure studies in the Louvre for the chapel in Saint-Sulpice are on beige paper, while most of the surviving studies for the salon d'Hercule at Versailles, a slightly later project, are on blue paper.

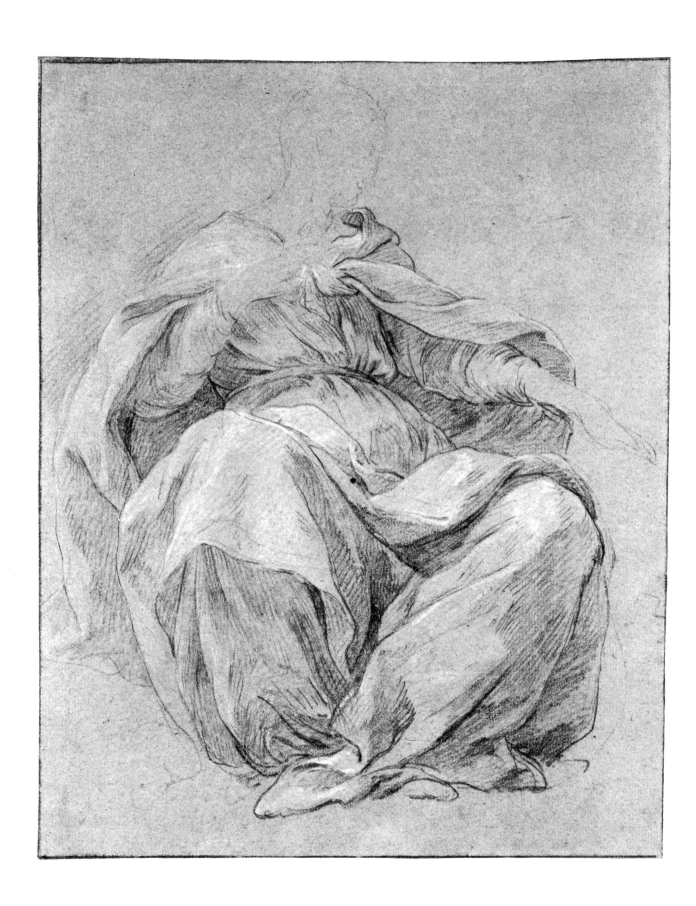

FRANÇOIS LEMOINE

168. *Seated Draped Figure*

Black chalk, heightened with white, on blue paper. 30.5 x 24.6 cm.
Lined. The old pale blue mount, with a white band surrounding the
drawing, is like those found on many drawings by François Lemoine in
the Cabinet des Dessins, Musée du Louvre. These mounts may have
been made in the artist's studio.

Modern pencil inscription at lower left of old mount, *Delafosse fecit*.

PROVENANCE: [Baderou]; purchased in Paris in 1963.

BIBLIOGRAPHY: *Annual Report*, 1963–1964, p. 62; Rosenberg,
1972, p. 176, under no. 79; Bordeaux, 1974, p. 313, fig. 21, mis-
takenly identified as a study for a figure of Force; Bordeaux, 1985, pp.
125, 173, no. D.156, fig. 283, as a study for Force.

Rogers Fund, 1963
63.105

Study for the drapery of the allegorical figure of Valor
caressing a lion that appears in the southeast corner of
Lemoine's ceiling decoration in the salon d'Hercule at
Versailles (repr. Van der Kemp, 1981, p. 35; Bordeaux,
1985, fig. 89.4). Lemoine began work on this vast enter-
prise in May of 1733, and the ceiling was unveiled on
September 26, 1736.

169. *Three Winged Putti Supporting a Garland*

Black chalk on blue paper. Framing lines in pen and brown ink. 21.5 x
29.7 cm. (overall). A vertical strip measuring .6 cm. in width has been
added at right. Lined.

Inscribed in pen and black ink at lower margin of old mount, FRANCOIS
LE MOINE / *Etudes pour le plafond du Sallon d'Hercules*.

PROVENANCE: Jean-Denis Lempereur (Lugt 1740); Lempereur sale,
Paris, May 24, 1773, and following days, part of no. 510, "Trois
études d'enfans sur une même feuille"; Chevalier de Damery (Lugt
2862); Van Parijs (Lugt 2531); Van Parijs sale, Amsterdam, Frederik
Muller, January 11–12, 1873, no. 159; Charles Mewes; [Jeudwine];
purchased in London in 1968.

BIBLIOGRAPHY: *Exhibition of Old Master Drawings Presented by W. R.
Jeudwine and L'Art Ancien S.A.*, London, 1968, no. 17, pl. VII; *Annual
Report*, 1968–1969, p. 67; Rosenberg, 1972, p. 176, under no. 79;
Bordeaux, 1974, p. 313, fig. 23; Bordeaux, 1985, pp. 125, 174, no.
D.164, fig. 291).

Rogers Fund, 1968
68.80.2

These putti, supporting a garland of oak leaves, appear in
front of the painted cornice at the center of the eastern
side of the ceiling of the salon d'Hercule at Versailles
(repr. Van der Kemp, 1981, p. 33; Bordeaux, 1985, fig.
89).

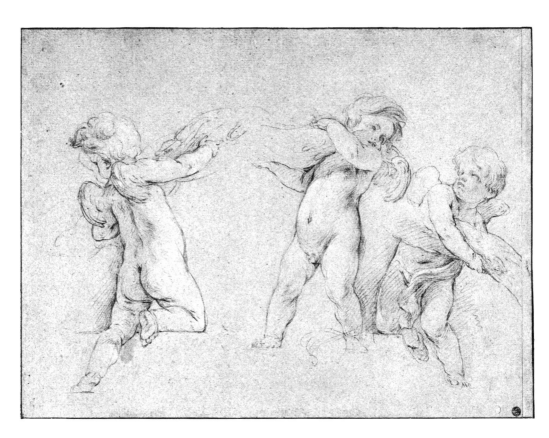

170. *Alexander Victorious over Porus*

Brush and brown wash, heightened with white, over black chalk, on blue paper. 31.2 x 43.9 cm. All four incurved corners of the sheet have been filled in. Lined.

Inscribed in pen and brown ink at lower margin of old mount (now detached), *François Le Moine / 1688–1737 / Alexandre et Darius*.

PROVENANCE: [Feist]; purchased in New York in 1962.

BIBLIOGRAPHY: *Annual Report*, 1962–1963, p. 63, as Alexander and Darius; *London, Royal Academy*, 1968, p. 94, no. 427, fig. 103, as Alexander and Darius; Gillies and Ives, 1972, no. 32; Rosenberg, 1972, p. 176, under no. 79, as Alexander and Darius; *L'art européen à la cour d'Espagne au XVIIIᵉ siècle*, exhibition catalogue, Bordeaux, Paris, Madrid, 1979–1980, drawing not exhibited but mentioned p. 146 under no. 82; Bjurström, 1982, under no. 1057; Bordeaux, 1985, pp. 175–176, no. D.171, fig. 298.

Rogers Fund, 1962
62.238

Design for a painting commissioned from Lemoine in 1736 by the Italian architect Filippo Juvara for the decoration of the throne room of the country palace of Philip V, La Granja, at San Ildefonso near Segovia. It was to have been one of a series of eight paintings representing scenes from the life of Alexander the Great. Seven of the scenes were commissioned from outstanding Italian artists of the time—Solimena, Trevisani, Conca, Masucci, Pittoni, Creti, and Parodi. Lemoine was the only French artist called upon. The commission no doubt reflected the immediate renown of the ceiling painting in the salon d'Hercule at Versailles (see Nos. 168 and 169 above), which was unveiled the same year.

Juvara supplied all of the artists with very specific descriptions of the subjects to be depicted, as well as the dimensions of the horizontal paintings, all of which were to have incurved corners. Each scene was meant to illustrate some royal attribute, and Alexander's pardon of the

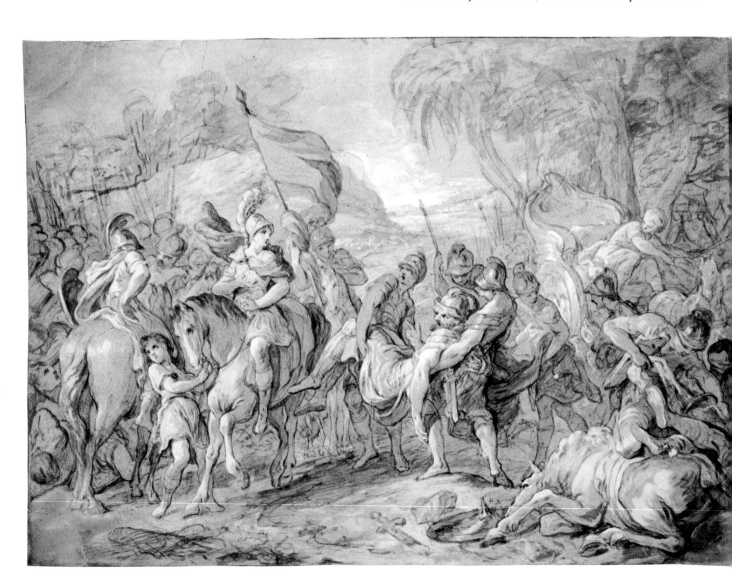

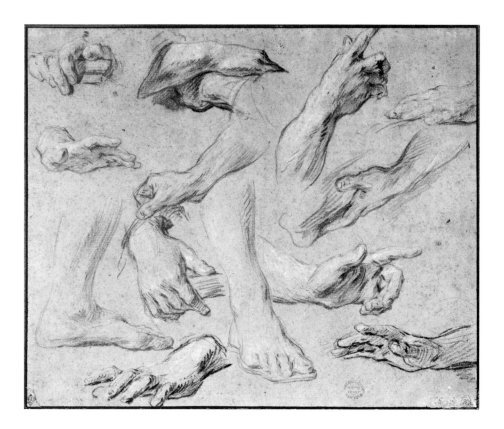

defeated Indian king Porus was intended to represent the virtue of Clemency.

Another design by Lemoine for the same composition, with notable variations, is in Stockholm (Bjurström, 1982, no. 1057, repr.; Bordeaux, 1985, p. 175, no. D.170, fig. 297). Lemoine sent two alternative designs to Spain for approval, one of which was accepted. Unfortunately, it is impossible to say whether the New York and Stockholm drawings were those sent to Spain, or which of them comes closest to the approved composition. After Lemoine took his own life on June 4, 1737, the canvas was found in his studio in an unfinished, monochrome state, "seulement dessinée sur la toile" (Bottineau, 1960, pp. 516, 549–550). The unfinished painting is now lost.

The commission then passed to Carle Vanloo, recommended by the Spanish ambassador to France as the best history painter available. Vanloo's definitive version was shown in the Paris Salon of 1739 and sent to Spain in 1741 (Sahut, 1977, p. 48, no. 63, repr.).

171. *Studies of Hands and Feet*

Red and black chalk, heightened with white, on beige paper. Framing lines in pen and brown ink. 19.6 x 24.5 cm. Lower right corner abraded; tear at lower left corner. Lined.

Inscribed in pen and black ink at lower margin of old mount, WATTEAU.

PROVENANCE: E. Desperet (Lugt 721); Desperet sale, Paris, June 7–10, 12–13, 1865, part of no. 442, "François Le Moine. Études de mains et de pieds . . . à la sanguine et à la pierre noire"; purchased in London in 1906.

BIBLIOGRAPHY: *Metropolitan Museum of Art Bulletin*, December 1906, p. 162, as Watteau; Rosenberg, 1972, p. 176, under no. 79; Bordeaux, 1985, pp. 82, 188, no. X.54, fig. 354, the attribution to Lemoine rejected.

Rogers Fund, 1906
06.1042.11

The drawing figured in the 1865 Desperet sale under the correct name, Lemoine; the attribution to Watteau must have been made at a later date. In any case, the drawing was acquired for the Museum by Roger Fry as the work of Watteau.

Without knowing of Desperet's attribution, in 1972 Pierre Rosenberg suggested that on stylistic grounds these studies appear to be the work of Lemoine. He proposed a possible connection with the artist's now lost *Blinding of Elymas*, the *May* of 1719, for Saint-Germain-des-Prés, Paris.

Jean-Luc Bordeaux does not accept the attribution of this drawing to Lemoine.

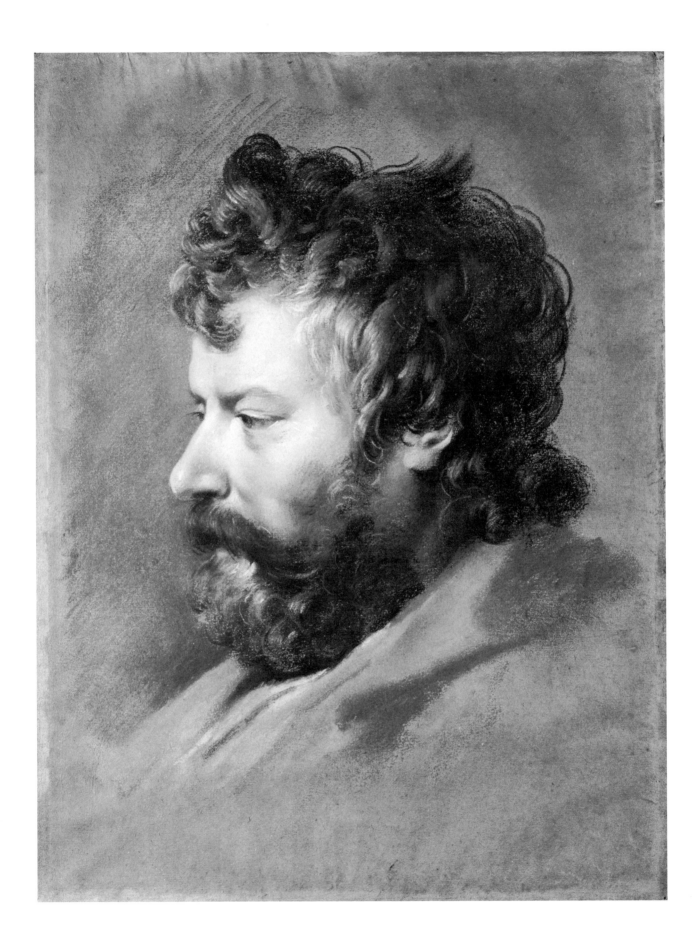

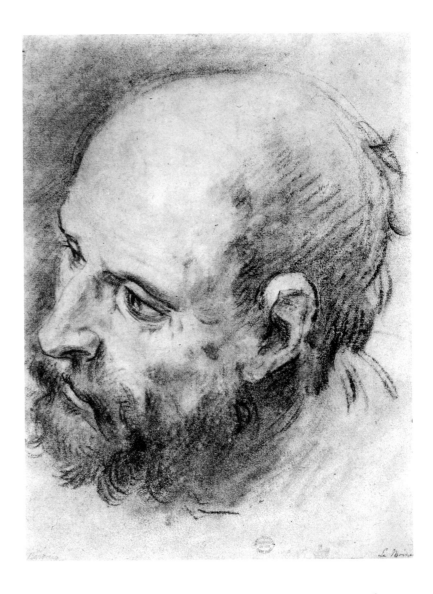

FRANÇOIS LEMOINE

172. *Head of a Bearded Man in Profile to Left*

Pastel on brown paper. 43.0 x 32.5 cm.

PROVENANCE: Pierre-Jean Mariette ?; Mariette sale, Paris, 1775–
1776, possibly part of no. 1292, "Une Tête d'homme à barbe, faite au
pastel, et savamment touchée"; [Baderou]; purchased in Paris in
1967.

BIBLIOGRAPHY: *Annual Report*, 1967–1968, p. 87; Gillies and Ives,
1972, no. 31; Rosenberg, 1972, p. 176, under no. 79; Rosenberg and
Bergot, 1981, pp. 54–55, under no. 68; Bordeaux, 1985, p. 145, no.
D.19, fig. 146.

Rogers Fund, 1967
67.163

173. *Head of a Bearded Man Looking Left*

Black chalk, stumped, red chalk, pink pastel, on beige paper. 30.1 x
22.7 cm.

Inscribed in pen and brown ink at lower right, *Le Moine*; faint modern
inscription in pencil at lower left, *Baroccio*.

PROVENANCE: Purchased in London in 1909.

BIBLIOGRAPHY: Bordeaux, 1985, p. 142, no. D.2, fig. 127.

Rogers Fund, 1910
10.45.16

The inscription, *Le Moine*, appears to be in the same hand
as that on the beautiful pastel study for the head of Hebe
for the salon d'Hercule, a drawing from the Lempereur
collection now in the British Museum (1850-3-9-1; repr.
Bacou, 1971, pl. IX).

ANICET-CHARLES-GABRIEL LEMONNIER

Rouen 1743 – Paris 1824

174. *Prelate in Mitre and Cope with Arms Upraised*

Red chalk. 51.6 x 41.2 cm. Horizontal creases at center.

Inscribed in black chalk at lower left, *par Lemonnier · de Rouen*; faint red crayon inscription at lower right, *Edme Bouchardon*.

PROVENANCE: Franklin M. Biebel; Susan Biebel.

BIBLIOGRAPHY: *Annual Report*, 1974–1975, p. 50.

Gift of Susan Biebel, in memory of Franklin M. Biebel, 1975
1975.161

NICOLAS-BERNARD LÉPICIÉ

Paris 1735 – Paris 1784

175. *Seated Male Nude Facing Right*

Charcoal, stumped, black chalk, heightened with white, on gray-green paper. Framing lines in pen and brown ink. 50.7 x 34.0 cm. Lined.

Signed in pen and brown ink at lower left, *Lépicié*.

PROVENANCE: François Renaud (Lugt Supp. 1042); Iolo Williams (according to vendor); [Colnaghi]; purchased in London in 1961.

BIBLIOGRAPHY: *Annual Report*, 1961–1962, p. 67.

Rogers Fund, 1961
61.130.19

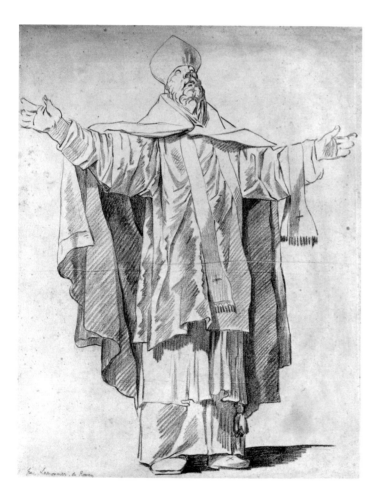

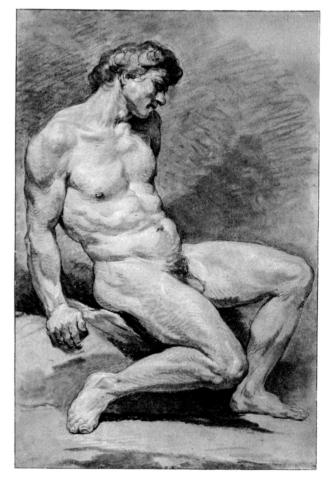

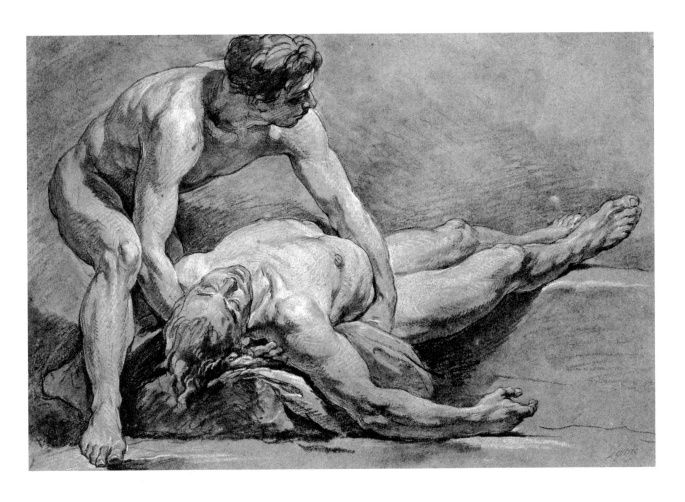

176. *Two Nude Male Figures*

Charcoal, stumped, black chalk, heightened with white, on gray-green paper. Traces of framing lines in pen and brown ink. 33.6 x 50.8 cm. Lined.

Signed in pen and brown ink at lower right, *Lépicié*.

PROVENANCE: [Galerie de Bayser]; purchased in Paris in 1981.

BIBLIOGRAPHY: *Exposition de dessins et sculptures de maîtres anciens, 1980. Galerie de Bayser,* Paris, 1980, no. 29, repr.; *Annual Report,* 1980–1981, p. 27.

Harry G. Sperling Fund, 1981
1981.15.4

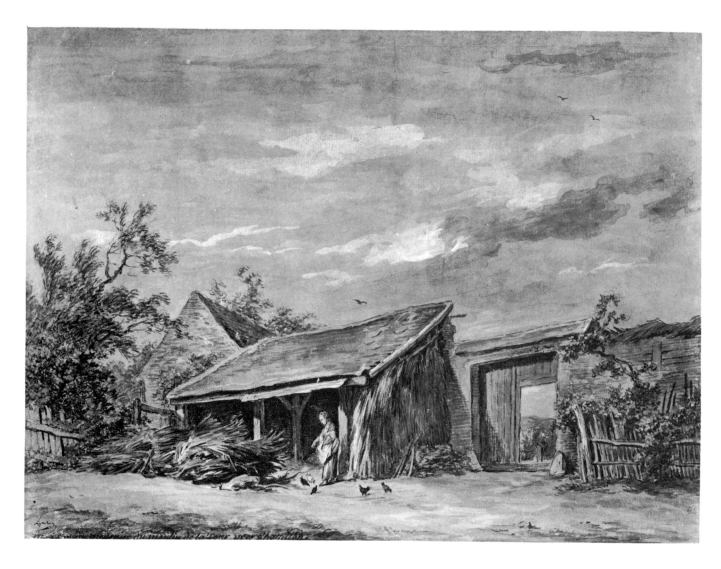

NICOLAS-BERNARD LÉPICIÉ

177. *Farmyard*

Brush and brown wash, watercolor and gouache, over black chalk, on
gray-brown-washed paper. 23.8 x 33.0 cm. Lined.

Abbreviated signature in pen and brown ink at lower left, *Lpc.*; in-
scribed in pen and brown ink at lower left margin, *Maison du meusnier
du moulin de la Tour pres Chattillon.*

PROVENANCE: Lagrenée (according to vendor); sale, Paris, Nouveau
Drouot, salle 5, March 1–2, 1983, no. 126, purchased by the Metro-
politan Museum.

BIBLIOGRAPHY: *Annual Report*, 1983–1984, p. 23.

Purchase, Mrs. Carl L. Selden Gift, in memory of Carl L. Selden, 1983
1983.234

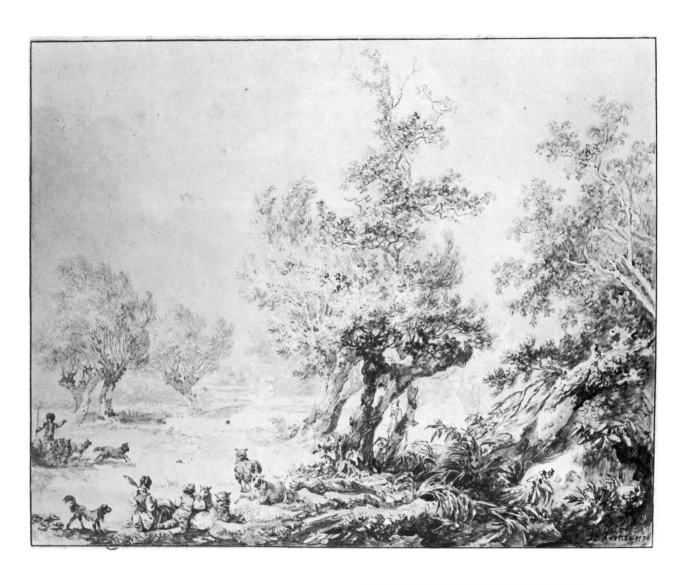

JEAN-BAPTISTE LEPRINCE

Metz 1734 – Saint-Denis-du-Port 1781

178. *Shepherd with His Flock in a Clearing*

Brush and brown wash, over black chalk. Framing lines in pen and brown ink. 27.0 x 34.7 cm. Scattered brown stains.

Signed and dated in pen and brown ink at lower right, *Le Prince 1776*.

PROVENANCE: [Cailleux]; purchased in Paris in 1961.

BIBLIOGRAPHY: *Annual Report*, 1961–1962, p. 67.

Rogers Fund, 1961
61.164

LOUIS-NICOLAS DE LESPINASSE,
le chevalier de Lespinasse

Pouilly-sur-Loire 1734 – Paris 1808

179. *The Château de Versailles Seen from the Gardens*

Pen and black ink, watercolor, heightened with white, over traces of graphite. 20.8 x 34.4 cm. Lined.

Monogram in pen and brown ink at lower left, *D.L.*

PROVENANCE: Jacques Doucet; Doucet sale, Paris, Hôtel Drouot, May 16–17, 1906, no. 35, repr.; Susan Dwight Bliss.

BIBLIOGRAPHY: Paris, 1900, p. 31, part of no. 183bis (with eight other topographic views by Lespinasse lent by Jacques Doucet); *Annual Report*, 1966–1967, p. 59.

Bequest of Susan Dwight Bliss, 1966
67.55.20

Tuby's lead group, *Apollo in His Chariot*, is seen from behind in the foreground. To the right is Jules Hardouin-Mansart's marble Colonnade, while one of the two domed pavilions of the bosquet des Dômes appears on the left. That these architectural features of the garden can be seen so clearly indicates that Lespinasse's view must have been drawn not long after the replanting of the gardens at Versailles had begun in the winters of 1774–1775 and 1775–1776. The new trees and shrubs had not yet attained their full height, which would have concealed these pavilions in a general view of the garden (Verlet, 1961, pp. 634–635).

Another aid to dating this drawing is the fact that the three gilded lead baldachins of the bosquet des Bains d'Apollon are visible just above the domed pavilion at left. These baldachins were demolished in the course of Hubert Robert's radical renovation of this bosquet undertaken in 1777 and finished in 1781 (Verlet, 1961, pp. 205, 635–636).

The drawing was engraved by François-Denis Née as an illustration for the *Voyage pittoresque de la France* (1784–1792). The plate is the first in a series devoted to the Île de France and is entitled, I^{re} VUE DU CHATEAU DE VERSAILLES DU COTÉ DES JARDINS, *prise de l'espace entre le Canal et le Bassin d'Apollon.*

See No. 180 below.

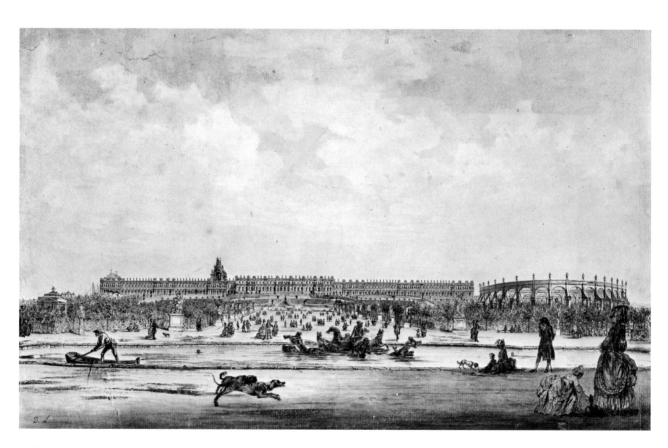

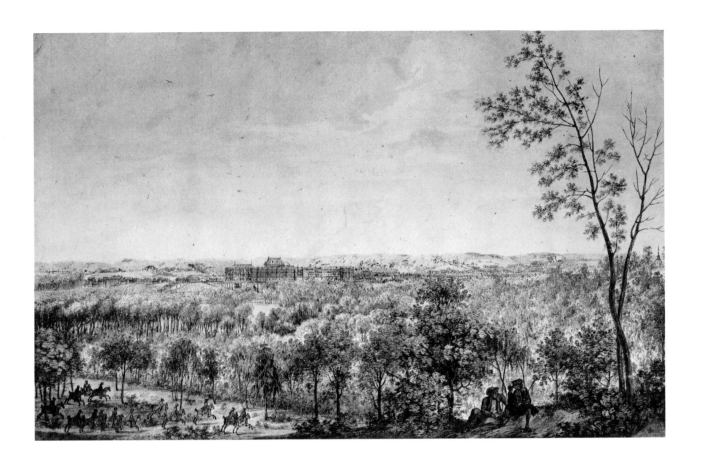

180. *Versailles Seen from the Southwest*

Pen and black ink, watercolor and gouache, heightened with white, over traces of graphite. 21.0 x 34.3 cm. Lined.

PROVENANCE: Jacques Doucet; Doucet sale, Paris, Hôtel Drouot, May 16–17, 1906, no. 34; Susan Dwight Bliss.

BIBLIOGRAPHY: See No. 179 above.

Bequest of Susan Dwight Bliss, 1966
67.55.21

Engraved by Mlle Denis for the *Voyage pittoresque de la France* with the title Vᵉ VUE DE LA VILLE ET DU CHA-TEAU DE VERSAILLES, *prise de la hauteur du Bois de Satory.*

See No. 179 above.

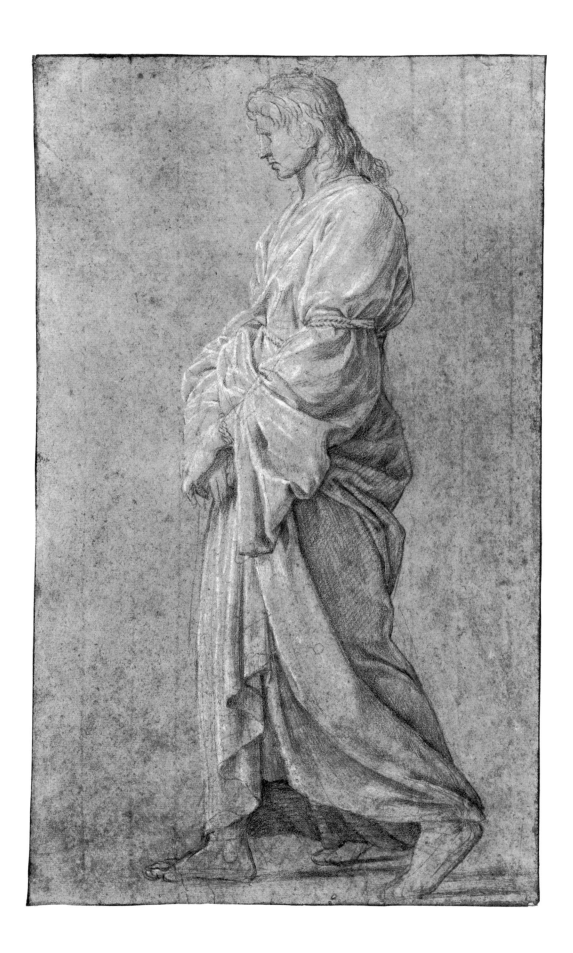

EUSTACHE LE SUEUR

Paris 1616 – Paris 1655

181. *Standing Male Figure with Arms and Hands Bound*

Black chalk, heightened with white, on brown paper. Framing lines in pen and brown ink. 42.8 x 26.0 cm. Minor losses at upper and lower margins. Lined.

Inscribed in pencil on reverse of old mount, *Le Sueur 30c Collect D. Girardon. j. L. p. | 12#*.

PROVENANCE: François Girardon ?; Jean de Julienne; Julienne sale, Paris, March 30–May 22, 1767, part of no. 748; Jacques Petit-Horry (his mark, JPH in a triangle, not in Lugt); purchased in Paris in 1972.

BIBLIOGRAPHY: *Dessins du XVIe et du XVIIe siècle dans les collections privées françaises*, exhibition catalogue, Galerie Claude Aubry, Paris, 1971, no. 65, repr.; *Annual Report*, 1972–1973, p. 34; Bean, 1975, no. 51, repr.; *Notable Acquisitions*, 1965–1975, p. 63, repr.; Brugerolles, 1981, p. 278, repr.

Rogers Fund, 1972
1972.224.5

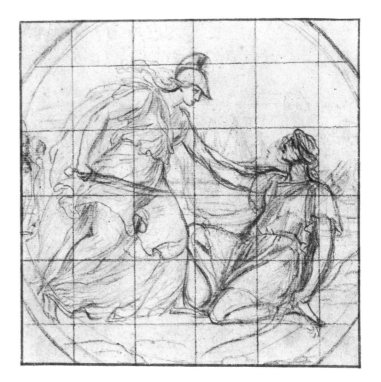

A study for the bound figure of St. Gervase used by Le Sueur in a vast tapestry cartoon, now in the Musée du Louvre, representing the Lombard martyrs St. Gervase and St. Protase refusing to sacrifice to Jupiter; this was the first of a series of cartoons representing the story of Gervase and Protase commissioned in 1651 for the church of Saint-Gervais in Paris (Rosenberg, Reynaud, Compin, 1974, I, no. 538, repr.).

A study for the figure of St. Protase in this composition is in a private collection in Paris, and a nude study for one of the soldiers is in the École des Beaux-Arts, Paris (Brugerolles, 1981, pp. 278–279, both drawings repr.).

182. *Design for a Medallion: Huntress Kneeling before an Armed Goddess*

Black chalk. Squared in black chalk. Framing lines in pen and brown ink. 15.4 x 15.9 cm. Lined.

Inscribed in pen and brown ink on reverse of old mount, *N⁰ 14. E. lesueur*.

PROVENANCE: [Galerie de Bayser]; purchased in Paris in 1979.

BIBLIOGRAPHY: *Exposition de dessins de maîtres anciens et modernes, 1978. Galerie de Bayser*, Paris, 1978, no. 22, repr.; *Annual Report*, 1978–1979, p. 25.

Harry G. Sperling Fund, 1979
1979.10.4

EUSTACHE LE SUEUR

183. *God the Father*

Black chalk, heightened with white, on brown paper. Framing lines in pen and brown ink. 25.6 x 38.5 cm. Lined.

Inscribed in pen and brown ink at lower left, *Le Sueur*.

PROVENANCE: A. Bourduge (Lugt 70); [Doll and Richards]; purchased in New York in 1947.

BIBLIOGRAPHY: *Annual Report*, 1947, p. 21; Rosenberg, 1972, p. 179, under no. 84.

Rogers Fund, 1947
47.43.2

The figure derives from Michelangelo's God the Father in the *Creation of Adam* in the Sistine ceiling, which Le Sueur would have known through engravings.

Another study by Le Sueur for the same figure on a somewhat larger sheet, which includes the feet at lower right, is in the École des Beaux-Arts, Paris (Inv. 1195).

184. *Minerva Presenting Two Portraits to Apollo*

Black chalk. Squared in red chalk. Contours incised for transfer. Framing lines in pen and brown ink. 14.1 x 20.4 cm. Verso blackened for transfer.

Illegible list of names in pen and brown ink on verso covered by blacking for transfer; inscribed in pen and brown ink on reverse of old mount, *N⁰ 16 E. lesueur.*

PROVENANCE: Private collection, Paris; purchased in New York in 1982.

BIBLIOGRAPHY: *Annual Report*, 1981–1982, p. 23.

Harry G. Sperling Fund, 1982
1982.93.4

In a letter to a previous owner of this drawing, Alain Mérot pointed out that it is a study for an illustration in a manuscript volume of lute music by Denis Gaultier, *La rhétorique des dieux*, now preserved in the Print Room at Berlin-Dahlem. Le Sueur's drawing was copied in the manuscript in brush and wash by Robert Nanteuil, who, in the medallions, added portraits of the lutenist Denis Gaultier and of the daughter of Anne de Chambré, the gentleman *amateur* who commissioned the manuscript (J. Cordey, *Gazette des Beaux-Arts*, I, 1929, repr. p. 39).

In the Cabinet des Dessins, Musée du Louvre, there is a drawing by Le Sueur for the title page of the volume executed by Abraham Bosse (Inv. RF 30664, Guiffrey and Marcel, IX, 1921, no. 9159, repr.; the illustration by Bosse repr. J. Cordey, *Gazette des Beaux-Arts*, I, 1929, p. 39).

LOUIS LICHERIE

Houdan 1629 – Paris 1687

185. *A Concert*

Black chalk, heightened with white, on brown paper. Contours incised for transfer. 43.9 x 53.7 cm. Vertical crease at center; upper and lower left corners made up, surface abraded. Lined.

Inscribed in pen and brown ink at lower margin left of center, *L. Lichery desiné*; in pen and purple ink on reverse of mount, *D'après une communication obligeante de M. Aug. Raffet, du Cabinet des estampes | à la Bibliothèque N^e, cette composition de Licherie a bien été faite pour un | Almanach, celui de l'année 1679; elle est intitulée "l'Accord des Nations par le moyen de la paix." On trouve cette estampe dans la collection Hennin, | tom. 56 fol. 39. | 19 janvier 1894.*

PROVENANCE: [Prouté]; [Hirsch]; purchased in New York in 1962; transferred from the Department of Prints and Photographs in 1984.

BIBLIOGRAPHY: *Catalogue "Cochin" 1962. Paul Prouté et ses fils*, Paris, 1962, no. 7, repr.; *Metropolitan Museum of Art Bulletin*, October-November 1971, p. 93, repr.; A. H. Mayor, *Prints and People*, New York, 1971, no. 85, repr.

Purchase, Anne and Carl Stern Gift, 1962
62.272

Design for the lower part of a calendar for the year 1679 entitled *L'acord des nations par le moïen de la paix* (*Collection Hennin*, II, 1, 1878, p. 159, no. 4993). In the print the image is reversed, and the left-handed musicians of the drawing are right-handed.

DANIEL MAROT, l'aîné

Paris ca. 1663 – The Hague 1752

186. Ceiling Design with an Allegory of Victory

Pen and brown ink, brown wash, over traces of graphite. Verso: slight graphite sketch of a seated, bearded man with upraised right arm. 18.2 x 18.7 cm. Two *pentimenti* each measuring ca. 2.7 x 6.2 cm. have been affixed to the drawing at center of upper and right margins. Scattered creases, stains, and losses.

PROVENANCE: Marquis de Biron; purchased in Geneva in 1937.

BIBLIOGRAPHY: Allen, 1938, p. 78; Williams, 1939, pp. 48, 51, fig. 1.

Rogers Fund, 1937
37.165.103

H. W. Williams, Jr., pointed out the similarity of this project to a ceiling design by Daniel Marot that appears in *Nouveaux livre de placfond inventée et gravés par D. Marot Architecte du feu Guilliaume III Roy de la Grande Bertagne fait à La Haye . . .* (repr. *L'oeuvre de Daniel Marot*, Paris, n.d., I, pl. 77).

CHARLES MELLIN

Nancy ca. 1597 – Rome 1649

187. The Presentation of the Infant Jesus in the Temple

Pen and brown ink, brown wash, over traces of graphite. 21.8 x 15.1 cm. Lined.

Inscribed in pen and brown ink at lower left, *Poussin*.

PROVENANCE: Hubert Marignane (Lugt Supp. 1343a on verso, and mark on recto, H within an M, not in Lugt); sale, Geneva, Nicolas Rauch, June 11–15, 1960, no. 309, repr., as Nicolas Poussin; [Galerie de Bayser]; purchased in Paris in 1981.

BIBLIOGRAPHY: *Exposition de dessins et sculptures de maîtres anciens, 1980. Galerie de Bayser*, no. 30, repr.; *Annual Report*, 1980–1981, p. 27; P. Rosenberg, *Burlington Magazine*, CXXIV, 1982, p. 698, note 21.

Harry G. Sperling Fund, 1981
1981.15.5

This drawing may be added to the group of four preparatory studies, already published by Jacques Thuillier, for Mellin's lost painting, *The Presentation of the Infant Jesus in the Temple* (Thuillier, 1981, pp. 617–618, 665–667, figs. 52–54). The picture was commissioned from Mellin in 1643 for the church of SS. Annunziata, Naples, where it was destroyed by fire in 1757; the composition is known through an anonymous reproductive etching (see Thuillier, 1982, pp. 266–269).

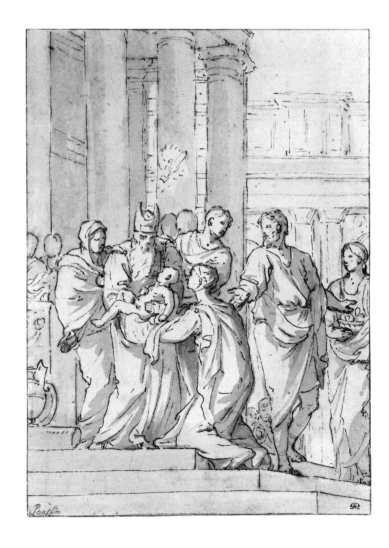

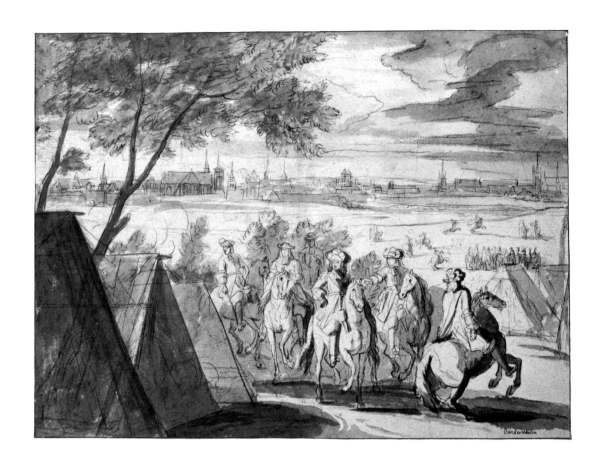

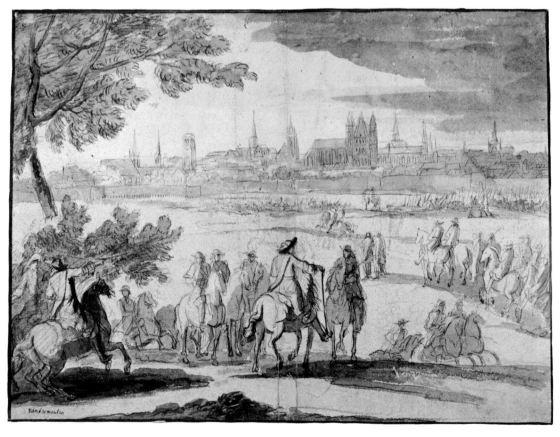

ADAM FRANS VAN DER MEULEN

Brussels 1632 – Paris 1690

188. *Louis XIV before Douai*

Gray and gray-brown wash, over black chalk. Framing lines in pen and black ink. 29.5 x 40.9 cm.

Inscribed in pen and brown ink at lower right, *vandermeulen*; on verso, *Doway / by / Fra. Vandermeulen / dec. 1690 aet. 56 / p. 65*.

PROVENANCE: Purchased in London in 1908.

BIBLIOGRAPHY: R. Fry, *Metropolitan Museum of Art Bulletin*, January 1909, p. 9; G. S. Hellman, *Print-Collector's Quarterly*, December 1915, repr. pp. 395, 396; d'Hulst, 1961, pp. 114–122, fig. 4; *Flemish Drawings and Prints*, 1970, no. 17.

Rogers Fund, 1908
08.227.8

189. *Louis XIV before Tournai*

Gray and gray-brown wash, over black chalk. Framing lines in pen and brown ink. 30.3 x 41.9 cm. Vertical creases at center.

Inscribed in pen and brown ink at lower left, *vandermeulen*; on verso, *p. 56 / Tournay / by / Fra. Vandermeulen dec. 1690 aet. 56*.

PROVENANCE: Purchased in London in 1908.

BIBLIOGRAPHY: R. Fry, *Metropolitan Museum of Art Bulletin*, January 1909, p. 9; d'Hulst, 1961, pp. 114–122, fig. 1; *Flemish Drawings and Prints*, 1970, no. 18.

Rogers Fund, 1908
08.227.9

190. *Fallen Soldier, a Cavalier, and Study of a Hand*

Black chalk, heightened with white, on blue paper. 13.5 x 24.6 cm. Lined.

Inscribed in pen and brown ink at lower margin of old mount, *Vander Mulln*; numbered in pen and brown ink on reverse of old mount, *E / n.° 52*.

PROVENANCE: Earl Spencer (Lugt 1530); Spencer sale, London, T. Philipe, June 10–17, 1811, no. 483, with Nos. 191 and 192 below, "Three—two thrown, one dead; the third a foot soldier, presenting—all in the same manner; black chalk on blue paper, heightened"; [Bier]; purchased in London in 1964.

BIBLIOGRAPHY: *Annual Report*, 1964–1965, p. 51; *Flemish Drawings and Prints*, 1970, no. 22.

Rogers Fund, 1964
64.182.3

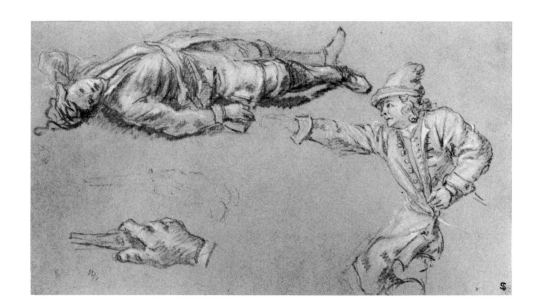

191. *Fallen Soldier Looking Upward*

Black chalk, heightened with white, on blue paper. 9.1 x 14.7 cm. Slight losses at lower left corner. Lined.

Inscribed in pen and brown ink at lower margin of old mount, *Vander Meulen*; numbered in pen and brown ink on reverse of old mount, *A. / n.⁰ 59.*

191

PROVENANCE: See No. 190 above.

BIBLIOGRAPHY: *Annual Report*, 1964–1965, p. 51; *Flemish Drawings and Prints*, 1970, no. 21; *du*, 8, 1982, p. 90, repr. upside down.

Rogers Fund, 1964
64.182.2

192. *Two Soldiers Moving to the Right*

Black chalk, heightened with white, on blue paper. 16.8 x 23.9 cm. Lined.

Inscribed in pen and brown ink at lower margin of old mount, *Vander Mullen*; numbered in pen and brown ink on reverse of old mount, *E / n.⁰ 53.*

PROVENANCE: See No. 190 above.

BIBLIOGRAPHY: *Annual Report*, 1964–1965, p. 51; *Flemish Drawings and Prints*, 1970, no. 20.

Rogers Fund, 1964
64.182.1

192

PIERRE MIGNARD

Troyes 1612 – Paris 1695

193. *Allegorical Figures for a Ceiling Decoration*

Black chalk, heightened with white, on beige paper. 29.1 x 40.0 cm.
Repaired loss at lower left; water stain at left margin. Lined.

Inscribed in pen and brown ink on reverse of old mount, *Charle Le Brun*.

PROVENANCE: Jacques Petit-Horry (his mark, JPH in a triangle, not in Lugt); purchased in Paris in 1972.

BIBLIOGRAPHY: *Annual Report*, 1972–1973, p. 34.

Fletcher Fund, 1972
1972.224.6

A woman crowned with foliage holds up a naked babe; she is seated on the prow of a ship, ornamented with a figure of Atlas. The female figure at left grasps what appears to be a torch.

JEAN-GUILLAUME MOITTE
Paris 1746 – Paris 1810

194. *Kneeling Draped Male Figure*

Red chalk. Framing lines in pen and brown ink. 25.6 x 33.0 cm. Loss at center of upper margin made up, and the top of the figure's head continued in another hand. Lined.

Signed and dated in pen and brown ink at lower right, *Moitte Sculpteur 1776*. A double page from a French account book with numerous entries in pen and brown ink has been used to back the old mount; these accounts date from May 1764.

PROVENANCE: [Galerie de Bayser]; purchased in Paris in 1982.

BIBLIOGRAPHY: *Annual Report*, 1981–1982, p. 23.

Purchase, Mrs. Carl L. Selden Gift, in memory of Carl L. Selden, 1982
1982.62

195. *Design for a Frieze with Two Women Standing by an Urn*

Pen and brown ink, brown wash, heightened with white, over traces of black chalk. 33.6 x 49.0 cm. Vertical crease at center; surface somewhat abraded, especially at lower center. Lined.

PROVENANCE: [Schatzki]; purchased in New York in 1962.

BIBLIOGRAPHY: *Annual Report*, 1962–1963, p. 64, as Cades; J. Vilain, *Revue du Louvre et des Musées de France*, XXVI, 2, 1976, p. 76, fig. 12.

Rogers Fund, 1962
62.242

This design had been tentatively attributed to Giuseppe Cades until its close stylistic connection with a drawing of three caryatids by Moitte in the Musée Vivenet, Compiègne, was noted (for the Compiègne drawing see J. Vilain in *Néo-Classicisme français*, 1974, no. 102, repr.). Since then a comparable drawing of two caryatids has appeared (sale, Monte Carlo, Sotheby Parke Bernet Monaco, March 5, 1984, no. 928, repr.).

The massive female figures in all of these drawings are close to the caryatids that flank the central medallion in Moitte's elaborate wash drawing of the *Judgment of Paris* that was shown in the Salon of 1789 and is now in Leningrad (*Projets et dessins d'architectes et ornemanistes français. XVIIIᵉ—début XIXᵉ siècle*, exhibition catalogue in Russian, State Hermitage Museum, Leningrad, 1971, no. 62, repr.).

JEAN-MICHEL MOREAU,
called Moreau le jeune
Paris 1741 – Paris 1814

196. *Perfect Harmony*

Pen and brown ink, brown wash, over traces of graphite. 21.6 x 26.7 cm. Light brown stains at left center and lower left.

Signed and dated in pen and brown ink at lower left, *J. M. Moreau Lejeune 1776*.

PROVENANCE: King Ludwig II of Bavaria ?; sale, Berlin, Lepke, May 1891 (according to Clayton); Baroness Willie de Rothschild (according to Clayton); Baroness Mathilde von Rothschild; Erich von Goldschmidt-Rothschild; Goldschmidt-Rothschild sale, Berlin, March 23–25, 1931, no. 39, repr.; Irwin Laughlin; Mrs. Hubert Chanler; sale, London, Sotheby's, June 10, 1959, no. 40, repr.; [Rosenberg and Stiebel]; Lesley and Emma Sheafer.

BIBLIOGRAPHY: Clayton, 1923, IV, p. 529; C. Dodgson, *Old Master Drawings*, II, 6, 1927, p. 24; London, Royal Academy, 1932, no. 847; London, Royal Academy, 1933, no. 714; Shoolman and Slatkin, 1950, p. 100, pl. 56; Rotterdam, Paris, New York, 1958–1959, no. 68, pl. 86; *Annual Report*, 1974–1975, p. 48; Bean, 1975, no. 53; Jean-Richard, 1985, pp. 67–68, under no. 76.

The Lesley and Emma Sheafer Collection,
Bequest of Emma A. Sheafer, 1973
1974.356.48

Engraved in the same direction by I.-S. Helman in 1777 and used as an illustration for the publication *Monument du costume physique et moral de la fin du dix-huitième siècle* (Bocher, 1882, no. 1355, *L'accord parfait*).

197. *The Wager Won*

Pen and brown ink, brown wash, over traces of graphite. 26.7 x 22.0 cm. Repaired tear at center of right margin; scattered light brown stains.

Signed and dated in pen and brown ink at lower left, *J. M. Moreau le j. / 1778*.

PROVENANCE: King Ludwig II of Bavaria ?; sale, Berlin, Lepke, May 1891 (according to Clayton); Baroness Willie de Rothschild (according to Clayton); Baroness Mathilde von Rothschild; Erich von Goldschmidt-Rothschild; Goldschmidt-Rothschild sale, Berlin, March 23–25, 1931, no. 40, repr.; Irwin Laughlin; Mrs. Hubert Chanler; sale, London, Sotheby's, June 10, 1959, no. 41, repr.; [Rosenberg and Stiebel]; Lesley and Emma Sheafer.

BIBLIOGRAPHY: Clayton, 1923, IV, p. 552; C. Dodgson, *Old Master Drawings*, II, 6, 1927, p. 24; London, Royal Academy, 1932, no. 853; London, Royal Academy, 1933, no. 715; *Annual Report*, 1974–1975, p. 50; Bean, 1975, no. 54; V. Carlson in Baltimore, Boston, Minneapolis, 1984, p. 247, note 5.

MOREAU LE JEUNE

197

MOREAU LE JEUNE (NO. 197)

The Lesley and Emma Sheafer Collection,
Bequest of Emma A. Sheafer, 1973
1974.356.49

Etched in reverse by Camligue and used as an illustration
for the publication *Monument du costume physique et moral de
la fin du dix-huitième siècle* (Bocher, 1882, no. 1364, *Le
pari gagné*).

198. *Assemblée des Notables, Versailles, 1787*

Pen and black ink, gray wash, over traces of graphite. 28.2 x 40.5 cm.
Lined.

Signed and dated in pen and black ink at lower right, *J. M. moreau le j^ne
1787*; inscribed in pen and brown ink at lower center, ASSEMBLÉE DES
NOTABLES M.DCC.LXXXVII.

PROVENANCE: [Cailleux]; purchased in Paris in 1984.

BIBLIOGRAPHY: *Annual Report*, 1984–1985, p. 26.

Van Day Truex Fund, 1984
1984.381

On December 29, 1786, at the urging of his minister
Calonne, Louis XVI announced the convocation of an
Assemblée des Notables to deal with the imminent bank-
ruptcy of the nation. The opening session was scheduled
for January 24 of the following year, and the administra-
tion of the Menus-Plaisirs constructed in great haste and
at great (and much criticized) expense a special hall for the
meetings of the assembly. The architect of the project was
Pierre-Adrien Pâris (see Gruber, 1972, pp. 141–143).

Moreau le jeune represents the assembly in session in
the sumptuously decorated temporary chamber, built
within the hôtel des Menus-Plaisirs at Versailles. The
king presides, enthroned on a dais with a great baldachin
above. The six tapestries hung on the long walls are the
Van der Meulen battle scenes from the Gobelins series
L'histoire du roi. Moreau made another version of this
drawing, almost twice the size and with many variations;
the large version, deposited at Versailles by the Cabinet
des Dessins of the Musée du Louvre, was probably in-
tended for a never executed engraving commemorating
the opening session of the Assemblée des Notables that in
fact took place on February 22, 1787 (Gruber, 1972, pp.
205–206, fig. 100).

ASSEMBLÉE DES NOTABLES M.DCC.LXXXVII.

199. *Outing in a Wood*

Pen and black ink, brown wash, over traces of black chalk. Horizontal ruled black chalk line 2.8 cm. from top margin; above this line the contours of the foliage have not been reinforced with ink. 31.3 x 48.8 cm. Repaired tear at lower left.

PROVENANCE: Lebeuf de Montgermont; Lebeuf de Montgermont sale, Paris, Galerie Georges Petit, June 16–19, 1919, no. 260, repr., "La promenade au bois"; Edgar Rahir (according to Sotheby's); Irwin Laughlin; Mrs. Hubert Chanler; sale, London, Sotheby's, June 10, 1959, no. 44, repr.; [Bernier]; purchased in Paris in 1964.

BIBLIOGRAPHY: *Annual Report*, 1964–1965, p. 52; Gillies and Ives, 1972, no. 34.

Rogers Fund, 1964
64.75

A fairly exact replica of this drawing, possibly an old copy, was sold in Monte Carlo at Sotheby Parke Bernet Monaco on November 26, 1979, no. 532, repr.

LOUIS-GABRIEL MOREAU,
called Moreau l'aîné

Paris 1739 – Paris 1805

200. *Windswept Landscape*

Watercolor and gouache, over traces of black and red chalk. 39.9 x 52.6 cm. Lined.

PROVENANCE: [Wildenstein]; Mrs. Corina Kavanagh, Buenos Aires (according to Sotheby's); sale, London, Sotheby's, March 11, 1964, no. 228, repr.; [Colnaghi]; Walter C. Baker.

BIBLIOGRAPHY: *Annual Report*, 1979–1980, p. 27.

Bequest of Walter C. Baker, 1971
1972.118.222

201. *View of a Park*

Watercolor and gouache, over traces of graphite, on blue paper. 32.3 x 48.1 cm.

Initialed in pen and brown ink at lower right, *L.M.*

PROVENANCE: Marius Paulme (Lugt 1910); Paulme sale, Paris, Galerie Georges Petit, May 13–15, 1929, no. 161, repr., as "Le Parc de Saint-Cloud"; George Blumenthal; Ann Payne Blumenthal.

BIBLIOGRAPHY: G. Wildenstein, *Un peintre de paysage au XVIIIᵉ siècle, Louis Moreau*, Paris, 1923, p. 65, no. 107, pl. 50 (with additional bibliography); *Blumenthal Collection Catalogue*, V, 1930, pl. XIX, as "Park of Saint-Cloud."

Gift of Ann Payne Blumenthal, 1943
43.163.21

The drawing has been described as a view of the park at Saint-Cloud, but Georges Wildenstein, in his monograph on Moreau l'aîné, more prudently entitled it *Vue d'un parc, à la fin du XVIIIᵉ siècle*.

202. *Shepherdess near a Waterfall*

Gouache, over traces of graphite, on vellum. 18.8 x 24.5 cm. Partially lined with paper.

PROVENANCE: Sale, London, Christie's, November 24, 1922, no. 29 with No. 203 below; Alexandrine Sinsheimer.

BIBLIOGRAPHY: *Annual Report*, 1958–1959, p. 56.

Bequest of Alexandrine Sinsheimer, 1958
59.23.62

203. *Figures on a Country Road*

Gouache, over traces of graphite, on vellum. 18.6 x 24.3 cm. Partially lined with paper.

PROVENANCE: Sale, London, Christie's, November 24, 1922, no. 29 with No. 202 above; Alexandrine Sinsheimer.

BIBLIOGRAPHY: *Annual Report*, 1958–1959, p. 56.

Bequest of Alexandrine Sinsheimer, 1958
59.23.63

202

203

185

CHARLES–JOSEPH NATOIRE

Nîmes 1700 – Castel Gandolfo 1777

204. *The Holy Family Appearing to St. Francis, St. Augustine, and St. Roch, after Giovanni Lanfranco*

Pen and brown ink, brown wash, heightened with white, over black chalk. 30.7 x 23.4 cm.

Inscribed in pen and dark brown ink at lower left, *Lanfranc*.

PROVENANCE: [Stein]; purchased in Paris in 1977.

BIBLIOGRAPHY: *Annual Report*, 1976–1977, p. 45.

Harry G. Sperling Fund, 1977
1977.130

The painting that Natoire copied is now lost, but it may well have been the "quadro della Madonna con alcuni Santi" that Bellori mentions as an early work in S. Agostino, Piacenza (G. P. Bellori, *Le vite de' pittori, scultori e architetti moderni* [1672], edited by E. Borea, Turin, 1976, p. 378). Natoire copied a number of paintings by Italian masters when he was in Emilia in 1728–1729 on his way back to Paris after his first stay in Rome.

205. *The Departure of Sancho Panza for the Island of Barataria*

Pen and brown ink, pale brown wash, over black chalk. 17.0 x 29.8 cm. Lined.

Inscribed in pen and brown ink at lower left, *C. natoire*.

PROVENANCE: E. Calando (Lugt 837); Calando sale, Paris, Hôtel Drouot, December 11-12, 1899, no. 153; Mathias Komor (Lugt Supp. 1882a); purchased in New York in 1961.

BIBLIOGRAPHY: *Annual Report*, 1960–1961, p. 64; Gillies and Ives, 1972, no. 36; Rosenberg, 1972, p. 186, under no. 96; Duclaux, 1975, p. 35; Compiègne and Aix-en-Provence, 1977, pp. 44–49, figs. 30–32 (the cartoon), fig. 36 (our drawing), fig. 42 (the tapestry).

Rogers Fund, 1961
61.2.6

Soon after his return from Rome in 1730, Natoire received from a rich *fermier général*, Pierre Grimod Dufort, a commission for a series of tapestry cartoons illustrating the then very popular adventures of Don Quixote. Between 1735 and 1744 ten scenes were woven at the Manufacture de Beauvais. Only one *tenture* was produced; nine of the tapestries are now in Aix-en-Provence, while most of the cartoons are preserved at Compiègne. Our drawing is a composition study for the eighth scene, *Départ de Sancho pour l'île de Barataria*.

See Nos. 206 and 207 below.

 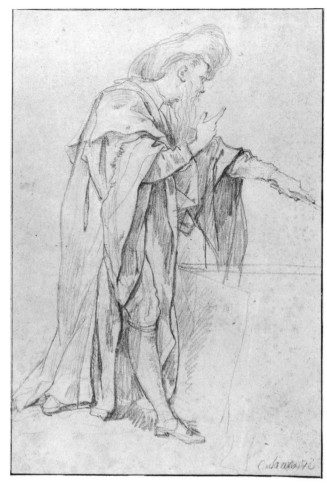

CHARLES-JOSEPH NATOIRE

206. *Standing Male Figure with Left Arm Extended*

Red chalk, heightened with white, on beige paper. 38.7 x 26.5 cm. Scattered stains. Lined.

Inscribed in black chalk at lower right, *C. natoire*; numbered in pen and brown ink at upper left, *18*.

PROVENANCE: [Powney]; purchased in London in 1965.

BIBLIOGRAPHY: *An Exhibition of Early Drawings and Watercolors Presented by Christopher Powney*, London, 1965, no. 15; *Annual Report*, 1965–1966, p. 75; Gillies and Ives, 1972, no. 37; Rosenberg, 1972, p. 186, under no. 96; Duclaux, 1975, p. 35; Compiègne and Aix-en-Provence, pp. 49–55, figs. 43 and 46 (the cartoon), fig. 45 (our drawing), fig. 53 (the tapestry).

Rogers Fund, 1965
65.132

Study for the figure of the physician Pedro Rezio, who extends his wand to prevent Sancho Panza from eating the

delicacies presented to him at a banquet on the island of Barataria. This banquet is the subject of the ninth scene in the Don Quixote tapestry series. The pose and left-handed gesture of the figure correspond quite closely to those of Pedro Rezio in the cartoon; in the tapestry the figure is reversed, and the physician extends the wand with his right hand.

See Nos. 205 and 207.

207. *Standing Male Figure with Left Arm Extended*

Red chalk, heightened with white, on beige paper; one stroke of black chalk at bottom of sleeve. Framing lines in pen and brown ink. 41.5 x 28.3 cm. Lined.

Inscribed in black chalk at lower right in the same hand as No. 206 above, *C. natoire*. This has been changed in black chalk by a later hand to, *Carlo Marati*.

188

PROVENANCE: Purchased in New York in 1983.

BIBLIOGRAPHY: *Annual Report*, 1983–1984, p. 24.

Purchase, Emma Swan Hall Gift, in memory of Nathalie Swan Rahv,
1983
1983.266

In 1969 Stanislawa Sawicka published a wash drawing by
Natoire in the Print Room of the University Library,
Warsaw, that is a composition study with a number of
important variations for the tapestry cartoon *Le repas de
Sancho dans l'île de Barataria (Miscellanea I.Q. van Regteren
Altena*, Amsterdam, 1969, pp. 190–194, fig. 1; Com-
piègne and Aix-en-Provence, p. 54, fig. 51). In the car-
toon and in No. 206 above, the physician Pedro Rezio
rests his right hand on his hip; while in the present
drawing and in the Warsaw composition study the physi-
cian raises his right hand in admonition.

208. *Gardens of the Villa d'Este at Tivoli*

Pen and brown ink, brown and gray wash, watercolor, heightened
with touches of white, over black and red chalk. 31.4 x 47.5 cm.

Signed and dated in pen and brown ink at lower right, *villa d'est en
Tyvoly / aprille 1760. / C. N.*

PROVENANCE: Sale, London, Sotheby's, March 25, 1965, no. 125,
repr., purchased by the Metropolitan Museum.

BIBLIOGRAPHY: *Annual Report*, 1965–1966, p. 75; Berckenhagen,
1970, p. 240, under no. 3007; Dayton, Ohio, 1971, no. 10, repr.;
Gillies and Ives, 1972, no. 35; Rosenberg, 1972, p. 187, under no.
99; Storrs, 1973, no. 63, fig. 18; *Notable Acquisitions*, 1965–1975, p.
54, repr.; A. Busiri Vici, *Antichità viva*, XV, 2, 1976, pp. 40–41, fig.
17; *Rome in the 18th Century*, 1978, n.pag. [14].

Rogers Fund, 1965
65.65

The view is across the gardens; at upper right can be seen
the pavilion housing the water organ, and even further to
the right the apse of the church of S. Pietro.

In the Kunstbibliothek, Berlin, there is an old copy on
tracing paper of our drawing (Berckenhagen, 1970, p.
240, no. 3007).

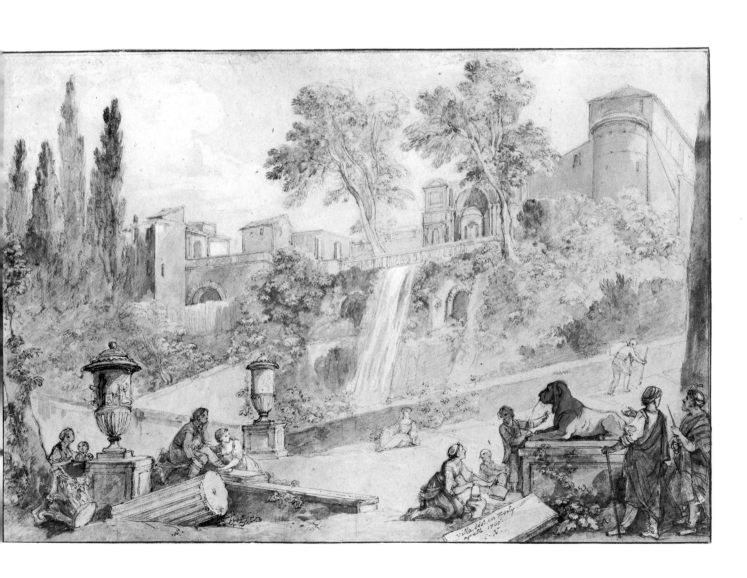

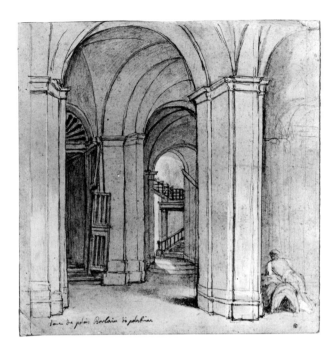

209. *Staircase in the Palazzo Barberini, Palestrina*

Pen and brown ink, brown wash, heightened with white, over black chalk. 23.0 x 22.7 cm. Upper right corner replaced; repaired tear at lower left corner. Lined.

Inscribed in pen and brown ink at lower left in the artist's hand, *veue du palais Barbarin di palestrine.*

PROVENANCE: Eugène Rodrigues (Lugt 897); H. M. Calmann.

BIBLIOGRAPHY: *Annual Report*, 1952, p. 18; *Rome in the 18th Century*, 1978, n.pag. [14].

Gift of H. M. Calmann, 1952
52.138

210. *Landscape with a Large Villa on a Hilltop*

Red chalk, pen and brown ink, red and gray wash, heightened with white; traces of black chalk underdrawing for figure and animals. 41.8 x 27.6 cm. (overall). The support consists of three sheets joined horizontally in the lower half of the composition. Lined.

Inscribed in pen and dark brown ink at lower left, *Adam* (Lugt 4) over a largely illegible inscription in pen and lighter brown ink that appears to end with the date, *1759.*

PROVENANCE: Lambert-Sigisbert Adam (Lugt 4); Harry G. Sperling.

BIBLIOGRAPHY: *Annual Report*, 1974–1975, p. 50.

Bequest of Harry G. Sperling, 1971
1975.131.120

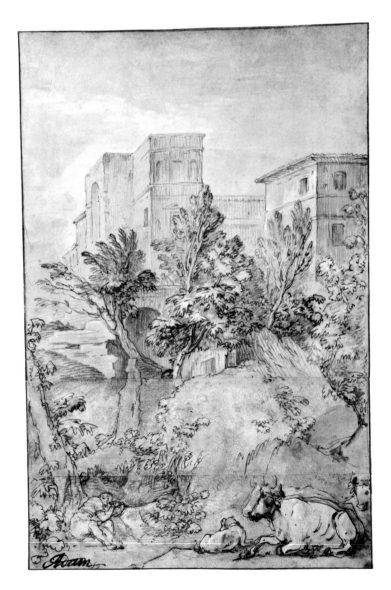

Originally the drawing measured 34.3 cm. in height, but the artist then cut the sheet horizontally somewhat below center and inserted a piece of paper 7.5 cm. high on which he continued the drawing in the same technique. This addition was presumably made to give a greater elevation to the landscape composition.

The "Adam" signature (Lugt 4) over the date 1759 is puzzling since Lambert-Sigisbert Adam died, and his posthumous sale occurred, in that very year.

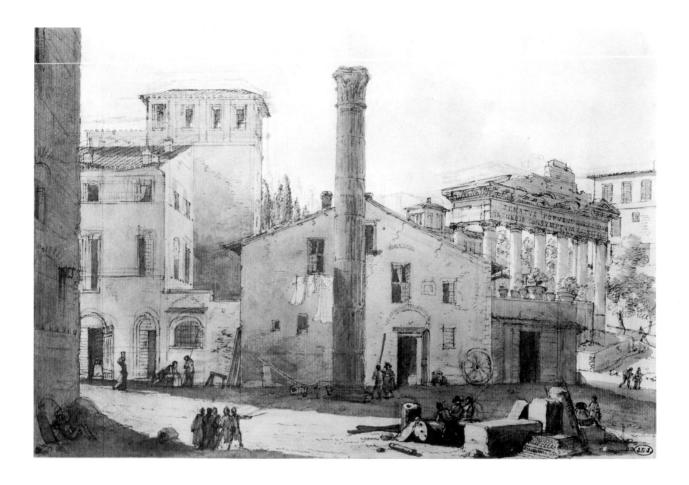

VICTOR-JEAN NICOLLE

Paris 1754 – Paris 1826

211. *View of the Roman Forum with the Column of Phocas and the Temple of Saturn*

Pen and brown ink, gray wash, over red chalk. 20.5 x 31.2 cm.

PROVENANCE: [Colnaghi]; Jean-Camille Jammes (Lugt Supp. 1430a); collection J.C.J. sale, Paris, Hôtel Drouot, salle 10, November 5, 1953, no. 95; [Galerie de Bayser et Strolin]; purchased in Paris in 1961.

BIBLIOGRAPHY: *Annual Report*, 1961–1962, p. 67; London, Royal Academy, 1968, p. 102, no. 499, fig. 207; Dayton, Ohio, 1971, p. 23, no. 39, repr.; *Rome in the 18th Century*, 1978, n. pag. [14].

Rogers Fund, 1961
61.124.1

A similar view, somewhat smaller and drawn from a slightly different angle, was on the market in New York in 1984 (*Old Master Drawings, Colnaghi*, exhibition catalogue, New York, no. 45, repr.).

A broader view of the site including the arch of Septimius Severus is in the École des Beaux-Arts, Paris (Brugerolles, 1981, no. 141, repr.).

See also No. 213 below.

212. *The Tiber at the Outskirts of Rome*

Pen and brown ink, gray wash, over red chalk and traces of graphite. 21.4 x 32.3 cm.

PROVENANCE: [Colnaghi]; Jean-Camille Jammes (Lugt Supp. 1430a); collection J.C.J. sale, Paris, Hôtel Drouot, salle 10, November 5, 1953, no. 92 or 93; [Galerie de Bayser et Strolin]; purchased in Paris in 1961.

BIBLIOGRAPHY: *Annual Report*, 1961–1962, p. 67; London, Royal Academy, 1968, p. 102, no. 500; Dayton, Ohio, 1971, no. 40, repr.; *Rome in the 18th Century*, 1978, n.pag. [15].

Rogers Fund, 1961
61.124.2

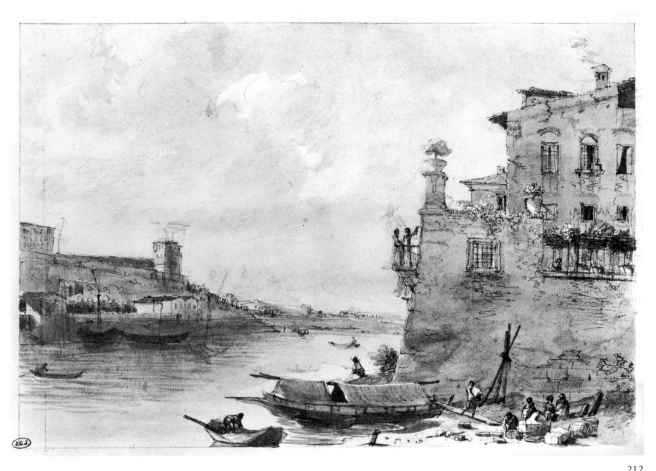

VICTOR-JEAN NICOLLE

213. *View of the Roman Forum with the Temple of Saturn in the Background*

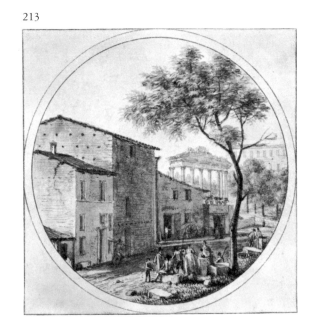

Pen and brown ink, watercolor. 7.4 x 7.4 cm. Lined.

Inscribed in pen and brown ink on old mount, *Vue des restes du Temple de la Concorde, situés sur le mont Capitolin, à Rome* (in the eighteenth century the Temple of Saturn was thought to be that of Concord).

PROVENANCE: Alexandrine Sinsheimer.

BIBLIOGRAPHY: *Annual Report*, 1958–1959, p. 56.

Bequest of Alexandrine Sinsheimer, 1958
59.23.40

The composition is based on the view recorded in No. 211 above. The Column of Phocas can just be detected to the left of center.

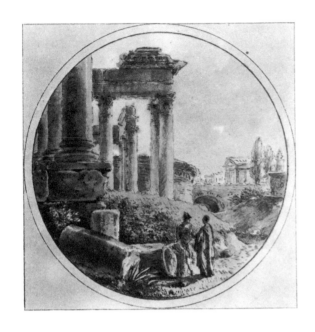

214. *Fantasy View of the Roman Forum*

Pen and brown ink, watercolor. 7.8 x 7.8 cm. Lined.

PROVENANCE: Alexandrine Sinsheimer.

BIBLIOGRAPHY: *Annual Report*, 1958–1959, p. 56.

Bequest of Alexandrine Sinsheimer, 1958
59.23.41

215. *Town in an Alpine Valley*

Pen and brown ink, brown and red-brown wash, pale blue gouache (the river), heightened with white, over graphite. 30.8 x 43.1 cm. Lined.

Inscribed in pen and black ink on wall at lower right, *Nicolle fect*.

PROVENANCE: [Colnaghi]; purchased in London in 1963.

BIBLIOGRAPHY: *Annual Report*, 1963–1964, p. 62.

Rogers Fund, 1963
63.76.5

194

216. *Village in an Alpine Valley*

Pen and brown ink, brown and red-brown wash, pale blue gouache (the river), heightened with white, over graphite. 30.4 x 43.0 cm. Lined.

Inscribed in pen and black ink at lower right, *Nicolle fecit.*

PROVENANCE: [Colnaghi]; purchased in London in 1963.

BIBLIOGRAPHY: *Annual Report*, 1963–1964, p. 62.

Rogers Fund, 1963
63.76.6

217. *Courtyard of the Château de Saint-Cloud*

Pen and brown ink, watercolor, over traces of graphite. 20.1 x 32.1 cm. Scattered stains.

Signed in pen and brown ink at lower left corner, *V. J. Nicolle.*

PROVENANCE: James Hazen Hyde; transferred from the Department of Prints and Photographs in 1985.

BIBLIOGRAPHY: *Annual Report*, 1959–1960, p. 62.

Gift of Estate of James Hazen Hyde, 1959
59.210

JEAN-BAPTISTE OUDRY
Paris 1686 – Beauvais 1755

218. *Angry Swan*

Black chalk, heightened with white, on blue-green paper. 24.7 x 38.0 cm. Lined.

Inscribed in pen and brown ink at lower right, *J. B. oudri.*

PROVENANCE: Georges Haumont; sale, Paris, Hôtel Drouot, salle 1, January 21, 1970, no. 9, repr.; [Agnew]; purchased in London in 1970.

BIBLIOGRAPHY: *L'art français au XVIII^e siècle*, exhibition catalogue, Charlottenborg Palace, Copenhagen, 1935, no. 469; *Annual Report*, 1969–1970, p. 72; *Gazette de l'Hôtel Drouot*, LXXX, 7, February 12, 1971, p. 8, repr., p. 9; Bean, 1972, no. 71; *Notable Acquisitions*, 1965–1975, p. 61, repr.; Opperman, 1977, II, p. 818, no. D930, p. 961.

The Mr. and Mrs. Henry Ittleson, Jr. Purchase Fund, 1970
1970.133

JEAN-BAPTISTE OUDRY

219. *The Dream of an Inhabitant of Mogul*
(La Fontaine, *Fables*, XI, 4)

Brush, black ink and gray wash, heightened with white, on blue paper. Framing lines in dark brown ink and blue wash. 31.2 x 25.7 cm. (overall). The drawing, excluding the border, measures 24.1 x 18.9 cm.

Signed and dated in pen and brown ink at lower right, *JB. oudry / 1732*; inscribed at upper margin of verso, *91. t. 2ᵉ*.

PROVENANCE: For the complex early provenance see Opperman, 1982, p. 157; Louis Olry-Roederer; [Rosenbach]; Raphael Esmerian; Esmerian sale, part III, Paris, Palais Galliera, June 6, 1973, part of no. 46; [Virch]; purchased in New York in 1976.

BIBLIOGRAPHY: Locquin, 1912, p. 170, no. 1163; *Annual Report*, 1975–1976, p. 36; Opperman, 1977, II, p. 706, no. D450, p. 953; Opperman, 1982, pp. 157–165, under nos. 76–85 (with complete bibliography).

Purchase, Emma Swan Hall Gift, 1976
1976.99

Like No. 220 below, this drawing is one of the 275 illustrations for La Fontaine's *Fables* drawn by Oudry between 1729 and 1734. It was not until 1751 that the publisher Montenault purchased the drawings with the intention of using them to illustrate an edition of the *Fables*, which appeared in four volumes from 1755 to

1760. Oudry's very painterly brush drawings were deemed unsuitable for direct translation to the engraved plate, and all the compositions were copied in pencil in a more linear style by Cochin le jeune.

Le songe d'un habitant du Mogol was engraved in reverse with the legend *J. B. Oudry inv.*, *L. B. Prevost sculp.*

220. *The Fox, the Flies, and the Hedgehog*
(La Fontaine, *Fables*, XII, 13)

Brush, black ink and gray wash, heightened with white, on blue paper. Framing lines in black ink and blue wash. 30.8 x 25.8 cm. (overall). The drawing, excluding the border, measures 24.1 x 18.8 cm.

Signed and dated in pen and black ink at lower left, *JB. oudry / 1733*; inscribed at upper margin of verso, *127. Tom. 2ᵉ.*

PROVENANCE: See No. 219 above.

BIBLIOGRAPHY: Locquin, 1912, p. 171, no. 1184; *Annual Report*, 1975–1976, p. 36; Opperman, 1977, II, p. 709, no. D486, p. 953; Opperman, 1982, pp. 157–165, under nos. 76–85 (with complete bibliography).

Harry G. Sperling Fund, 1976
1976.188

Le renard, les mouches, et le hérisson was engraved in reverse with the legend *J. B. Oudry inv.*, *Chedel sculp.*

See No. 219 above.

221. *Acheloüs Transformed into a Bull*

Black chalk, heightened with white, on blue-green paper. 27.3 x 29.0 cm. Lined.

Signed and dated in black chalk at lower left, *JB. Oudry / 1732.*

PROVENANCE: E. R. Lamponi-Leopardi (Lugt 1760); Lamponi sale, Florence, November 10–19, 1902, no. 966, pl. XIII; purchased in London in 1911.

BIBLIOGRAPHY: Benisovich, 1943, p. 73, p. 75, fig. A; H. N. Opperman, *Allen Memorial Art Museum Bulletin*, XXVI, 2, 1969, pp. 49–71, fig. 8; Opperman, 1977, II, p. 656, no. D149, p. 1071, fig. 198; Opperman, 1982, pp. 151–152, fig. 71a, under no. 71.

Rogers Fund, 1911
11.66.15

In the Lamponi sale the drawing was described simply as a "Paysage imaginaire avec un taureau libre et un cerf en repos," and Michael Benisovich seems to have been the first to identify the subject, which is drawn from Ovid's *Metamorphoses* (IX, 80–89).

Acheloüs appears at the right; in the foreground lies his left horn, transformed by the river nymphs into a cornucopia. Hal Opperman points out that the presence of the dead or sleeping stag at the left is difficult to explain, but that it may refer to the story of Hercules and the Cerynean hind.

Though the drawing must be related to the *Metamorphoses* tapestries designed by Oudry for the manufacture de Beauvais, no cartoon of this subject was executed.

222. *View in the Gardens of Arcueil*

Charcoal, stumped, black chalk, heightened with white, on blue-green paper. 31.3 x 52.3 cm. Lined.

Signed and dated in pen and brown ink at lower left, *JB oudry 1744.*

PROVENANCE: Purchased in London in 1910.

BIBLIOGRAPHY: Benisovich, 1943, p. 73; Bean, 1964, no. 57, repr.; Opperman, 1977, II, pp. 850–851, no. D1052; Opperman, 1982, pp. 242–243, no. 137, repr.

Rogers Fund, 1910
10.45.28

Hal Opperman has identified some fifty drawn views by Oudry of the abandoned park and gardens surrounding the château of the prince de Guise at Arcueil near Paris. These drawings, dating from 1744 to 1747, were exe-cuted in black and white chalk on blue paper. The present example is exceptionally well preserved; a great many of the Arcueil drawings have suffered gravely from over-exposure to light, and their blue paper has turned to a dull gray.

AUGUSTIN PAJOU
Paris 1730 – Paris 1809

223. *Project for a Monumental Fountain*

Pen, brown and black ink, brown and gray wash, over traces of black chalk. 39.6 x 61.0 cm. Lined.

Initialed and dated in pen and black ink at lower left, *P. fe 1767.*; inscribed in pen and brown ink below the central figure, PROVINCIAE / MUNIFICENTIA; on banderole at center, . . . FEM . . . ; on scroll at left of center, . . . PRINCI / ANNO / FEL / REGNAN / CIVITA / . . .

PROVENANCE: [Cailleux]; purchased in Paris in 1979.

BIBLIOGRAPHY: *Charles de Wailly, peintre architecte dans l'Europe des lumières*, exhibition catalogue, Caisse nationale des monuments histori-ques et des sites, Paris, 1979, p. 116, no. 143, "Projet de fontaine monumentale (pour les jardins du Peyrou à Montpellier ?)"; *Annual Report*, 1979–1980, p. 27.

Harry G. Sperling Fund, 1979
1979.388

When this drawing was exhibited in Paris in 1979, it was suggested that it might be a scheme intended for the place du Peyrou at Montpellier. The iconography of the design confirms this hypothesis. The seated Athena-like figure in a niche, wearing a plumed helmet and holding a spear and a shield with a sketchy indication of the cross of the house of Toulouse (*de gueule, à la croix vuidée, clechée, pommetée et allaisée d'or*), symbolizes the province of Lan-guedoc. The province is represented in this fashion on the title pages of all five volumes of the *Histoire générale de Languedoc* (1730–1745), by the Maurist scholars Dom Cl. Devic and Dom J. Vaissete. The image was drawn by Pierre-Jacques Cazes and engraved by Cochin le père.

The inscription PROVINCIAE MUNIFICENTIA (by the munificence of the province) alludes to the fact that the États de Languedoc underwrote the cost of the terracing and embellishment of the Peyrou, the terminus of an aqueduct which brought water to Montpellier. The earth goddess Cybele, crowned with city walls, is seated at the left. Cybele personifies the city of Montpellier, as she does on Jean-Louis Journet's fontaine de l'Intendance of 1775 (repr. A. Fliche, *Montpellier*, Paris, 1935, p. 70). The winged genius striking the rock to right of center pre-sumably symbolizes the element of Water.

Pajou's never executed project is dated 1767, the year in which work was begun on Étienne Giral's elegant *château d'eau* that still ornaments the extremity of the upper terrace of the Peyrou (Hautecoeur, 1952, p. 143, fig. 54).

Pajou was involved in other projects for the place du Peyrou. He was one of four sculptors, with Clodion, Moitte, and Julien, commissioned in 1784 to execute statues of *grands hommes* of the reign of Louis XIV for the Peyrou, a scheme not realized at the outbreak of the Revolution. Pajou's terracotta model for his commission, a group representing Colbert and Duquesne, is in the Musée Fabre at Montpellier (J. Claparède, *Revue des Arts*, VII, 3, 1957, pp. 109–113, fig. 2). In addition, a drawn project for a *Temple de la Raison sur la place du Peyrou*, datable ca. 1793, has been attributed to Pajou (Hautecoeur, 1952, p. 144, fig. 55; *Projets et dessins pour la place royale du Peyrou à Montpellier*, Anduze, 1983, p. 67, fig. 70).

224. *Design for a Vase and Supporting Console*

Pen and brown ink, brown wash, heightened with white, over black chalk. 31.6 x 18.0 cm.

Signed twice in pen and brown ink at lower right, *Pajou* and *Pajou f.*

PROVENANCE: Alliance des Arts (Lugt 61); Eugène Tondu; Tondu sale, Paris, May 10–13, 1865, part of no. 373; Edmond and Jules de Goncourt (Lugt 1089); Goncourt sale, Paris, February 15–17, 1897, no. 224; marquis de Biron; Biron sale, Paris, Galerie Georges Petit, June 9–11, 1914, no. 40, bought in; purchased in Geneva in 1937.

BIBLIOGRAPHY: Paris, École des Beaux-Arts, 1879, no. 563; Chennevières, 1880, p. 99; *Dessins de décoration et d'ornement de maîtres anciens*, exhibition catalogue, Musée des Arts Décoratifs, Paris, 1880, no. 291; Goncourt, 1881, I, p. 132; H. Stein, *Augustin Pajou*, Paris, 1912, pp. 228, 418; Allen, 1938, p. 78; Williams, 1939, p. 52, fig. 5; *Metropolitan Museum, European Drawings*, 1943, no. 33, repr.; Hautecoeur, 1952, p. 400, note 6; M. N. Benisovich, *Art Bulletin*, XXXV, 4, 1953, p. 298, fig. 8; Thomas, 1961, no. 65, pl. XVI; Bean, 1964, no. 60, repr.; Byam Shaw, 1970, p. 257.

Rogers Fund, 1937
37.165.104

223

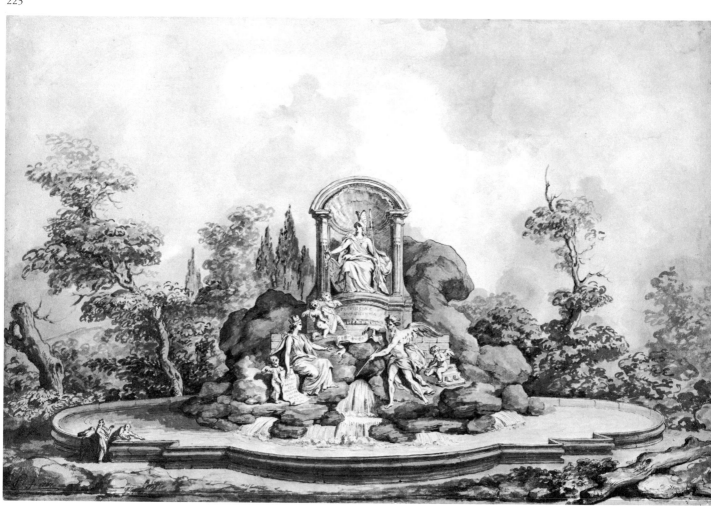

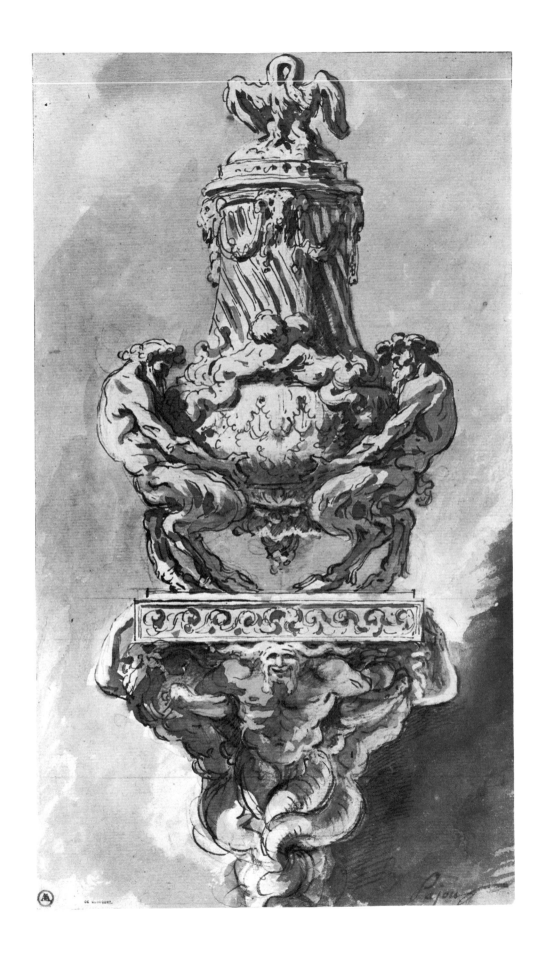

PHILIPPE-LOUIS PARIZEAU

Paris 1740 – Paris 1801

225. *Messenger at the Door of a Guardhouse*

Pen and brown ink, brown wash, over red chalk, and traces of graphite. The underdrawing in red chalk is a counterproof. 37.4 x 23.2 cm. (overall). A strip measuring 1.6 cm. in height has been added at the lower margin and the drawing continued in the same hand. Losses in brown pigment at upper left and lower right.

Signed in pen and brown ink on step at lower center, *Ph L Parizeau 1768*; inscribed in pen and brown ink on reverse of old mount, *soisantequinze*; numbered, *n⁰ 19*.

PROVENANCE: [Colnaghi]; purchased in London in 1985.

BIBLIOGRAPHY: *Annual Report*, 1984–1985, p. 26.

Harry G. Sperling Fund, 1985
1985.112.3

The subjects of this and the following drawing are uncertain, and they both may be picturesque, rather melodramatic inventions. Prison and guardhouse scenes with soldiers in armor, directly inspired by the etchings of Salvator Rosa, were popular in the 1750s and 1760s. Good examples of this genre are Carle Vanloo's drawing

Corps de garde of 1757 that was engraved by J.-C. François (Baltimore, Boston, Minneapolis, 1984, no. 39, repr.), and François Boucher's drawing *Soldats romains et prisonniers* engraved in 1762 by Per Gustaf Floding (Jean-Richard, 1978, no. 1013, repr.).

In the Royal Print Room, Copenhagen, there is a guardhouse scene by Parizeau that is very close in subject, style, and dimensions to our two drawings (Tu 30,2; Gernsheim photograph 77817).

Pen and brown ink, brown wash, over red chalk, and traces of graphite. The underdrawing in red chalk is a counterproof. 37.2 x 23.7 cm. (overall). A strip measuring 1.5 cm. in height has been added at lower margin and the drawing continued in the same hand. Scattered losses in brown pigment.

Inscribed in pen and brown ink on reverse of old mount, *soisanteseize*; numbered, *n⁰ 19*.

PROVENANCE: [Colnaghi]; purchased in London in 1985.

BIBLIOGRAPHY: *Annual Report*, 1984–1985, p. 26.

Harry G. Sperling Fund, 1985
1985.112.2

226. *Prisoners Led Out of a Dungeon*

See No. 225 above.

227

CHARLES PARROCEL

Paris 1688 – Paris 1752

227. *The Penitent St. Mary Magdalene*

Red chalk. Framing lines in pen and brown ink. 49.1 x 33.2 cm.
Vertical and horizontal creases. Lined.

Signed and dated in pen and dark brown ink at lower left, *C Parrocel
1742.*; numbered at upper center, 59.

PROVENANCE: Sale, Paris, Nouveau Drouot, salle 7, October 10–11,
1983, no. 145; [Colnaghi]; purchased in London in 1984.

BIBLIOGRAPHY: *P. and D. Colnaghi and Co. An Exhibition of Old
Master Drawings*, London, 1984, no. 32, repr.; *Annual Report*, 1984–
1985, p. 25.

Purchase, Mrs. Carl L. Selden Gift, in memory of Carl L. Selden, 1984
1984.312

Religious subjects are rare in Charles Parrocel's work, and
this representation of the penitent Magdalene is treated
rather lightheartedly. Both the posture and the physical
type of the figure seem inspired by the example of Claude
Vignon; the latter's drawing of St. Helena holding the
Cross comes to mind (now Fogg Museum; repr. Rosen-
berg, 1972, no. 145, pl. 1).

228. *Lansquenets Talking with Market Women*

Red chalk. 17.2 x 13.2 cm. Lined.

PROVENANCE: [Parsons]; purchased in London in 1907.

BIBLIOGRAPHY: Rosenberg, 1972, p. 192, under no. 105.

Rogers Fund, 1907
07.282.8

Judith Cohen was the first to point out that this drawing
was engraved, in the same direction, by J. G. Wille as
part of a series of twelve scenes of military life, all after
Charles Parrocel (Le Blanc, 1847, nos. 74–85; our draw-
ing is for no. 83). At the Royal Print Room in Copen-
hagen, there are drawings by Charles Parrocel for three
other prints in the series: Tu 24,2 for no. 76, in the same
direction; Tu 24,1 for no. 79, in the same direction; Tu
24,3 for no. 85, in reverse. In the British Museum, there
is an additional drawing related to the series: 1943-11-
13-81 for no. 81, in the same direction.

228

229. *Scene of Military Life: Cavalry Officer
Giving Orders*

Red chalk; the frame is drawn in red chalk over a preliminary sketch in
graphite. 46.7 x 35.2 cm. Repaired tear at upper left. Lined.

Signed and dated in pen and brown ink at lower right, *charle Parrocel.
f. 1744.*

PROVENANCE: Jean-Denis Lempereur (Lugt 1740); Lempereur sale,
Paris, May 24, 1773, and following days, part of no. 652, "Deux
compositions à la sanguine, pour des dessus de portes de l'appartement
de Monsieur le Dauphin à Versailles"; Henri Delacroix (his mark, an
interlaced HD, not in Lugt); sale, collection H. D., Paris, Palais
Galliera, March 31, 1962, no. 62, pl. XXIII; [Slatkin]; purchased in
New York in 1963.

BIBLIOGRAPHY: *Annual Report*, 1962–1963, p. 63; Gillies and Ives,
1972, no. 40; Rosenberg, 1972, p. 192, under no. 105.

Rogers Fund, 1963
63.3

This large drawing is a study, with significant variations,
for one of two overdoors commissioned from Charles Par-
rocel in 1744 for the decoration of the appartement du
Dauphin in the château de Versailles. These rooms were
decorated for the son of Louis XV just before his marriage

Charle Parrocel f. 1744.

in February 1745 to Marie-Thérèse, daughter of Philip V, king of Spain (Verlet, 1961, p. 477).

The painting and its pendant, another scene of military life, are both preserved in the Musée de Versailles (Constans, 1980, nos. 3570 and 3569, respectively). The canvases are both rectangular, measuring 1.54 x 1.39 m., thus the shaped frame indicated in the drawing was probably an architectural feature of the room in which the paintings were originally hung.

The drawing was one of two in the Lempereur sale described as studies for paintings intended for the Dauphin's apartment; the present whereabouts of the second drawing is unknown.

ÉTIENNE PARROCEL

Avignon 1696 – Rome 1776

230. *Seated Woman with a Child on Her Lap*

Black chalk, heightened with white. 51.1 x 40.5 cm. Scattered creases, and small losses. Lined.

PROVENANCE: Sale, London, Sotheby's, December 7, 1976, no. 3; [Tan Bunzl]; purchased in London in 1979.

BIBLIOGRAPHY: *Yvonne Tan Bunzl. Somerville and Simpson Ltd. Old Master Drawings*, exhibition catalogue, London, 1978, no. 48, pl. XVIII; *Annual Report*, 1978–1979, p. 25.

Purchase, Mr. and Mrs. Carl Selden Gift, 1979
1979.64

The infant appears to be slipping a ring on the finger of a hand indicated at right; thus the drawing may be a study for a Mystic Marriage of St. Catherine of Alexandria. The firmly modeled forms of Virgin and Child are typical of Étienne Parrocel, and the figures may be compared with a similar group in a painting by the artist in the Detroit Institute of Arts, the *Virgin and Child Appearing to St. Philip Neri* (repr. *Bulletin of the Detroit Institute of Arts*, XXIV, 5, 1945, p. 71).

Étienne Parrocel's work as a draughtsman has only recently been studied. The late Anthony M. Clark identified a group of documented drawings by the master in an English private collection; one of these drawings entered his own collection, another was presented to the Fitzwilliam Museum, Cambridge (P. Rosenberg in Philadelphia, 1980, no. 23, repr.; Paris, Lille, Strasbourg, 1976, no. 76, repr.).

More recently Lawrence Turčić identified a black chalk drawing of a kneeling priest that appeared on the market (New York, Sotheby Parke Bernet, January 18, 1984, no. 152, repr., as Étienne Parrocel) as a study for the figure of St. John Francis Régis in a painting representing that Jesuit saint interceding for victims of the plague, signed and dated *Stephanus Parrocel pinxit Romae 1739*. The picture was executed in Rome for a Jesuit church in Marseille and it is now in the Musée des Beaux-Arts of that city (Marseille, 1908, repr. opp. p. 212).

Turčić also pointed out that a chalk drawing in the Frits Lugt Collection representing two Jesuits—one reclining with a crucifix at his breast, the other kneeling beside him—is strikingly similar in handling and in physical type to the study for the Marseille painting. The Lugt sketch may be a study for the principal figures in a Death of St. Francis Xavier or of St. John Francis Régis (J. Byam Shaw, *The Italian Drawings of the Frits Lugt Collection*, Paris, 1983, I, no. 337, III, pl. 389, as Bolognese school, XVIIth century).

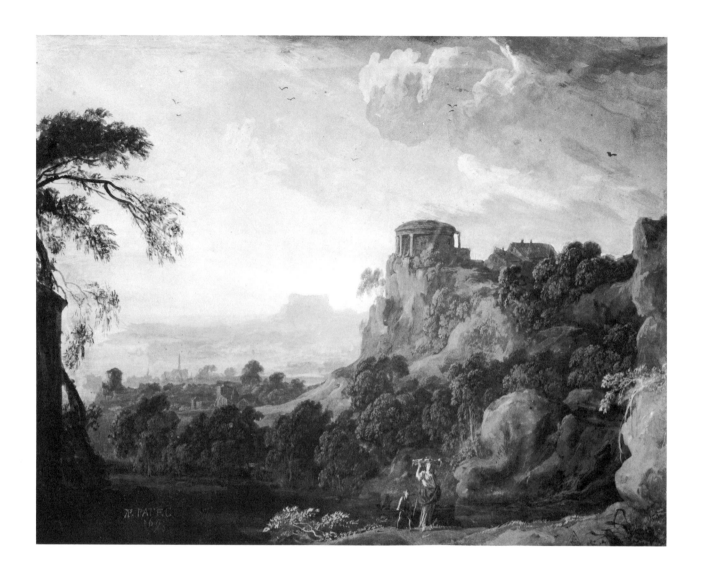

PIERRE-ANTOINE PATEL,
called Patel le fils

Paris 1648 – Paris 1707

231. *Landscape with a Circular Temple on a Mountain*

Gouache on vellum. 15.0 x 19.7 cm.

Signed and dated in brush and white gouache at lower left, PA. PATEL / *1693*.

PROVENANCE: Lestevenon (according to Lagoy); marquis de Lagoy (Lugt 1710, one of two landscapes under no. 301 in manuscript inventory of Lagoy collection); [Bier]; purchased in London in 1961.

BIBLIOGRAPHY: *Annual Report*, 1961–1962, p. 66; R. Bacou, *L'Oeil*, 91–92, 1962, p. 52, repr.; Rosenberg, 1972, p. 92, under no. 106.

Rogers Fund, 1961
61.170

LAURENT PÉCHEUX

Lyon 1729 – Turin 1821

232. *St. Peter Baptizing Cornelius*
(Acts 10:44–48)

Pen and brown ink, gray wash, over red and black chalk. 52.4 x 32.7 cm.

Inscribed in pen and brown ink on reverse of old mount, now detached, *Disegno originale di Lorenzo Pecheux Lionese / Ex Coll: Henrici Hamal Leodsis.*

PROVENANCE: Henry Hamal (Lugt 1231); unidentified collector's mark (HL within a heart, in red); sale, New York, Sotheby Parke Bernet, January 18, 1984, no. 195, repr., as the Baptism of Constantine ?, purchased by the Metropolitan Museum.

BIBLIOGRAPHY: *Annual Report*, 1983–1984, p. 24.

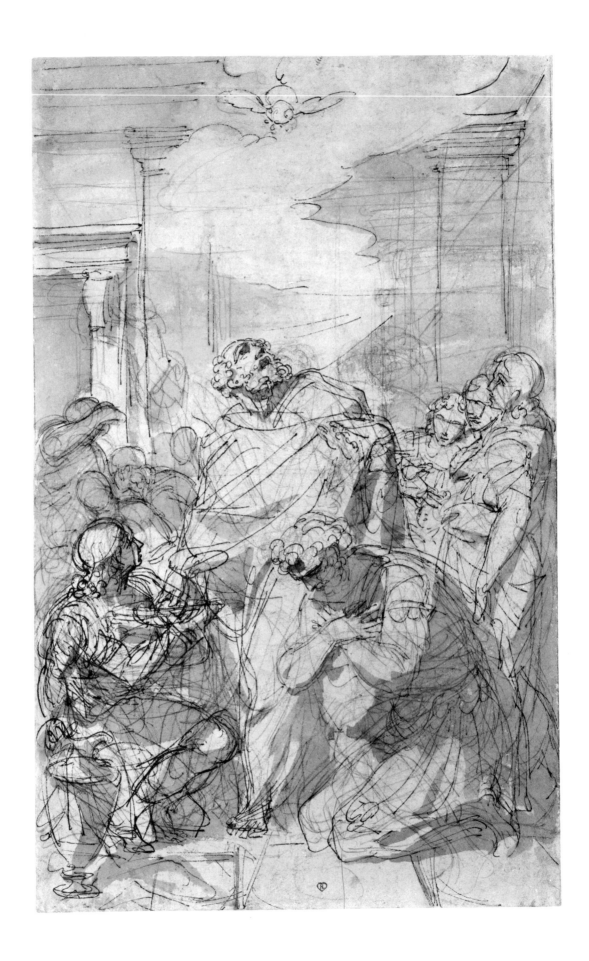

Purchase, The Howard Bayne Fund Gift, 1984
1984.19

Study for a now lost painting executed by Pécheux in Rome for the church of Saint-Nizier in his native city of Lyon. The painting figures as the fourth work described on a chronological list kept by the artist himself, *Note des tableaux que j'ai fait à Rome, où je suis arrivé le 2 janvier 1753....* The entry reads, "Pour Lyon deux: un pour St. Nizier, chapelle du baptistère, *St. Pierre qui baptise Corneille*; l'autre pour les Messieurs de S.te Geneviève: *Jacob et Laban*: figures grandes comme nature. Ces deux tableaux furent pris par un corsaire qui les vendit à Nice." Pécheux painted another *Jacob et Laban* for the Génovéfains to replace their stolen picture, but he did not repeat the lost altarpiece for Saint-Nizier (Bollea, 1942, p. 393).

There is another drawing by Pécheux for this composition in the Biblioteca Reale, Turin (Bollea, 1942, p. 330, repr.; Roli and Sestieri, 1981, pp. 8–9, pl. 10).

PIERRE PEYRON

Aix-en-Provence 1744 – Paris 1814

233. *The Despair of Hecuba*

Pen and black ink, gray wash, over slight traces of black chalk. 16.6 x 22.7 cm. Scattered spots of brown pigment. Lined.

Signed in pen and black ink at lower left, *P. Peyron. f.*; inscribed at center of lower margin in the artist's hand, *hecube*.

PROVENANCE: [Baderou]; purchased in Paris in 1965.

BIBLIOGRAPHY: *Annual Report*, 1965–1966, p. 75, as Death of Hecuba; Rosenberg, 1972, p. 194, under no. 109, as Death of Hecuba; P. Rosenberg and U. van de Sandt, *Pierre Peyron, 1744–1814*, Neuilly-sur-Seine, 1983, p. 121, no. 109, fig. 92.

Rogers Fund, 1965
65.125.2

Pierre Rosenberg and Udolpho van de Sandt, who date the drawing 1784, point out that it represents not the death of Hecuba, but her despair as Ulysses takes her daughter Polyxena to be sacrificed at the tomb of Achilles.

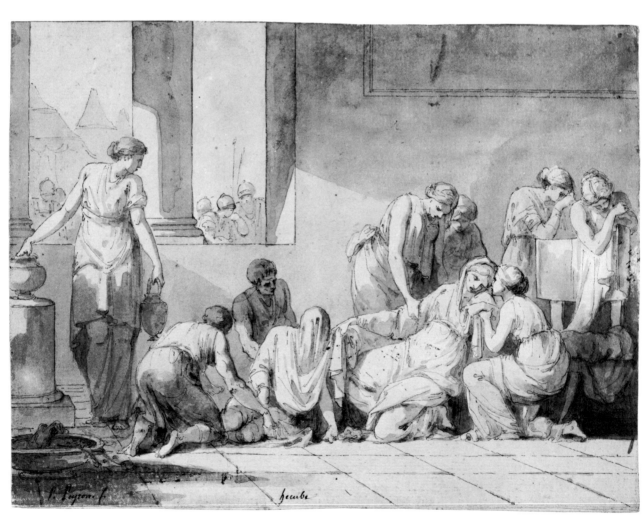

BERNARD PICART

Paris 1673 – Amsterdam 1733

234. *La Coquette*

Pen and gray ink, gray wash, heightened with white, over traces of
graphite. Contours incised. 7.4 x 11.2 cm. A *pentimento* in the foliage
has been added at the left of the seated figure. Vertical stain near left
margin. Lined.

Signed and dated in pen and brown ink at lower left margin, *B. Picart.
1716*; inscribed in pencil on reverse of old mount, *This is engraved and
published | A Paris chez I. Mariette Rue St. Jacqu . . . | aux Colonnes
d'Hercule. | J.P.H. has this print bound in a small volume.*

PROVENANCE: Baron Jérôme Pichon; Pichon sale, Paris, Hôtel
Drouot, salle 3, May 17–21, 1897, no. 109, "La Coquette.—Le
Bain.—Le Repos.—Le Goûter. 4 dessins pour dessus de boites"; J. P.
Heseltine (Lugt 1508); Heseltine sale, London, Sotheby's, May 27–
29, 1935, part of no. 261; Sir Bruce S. Ingram (Lugt Supp. 1405a);
[Colnaghi]; purchased in London in 1963.

BIBLIOGRAPHY: Duportal, *Bernard Picart*, in Dimier, 1928, p. 385,
no. 126; *Annual Report*, 1963–1964, p. 62.

Rogers Fund, 1963
63.167.3

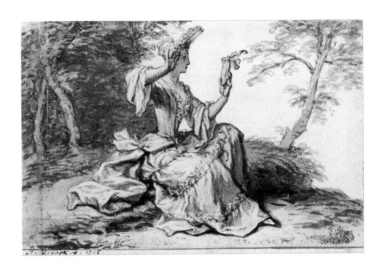

The French titles utilized for this and the following three
drawings (Nos. 235–237 below) are those that appeared
in the catalogue of the Pichon sale in 1897. Despite the
modern comments on the reverse of the mounts, and the
fact that the contours of the drawings have been indented
for transfer, these four compositions do not seem to have
been engraved by (or after) Bernard Picart. At any rate,
such engravings are not to be found in the extensive *Oeuvre*
of Picart at the Cabinet des Estampes, Biliothèque Na-
tionale, Paris. We are grateful to Mary O'Neill for this
information.

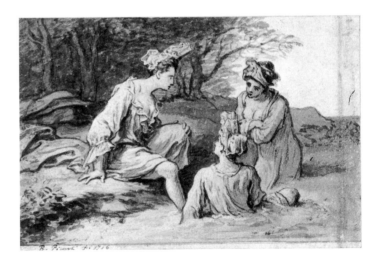

235. *Le Bain*

Pen and gray ink, gray wash, heightened with white, over traces of
graphite. Contours incised. 7.4 x 11.2 cm. Vertical stain near right
margin. Lined.

Signed and dated in pen and brown ink at lower left margin, *B. Picart
f. 1716*; inscribed in pencil on reverse of old mount, *This was also
probably engraved | but does not appear to be in | the series belonging to J.P.H.*

PROVENANCE: See No. 234 above.

BIBLIOGRAPHY: Duportal, *Bernard Picart*, in Dimier, 1928, p. 385, no. 127; *Annual Report*, 1963–1964, p. 62.

Rogers Fund, 1963
63.167.5

See No. 234 above.

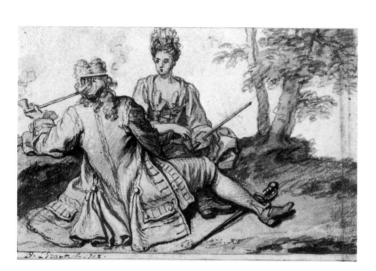

236. *Le Repos*

Pen and gray ink, gray wash, heightened with white, over traces of graphite. Contours incised. 7.4 x 11.2 cm. Two vertical stains near right margin. Lined.

Signed and dated in pen and brown ink at lower left margin, *B. Picart f. 1716*; inscribed in pencil on reverse of old mount, *Also engraved*.

PROVENANCE: See No. 234 above.

BIBLIOGRAPHY: Duportal, *Bernard Picart*, in Dimier, 1928, p. 385, no. 129; *Annual Report*, 1963–1964, p. 62.

Rogers Fund, 1963
63.167.4

See No. 234 above.

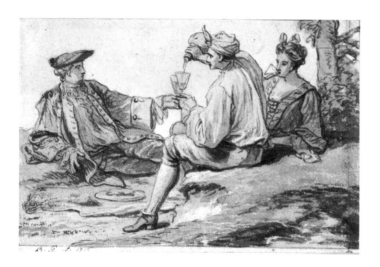

237. *Le Goûter*

Pen and gray ink, gray wash, heightened with white, over traces of graphite. Contours incised. 7.4 x 11.2 cm. Small loss and vertical stain near right margin. Lined.

Initialed and dated in pen and brown ink at lower margin, *B.P.f. 1716*; inscribed in pencil on reverse of old mount, *This is also engraved and published by I Mariette*.

PROVENANCE: See No. 234 above.

BIBLIOGRAPHY: Duportal, *Bernard Picart*, in Dimier, 1928, p. 385, no. 128; *Annual Report*, 1963–1964, p. 62.

Rogers Fund, 1963
63.167.6

See No. 234 above.

238. *Mexican Sacrifice to the God of Hunting*

Pen and gray ink, gray wash, heightened with touches of white, over traces of graphite and red chalk. Contours indented. 14.8 x 20.9 cm. Verso reddened for transfer.

Signed and dated in pen and brown ink at lower left margin, *B Picart f 1722.*

PROVENANCE: James Hazen Hyde; transferred from the Department of Prints and Photographs in 1974.

BIBLIOGRAPHY: *Annual Report*, 1959–1960, p. 62; *The European Vision of America*, exhibition catalogue by Hugh Honour, National Gallery of Art, Washington, D.C., Cleveland Museum of Art, Grand Palais, Paris, 1975–1977, no. 172, repr.

Gift of Estate of James Hazen Hyde, 1959
1974.206

The drawing was engraved in reverse by Picart as an illustration for *Cérémonies et coutumes religieuses de tous les peuple du monde* (11 vols., Amsterdam, 1723–1743). The print, bearing the same date as the drawing, is entitled *Divinité qui préside à la chasse*; it illustrates a passage describing a rite honoring a Mexican god of the hunt. This text can be translated thus: "The Mexicans, especially those of Tlascalla, worshiped a god who had been a great hunter during his sojourn on earth. He was honored by a solemn hunt which is here illustrated. While the image of the god was placed on an altar at the summit of a mountain around which many fires were lit, the devout hunters pursued wild beasts who, to escape the flames, took refuge on the top of the mountain. The animals were killed before the idol to which their hearts were sacrificed. The hunt ended with cheerful songs and cries of joy, after which the hunters took back the idol in triumph and the devotion of the day ended with a solemn banquet." (*Cérémonies*, VI, part 1, 1723, p. 158).

Picart supplied 261 illustrations for this great work. Relatively few of the drawings appear to have survived: twenty-nine are preserved in the Teylers Museum, Haarlem (Duportal, *Bernard Picart*, in Dimier, 1928, pp. 386–387, nos. 190–218), and others are to be found in public collections here and abroad.

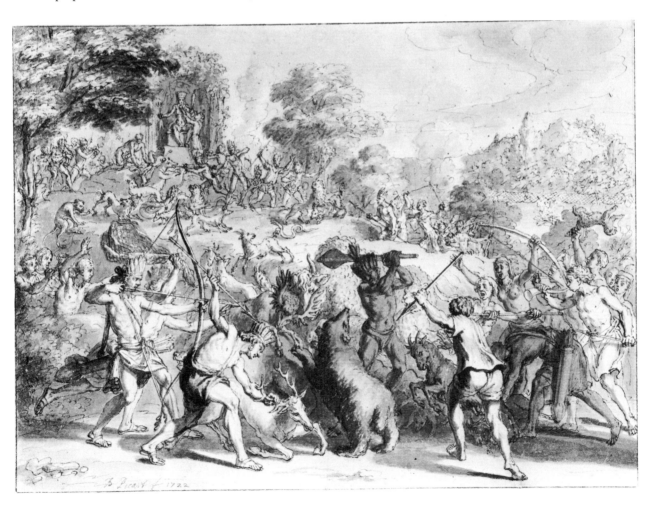

FOUR ILLUSTRATIONS FOR PHILIPP VON STOSCH'S *PIERRES ANTIQUES GRAVÉES*, AMSTERDAM, 1724, NOS. 239–242.

239. *A Muse*

Red chalk. Faintly squared in red chalk. Framing lines in black chalk. 20.7 x 14.9 cm. Lined.

Inscribed vertically in red chalk at left of figure, [*A*]*ΛΛΙΩΝO*[*Γ*]; numbered in pencil at lower right, *43**.

PROVENANCE: Captain E. G. Spencer-Churchill, Northwick Park (according to vendor); [Yvonne ffrench]; purchased in London in 1967.

BIBLIOGRAPHY: *Annual Report*, 1967–1968, p. 87; M. L. Myers in Philadelphia, 1980, pp. 30–32, under no. 19.

Rogers Fund, 1967
67.100.4

Drawing for pl. 7, which appears in the same direction (Reinach, 1985, p. 158). The title is "Muse, ouvrage d'Allion, gravé sur une cornalline. Du Cabinet de Strozzi, à Rome."

The full French title of Stosch's publication explains its purpose: *Pierres antiques gravées, sur lesquelles les graveurs ont mis leurs noms. Dessinées et gravées en cuivre sur les originaux ou d'après les empreintes, par Bernard Picart. Tirées des principaux cabinets de l'Europe, expliquées par M. Philippe de Stosch.*

In addition to Nos. 240, 241, and 242 below, there are drawings by Picart for this publication in the Anthony Morris Clark Bequest, Philadelphia Museum of Art (for pls. 18 and 23), in the British Museum, London (for pl. 1), and in a private collection in New York (for pls. 25 and 46). All of these drawings are said to have come from a dismembered album that contained some seventy drawings by Picart after engraved gems.

240. *A Muse*

Red chalk. Faintly squared in red chalk. Framing lines in black chalk. 20.6 x 15.0 cm. Lined.

Inscribed in red chalk to left of figure, *ONHCAC/ΕΠOΙEΙ*; numbered in pencil at lower right, *43*.

PROVENANCE and BIBLIOGRAPHY: See No. 239 above.

Rogers Fund, 1967
67.100.5

Drawing for pl. 45, which appears in the same direction (Reinach, 1895, pp. 173–174). The title is "Muse, ouvrage d'Onese, en pâte antique jaune et transparente. Du Cabinet de M. l'Abbé Pierre Andreini noble florentin."

241. *Presumed Portrait of Alexander the Great*

Red chalk. Framing lines in black chalk. 20.5 x 15.0 cm.

Inscribed in red chalk below bust, *ΠΥΡΓΟΤΕΛΗΣ*.

PROVENANCE and BIBLIOGRAPHY: See No. 239 above.

Rogers Fund, 1967
67.100.1

Drawing for pl. 55, which appears in the same direction (Reinach, 1895, p. 177). The title is "Alexandre le Grand de Macédoine, ouvrage de Pyrgotele, gravé sur une sardoine. Du Trésor du Prince Lothaire-François, Elécteur de Mayence."

242. *Presumed Portrait of Phocion*

Red chalk. Faintly squared in red chalk. Framing lines in black chalk. 21.9 x 14.8 cm. Lined.

Inscribed in red chalk to right of bust, *ΦΩΚΙΩΝOC* and below, *ΠΥΡΓΟΤΕΛΗΣ ΕΠOΙEΙ*.

PROVENANCE and BIBLIOGRAPHY: See No. 239 above.

Rogers Fund, 1967
67.100.2

Drawing for pl. 56, which appears in the same direction (Reinach, 1895, pp. 177–178). The title is "Phocion, ouvrage de Pyrgotele, gravé sur une sardoine."

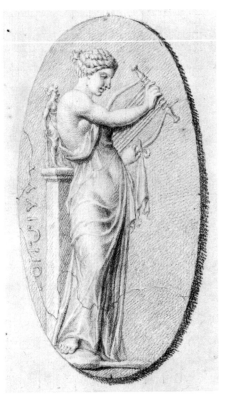

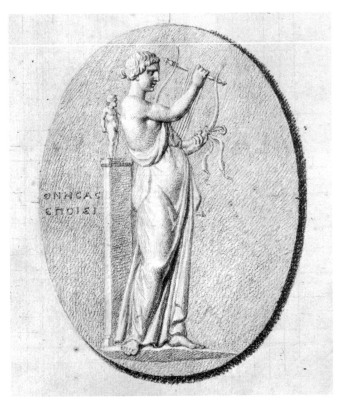

239 (detail) 240 (detail)

241 (detail) 242 (detail)

243. *Figures before an Altar*

Red chalk. 20.9 x 15.0 cm.

PROVENANCE: Captain E. G. Spencer-Churchill, Northwick Park (according to vendor); [Yvonne ffrench]; purchased in London in 1967.

BIBLIOGRAPHY: *Annual Report*, 1967–1968, p. 87.

Rogers Fund, 1967
67.100.3

This drawing after an engraved gem was not used in Philipp von Stosch's publication, *Pierres antiques gravées*.

JEAN-BAPTISTE-MARIE PIERRE

Paris 1714 – Paris 1789

244. *The Rape of Europa*

Red chalk. 36.9 x 37.2 cm. Lined.

Inscribed in pen and brown ink at lower right, *M·* Pierre.

PROVENANCE: [Komor]; Christian Humann; [Arnoldi-Livie]; purchased in Munich in 1982.

BIBLIOGRAPHY: *Vom Manierismus bis in die Goethezeit. Bilder und Zeichnungen*, exhibition catalogue, Galerie Arnoldi-Livie, Munich, 1982, no. 33, repr.; *Annual Report*, 1982–1983, p. 24.

Harry G. Sperling Fund, 1982
1982.190

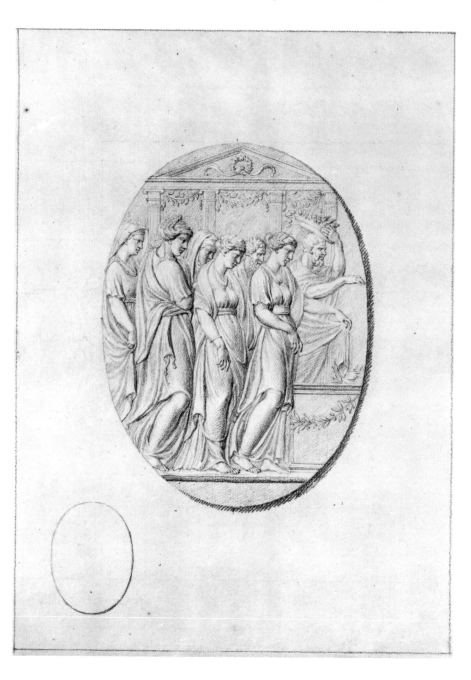

244

Study for, or record of, Pierre's cartoon for one of a set of Gobelins tapestries, *Les amours des dieux*, of 1757 (Fenaille, IV, p. 193, no. III). The cartoon, formerly in the Musée d'Arras, was destroyed during World War I.

Edith Standen kindly called our attention to a weaving of the tapestry after Pierre's cartoon, signed and dated *Cozette 1787*, that appeared in a sale in New York in 1974 (Sotheby Parke Bernet, March 2, 1974, no. 104, repr. in color). This tapestry corresponds very closely with our drawing.

245. *The Flight into Egypt*

Pen and brown ink, brown wash, heightened with white, on beige paper. 46.7 x 36.2 cm. Lined.

Signed in pen and brown ink at lower center, *Pierre*.

PROVENANCE: Jean Masson; Masson sale, Paris, Hôtel Drouot, November 23, 1927, no. 88; Germain Seligman (on mount his mark, interlaced GS, not in Lugt); Christian Humann; sale, New York, Sotheby Parke Bernet, April 30, 1982, no. 59, repr., purchased by the Metropolitan Museum.

245

BIBLIOGRAPHY: Rosenberg, 1972, no. 112, pl. 98 (with additional bibliography); P. Rosenberg, *L'Oeil*, 212–213, 1972, p. 15, fig. 15; M. Halbout, *Revue du Louvre et des Musées de France*, XXIII, 4–5, 1973, pp. 249–254, fig. 1 (our drawing), fig. 2 (the painting); M. Halbout and P. Rosenberg, *Bulletin of the Detroit Institute of Arts*, LVI, 3, 1978, pp. 168–176, fig. 11 (the painting), fig. 12 (our drawing); *Annual Report*, 1981–1982, p. 23; *Diderot*, 1984, p. 337, under no. 98.

Harry G. Sperling Fund, 1982
1982.94.1

Elaborate preparatory study, with many important variations in figures and landscape, for the painting exhibited in the Salon of 1761 and now in the Musée d'Art et d'Industrie, Saint-Étienne (repr. *Diderot*, 1984, p. 336).

246. *Cybele Prevents Turnus from Setting Fire to the Trojan Fleet by Transforming the Ships into Sea Goddesses* (Virgil, *Aeneid*, IX, 107–122)

Pen and brown ink, brown wash, heightened with white, over black chalk, on beige paper. 37.9 x 47.2 cm. Vertical crease at center. Lined.

Inscribed in pen and brown ink at lower margin of old mount, *No. 91. Piere fecit*; in pen and black ink in another hand, *403 /* ITE DEAE PELAGI. *Virgi. Enei* I. .IX.

PROVENANCE: Marquis de Chennevières (Lugt 2073); Chennevières sale, Paris, Hôtel Drouot, April 4–7, 1900, part of no. 403; [Didier Aaron]; purchased in Paris in 1981.

BIBLIOGRAPHY: Chennevières, *L'Artiste*, XIII, 1897, part XIX, p. 180; *Annual Report*, 1981–1982, p. 22; *Notable Acquisitions*, 1981–1982, p. 43, repr.

Harry G. Sperling Fund, 1981
1981.219

246

247. *St. Charles Borromeo Distributing Communion to Victims of the Plague in Milan*

Pen and gray ink, gray wash, over traces of black chalk. 47.4 x 32.6 cm. Scattered brown stains. Lined.

Signed in pen and brown ink at lower left, *Pierre*.

PROVENANCE: Marc Sandoz (according to Sotheby's); Clifford Duits (according to Sotheby's); Christian Humann; sale, New York, Sotheby Parke Bernet, January 21, 1983, no. 42, repr., purchased by the Metropolitan Museum.

BIBLIOGRAPHY: *Annual Report*, 1982–1983, p. 24.

Purchase, David L. Klein, Jr. Memorial Foundation, Inc. Gift, 1983
1983.29.1

Pierre treated this subject in a quite different and much more informal fashion in an etching that is presumably a relatively early work (Le Blanc, III, p. 203, no. 4). The monumental solemnity of this drawing, possibly a study for a never executed altarpiece, suggests that it is a work of the artist's maturity.

A number of the features of Pierre's composition are to be found in a painting by the much younger Anicet-Charles-Gabriel Lemonnier, *La peste de Milan*, shown in the Salon of 1785 (thus during Pierre's lifetime) and now in the Musée des Beaux-Arts, Rouen (repr. Locquin, 1978, fig. 205).

JEAN PILLEMENT

Lyon 1728 – Lyon 1808

248. *Decorative Fantasy with Exotic Figures in a Tree House*

Black and a little red chalk, blue and red pastel, blue and red wash. 59.3 x 42.0 cm.

Signed and dated in black chalk at lower center, *Jean Pillement / 1771*.

PROVENANCE: [Rosenberg and Stiebel]; Lesley and Emma Sheafer.

BIBLIOGRAPHY: *Annual Report*, 1974–1975, p. 48; *Sheafer Collection*, 1975, no. 38, with No. 249 below.

The Lesley and Emma Sheafer Collection,
Bequest of Emma A. Sheafer, 1973
1974.356.46

249. *Decorative Fantasy with Skaters and an Exotic Figure in an Ice Boat*

Black and a little red chalk, blue and red pastel, blue and red wash. 60.9 x 40.0 cm.

Signed and dated in black chalk at lower center, *J. Pillement / 1771*.

PROVENANCE: [Rosenberg and Stiebel]; Lesley and Emma Sheafer.

BIBLIOGRAPHY: *Annual Report*, 1974–1975, p. 48; *Sheafer Collection*, 1975, no. 38, with No. 248 above.

The Lesley and Emma Sheafer Collection,
Bequest of Emma A. Sheafer, 1973
1974.356.47

250. *Landscape with a Tower*

Black chalk, on pale blue-green paper. 19.7 x 31.0 cm.

Signed and dated in black chalk at lower left, *Jean Pillement / 1792*.

PROVENANCE: Austin Mitchell (according to vendor); [Durlacher]; purchased in New York in 1942.

Fletcher Fund, 1942
42.186.3

248

249

250

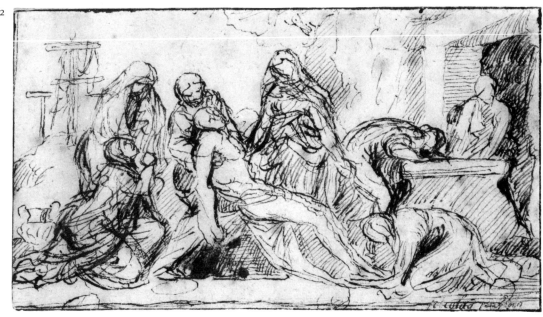

252

JACQUES-ANDRÉ PORTAIL

Brest 1695 – Versailles 1759

251. *Flowers in a Silver Caster, Fruit in the Foreground*

Watercolor over traces of graphite. 34.6 x 27.8 cm.

PROVENANCE: Abel-François Poisson, marquis de Ménars et de Marigny; marquis de Ménars sale, Paris, March 18 – April 6, 1782, no. 334; Marius Paulme (Lugt 1910); Paulme sale, Paris, Galerie Georges Petit, May 13–15, 1929, no. 198, pl. 133; George Blumenthal.

BIBLIOGRAPHY: M. Salinger, *Metropolitan Museum of Art Bulletin*, May 1950, pp. 260–261, repr.

Bequest of George Blumenthal, 1941
41.190.119

Marius Paulme seems to have been correct in identifying this exquisite watercolor, muted and velvety in finish, with lot number 334 in the *vente après décès* of the marquis de Marigny, who was very partial to the drawings of Portail. In the Marigny sale there were twenty-seven lots under the name of Portail, including a total of seventy-six drawings; nineteen of them, like the present example, were framed. Still life, mythological, religious, and genre subjects, as well as seventeen landscapes, were included. In fact the sale offered a good many more drawings by Portail than by Marigny's better-known favorites, Boucher and Greuze.

NICOLAS POUSSIN

Les Andelys 1594 – Rome 1665

252. *Lamentation over the Dead Christ*

Pen and brown ink. 8.7 x 15.5 cm. Lined.

Inscribed in pen and brown ink at lower right, *nicolas . . .*

PROVENANCE: [Calmann]; purchased in London in 1961.

BIBLIOGRAPHY: *Annual Report*, 1961–1962, p. 66; Bean, 1962, p. 168, repr.; Bean, 1964, no. 54, repr.; Rosenberg, 1972, p. 196, under no. 113; Friedlaender and Blunt, V, 1974, p. 80, no. 401, pl. 296; *Rome in the 17th Century*, 1976, n.pag. [15]; Blunt, 1979, pp. 21, 188, 195; Wild, 1980, II, p. 178, under no. 190.

Rogers Fund, 1961
61.123.1

The drawing is late and is very probably a study for the *Lamentation* in the National Gallery of Ireland, Dublin (Thuillier, 1974, no. 206, repr.).

253. *The Sorcerer Atlas Abducting Pinabello's Lady* (Ariosto, *Orlando Furioso*, Canto II, 38)

Pen and brown ink. Verso: slight black chalk sketch of a seated male figure in antique costume. 19.4 x 11.3 cm. Lower left corner replaced.

Numbered in pen and black ink at lower right, *146*; inscribed in pen and brown ink at lower left, *pusinu*.

254. *Cinerary Urn, after the Antique*

PROVENANCE: [Calmann]; [Seiferheld]; Walter C. Baker.

BIBLIOGRAPHY: Virch, 1962, no. 40 (with previous bibliography); Friedlaender and Blunt, V, 1974, p. 99, no. 428, pl. 309, with incorrect title; Blunt, 1979, p. 46, fig. 39, with incorrect title; *Annual Report*, 1979–1980, p. 27.

Bequest of Walter C. Baker, 1971
1972.118.224

Claus Virch was responsible for the identification of the relevant scene from Ariosto's *Orlando furioso*. On occasion the subject has mistakenly been called *Roger Carried Away from Bradamante on the Hippogriff*.

Pen and brown ink, brown wash, over black chalk. 28.6 x 22.6 cm.

PROVENANCE: James Jackson Jarves; Cornelius Vanderbilt.

BIBLIOGRAPHY: *Metropolitan Museum Handbook*, 1895, no. 583, as Roman school, 17th century; Friedlaender and Blunt, V, 1974, p. 33, no. 320, pl. 252.

Gift of Cornelius Vanderbilt, 1880
80.3.583

The attribution to Nicolas Poussin of this drawing, formerly classified with the anonymous seventeenth-century Roman material, is due to Anthony Blunt.

253

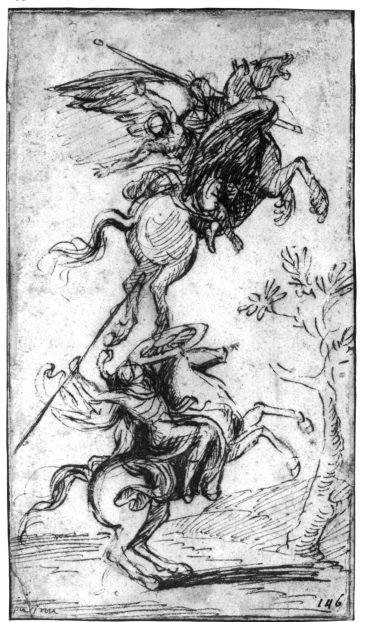

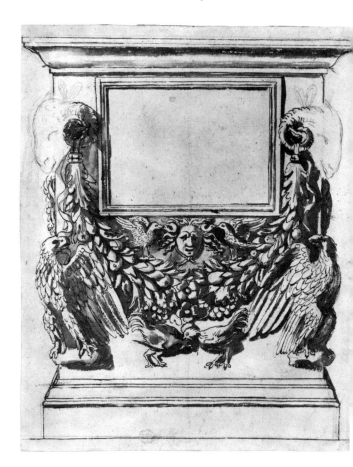

PIERRE PUGET

Marseille 1620 – Marseille 1694

255. *Design for the Decoration of a Warship*

Pen and brown ink, brown and gray wash, over black chalk, on vellum. Framing lines in dark brown ink. 51.1 x 61.6 cm. Upper left corner replaced; a number of repaired tears and losses; surface abraded.

Signed in pen and brown ink on pavement at lower left, *P Puget*.

PROVENANCE: Landau; Sir Bruce S. Ingram (Lugt Supp. 1405a); [Colnaghi]; purchased in London in 1963.

BIBLIOGRAPHY: Van Hasselt, 1961, no. 144, pl. 65 (with previous bibliography); *Annual Report*, 1963–1964, p. 62; A. Hyatt Mayor, *Apollo*, LXXXII, September 1965, pp. 242–244, repr.; K. Herding, *Zeitschrift für Kunstgeschichte*, 29, 2, 1966, pp. 133–148, fig. 8; *In the Presence of Kings*, exhibition catalogue, The Metropolitan Museum of Art, New York, n.d. [1967], no. 25, repr.; Herding, 1970, pp. 87, 94, pl. 166; Rosenberg, 1972, p. 201, under no. 120; W. Gaunt, *Marine Painting, an Historical Survey*, London, 1975, p. 60, p. 63, fig. 52.

Rogers Fund, 1963
63.167.2

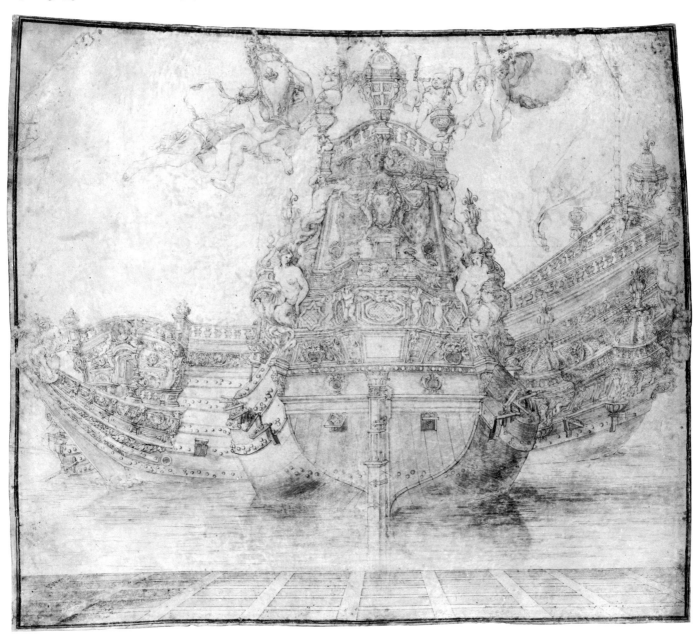

255 (detail)

The stern is represented at the center of the sheet; to the left and right are profile views of prow and stern. Above, genii hold the royal arms of France and putti the letters and numerals, *V, V* (interlaced), *L, R, L, 14* (*Vive le roi Louis 14*).

It is not possible to identify this project with a warship actually built for the French fleet. Klaus Herding proposed that the drawing represents a vessel called the *Royal-Louis*. This suggestion has been rejected by both Sabine de Boisfleury and Dean Walker. The *Royal-Louis* was designed by Charles Le Brun, and the carved ornament was carried out under the direction of François Girardon.

According to Mme de Boisfleury, the *Royal-Louis* was indeed represented in a drawing by Puget in the Albertina, Vienna (Inv. 15246), mistakenly thought by Herding to represent a ship called the *Monarque* (Boisfleury, 1972, p. 109).

256. *Design for a Tabernacle*

Pen and brown ink, brown wash, heightened with white, over graphite. 39.0 x 24.4 cm. The support consists of three pieces of paper. Upper corners made up; vertical crease at center; repaired tears and losses. Lined.

PROVENANCE: Purchased in New York in 1984.

BIBLIOGRAPHY: *Annual Report*, 1984–1985, p. 25.

Purchase, Mrs. Carl L. Selden Gift, in memory of Carl L. Selden, 1984
1984.268

This recently discovered and unpublished drawing is very closely related to a design for a tabernacle in the Musée Atger, Montpellier (*Dessins du Musée Atger*, 1974, no. 11, pl. VII). The Montpellier project, which lacks the cross at the summit of the composition, is nearly twice the size of our drawing. There are significant, if slight, differences between the two designs: in the architectural treatment of the surfaces of the tabernacle, and in the position of one of the sculptured figures. In our drawing the angel representing St. Matthew at lower center—one of the four symbols of the Evangelists that support the tabernacle—kneels on his left knee with his right leg projecting beyond the base, and he supports the heavy structure above with extended right hand. In the Montpellier drawing the angel rests on his right knee, and his arms are loosely crossed over his left leg.

Both the drawings for this exuberant tabernacle are rendered in Puget's most painstaking manner, and the pen work is very similar to that in our design for the *Decoration of a Warship* (No. 255 above).

In a private collection in Paris there is a somewhat freer pen and wash design by Puget for the same tabernacle (Herding, 1970, pl. 156). Klaus Herding associated the drawings in Paris and Montpellier with Puget's plans for a now destroyed tabernacle in S. Siro, Genoa; we believe that he is mistaken in describing the Montpellier drawing as a studio copy (Herding, 1970, p. 161).

PIERRE PUGET

257. *Frigate at Sea*

Pen and black ink, gray wash, brown ink (for some of the rigging), over black chalk, on vellum. Framing bands in pen and brown ink, brown wash. 25.0 x 19.0 cm. Lower left corner abraded. Mounted on board.

Inscribed in pen and black ink on chest held by porter in foreground, *a monsieur de / magny com.^re des classes / N^+M*; on reverse of old mount board, *Original de puget pour son / compaire magny luy en fesant / un présent de tout son coeur.*

PROVENANCE: Nicolas de Magny; Dumon (according to Auquier); private collection, Gémenos (Bouches-du-Rhône); [Galerie de Bayser]; purchased in Paris in 1985.

BIBLIOGRAPHY: Auquier, p. 11, no. 32; Boisfleury, 1972, p. 110; S. de Boisfleury in Marseille, 1978, p. 130, under no. 182; *Annual Report*, 1984–1985, p. 26.

Harry G. Sperling Fund, 1985
1985.103

A presentation drawing dedicated to the artist's friend Nicolas de Magny, *commissaire des classes* (a recruiter of seamen for the royal navy). There are autograph replicas of this drawing, without dedications on the chest in the foreground, in the Musée des Beaux-Arts, Marseille, and in the Musée Grobet-Labadie, Marseille (S. de Boisfleury in Marseille, 1978, p. 130, no. 182).

JEAN-AUGUSTIN RENARD

Paris 1744 – Paris 1807

258. *Cloister of the Certosa di S. Martino, Naples*

Pen and gray ink, watercolor, over traces of black chalk. Framing lines in pen and brown ink. 22.6 x 33.9 cm.

PROVENANCE: [Kleinberger]; purchased in New York in 1961.

BIBLIOGRAPHY: *Annual Report*, 1960–1961, p. 64; Dayton, Ohio, 1971, p. 20, no. 32, repr.; J. Bean, *Master Drawings*, X, 2, 1972, p. 165, identified as an illustration for Saint-Non's *Voyage pittoresque*; Rosenberg and Bergot, 1981, p. 77.

Rogers Fund, 1961
61.20.3

The drawing was etched in the same direction by Germain and finished by Dupin as an illustration for *Voyage pittoresque ou description des royaumes de Naples et de Sicile* (I, part I, 1781, pl. 40, opp. p. 77). The legend reads, "Vue de l'intérieur du Cloître de la Chartreuse de S.ᵗ Martin à Naples. Dessinée d'après nature par Renard Architecte."

For other drawings reproduced in Saint-Non's *Voyage pittoresque* see Nos. 55, 99, and 266.

JEAN RESTOUT

Rouen 1692 – Paris 1768

259. *Seated Carthusian Holding an Open Book*

Red-brown, brown, cream, white, and flesh-colored oil paint on paper. Varnished. 29.1 x 21.9 cm.

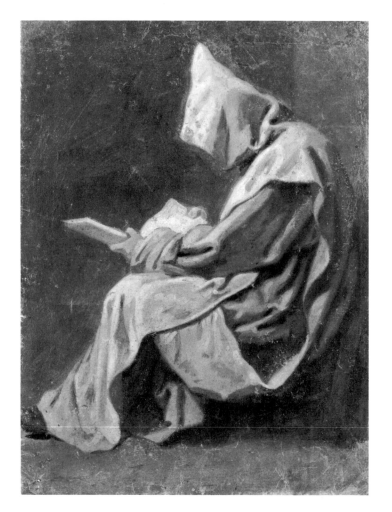

Inscribed in black chalk on verso, *Restout / en May 1711 / en 1 heure et / demy.*

PROVENANCE: Private collection, Saint Louis, Missouri (according to Sotheby's); sale, New York, Sotheby Parke Bernet, January 20, 1982, no. 33, repr., with mention of the painting in Dijon, purchased by the Metropolitan Museum.

BIBLIOGRAPHY: *Annual Report*, 1981–1982, p. 22.

Harry G. Sperling Fund, 1982
1982.25.1

This figure appears seated beside the kneeling St. Bruno in a version of Jean Jouvenet's celebrated composition *Saint Bruno priant à genoux* in the Musée Magnin, Dijon (Schnapper, 1974, p. 207, under no. 93, fig. 96). This seated Carthusian figures only in the Dijon version, which Antoine Schnapper does not consider to be by Jouvenet himself. Thus the Musée Magnin painting could well have been executed by the young Restout, while he was working in the studio of his uncle Jouvenet. If the inscription on the verso be exact, Restout was nineteen when he made this oil sketch; he had worked with his uncle from the age of fifteen (Rosenberg and Schnapper, 1970, p. 19).

260. *Seated Male Nude*

Black chalk, stumped, heightened with white, on beige paper. 49.9 x 36.1 cm.

PROVENANCE: [Colnaghi]; purchased in London in 1985.

BIBLIOGRAPHY: *Colnaghi. Old Master Drawings*, exhibition catalogue, London, 1985, no. 40, repr.

Harry G. Sperling Fund, 1985
1985.245.1

Study for the figure of Christ, represented nude to the waist and with hands raised in blessing, who appears with God the Father and the Holy Spirit at the top of an altarpiece depicting the revelation of the Immaculate Conception of the Virgin to her parents Anne and Joachim (Rosenberg and Schnapper, 1970, p. 197, no. 51, repr.).

This *Conception de la Vierge*, signed and dated 1740, was painted by Restout for the chapel of the Filles de l'Instruction Chrétienne, rue Pot-de-fer, Paris (Dezallier d'Argenville, 1757, p. 373). The convent school was suppressed at the Revolution, and quite early in the nineteenth century the painting was brought to the United

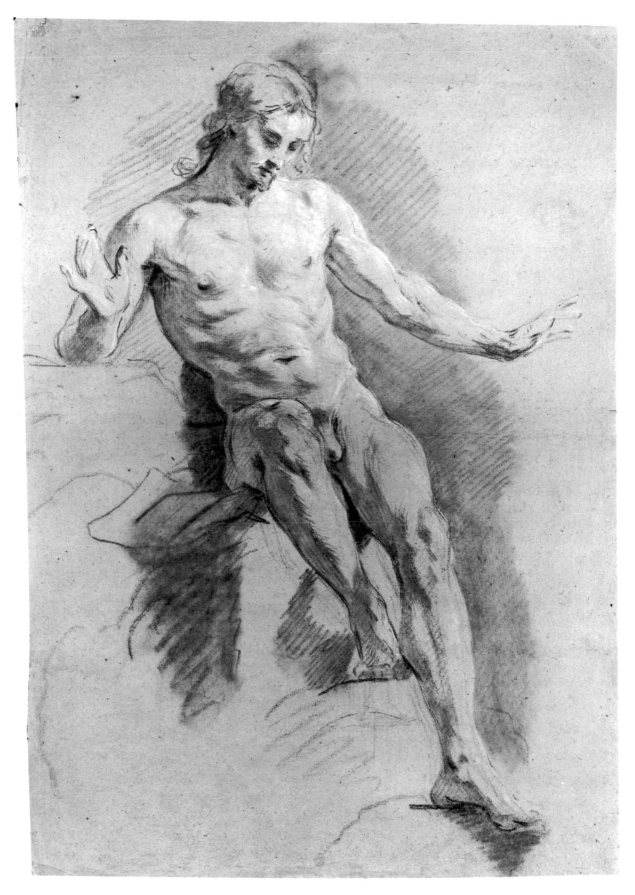

States by priests of the Society of St. Sulpice. It is presently in the Sulpician Seminary and University of St. Mary in Baltimore, Maryland.

In composition and iconography, Restout's painting owes much to the *Conception de la Vierge* by Charles de La Fosse, painted ca. 1703 for the monastère de l'Immaculée-Conception of the Récollettes on the rue du Bac in Paris (Dezallier d'Argenville, 1757, p. 401), and now in the Musée des Beaux-Arts, Le Havre.

261. *Head of a Bearded Man in Profile to Right*

Black and red chalk, heightened with touches of white, on beige paper. Lightly squared in graphite. 33.8 x 28.1 cm. Lined.

PROVENANCE: Sale, Paris, Nouveau Drouot, salle 7, October 10–11, 1983, no. 155, attributed to Restout; [Colnaghi]; purchased in London in 1984.

BIBLIOGRAPHY: *P. and D. Colnaghi and Co. An Exhibition of Old Master Drawings*, London, 1984, no. 27, repr.; *Annual Report*, 1984–1985, p. 25.

Purchase, Mrs. Carl L. Selden Gift, in memory of Carl L. Selden, 1984
1984.311

Full-scale study for the head of St. Ambrose in the *Invention et translation des corps de Saint Gervais et Saint Protais*, a painting shown in the Salon of 1750 and now in Saint-Amable, Riom (Rosenberg and Schnapper, 1970, p. 202, no. 75, repr.). In the painting (1.94 x 1.45 m.), St. Ambrose stands at the left, presiding over the disinterment of the Milanese protomartyrs Gervase and Protase.

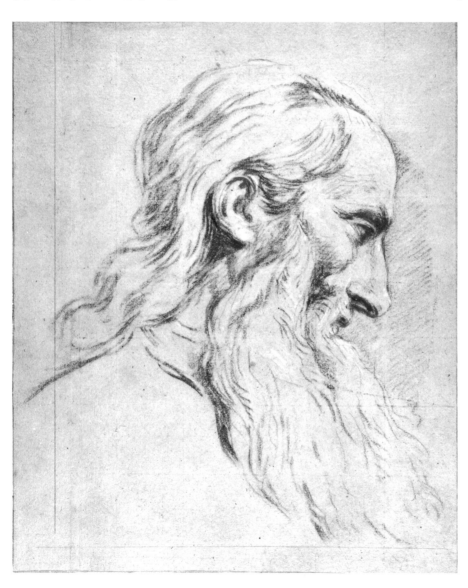

HUBERT ROBERT

Paris 1733 — Paris 1808

262. *Young Artists in the Studio*

Red chalk. Framing lines in pen and brown ink. 35.2 x 41.2 cm.

PROVENANCE: Jean-Pierre Norblin de la Gourdaine; Louis-Pierre-Martin Norblin; Mme de Connantré; baronne de Ruble; Mme de Witte; marquise de Bryas (all according to Virch); Walter C. Baker.

BIBLIOGRAPHY: Virch, 1962, no. 80; *Annual Report*, 1979—1980, p. 27.

Bequest of Walter C. Baker, 1971
1972.118.231

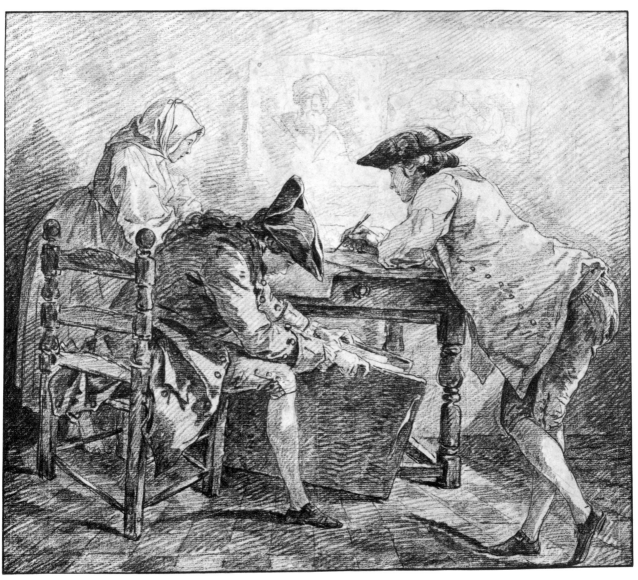

263. *The Nymphaeum of the Villa di Papa Giulio, Rome*

Red chalk. Framing lines in pen and brown ink. 39.8 x 53.0 cm.

PROVENANCE: Alexandrine Sinsheimer.

BIBLIOGRAPHY: *Annual Report*, 1958–1959, p. 56; Dayton, Ohio, 1971, p. 17, no. 25, repr.

Bequest of Alexandrine Sinsheimer, 1958
59.23.71

The nymphaeum in the second courtyard of the Villa di Papa Giulio is the work of Bartolomeo Ammanati (Venturi, XI, 2, figs. 220–229). In the Musée de Valence (Beau, 1968, no. 35, repr.) there is a somewhat smaller red chalk view of the first courtyard of this villa, which

was built for Julius III about 1551–1553. The drawing in Valence is dated 1762, which would be applicable here as well.

264. *Figures in a Roman Arcade*

Red chalk. Framing lines in pen and brown ink. 44.5 x 33.7 cm. Lined.

Dated in red chalk at lower left in the artist's hand, *1763*.

PROVENANCE: G. W. Riggs; Mlle de L.; sale, Paris, Galerie Charpentier, June 22, 1933, no. 19 (all according to Virch); Walter C. Baker.

BIBLIOGRAPHY: Virch, 1962, no. 83; *Annual Report*, 1979–1980, p. 27.

Bequest of Walter C. Baker, 1971
1972.118.228

263

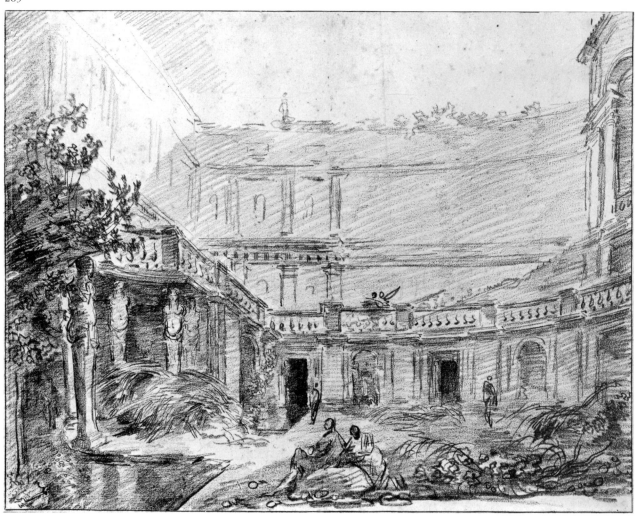

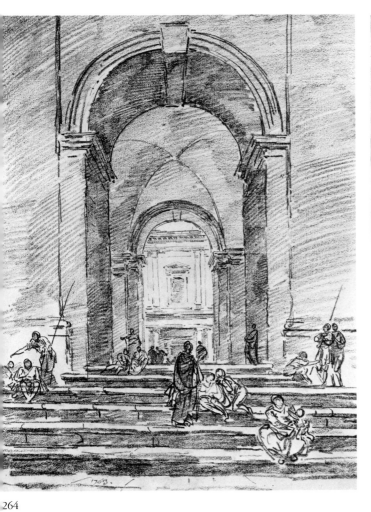

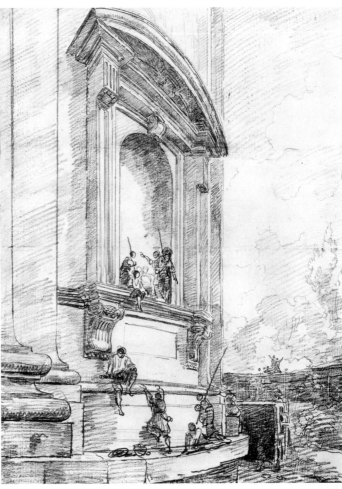

264

265. *Figures in One of Michelangelo's Niches on the Apse of St. Peter's, Rome*

Red chalk. Framing lines in pen and brown ink. 45.6 x 33.5 cm. Lined.

PROVENANCE: G. W. Riggs; Mlle de L.; sale, Paris, Galerie Charpentier, June 22, 1933, no. 18, repr. (all according to Virch); Walter C. Baker.

BIBLIOGRAPHY: Virch, 1962, no. 82, repr.; J. Meder, *The Mastery of Drawing*, translated and revised by Winslow Ames, New York, 1978, II, p. 193, repr.; *Annual Report*, 1979–1980, p. 27.

Bequest of Walter C. Baker, 1971
1972.118.229

266. *Entrance to the Grotto of Posíllipo*

Brush and brown wash, over red chalk and a little black chalk. Framing lines in pen and brown ink. 46.5 x 33.2 cm. Horizontal crease at center. Lined.

Inscribed in pen and black ink in cartouche at lower margin of old mount, *Entrée de la Grotte / de Pausilipe à Naples*.

PROVENANCE: [Parsons]; Harold K. Hochschild.

BIBLIOGRAPHY: *Illustrated Catalogue of Original Drawings by Old Masters. No. 46. E. Parsons and Sons*, London, n.d. [1930?], no. 372, repr. opp. p. 27; H. W. Williams, Jr., *Metropolitan Museum of Art Bulletin*, August 1940, p. 157; Benisovich, 1943, p. 73; Dayton, Ohio, 1971, no. 18, repr.; Gillies and Ives, 1972, no. 41.

Gift of Harold K. Hochschild, 1940
40.91.17

The red chalk underdrawing is a counterproof that Robert worked up with brush and brown wash. The same composition in the same direction, with the addition of a few more figures, appears in Saint-Non's *Voyage pittoresque ou description des royaumes de Naples et de Sicile*. The illustration occurs in volume I, part I (1781), as pl. 37, opposite p. 82, with the following legend, "Vue de l'entrée de la Grotte du Pausilipe près de Naples. Dessinée d'après

235

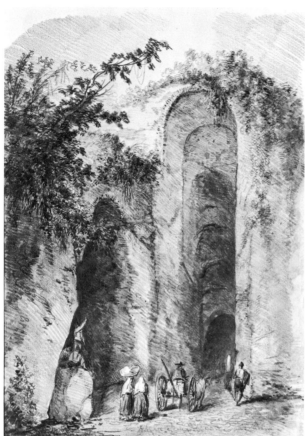

266

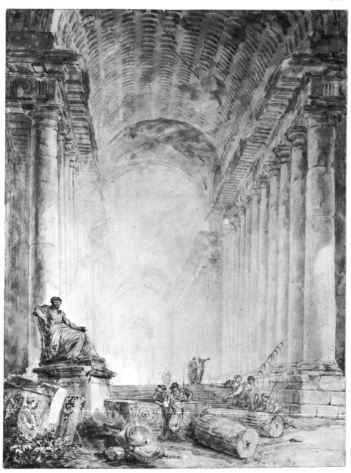

267

nature par Robert Peintre du Roi. Gravé à l'eau forte par Marillier. Terminé par de Ghendt."

The relationship of this worked-up counterproof to the engraved illustration is puzzling, since the drawing is almost four times the size of the print.

For other drawings reproduced in Saint-Non's *Voyage pittoresque* see Nos. 55, 99, and 258 above.

267. *Figures in a Colonnade*

Pen and black ink, gray and blue wash, heightened with white, over black chalk. 58.8 x 44.6 cm. (overall). The support consists of two sheets joined horizontally 10.8 cm. from lower margin. The drawing has been faded and discolored by overexposure to light.

PROVENANCE: Marquis de Biron; Biron sale, Paris, Galerie Georges Petit, June 9–11, 1914, no. 54, repr.; Alexandrine Sinsheimer.

BIBLIOGRAPHY: *Annual Report*, 1958–1959, p. 56; Carlson, 1978, p. 124, under no. 49.

Bequest of Alexandrine Sinsheimer, 1958
59.23.68

268. *Artist Sketching a Young Girl*

Red chalk. Framing lines in pen and brown ink. 25.5 x 33.8 cm. Brown stain at lower right.

PROVENANCE: Jean-Pierre Norblin de la Gourdaine; Louis-Pierre-Martin Norblin; Mme de Connantré; baronne de Ruble; Mme de Witte; marquise de Bryas (all according to Virch); Walter C. Baker.

BIBLIOGRAPHY: *Great Master Drawings of Seven Centuries*, exhibition catalogue, M. Knoedler, New York, 1959, no. 56, repr.; C. Virch, *Metropolitan Museum of Art Bulletin*, June 1960, p. 312, repr.; Virch, 1962, no. 81, repr.; *Annual Report*, 1979–1980, p. 27.

Bequest of Walter C. Baker, 1971
1972.118.230

269. *Figures among Ruins*

Pen, brown and gray ink, brown and gray wash, over black chalk. 56.0 x 74.0 cm. Surface abraded at lower left.

Signed and dated in pen and gray ink on tomb at left, H. ROBERT DEL[i] / ANNO D *1778*.

PROVENANCE: Cailleux (mark, C..x in an oval, not in Lugt); duchesse de Richelieu.

BIBLIOGRAPHY: *Annual Report*, 1966–1967, p. 59; Carlson, 1978, no. 47, repr.

Gift of Madame la Duchesse de Richelieu, 1967
67.129

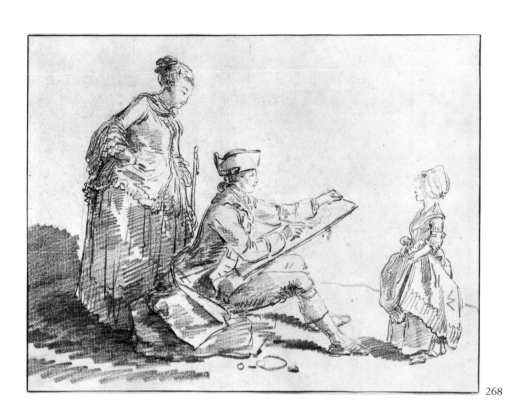

268

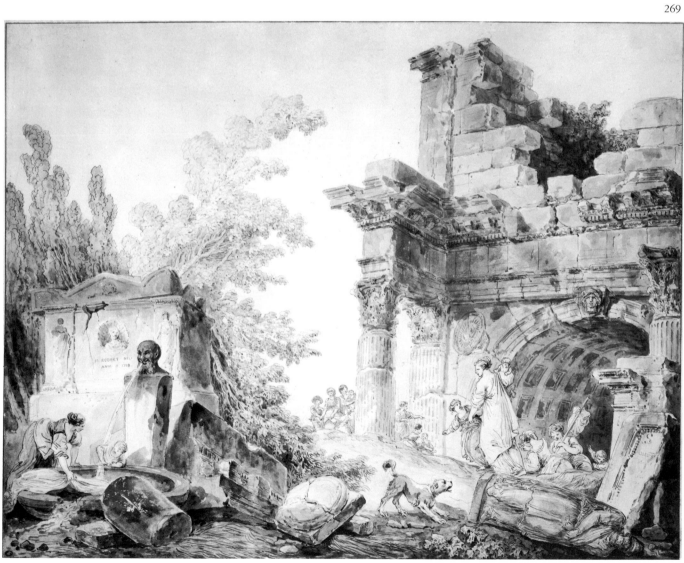

NICOLAS ROBERT

Langres 1614 – Paris 1685

270. *Three Parrots*

Red chalk. 22.5 x 18.6 cm. Lined.

Initialed in pen and dark brown ink at lower right, *NR*.

PROVENANCE: English private collection (according to vendor); [Morton Morris]; purchased in London in 1984.

BIBLIOGRAPHY: *Annual Report*, 1984–1985, p. 26; *Notable Acquisitions*, 1984–1985, p. 29, repr. in color.

Purchase, Mrs. Carl L. Selden Gift, in memory of Carl L. Selden, 1984
1984.391

The drawing was engraved in the same direction by Robert himself as pl. 26 in *Diverses oyseaux dessignées et gravées d'après le naturel par N. Robert* (F. Poilly, Paris, n.d. [1675?]). The title of the plate is *Psittacus / Perrequets* [sic].

In the British Museum there is a red chalk drawing of a

turkey and a black chalk drawing of a duck that were engraved in the same publication (1919-12-16-56 and 1919-12-16-58).

BIBLIOGRAPHY: *Annual Report*, 1984–1985, p. 26; *Notable Acquisitions*, 1984–1985, p. 29.

Purchase, Mrs. Carl L. Selden Gift, in memory of Carl L. Selden, 1984
1984.390

271. *Curlews and Ducks*

Red chalk. 22.7 x 18.6 cm. Lined.

Initialed in pen and dark brown ink at lower right, *NR*.

PROVENANCE: See No. 270 above.

A less finished red chalk drawing by Nicolas Robert of a very similar curlew is in the British Museum (1919-12-16-57).

A different curlew appears in pl. 17 of *Diverses oyseaux*, sharing the scene with a lapwing.

See No. 270 above.

FRANÇOIS ROËTTIERS

London 1685 – Vienna 1742

272. *Bacchanal*

Pen and point of brush, brown ink, on beige paper. 24.9 x 30.5 cm. Lined.

Inscribed in pen and brown ink at lower left margin, *fran. Roëttiers in. et f.*

PROVENANCE: Pierre-Jean Mariette (Lugt 2097); Mariette sale, Paris, 1775–1776, part of no. 1352, "Deux Bacchanales, dans la composition desquelles il entre plus de quinze figures, faites à la plume et à l'encre de la Chine"; J. J. Peoli (Lugt 2020); Peoli sale, New York, American Art Galleries, May 8, 1894, and following days, no. 550 or 552; sale, London, Christie's, April 12, 1983, no. 143, repr., purchased by the Metropolitan Museum.

BIBLIOGRAPHY: *Annual Report*, 1982–1983, p. 24.

Harry G. Sperling Fund, 1983
1983.147

This drawing was sketched by Gabriel de Saint-Aubin in his copy of the Mariette sale catalogue, now in the Museum of Fine Arts, Boston.

AUGUSTIN DE SAINT-AUBIN

Paris 1736 – Paris 1807

273. *Half Figure of a Woman Wearing a Cap, in Profile to Right*

Graphite, heightened with a little white. Framing lines in pen and brown ink. 17.6 x 12.2 cm. Lined.

Inscribed in graphite at lower margin of old mount, *aug. de S.̣ Aubin del. 1770.*

PROVENANCE: [Galerie de Bayser et Strolin]; purchased in Paris in 1963.

BIBLIOGRAPHY: *Annual Report*, 1963–1964, p. 62; Gillies and Ives, 1972, no. 42.

Rogers Fund, 1963
63.92.2

GABRIEL DE SAINT-AUBIN

Paris 1724 – Paris 1780

274. *Germain-Augustin and Rose de Saint-Aubin, Drawn by Their Uncle*

Gray wash, over black chalk and graphite. 18.2 x 12.2 cm. Lined.

Inscribed very faintly in graphite at upper margin in the artist's hand, *augustin de St aubin 1766 janvier* [?]; at lower margin, *G. de S¹ aubin et Rose de S¹ aubin dessinés par leur oncle gabriel*. The same inscription repeated in pen and brown ink by another hand at lower margin of old mount.

PROVENANCE: Ransonnette; Ransonnette sale, Paris, February 21–23, 1878, no. 20; Hippolyte Destailleur; Destailleur sale, Paris, May 26–27, 1893, no. 112, 2; Destailleur sale, Paris, May 19–23, 1896, no. 852; J. Bouillon (according to Dacier); Walter Burns (according to Schiff sale catalogue); Mortimer L. Schiff; Schiff sale, London, Christie's, June 24, 1938, no. 51; [Wildenstein]; Walter C. Baker.

BIBLIOGRAPHY: Goncourt, 1880–1882, I, pp. 426–427; Dacier, 1929–1931, I, p. 84, II, p. 44, no. 238; Virch, 1962, no. 77, repr.; *Annual Report*, 1979–1980, p. 27.

Bequest of Walter C. Baker, 1971
1972.118.233

Dacier pointed out that the girl and boy represented are the youngest children of Gabriel's brother, Germain de Saint-Aubin: Catherine-Noëlle, called Rose, born in 1755, and Germain-Augustin, born in 1758. Rose holds a *vielle à roue* (hurdy-gurdy) of which only the head and tuning pegs are visible.

275. *Allegory on the Marriage of the Dauphin and Marie-Antoinette in 1770*

Gray wash, over black chalk, accents in pen and brown ink; the two shields at lower margin in black chalk only. Framing lines in pen and brown ink; margins tinted with blue-green wash. 22.1 x 17.1 cm. Lined.

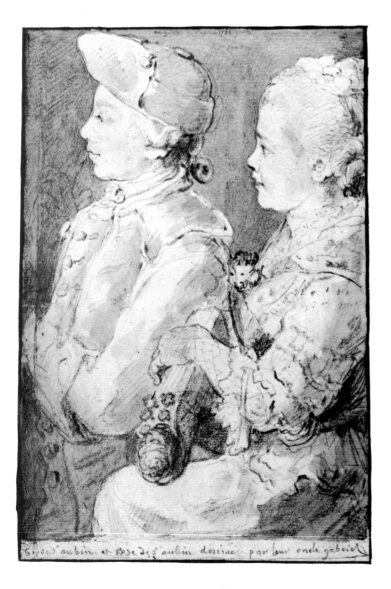

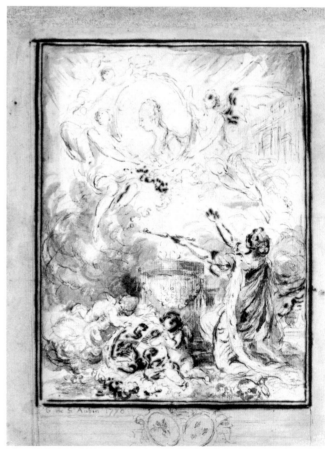

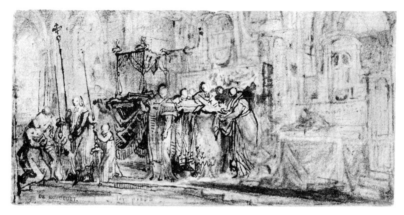

276

Signed and dated in black chalk at lower left, *G de Sᵗ Aubin 1770.*

PROVENANCE: Marcel Thévenin; Thévenin sale, Paris, Hôtel Drouot, salle 7, April 28, 1906, no. 40, repr.; marquis de Biron; Biron sale, Galerie Georges Petit, June 9–11, 1914, no. 59, repr., bought in; purchased in Geneva in 1937.

BIBLIOGRAPHY: Dacier, 1929–1931, II, p. 17, no. 84; Allen, 1938, p. 78; Williams, 1939, pp. 51–52, fig. 4; Benisovich, 1943, p. 73; *Saint-Aubin*, 1975, no. 49, repr. p. 100.

Rogers Fund, 1937
37.165.106

The allegorical figure of France kneels before an altar upon which rest two hearts; above, winged figures support a medallion portrait of Marie-Antoinette. At lower left putti hold a shield with the arms of the Dauphin (later Louis XVI). The fact that these arms are reversed and that France holds the sceptre in her left hand suggests that the drawing may be a project for an engraving.

At the lower margin the arms of Austria and of France are lightly indicated in black chalk.

276. *Coronation Regalia Carried in Procession at Saint-Denis*

Pen and black ink, a little gray wash, over black chalk. 5.2 x 10.3 cm. Repaired losses at upper center and upper right. Lined.

Inscribed in black chalk at lower margin, *14 pieds.*

PROVENANCE: Edmond and Jules de Goncourt (Lugt 1089); Goncourt sale, Paris, February 15–17, 1897, no. 263, "Une châsse promenée à la porte d'une église par le clergé"; Albert Lehmann; Lehmann sale, part II, Paris, Galerie Georges Petit, June 8, 1925, no. 171; [Cailleux]; purchased in Paris in 1984.

BIBLIOGRAPHY: Goncourt, 1881, I, p. 147, "Une châsse promenée à la porte d'une église par le clergé"; Dacier, 1929–1931, II, p. 112, no. 635; *Annual Report*, 1984–1985, p. 26.

Purchase, Jacob Bean Gift, 1984
1984.384

Alain Gruber identifies the scene as the ceremonial removal from the abbey church of Saint-Denis of regalia to be used in the coronation of Louis XVI at Reims (letter of July 10, 1985).

Dr. Gruber calls attention to an entry in the *Mémoires secrets* under the date of the coronation, June 11, 1775, that refers to the regalia preserved at Saint-Denis. "On vient de donner imprimé un *Détail des Richesses tirées du Trésor de l'Abbaye de St. Denis, pour servir au Sacre de Louis XVI.* Elles consistent en la *Couronne* de l'Empereur Charlemagne; le *Sceptre*; la *Main de justice*; *l'Épée* de Charlemagne; *l'Agraffe*, pour attacher le manteau Royal; les *Éperons*, et le *Livre* contenant les prières usitées à cette cérémonie. Trois Religieux, savoir le Prieur, le plus ancien des deux Gardes du Trésor et un Député nommé par le Chapitre, accompagnent ce dépôt précieux à Rheims, et le ramènent à St. Denis" (*Mémoires secrets pour servir à l'histoire de la république des lettres en France, depuis MDCCLXII jusqu' à nos jours . . .* , VIII, London, 1780, p. 76).

For the coronation of Louis XVI see also No. 7 above.

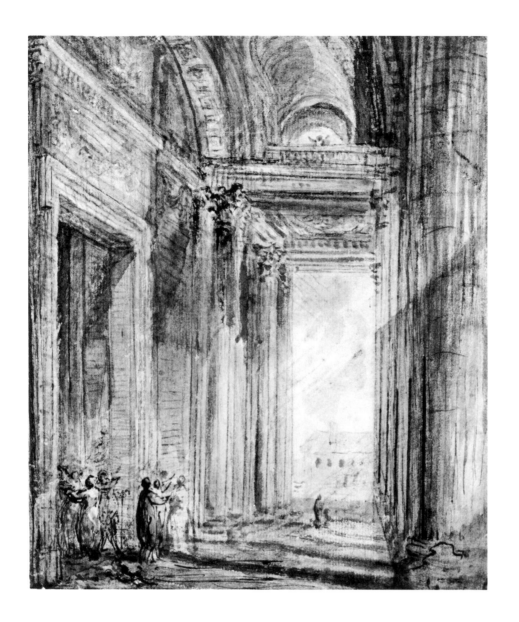

GABRIEL DE SAINT-AUBIN

277. *Figures in the Portico of Sainte-Geneviève (le Panthéon), Paris*

Pen and brown ink, brown and gray wash, over black chalk. 18.1 x 15.3 cm.

PROVENANCE: Alexandrine Sinsheimer.

BIBLIOGRAPHY: Dacier, 1929–1931, II, p. 66, no. 418; *Annual Report*, 1958–1959, p. 56; *Saint-Aubin*, 1975, no. 56, repr. p. 105.

Bequest of Alexandrine Sinsheimer, 1958
59.23.73

278. *Theatrical Divertissement Offered at a Gala Evening Party*

Pen and brown ink, watercolor, and gouache. 20.2 x 26.1 cm. Scattered losses at margins. Lined.

PROVENANCE: Pérignon; Pérignon sale, Paris, May 30–June 1, 1864, no. 462 (according to Dacier); Hippolyte Destailleur; Destailleur sale, May 19–23, 1896, no. 869; E. Lion; Lion sale, Paris, Hôtel Drouot, December 12–13, 1907, no. 164, repr.; sale, Paris, Hôtel Drouot, salle 6, June 25–26, 1930, no. 16; [J. Seligmann]; Mr. and Mrs. Herbert N. Straus.

BIBLIOGRAPHY: Dacier, 1929–1931, II, p. 116, no. 659, pl. XXIV; London, Royal Academy, 1932, p. 393, no. 803; London, Royal Academy, 1933, p. 162, no. 758, pl. 172; Shoolman and Slatkin, 1950, pl. 41; Rotterdam, Paris, New York, 1958–1959, no. 81, pl. 50; Mongan, 1962, no. 708, repr. in color; Gillies and Ives, 1972, no. 43; *Saint-Aubin*, 1975, no. 46, repr. p. 91; *Annual Report*, 1977–1978, p. 36, repr.; *Notable Acquisitions*, 1975–1979, p. 57, repr.

Bequest of Therese Kuhn Straus, in memory of her husband, Herbert N. Straus, 1977
1978.12.2

JEAN DE SAINT-IGNY

Rouen 1595/1600 ? – Paris ? after 1649

279. *Cavaliers in a City Square*

Pen and brown ink. 23.9 x 20.8 cm. Repaired losses. Lined.

Inscribed in pencil on reverse of old backing, *De Saint Igny 1770*; in another hand, *n° 3100*.

PROVENANCE: Paignon-Dijonval; vicomte Morel de Vindé (see Lugt 2520); Henry Scipio Reitlinger; Reitlinger sale, London, Sotheby's, April 14, 1954, no. 343; [Colnaghi]; purchased in London in 1954.

BIBLIOGRAPHY: Bénard, 1810, part I, p. 133, no. 3100; J. Hédou, *Jean de Saint-Igny*, Rouen, 1887, p. 46; *Exhibition of Old Master Drawings. P. and D. Colnaghi and Co.*, London, 1954, no. 16; *Annual Report*, 1954–1955, p. 18; Rosenberg, 1971, p. 87, fig. 4; Rosenberg, 1972, p. 11; *France in the Golden Age. Seventeenth-Century French Paintings in American Collections*, exhibition catalogue by P. Rosenberg, The Metropolitan Museum of Art, New York, 1982, p. 317.

Rogers Fund, 1954
54.142

JACQUES SARAZIN

Noyen 1592 – Paris 1660

280. *Bacchanal: Drunken Silenus Helped onto His Ass*

Black chalk. Framing lines in red chalk. 9.2 x 20.1 cm.

Inscribed in pen and brown ink at lower left, *Sarasin.*

PROVENANCE: Pierre Crozat ? (2403 with the paraph, Lugt 2951); marquis de Chennevières (Lugt 2073); Chennevières sale, Paris, Hôtel Drouot, April 4–7, 1900, part of no. 464; [Wildenstein]; purchased in New York in 1961.

BIBLIOGRAPHY: Chennevières, *L'Artiste*, XI, 1896, part XIV, p. 259, "Bacchanale; Silène sur son âne, et entouré et soutenu par des Satyres et des Bacchantes. À la pierre noire; collection Crozat"; *Annual Report*, 1961–1962, p. 66; Rosenberg, 1972, p. 210, under no. 133; Fogg Art Museum, 1980, p. 44, under no. 4; Rouen, 1984, p. 34, under no. 32.

Rogers Fund, 1961
61.161.3

It has been noted that similar inscriptions, *Sarasin* or *Sarrasin*, all probably in the same hand, appear on drawings in the Cabinet des Dessins, Musée du Louvre, the Cooper-Hewitt Museum, New York, the Nationalmuseum, Stockholm, the Baderou Collection in Rouen, and in a private collection in New York. To this group should be added a pen and red chalk study for allegorical figures of Virtue and Victory in the British Museum (1946-7-13-1150; Popham, 1935, p. 229).

ISRAËL SILVESTRE

Nancy 1621 – Paris 1691

281. *View of the Ponte Vecchio, Seen from the Uffizi in Florence*

Gray, green, and pink wash, over graphite. 26.3 x 42.1 cm.

PROVENANCE: Earl of Abingdon; sale, London, Sotheby's, July 17, 1935, part of no. 5; [Colnaghi]; Sir Bruce S. Ingram (Lugt Supp. 1405a, with the letter *A* below); [Colnaghi]; purchased in London in 1963.

BIBLIOGRAPHY: J. J. Byam Shaw, *Mitteilungen des Kunsthistorischen Institutes in Florenz*, VIII, 3, 1959, pp. 174–178, fig. 3; Van Hasselt, 1961, no. 147, pl. 63 (with additional bibliography); *Annual Report*, 1963–1964, p. 62; Rosenberg, 1971, p. 91, fig. 26; Dayton, Ohio, 1971, no. 5, repr.; Rosenberg, 1972, p. 211, under no. 134; Thuillier, 1982, repr. p. 350, p. 352 (not exhibited).

Rogers Fund, 1963
63.167.1

Sava sin

247

282. *Fountain with a Rock Arch in a Park*

Pen and brown ink, gray wash. Framing lines in pen and black ink.
25.4 x 42.5 cm. Horizontal crease below center. Lined.

PROVENANCE: Marquis de Chennevières (Lugt 2072); Chennevières
sale, Paris, Hôtel Drouot, April 4–7, 1900, probably part of no. 473;
[Feist]; purchased in New York in 1973.

BIBLIOGRAPHY: *European Master Drawings. Herbert E. Feist*, exhibi-
tion catalogue, New York, 1973, no. 37, repr.; *Annual Report*,
1972–1973, p. 34; Bean, 1975, no. 56.

Rogers Fund, 1973
1973.113

LOUIS DE SILVESTRE

Sceaux 1675 – Paris 1760

283. *The Sacrifice of Manoah* (Judges 13:8–25)

Red chalk. 28.9 x 36.8 cm.

Inscribed in pen and brown ink at lower left, *L. de Silvestre fecit.*; in pencil at lower right, *L de Silvestre fecit.*

PROVENANCE: [Seiferheld]; Christian Humann; sale, New York, Sotheby Parke Bernet, June 12, 1982, no. 33, repr., purchased by the Metropolitan Museum.

BIBLIOGRAPHY: *Master Drawings, Paintings, Gouaches, Watercolors. Seiferheld and Company, Inc. Autumn 1968, No. 15*, New York, 1968, no. 27, repr.; *Annual Report*, 1982–1983, p. 23.

Purchase, David L. Klein, Jr. Memorial Foundation, Inc. Gift, 1982
1982.173

The same subject, quite differently composed and vertical in format, occurs in a painting by Louis de Silvestre in Dresden that is signed and dated 1732 (H. Marx, *Staatliche Kunstsammlungen Dresden. Gemäldegalerie alte Meister. Die Gemälde des Louis de Silvestre*, Dresden, 1975, no. 1, repr.).

JACQUES STELLA

Lyon 1596 – Paris 1657

284. *Five Men Moving a Block of Stone*

Pen and brown ink, gray wash, over traces of black chalk. Framing lines in red chalk, pen and brown ink, and yellow wash. 16.5 x 25.4 cm. Lined.

Initialed in pen and brown ink on the block of stone, *JS* (interlaced); inscribed in pen and brown ink at lower right, *Stella*.

PROVENANCE: Paignon-Dijonval; vicomte Morel de Vindé (see Lugt 2520); [Colnaghi]; purchased in London in 1962.

BIBLIOGRAPHY: Bénard, 1810, part I, p. 123, part of no. 2822, as Antoine Bouzonnet Stella; *Annual Report*, 1962–1963, p. 63; Rosenberg, 1972, p. 213, under no. 137; Davidson, 1975, p. 147–157, pl. 11 and repr. on cover.

Rogers Fund, 1962
62.130.3

The drawing was one of fourteen scenes of popular life that figured in the Paignon-Dijonval collection under the name of Antoine Bouzonnet Stella; Gail S. Davidson has convincingly proposed an alternative attribution to Jacques Stella. In addition to our drawing, four further genre scenes from the group of fourteen are known today: one is in the Ashmolean Museum, Oxford, another in the Fogg Art Museum, Cambridge, Mass., and two in a private collection in New York (repr. Davidson, 1975, pls. 10, 13, 12, and 14, respectively).

PIERRE SUBLEYRAS

Saint-Gilles (Gard) 1699 – Rome 1749

285. *St. Benedict Resuscitating an Infant*

Black chalk, heightened with white, on gray-green paper. 22.2 x 15.5 cm.

PROVENANCE: Sale, London, Christie's, November 26–27, 1973, no. 276, repr.; [Stein]; purchased in Paris in 1973.

BIBLIOGRAPHY: *Annual Report*, 1974–1975, p. 51; Bean, 1975, no. 57; *Rome in the 18th Century*, 1978, n.pag. [17].

Harry G. Sperling Fund, 1974
1974.354

Study, with variations, for a painting executed in 1744 for the Olivetan Benedictines of Perugia; the picture is now in S. Francesca Romana, Rome (repr. H. Voss, *Die Malerei des Barock in Rom*, Berlin, 1924, p. 404). The oil sketch in the Louvre corresponds more closely to the painting (Rosenberg, Reynaud, Compin, 1974, II, no. 786, repr.).

JEAN-THOMAS THIBAULT

Montier-en-Der (Haute-Marne) 1757 – Paris 1826

286. *A Road below the Villa d'Este at Tivoli*

Pen and brown ink, brown wash and watercolor, over traces of graphite and black chalk. 25.8 x 33.7 cm.

Initialed in pen and brown ink on rock at lower left, *I·T·T·*

PROVENANCE: [Hazlitt, Gooden and Fox]; purchased in London in 1978.

BIBLIOGRAPHY: *Nineteenth Century French Drawings. Hazlitt, Gooden and Fox*, exhibition catalogue, London, 1978, no. 2, pl. 7; *Annual Report*, 1978–1979, p. 25.

Purchase, Mr. and Mrs. David T. Schiff Gift, 1978
1978.292.1

In the right background can be seen the walls supporting the upper gardens of the Villa d'Este, and the campanile of S. Maria Maggiore.

ROBERT LEVRAC DE TOURNIÈRES

Caen 1667 – Caen 1752

287. *Portrait of a Gentleman in an Oval Field*

Black and white chalk, stumped, gray wash, white gouache, on gray-green paper. Squared in black chalk. Framing lines in pen and brown ink. 31.1 x 24.9 cm.

PROVENANCE: Jacques-Auguste Boussac (Lugt Supp. 729b); Boussac sale, Paris, Galerie Georges Petit, May 10–11, 1926, no. 96, repr. p. 48, "Portrait d'un magistrat"; Jean-Pierre Selz; John M. Brealey.

BIBLIOGRAPHY: Bataille in Dimier, 1928, p. 241, dessin no. 6; *Annual Report*, 1984–1985, pp. 24–25.

Gift of John M. Brealey, 1984
1984.456

PIERRE-CHARLES TRÉMOLIÈRES

Cholet 1703 – Paris 1739

288. *The Ascension of Christ*
VERSO. *Head of a Bearded Man Looking Down*

Black chalk and charcoal, stumped, heightened with white, on gray-blue paper (recto); black and red chalk, charcoal, stumped, heightened with white (verso). 81.0 x 47.1 cm. Arched top. The support consists of two sheets joined horizontally 22.8 cm. from lower margin. Several horizontal creases; pigment stain at upper right of verso.

Inscribed in pen and brown ink at lower left, *Vanloo*.

PROVENANCE: Sale, Monte Carlo, Sotheby's Monaco, December 8, 1984, no. 56, recto repr.; [Cailleux]; purchased in Paris in 1985.

BIBLIOGRAPHY: *Annual Report*, 1984–1985, p. 26.

Harry G. Sperling Fund, 1985
1985.102

A large design, with a number of variations, for the *Ascension* painted by Trémolières for the church of the Charterhouse of Lyon, Saint-Bruno-des-Chartreux (Mé-

janès and Vilain, 1973, p. 69, no. 17, pl. XXXIII). The painting, signed and dated 1737, is still in place in the left transept of the church, in a magnificent frame designed by the architect Soufflot.

The head of the bearded man on the verso, looking down and resting his cheek on his hand, does not seem to be related to the Ascension composition, nor to that of the *Assumption of the Virgin* that Trémolières painted for the opposite transept in the same year, 1737.

LOUIS TRINQUESSE

Born ca. 1745 – Died after 1797

289. *Profile Bust of an Officer*

Red chalk. Diameter 21.3 cm. Gray spot at lower right. Lined.

Signed in red chalk at lower margin, *L. Trinquesse. f.*

PROVENANCE: [Galerie de Bayser et Strolin]; purchased in Paris in 1967.

BIBLIOGRAPHY: *Annual Report*, 1967–1968, p. 87; J. Wilhelm, *Revue de l'Art*, 25, 1974, p. 60, fig. 14.

Rogers Fund, 1967
67.150

The subject is identified in an old inscription on the now-detached backing as "Reddy de La Grange, Colonel de gendarmerie."

FRANÇOIS DE TROY

Toulouse 1645 – Paris 1730

290. *Gentleman Seated at a Table*

Black chalk, heightened with white, on beige paper. 45.5 x 29.0 cm. Margins irregular.

Inscribed in pencil at lower left, *De Troy*; numbered at lower right, 27 and 395.

PROVENANCE: [Galerie de Bayser]; purchased in Paris in 1982.

BIBLIOGRAPHY: *Annual Report*, 1981–1982, p. 23.

Purchase, Mrs. Carl L. Selden Gift, in memory of Carl L. Selden, 1982
1982.63

de Croy.

CARLE VANLOO

Nice 1705 – Paris 1765

291. *Huntress with a Horn*

Red chalk. Traces of framing lines in pen and brown ink. Verso: ground plan of the central hall of the Palazzina di Caccia at Stupinigi in pen and brown ink, and elevations in red chalk. 42.0 x 27.5 cm. Horizontal crease at center; scattered stains.

Inscribed in red chalk at lower margin, *Studio Originale fatto da Carlo Vanlóo | p. la volta della palazzina del Ré | di Sardegna detta | Stupinigi.*

PROVENANCE: Cephas G. Thompson.

BIBLIOGRAPHY: *Metropolitan Museum Handbook*, 1895, no. 795; Benisovich, 1943, p. 70, p. 72, fig. C, p. 73; M. N. Benisovich, *Art Quarterly*, XXII, 1, 1959, p. 58, fig. 3, p. 59; Griseri, 1963, p. 123, no. 428, pl. 220; Dayton, Ohio, 1971, no. 11, repr.; Rosenberg, 1972, p. 217, under no. 141; M. Geiger in *Musée des Beaux-Arts de Dijon. Dessins de la collection His de la Salle*, Dijon, 1974, p. 95; Sahut, 1977, no. 326, repr., not exhibited; Roli and Sestieri, 1981, p. 7, pl. 8.

Gift of Cephas G. Thompson, 1887
87.12.125

Study for a nymph holding a hunting horn who appears in the fresco *Diana Resting after the Hunt*, painted by Vanloo in 1733 on the ceiling of the queen's bedroom in the Palazzina di Caccia at Stupinigi near Turin (repr. Mallè, 1981, pp. 130–136). At the Musée des Beaux-Arts, Dijon, there is a red chalk study for a reclining nymph in the same composition; the inscription on the Dijon drawing, *Originale di Carlo Vanloo*, is in the same hand as that on our drawing (Sahut, 1977, no. 325, repr.).

The Metropolitan Museum recently acquired another drawing related to decorations at Stupinigi. This is a *Vision of St. Hubert* by the Piedmontese painter Vittorio Amedeo Rapous (1983.131.2, Harry G. Sperling Fund); it is his study for an altarpiece of 1768 for a small oratory in the king's apartments in the Palazzina di Caccia (Mallè, 1981, repr. opp. p. 206, p. 209).

292. *Allegorical Composition in Honor of George I, King of England*

Red chalk on beige paper. Framing lines in pen and brown ink at lower margin. 66.5 x 44.6 cm. The support consists of two sheets of paper joined horizontally at center. Scattered creases and stains. Lined.

Inscribed in pen and brown ink at lower right margin, *C. vanloo.*

PROVENANCE: Purchased in New York in 1980.

BIBLIOGRAPHY: Sahut, 1977, no. 468, "dessin perdu"; *Annual Report*, 1979–1980, p. 27.

Harry G. Sperling Fund, 1980
1980.13

Full-scale design for an inscription plate dedicated to George I, king of England, in McSwiny's *Tombeaux des princes, des grands capitaines et autres hommes illustres qui ont fleuri dans la Grande Bretagne vers la fin du XVII et le commencement du XVIII siècle*, which appeared in 1741 (for this curious publication see F. Haskell, *Patrons and Painters*, New York, 1963, pp. 287–292). There are a number of significant differences between this drawing and the inscription plate as engraved by Nicolas Dorigny, especially in the figures that flank the Garter Star at the top of the composition (for the engraving see *Inventaire 17ᵉ siècle*,

C. vanloo.

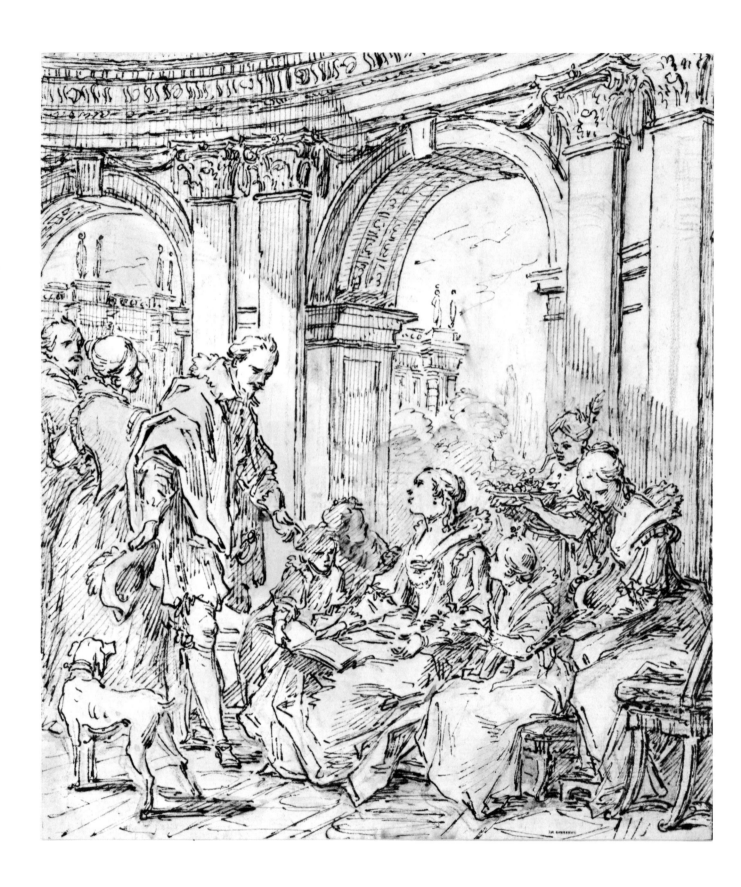

III, 1954, p. 503, no. 108). The definitive design for the upper part of the composition is recorded in a large wash drawing by Vanloo in the State Hermitage Museum, Leningrad (*Disegni dell' Europa Occidentale dall' Ermitage di Leningrado*, exhibition catalogue, Gabinetto Disegni e Stampe degli Uffizi, Florence, 1983, no. 99, fig. 95).

293. *A Costume Piece: La Conversation Espagnole*

Pen and brown ink, brown wash, over black chalk. 25.5 x 22.3 cm.

PROVENANCE: Émile Norblin; Norblin sale, Paris, Hôtel Drouot, March 16–17, 1860, *Supplément* no. 16; D.-G. d'Arozarena; Arozarena sale, Paris, Hôtel Drouot, May 29, 1861, no. 92; Edmond and Jules de Goncourt (Lugt 1089); Goncourt sale, Paris, Hôtel Drouot, February 15–17, 1897, no. 332; [Cailleux]; purchased in Paris in 1983.

BIBLIOGRAPHY: Paris, École des Beaux-Arts, 1879, no. 535, lent by E. de Goncourt; Chennevières, 1880, p. 102; Goncourt, 1881, I, p. 169; Réau, 1938, p. 82, no. 31; Sahut, 1977, p. 75, under no. 147; *Annual Report*, 1983–1984, p. 24; *Notable Acquisitions*, 1983–1984, p. 71, repr.

Harry G. Sperling Fund, 1983
1983.299

Study for a painting commissioned from Vanloo by his friend and patroness, Mme Geoffrin. One of her friends, the baron de Grimm, reported in the *Correspondance littéraire* for October 1754 that the painting, which he acclaimed as one of Vanloo's finest, was executed by the artist under the watchful eye of Mme Geoffrin, a woman of decided taste. The drawing differs in many ways from the finished painting, which is now in the State Hermitage Museum, Leningrad (Sahut, 1977, no. 147, repr.).

The subject of the composition is ambiguous, perhaps deliberately so. Mme Geoffrin referred to the painting as a *galanterie*. For Grimm it represented a widowed Flemish countess, her daughter beside her, receiving the visit of a suitor. When the picture was shown at the Salon of 1755 it was called simply *Une conversation*, and in the Salon of 1769 a reproductive print by B.-F. Beauvarlet was exhibited with the title *La conversation espagnole*. However, the adjective *espagnole* probably alludes to the fancy-dress "Spanish" costumes worn by the cast of characters—wide lace collars, slashed sleeves, and the gentleman's broadbrimmed hat with a plume.

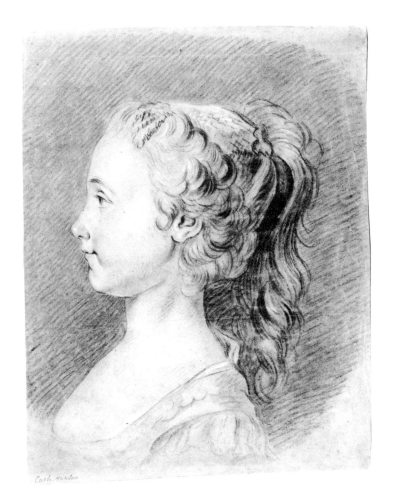

294. *The Artist's Daughter, Marie-Rosalie Vanloo*

Charcoal, stumped, gray wash, heightened with white, on beige paper. 36.1 x 28.3 cm. Horizontal crease below center.

Inscribed in pen and brown ink at lower left, *Carle vanloo*.

PROVENANCE: [Schab]; Richard and Trude Krautheimer.

BIBLIOGRAPHY: *Master Drawings and Prints 1500–1960. William H. Schab Gallery, Catalogue Forty-Eight*, New York, n.d., no. 154, repr.; *Annual Report*, 1974–1975, p. 50; Sahut, 1977, no. 399, repr., not exhibited.

Gift of Richard and Trude Krautheimer, 1974
1974.366

A similar drawing of Marie-Rosalie, signed *Carle Vanloo*, was reproduced in the crayon manner on blue paper by Louis-Marin Bonnet (Hérold, 1935, pp. 53–54, no. 55A).

295. *The Sacrifice of Iphigenia*

Pen and brown ink, brown, blue, red, and pale yellow wash, heightened with white, over traces of black chalk, on brown-washed paper. 75.2 x 93.4 cm. The sheet consists of fourteen pieces of cream-colored paper mounted on a paper support.

Signed in pen and brown ink at lower left, *Carle Vanloo*; the old mount bore an inscription in pen and brown ink, *Questo Dissegno deve ritornare à Madama Vanloô à Parigi. / Per Lorenzo / Somis.*

PROVENANCE: Christine Vanloo, the artist's widow; her posthumous sale, Paris, April 30, 1785, no. uncertain; Chariot; Chariot sale, Paris, January 28, 1788, no. 121; [Duits]; purchased in London in 1953.

BIBLIOGRAPHY: *Annual Report*, 1953, p. 23; F. H. Dowley, *Master Drawings*, V, 1, 1967, pp. 42–47, fig. 1 (the painting), pl. 32 (our drawing); London, Royal Academy, 1968, no. 449, fig. 153; Gillies and Ives, 1972, no. 33; Rosenberg, 1972, p. 217, under no. 141; Sahut, 1977, no. 363, repr., not exhibited; Athens, 1979, no. 56, repr.

Rogers Fund, 1953
53.121

Preliminary *ébauche* for a large painting commissioned by Frederick II, king of Prussia, for the marble hall of the Neues Palais at Potsdam, and shown in the Salon of 1757 (Sahut, 1977, no. 158, repr.). The sketch differs in many ways from the painting, where the composition is reversed and crowded with more accessory figures.

In the Musée des Beaux-Arts, Quimper, there is a black chalk study for the figure of Agamemnon as he appears in the painting (Sahut, 1977, no. 364, repr.).

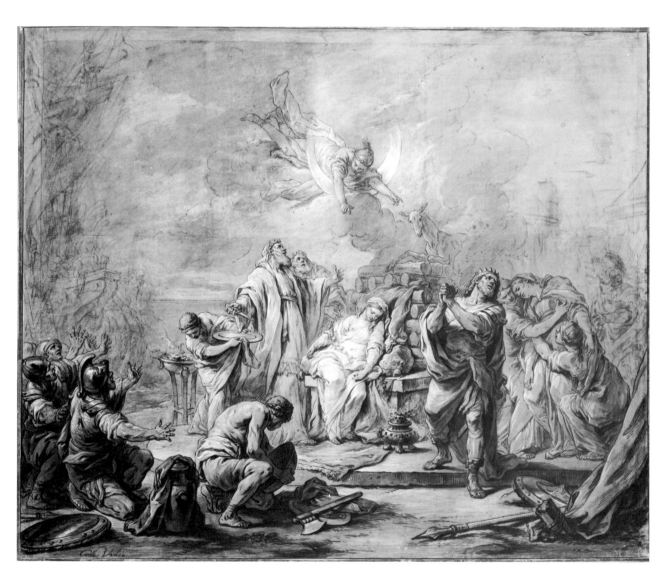

SIX SCENES FROM
THE LIFE OF ST. GREGORY
THE GREAT, NOS. 296–301

296. *St. Gregory Distributing His Worldly Goods to the Poor*

Pen and brown ink, brown and gray wash, heightened with white, over traces of graphite. 21.8 x 12.9 cm. Arched top. A *pentimento* with the figures of St. Gregory and two assistants has been added at left. Lined. The old mount, measuring 31.6 x 20.7 cm., includes an engraved frame.

Inscribed in pen and brown ink on a strip of paper affixed to the lower margin of old mount, *Saint Grégoire, à l'imitation des apôtres, vend tous ses biens, et / les distribue aux pauvres.*; signed at lower right, *Carle Vanloo.*

PROVENANCE: Carle Vanloo sale, Paris, September 12, 1765, part of no. 11 (seven drawings); Jacques-Augustin de Silvestre; Silvestre sale, Paris, February 28 – March 25, 1811, part of no. 558 (seven drawings); Marius Paulme; sale, Paris, Galerie Georges Petit, April 27, 1932, no. 39 (six drawings); sale, Paris, Palais Galliera, December 14, 1960, no. 9 (six drawings, three repr.); private collection, Paris; [Galerie de Bayser]; purchased in Paris in 1977.

BIBLIOGRAPHY: Dandré-Bardon, 1765, p. 66, "Liste des Ouvrages . . . 1762. Sept desseins de la vie de S. Grégoire; mêmes sujets et compositions différentes des esquisses peintes. Chez M. Silvestre"; Paris, 1900, p. 42, no. 301, "Dessins pour la décoration de la chapelle Saint-Grégoire, aux Invalides. Collection de M. Marius Paulme"; M. Sandoz, *Gazette des Beaux-Arts*, LXXVII, 1971, pp. 129–144, the drawings repr. p. 133, figs. 8–9; Sahut, 1977, nos. 367–372, repr. (with additional bibliography); *Dessins de maîtres anciens*, 1977. *Galerie de Bayser*, Paris, 1977, nos. 24–29, repr.; *Annual Report*, 1977–1978, p. 37; *Diderot*, 1984, pp. 376–382.

Harry G. Sperling Fund, 1977
1977.416e

One of the great pictorial enterprises of the last years of the reign of Louis XIV was the decoration of the Dôme des Invalides; Charles de La Fosse, Jean Jouvenet, Noël Coypel, Louis de Boullongne, Bon Boullongne, and Michel Corneille were all involved. Michel Corneille painted seven scenes of the life of St. Gregory the Great in one of the four corner chapels dedicated to the doctors of the Latin Church. Six of these scenes occupied arch-topped or shaped (*chantourné*) fields on the curved walls of the upper story of the chapel, while a representation of the saint in glory figured in a circular field on the domed ceiling. Not long after their completion, Corneille's decorations were engraved by Cochin le père, as were all the other paintings in the church.

Most of the painted decoration in the Dôme des Invalides has survived, but by the middle of the eighteenth century Michel Corneille's paintings had suffered so severely from dampness that the royal administration decided to replace them. Carle Vanloo, *premier peintre*, was asked to supply designs for a new St. Gregory cycle. According to his fellow academician and biographer Michel-François Dandré-Bardon, it was in 1762 that Vanloo executed the six drawn projects catalogued here, and in addition a now lost design for the circular composition with *St. Gregory in Glory*. Vanloo cut his drawings to the shape of Corneille's painted compositions and pasted them onto Cochin's engravings in such a way that the sculptured frames of the paintings—permanent architectural features of the chapel—were visible. Thus these models gave a clear notion of how the finished paintings would appear in the chapel.

Two years later, according to Dandré-Bardon, Vanloo executed seven oil sketches in which the compositions were further refined. Vanloo died before the paintings could be undertaken, and the seven oil sketches were shown in the posthumous exhibition of his work in the Salon of 1765.

Judging from the engravings, Corneille's depictions of the life of Gregory were stilted and uninspired. Vanloo borrowed nothing from Corneille and even changed the subjects of five of the paintings. Employing an up-to-date narrative style, Vanloo created easily legible compositions full of touching genre details. These scenes from the life of St. Gregory are felicitous testimony to Vanloo's mastery of narrative painting, *la peinture d'histoire*.

After Vanloo's death, the commission for the redecoration of the chapel of St. Gregory was given to Gabriel-François Doyen, who executed a series of dramatic compositions entirely different from those projected by Vanloo. Doyen's figures are conceived on an heroic scale and are seen in steep perspective from below (Sandoz, 1981, pp. 50–60, figs. 1–8).

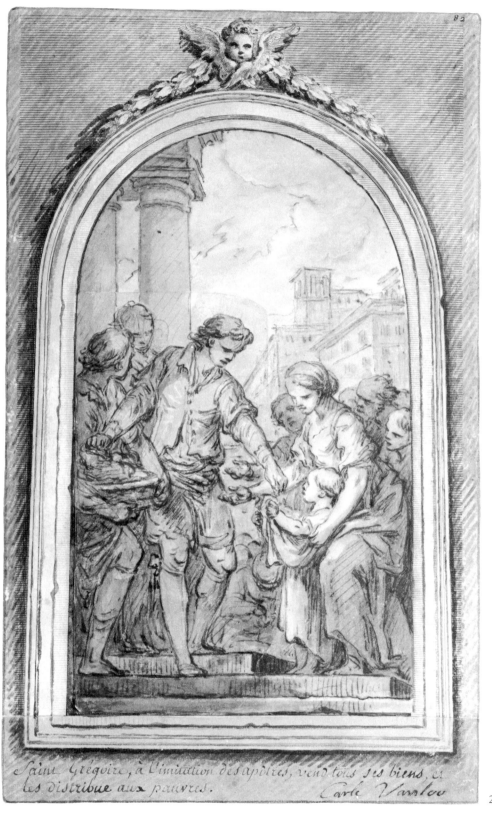

Saint Grégoire, à l'imitation des apôtres, vend tous ses biens, et
les distribue aux pauvres. Carle Vanloo

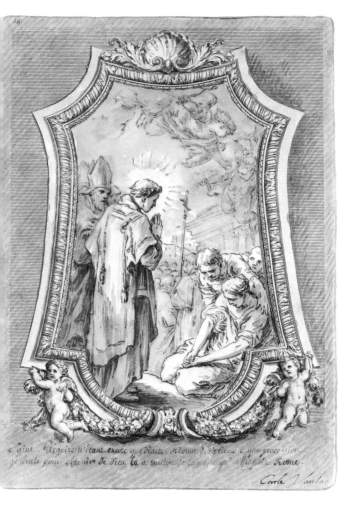

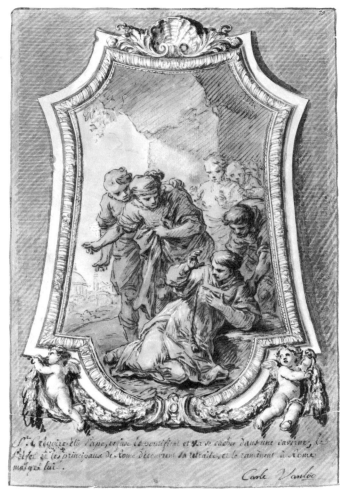

CARLE VANLOO

297. *St. Gregory as Deacon Directing Prayers and Processions for the Cessation of the Plague*

Pen and brown ink, brown and gray wash, heightened with a little white, over traces of graphite. 20.1 x 13.9 cm. *Chantourné*. Lined. The mount, measuring 31.0 x 22.6 cm., includes an engraved frame. The old mount somewhat abraded at lower margin.

Inscribed in pen and brown ink on a strip of paper affixed to the lower margin of old mount, *Saint Grégoire n'étant encore que diacre ordonne des prières et une procession / générale pour obtenir de dieu la cessation de la peste qui affligeoit Rome.*; signed at lower right, *Carle Vanloo.*

Harry G. Sperling Fund, 1977
1977.416a

For provenance, bibliography, and comment, see No. 296 above.

298. *St. Gregory Reluctant to Accept His Election as Bishop of Rome*

Pen and brown ink, brown and gray wash, heightened with white, over slight traces of graphite. 20.3 x 13.9 cm. *Chantourné*. Lined. The mount, measuring 30.8 x 23.1 cm., includes an engraved frame.

Inscribed in pen and brown ink on a strip of paper affixed to the lower margin of old mount, *S.¹ Grégoire élû Pape, refuse le pontificat et va se cacher dans une caverne, le / Préfet et les principaux de Rome découvrent sa retraite et le ramènent à Rome / malgré lui.*; signed at lower right, *Carle Vanloo.*

Harry G. Sperling Fund, 1977
1977.416d

For provenance, bibliography, and comment, see No. 296 above.

299. *The Clergy of Rome Paying Homage to St. Gregory after His Investiture*

Pen and brown ink, brown and gray wash, heightened with a little white, over traces of graphite. 20.3 x 13.7 cm. *Chantourné*. Lined. The mount, measuring 30.8 x 23.1 cm., includes an engraved frame.

Inscribed in pen and brown ink on a strip of paper affixed to lower margin of old mount, *Saint Grégoire au moment de son installation, reçoit l'adoration / de son Clergé*; signed at lower right, *Carle Vanloo*.

Harry G. Sperling Fund, 1977
1977.416c

For provenance, bibliography, and comment, see No. 296 above.

300. *The Mass of St. Gregory*

Pen and brown ink, brown and gray wash, heightened with white, over traces of graphite and a little black chalk. 20.1 x 13.9 cm. *Chantourné*. Lined. The mount, measuring 31.1 x 23.1 cm., includes an engraved frame. The old mount abraded at lower right.

Inscribed in pen and brown ink on a strip of paper affixed to lower margin of old mount, *S.ᵗ Grégoire pour convertir une femme qui se mocquoit de la transsubstantiation obtient de Dieu / par ses prières que l'hostie consacrée laissât voir la chair et le sang. . . . / apparences; cette femme frappée d'un si grand miracle, déteste son hérésie. . . .*; signed at lower right, *Carle Vanloo*.

Harry G. Sperling Fund, 1977
1977.416f

For provenance, bibliography, and comment, see No. 296 above.

301. *St. Gregory Dictating His Homilies to a Secretary*

Pen and brown ink, brown and gray wash, over graphite. 22.0 x 12.9 cm. Arched top. Three *pentimenti*: one covering the lower third of the composition, one for the figure of the secretary, and one for the two candles and St. Gregory's right hand. Lined. The mount, measuring 32.1 x 20.8 cm., includes an engraved frame. The drawing somewhat abraded at left.

Inscribed in pen and brown ink on a strip of paper affixed to lower margin of old mount, *Saint Grégoire dictant ses homélies à un de ses Secrétaires*; signed at lower right, *Carle Vanloo*.

Harry G. Sperling Fund, 1977
1977.416b

For provenance, bibliography, and comment, see No. 296 above.

299

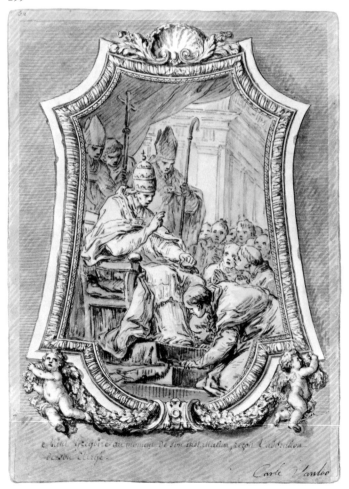

300

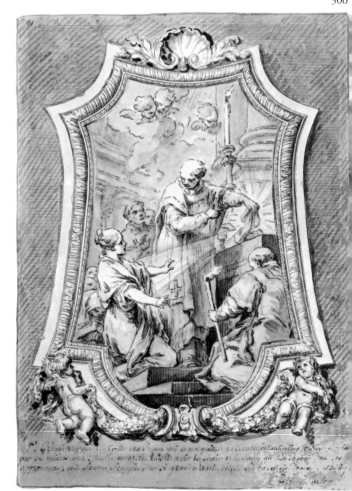

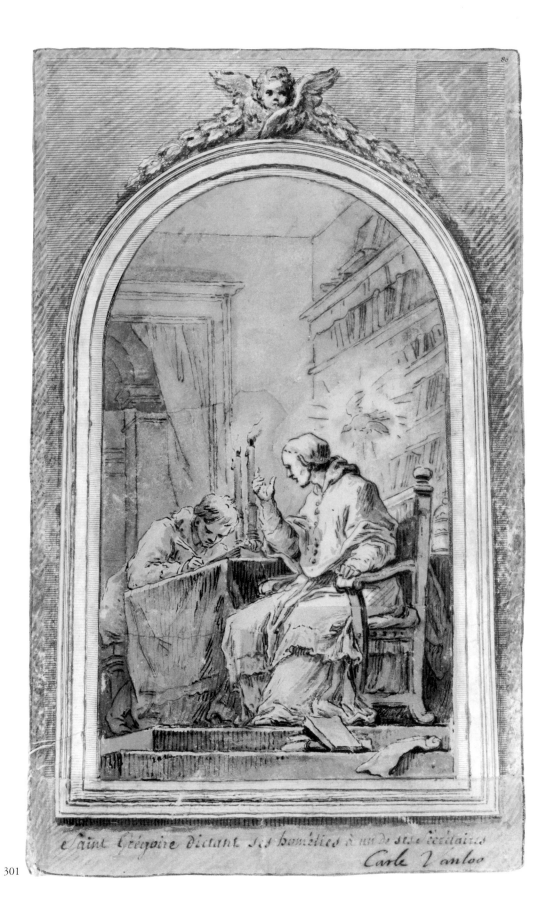

Saint Grégoire dictant ses homélies à un de ses secrétaires

Carle Vanloo

301

LOUIS-CLAUDE VASSÉ

Paris 1716 – Paris 1772

302. *Venus Teaching Cupid to Use His Bow*

Red chalk. Framing lines in pen and black ink. 39.1 x 24.6 cm.
Lined.

Inscribed in pen and brown ink on reverse of old mount, *Vassé*.

PROVENANCE: Germain Seligman (his mark, interlaced GS, not in
Lugt); Christian Humann; sale, New York, Sotheby Parke Bernet,
April 30, 1982, no. 67, repr., purchased by the Metropolitan Mu-
seum.

BIBLIOGRAPHY: *Annual Report*, 1981–1982, p. 23.

Harry G. Sperling Fund, 1982
1982.94.2

Study for, or record of, a marble group, *Vénus instruisant
l'Amour à tirer de l'arc*, now in the Musée de Versailles.

The work was commissioned from Vassé by the Bâti-
ments du Roi in 1749, finished by 1761, and in 1771
given by Louis XV to Mme du Barry for her pavilion at
Louveciennes.

Why Cupid's bow is lacking in the drawing is unclear,
and the original form and position of the bow is not
known. In the course of the nineteenth century the mar-
ble Cupid lost his left forearm and his bow. These features
were replaced in a very awkward restoration of the group
made as recently as 1921 (the statue before restoration
repr. *Archives de l'Art français*, XIV, 1927, pl. XIII; after
restoration, *Gazette des Beaux-Arts*, IV, 1930, repr. opp.
p. 46).

FRANÇOIS VERDIER

Paris 1651 – Paris 1730

303. *The Harpies Driven from the Table of King
Phineus by Zetes and Calais*

Black chalk, gray wash, heightened with white, on beige paper. 26.1
x 49.2 cm. (overall). The sheet is made up of three pieces of paper
joined vertically 6.0 cm. from left margin and 6.5 cm. from right
margin. Vertical crease at center. Lined.

PROVENANCE: [Colnaghi]; purchased in London in 1967.

BIBLIOGRAPHY: *Annual Report*, 1967–1968, p. 87.

Rogers Fund, 1967
67.95.7

GUY-LOUIS VERNANSAL

Fontainebleau 1648 – Paris 1729

304. *The Wedding Feast of Bacchus and
Ariadne*

Pen and brown ink, gray wash, heightened with white, over red chalk,
on beige paper. 19.5 x 57.5 cm. Two arches cut out at lower margin.
Vertical crease at center. Lined.

Inscribed in pen and brown ink at lower center of old mount, LEBRUN.

PROVENANCE: Charles Le Blanc; Le Blanc sale, Paris, December
3–6, 1866, no. 410, as Le Brun; [Seiferheld]; purchased in New York
in 1964.

BIBLIOGRAPHY: *Annual Report*, 1963–1964, p. 62, as Le Brun; Rosenberg, 1972, p. 174, under no. 75, as Le Brun; M. O'Neill, *Musée des Beaux-Arts d'Orléans. Catalogue critique. Les peintures de l'école française des XVIIᵉ et XVIIIᵉ siècles*, Nantes, 1981, I, p. 147, under no. 194; M. O'Neill, *Master Drawings*, XX, 3, 1982, pp. 259–260, fig. 1 (the painting in Orléans), pl. 9 (our drawing).

Rogers Fund, 1964
64.3

The drawing had been attributed to Charles Le Brun until Mary O'Neill pointed out that it is clearly a study, with many variations, for a very large canvas by Vernansal signed and dated 1709, now in the reserves of the Musée des Beaux-Arts, Orléans. The painting seems to have been intended for the upper part of a wall pierced by two arched doorways.

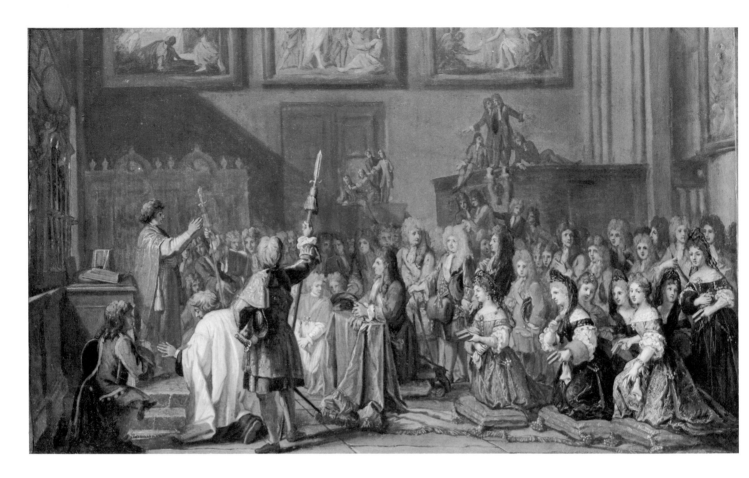

GUY-LOUIS VERNANSAL

305. *Louis XIV in Notre-Dame de Paris on
January 30, 1687, at a Thanksgiving
Service after His Recovery from a Grave
Illness*

Oil paint on paper, mounted on canvas. 43.0 x 75.8 cm.

Inscribed in brush and brown paint on stretcher, *Messe de Louis XIV
donné par le Duc de Mouchy* [?].

PROVENANCE: [Lynven]; purchased in New York in 1984.

BIBLIOGRAPHY: D. Meyer, *L'histoire du roy*, Paris, 1980, p. 135;
Annual Report, 1983–1984, p. 24.

Harry G. Sperling Fund, 1984
1984.400

Preparatory sketch for the cartoon of a Gobelins tapestry
intended for the continuation of *L'histoire du roi* of Charles
Le Brun. Vernansal was paid for his finished cartoon in
1716, but the tapestry was never woven (Fenaille, II,
1903, p. 100).

On the occasion of this visit the king was accompanied
by the Dauphin and the Dauphine, and by his brother and
sister-in-law, Monsieur and Madame; they are presum-
ably among the figures in attendance behind the king.

In this historical reconstruction Vernansal has taken a
certain liberty in indicating at upper left the lower part of
his own painting, *Jesus Resuscitating the Daughter of Jairus*
(now in the Musée d'Arras), a *May* for Notre-Dame in
1689, thus two years later than the event represented
here. The other two *Mays* cannot be identified today, nor
can the large painting at the extreme right.

CLAUDE-JOSEPH VERNET

Avignon 1714 – Paris 1789

306. *The Castel Nuovo in Naples, with a View of Mount Vesuvius*

Pen and brown ink, brown and gray wash, over black chalk. 33.4 x 49.4 cm. Lined.

Inscribed in pen and brown ink at lower left, XXIIII *tour duchateau Neuf a Naples*; at lower margin of old mount, *Vernett*.

PROVENANCE: Private collection, Vienna (according to vendor); sale, Versailles, March 13, 1966, no. 171; [Cailleux]; purchased in Paris in 1976.

BIBLIOGRAPHY: Conisbee, 1976, no. 57, repr.; *Annual Report*, 1976–1977, p. 45.

Harry G. Sperling Fund, 1976
1976.334.1

CLAUDE-JOSEPH VERNET

307. *Bridge in the Campagna*

Brown and gray wash, over black chalk. 28.6 x 46.0 cm. Lined.

Inscribed in pen and brown ink at lower margin of old mount, *Vernett*.

PROVENANCE: Private collection, Vienna (according to vendor); sale, Versailles, March 13, 1966, no. 152, repr.; [Cailleux]; purchased in Paris in 1976.

BIBLIOGRAPHY: Conisbee, 1976, no. 54, repr.; *Annual Report*, 1976–1977, p. 45; *Rome in the 18th Century*, 1978, n.pag. [18].

Harry G. Sperling Fund, 1976
1976.334.2

JOSEPH-MARIE VIEN

Montpellier 1716 – Paris 1809

308. *Maiden Offering Incense before a Statue of Juno*

Oil paint, over pen and brown ink, brown wash, on paper, mounted on canvas. 32.0 x 39.0 cm. Margins masked by strips of varnished paper.

PROVENANCE: Vien sale, Paris, May 17, 1809, and following days, part of no. 94, "Esquisses sur papier, sujets grecs . . . une Vestale versant de l'encens sur le feu d'un autel"; sale, Angers, April 30, 1980, no. 261, repr., attributed to J.-B. Pierre; [Lynven]; purchased in New York in 1983.

BIBLIOGRAPHY: *Annual Report*, 1983–1984, p. 24.

Van Day Truex Fund, 1983
1983.429

JOSEPH-MARIE VIEN

309. *Study of a Cope*

Red chalk, heightened with a little white, on beige paper. 41.7 x 26.3 cm.

Inscribed in red chalk at lower left, *Jo. Vien*.

PROVENANCE: Jean de Vichet (Lugt Supp. 1549); [Petit-Horry]; purchased in Paris in 1967.

BIBLIOGRAPHY: *Annual Report*, 1967–1968, p. 87; Gillies and Ives, 1972, no. 45; Rosenberg, 1972, p. 220, under no. 144.

Rogers Fund, 1967
67.116

Study for the cope worn by the kneeling St. Germanus of Auxerre in a painting, *Saint Germain et Saint Vincent*, shown in the Salon of 1755 and now in the Musée de Castres.

FRANÇOIS-ANDRÉ VINCENT
Paris 1746 – Paris 1816

310. *Caricature of the Painter Pierre-Charles Jombert*

Black chalk. 106.5 x 42.7 cm. The support consists of two sheets joined horizontally at center.

Inscribed in pen and brown ink on verso, *n° 17 / 6 Dessins / Charges sur les théatres / par Mauzaise.*

PROVENANCE: Jean-Baptiste Mauzaisse; probably Mauzaisse sale, Paris, March 19, 1845, possibly part of no. 31; [Powney]; purchased in London in 1967; transferred from the Department of Prints and Photographs, 1984.

The Elisha Whittelsey Collection,
The Elisha Whittelsey Fund, 1967
67.275

This exceptionally large caricature represents the painter Pierre-Charles Jombert (see Nos. 135 and 136 above), whose stay at the French Academy in Rome from 1773 to 1776 coincided in part with that of Vincent (there from 1771 to 1775). Vincent drew several portraits of Jombert in which the model is identified by inscriptions (see No. 311 below). The young Jombert was exceedingly tall and thin, with a small and delicately formed head marked by the mysterious illness that was to plague him all his life. His "attributes"—a high, pointed head covering like a nightcap and a curious pair of glasses that seem attached to his headgear—are conspicuous features of the present drawing. Other caricatures by Vincent that show Jombert wearing his high cloth cap are in the Musée Atger in Montpellier, while another was formerly in the Goncourt collection (see *Dessins du Musée Atger*, 1974, p. 31, no. 48).

A counterproof of the present drawing, worked up in brush and brown wash, is preserved in the Cabinet des Dessins, Musée du Louvre (RF 24.233, exhibited *Le théâtre et la danse en France, XVIIème–XVIIIème siècles*, 1959, no. 73). The counterproof in the Louvre is 18 cm. longer than our drawing and includes Jombert's shoes, which are missing here.

This caricature was acquired by the Print Department in 1967 as the work of Vincent's pupil Jean-Baptiste Mauzaisse, on the basis of the old notarial (?) inscription on the reverse. The drawing was probably presented to Mauzaisse by his master Vincent. After Mauzaisse's death the drawing no doubt was mistakenly thought to be his own work. At the time of the transfer of the drawing in

1984 it was recognized as a work by Vincent of exceptional brio, and as the original from which the counterproof now in the Cabinet des Dessins had been made.

In the Louvre there are six additional counterproofs of large caricatures attributed to Vincent; the originals of these have yet to be discovered (RF 24.234–24.239).

311. *Pierre-Charles Jombert, 1774*

Pen and brown ink. 15.4 x 13.3 cm.

Signed and dated in pen and brown ink at lower right, *Vincent R*[ome]. *1774*—; at lower left of old mount, *Jombert (Charles-Pierre) peintre.*

PROVENANCE: Henry Lemonnier (his mark, a brownish-red HL in an oval, not in Lugt); [Galerie de Bayser]; purchased in Paris in 1984.

BIBLIOGRAPHY: *Annual Report*, 1984–1985, p. 26.

Purchase, Mrs. Carl L. Selden Gift, in memory of Carl L. Selden, 1985 1985.6.1

See No. 310 above.

312. *Man Seated at a Keyboard Instrument,* *1774*

Pen and brown ink, brown and gray-brown wash. 32.3 x 20.5 cm. Lined.

Signed and dated in pen and brown ink at lower left, *Vincent f. R*[ome]. *1774*—.

PROVENANCE: [Wildenstein]; purchased in New York in 1974.

BIBLIOGRAPHY: Rosenberg, 1972, p. 222, under no. 147; *Annual Report*, 1973–1974, p. 37; Bean, 1975, no. 59; *Rome in the 18th Century*, 1978, n.pag. [19]; J.-P. Cuzin in *Études*, 1980, p. 99, note 9.

Harry G. Sperling Fund, 1974
1974.46

313. *Youth Sleeping in a Chair*

Black chalk, heightened with white, on beige paper. 45.0 x 33.6 cm. Lined.

PROVENANCE: [Baderou]; purchased in Paris in 1962.

BIBLIOGRAPHY: *Annual Report*, 1962–1963, p. 63; Rosenberg, 1972, p. 221, under no. 146.

Rogers Fund, 1962
62.127.2

The attribution to Vincent, originally proposed by Henri Baderou, is supported by Jean-Pierre Cuzin who suggests that the drawing dates from the beginning of Vincent's stay in Rome (1771–1775).

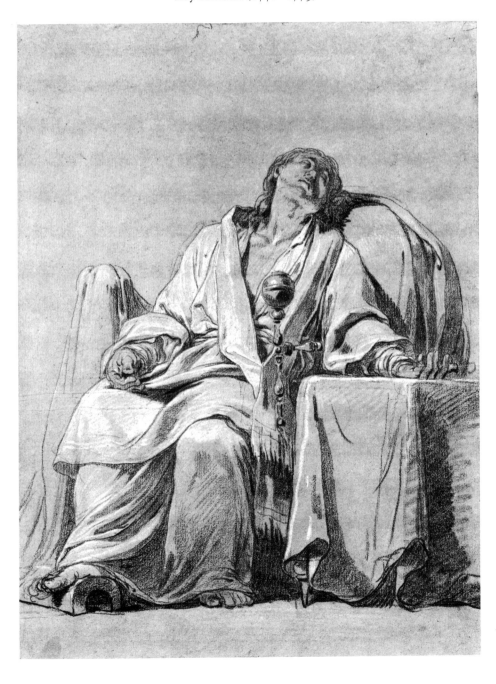

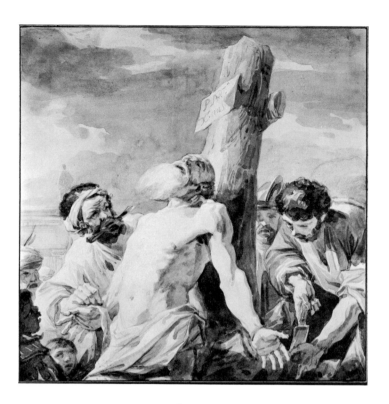

FRANÇOIS-ANDRÉ VINCENT

314. *The Flaying of St. Bartholomew, after Mattia Preti*

Brush and brown wash, over traces of graphite. 29.6 x 29.7 cm. Lined.

Inscribed in brush and brown wash on sign attached to tree trunk, *BART . . . / X!nus*; in pen and brown ink at lower left of old mount in the artist's hand, *d'après le C.*ier *Calabrese. | Vincent Napoli 1774-*.

PROVENANCE: Probably sold in Paris, November 11–15, 1874 (Vente M . . .), part of no. 165; [Petit-Horry]; purchased in Paris in 1973.

BIBLIOGRAPHY: *Annual Report*, 1973–1974, p. 37; Bean, 1975, no. 58; Williams, 1978, no. 71, repr.; Sandoz, 1981, p. 86; J.-P. Cuzin, *Bulletin de la Société de l'Histoire de l'Art français*, 1981 [1983], p. 118, fig. 32, pp. 119, 123–124, note 64.

Harry G. Sperling Fund, 1973
1973.317.2

The painting by Preti that Vincent copied is probably the one now in the Currier Gallery of Art, Manchester, New Hampshire (repr. *Painting in Naples 1606–1705*, exhibition catalogue, Royal Academy, London, 1982, no. 105).

315. *Back View of a Roman Servant Boy*

Black chalk. 30.8 x 16.1 cm. Horizontal crease and two small brown stains at center. Lined.

Inscribed in pencil on reverse of old mount, *Mansuetto domestique | à Rome de | mon grand-père*.

PROVENANCE: Henry Lemonnier (his mark, a brownish-red HL in an oval, not in Lugt); [Galerie de Bayser]; purchased in Paris in 1984.

BIBLIOGRAPHY: H. Lemonnier, *Gazette des Beaux-Arts*, XXX, 1903, p. 105, repr.; *Annual Report*, 1984–1985, p. 26.

Purchase, David L. Klein, Jr. Memorial Foundation, Inc. and Howard J. and Saretta Barnet Gifts, 1985
1985.6.2

Henry Lemonnier's inscription on the reverse of the old mount identifies this rather jaunty dwarf as the servant in Rome of his grandfather, the painter Anicet-Charles-Gabriel Lemonnier. The latter won a *prix de Rome* in 1772 (that reserved from 1770) and was a *pensionnaire* at the French Academy from 1774 to 1780. "Mansuetto," his hands self-assuredly on his hips, faces the spectator and stands beside his master Lemonnier in a pen and ink caricature by Vincent, signed and dated Rome 1775, that is now in the collection of Dr. and Mrs. John C. Weber, New York (*Exposition de dessins et sculptures de maîtres anciens, 1985. Galerie de Bayser*, Paris, 1985, no. 46, repr.).

The servant's nickname Mansuetto (more properly in Italian, Mansueto) may have had a sarcastic intention; this rather cocky servant hardly seems to be the "softie" meant by the Italian adjective *mansueto*.

A counterproof of our drawing is preserved in the Musée Atger, Montpellier (Album M 47 F°, fol. 24).

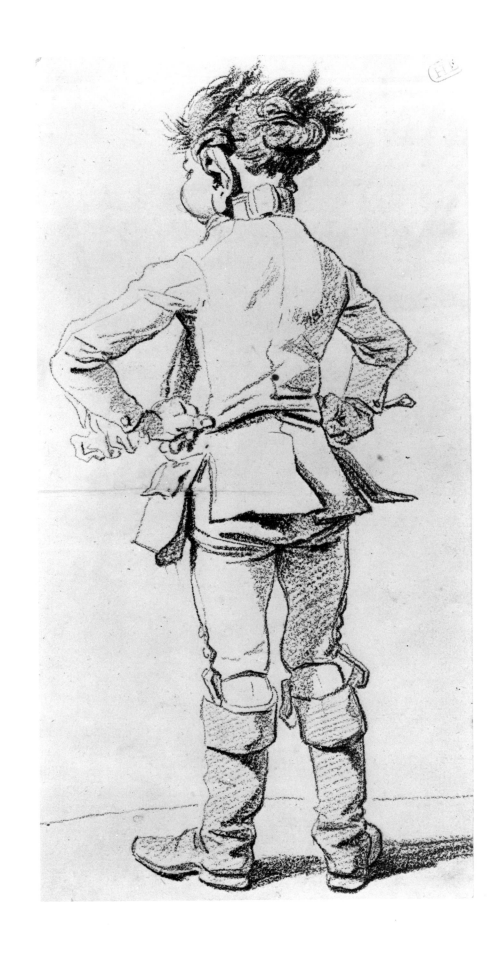

316. *Caricature of the Artist's Younger Brother, 1776*

Pen and brown ink, brown wash. 37.6 x 23.5 cm.

Signed and dated in pen and brown ink at lower left, -*Vincent f. P*[aris]. *1776.*-; at lower right, *Fr.ˢ· Alexandre Vincent dans son / plus galant négligé*; numbered in pen and brown ink at upper margin, ·*55*·

PROVENANCE: Paul Wallraf (according to vendor); [Bernier]; [Coe Kerr]; purchased in New York in 1972.

BIBLIOGRAPHY: *Dessins français du XVIIIᵉ siècle, L'Oeil, galerie d'art*, exhibition catalogue, Paris, 1969, no. 65, repr., wrongly described as a self-portrait of the artist; *Annual Report*, 1975–1976, p. 36.

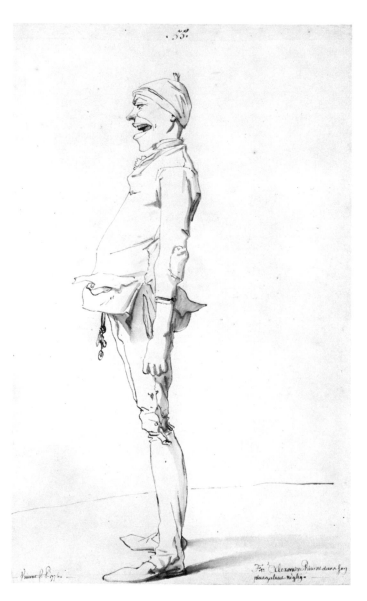

Harry G. Sperling Fund, 1976
1976.189

In a letter of February 24, 1976, Jean-Pierre Cuzin kindly pointed out that the figure represented in the drawing is the artist's younger brother Marie-Alexandre-François, who was born in 1755. Thus, the model would have been about twenty-one years of age in 1776, the year following François-André Vincent's return from Rome.

317. *Diana and Actaeon*

Black chalk, heightened with white, over stumped charcoal, on beige paper. 33.2 x 45.5 cm. Lined.

Signed and dated in pen and dark brown ink at lower left, *Vincent. 1778.*

PROVENANCE: [Galerie de Bayser et Strolin]; purchased in Paris in 1962.

BIBLIOGRAPHY: *Annual Report*, 1962–1963, p. 63; Rosenberg, 1972, p. 221, under no. 146.

Rogers Fund, 1962
62.124.1

This finished, highly pictorial drawing and its pendant, No. 318 below, were no doubt conceived as works of art in their own right, intended to be framed. Both have old French mounts with gold borders.

318. *Venus and Adonis*

Black chalk, heightened with white, over stumped charcoal, on beige paper. 33.1 x 45.7 cm. Vertical crease at center. Lined.

Signed and dated in pen and dark brown ink at lower right, *Vincent. 1778.*

PROVENANCE: [Galerie de Bayser et Strolin]; purchased in Paris in 1962.

BIBLIOGRAPHY: *Annual Report*, 1962–1963, p. 63; Rosenberg, 1972, p. 221, under no. 146.

Rogers Fund, 1962
62.124.2

See No. 317 above.

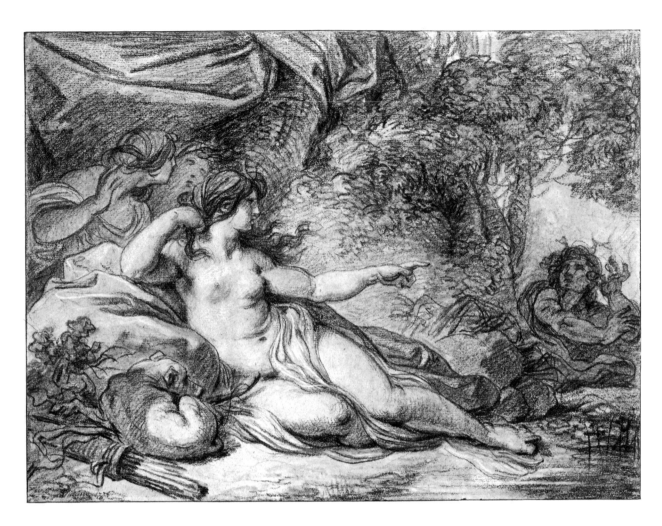

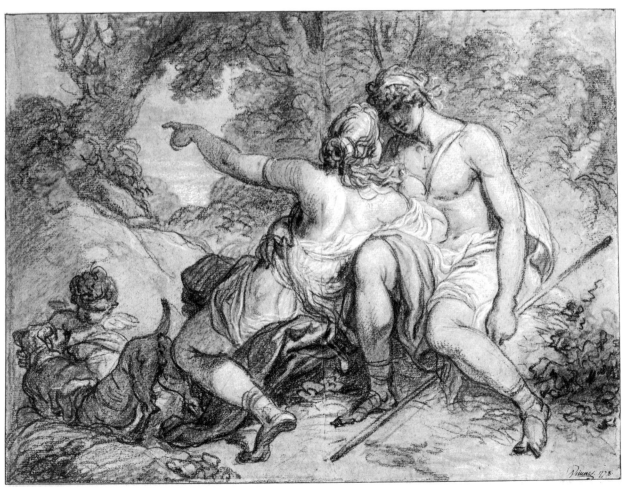

FRANÇOIS-ANDRÉ VINCENT

319. *The Clemency of Augustus*
(Corneille, *Cinna*, V, 3)
VERSO. *Knight Restraining a Female Figure*

Pen and brown ink, brown wash, over traces of red chalk; perspective lines in graphite (recto). Red chalk; squared in red chalk (verso). 33.7 x 38.3 cm.

Signed and dated in pen and black ink at lower right, *Vincent 1788*.

PROVENANCE: [Colnaghi]; purchased in London in 1985.

BIBLIOGRAPHY: *Colnaghi. Old Master Drawings*, exhibition catalogue, London, 1985, no. 46, recto and verso repr.

Harry G. Sperling Fund, 1985
1985.245.2

Composition study, in which the figures are all represented nude, for Vincent's *Clémence d'Auguste envers Cinna*, a painting shown in the Salon of 1787 and now in the castle at Zidlochovice in Czechoslovakia (B. Lossky, *Gazette des Beaux-Arts*, XIX, 1938, pp. 47–53, fig. 2). The Salon *livret* supplies a description of the subject: "Le moment est celui où Auguste semble dire, *soyons amis, Cinna, c'est moi que t'en convie*. À cet acte de grandeur d'âme, Livie, femme de l'Empereur, exprime son admiration; Émilie tombe à ses pieds, Cinna est frappé d'étonnement, et Maxime pénétré de honte." The painting represents the conclusion of Pierre Corneille's tragedy *Cinna*.

The expressive poses of the figures of Augustus, Cinna, Livia, and Aemilia in this drawing were retained by Vincent in the painting, though the figures are clothed in classical attire. The position of Maximus on the right is

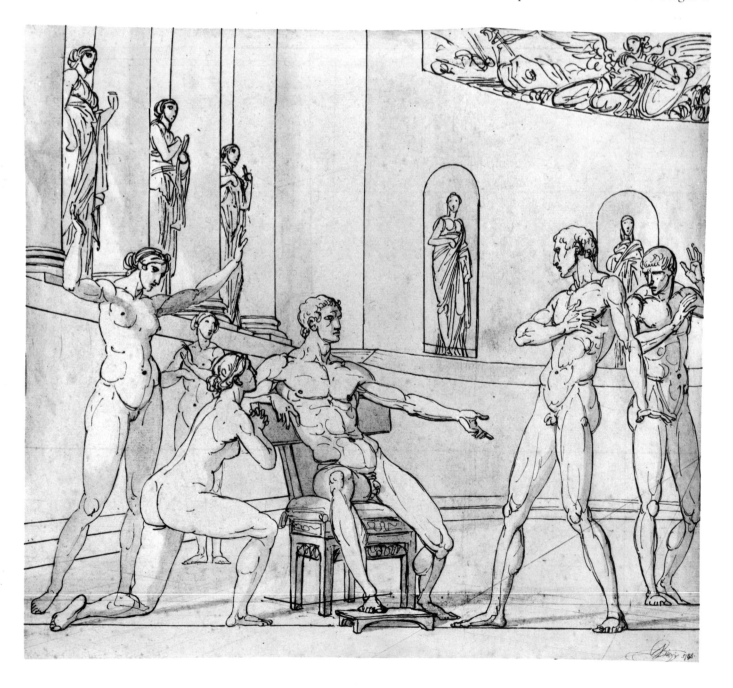

changed in the painting, and the female retainer at the right of Livia was suppressed.

Vincent made pen composition studies, with the figures nude as here, for several of his most important history paintings: in the National Gallery of Victoria, Melbourne, there is such a pen drawing for the *Paralytique guéri à la piscine*, shown in the Salon of 1783 and now in La Madeleine, Rouen; in the Musée Atger, Montpellier, there is a composition drawing for *Zeuxis choisissant pour modèles les plus belles filles de Crotone*, shown in the Salon of 1789, and now in the Musée du Louvre (Rosenberg, Reynaud, Compin, 1974, II, no. 900, repr.); in the Cabinet des Dessins, Musée du Louvre, there is a composition study for *Le jeune Pyrrhus à la cour de Glaucias*, shown in the Salon of 1791 and now in the castle at Zidlochovice (the drawing repr. *Acquisitions du Cabinet des Dessins 1973–1983*, exhibition catalogue, Musée du Louvre,

Paris, 1984, no. 101; the painting repr. *Gazette des Beaux-Arts*, XIX, 1938, p. 51, fig. 3).

Our drawing is signed and dated 1788, which is puzzling since the related painting was shown in the Salon of the previous year. However, Jean-Pierre Cuzin kindly pointed out that toward the end of his life, Vincent signed and misdated a number of his earlier drawings.

The brilliant identification of the study on the verso of the sheet is also due to Jean-Pierre Cuzin (letter of May 28, 1985). The figure is Rinaldo restraining Armida, and the drawing is a study for Vincent's *Renaud et Armide* shown in the same Salon of 1787 as the *Clémence d'Auguste* for which the drawing on the recto is a study. The *Renaud et Armide* was painted for the comte d'Artois; at the Revolution it entered the Musée du Louvre, in 1848 was lent to the Ministère de l'Intérieur, and has since disappeared. The only visual record of the painting is Martini's en-

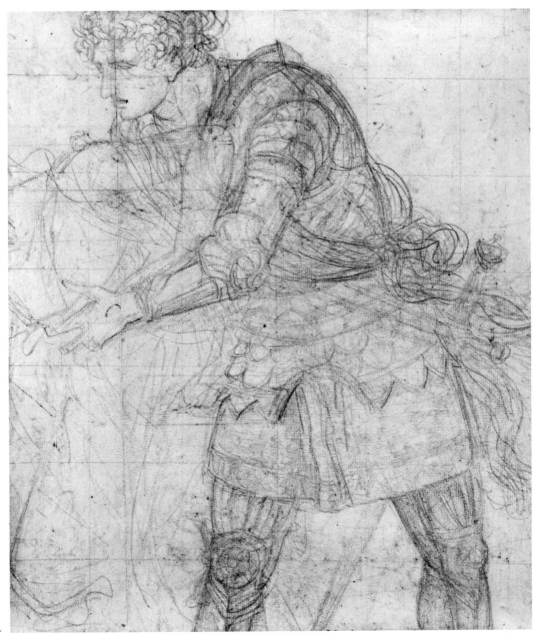

319 v.

graved panoramic view of the Salon of 1787, in which the canvas can be discerned at lower left. The Salon *livret* describes the action of the picture: "Le moment est celui où Renaud l'arrêtant, la serrant dans ses bras, et l'y retenant malgré les efforts qu'elle fait pour s'en arracher . . . *Jérusalem délivrée, Chant* XX."

320. *Standing Man with His Right Hand on His Chest*

Pen and brown ink, brown wash, over red chalk. Traces of squaring in graphite and red chalk. 38.0 x 24.4 cm.

Inscribed in pen and brown ink on verso, *B / n⁰ 12*; in pencil, *David*.

PROVENANCE: L.-J.-A. Coutan (Lugt 464); Walter C. Baker.

BIBLIOGRAPHY: Carnegie Institute, 1951, no. 155, repr., as David; Rotterdam, Paris, New York, 1958–1959, no. 109, pl. 87, as David; Virch, 1962, no. 88, repr., as David, with additional bibliography; Mongan, 1962, no. 714, repr. as David; *Annual Report*, 1979–1980, p. 27.

Bequest of Walter C. Baker, 1971
1972.118.236

In the past this drawing has often been exhibited and reproduced with a mistaken attribution to Louis David. On stylistic grounds, however, it is clearly the work of F.-A. Vincent. Quite recently a helpful suggestion made by Jean-Pierre Cuzin has led to the identification of the figure.

Vincent has posed a studio model, his hand at his heart, in a dramatic gesture of grateful astonishment. Wearing a Roman toga, the young man appears in exactly this pose as Cinna in Vincent's *Clémence d'Auguste envers Cinna*, a painting dated 1787 and shown in the Salon of the same year.

See No. 319 above.

321. *Battle of the Pyramids, July 21, 1798*

Pen and black ink, brown wash, heightened with white, on beige-washed paper. Squared in graphite. 41.8 x 75.1 cm.

PROVENANCE: Major General Edward James Montagu-Stuart-Wortley (according to vendor); [Tooth]; purchased in London in 1951.

BIBLIOGRAPHY: *Annual Report*, 1951, p. 32, as Baron Gros; *Dessins français du Metropolitan Museum*, 1973, no. 94, pl. 1; R. Bacou, *Revue du Louvre et des Musées de France*, XXIII, 4–5, 1973, p. 309, fig. 1, pp. 311–312; J.-P. Cuzin in *Age of Revolution*, 1975, pp. 672–673, under no. 201; *Arts under Napoleon*, 1978, no. 15; L. Turčić, *Burlington Magazine*, CXXVI, 1984, p. 524.

Rogers Fund, 1951
51.122

At the time of its acquisition in 1951, the drawing was ascribed to the baron Gros; however, in correspondence with the museum in 1956, Gaston Delestre tentatively proposed the name of Vincent. The drawing is in fact a preparatory study for Vincent's never completed, and now lost, *Bataille des Pyramides* commissioned in 1800 by Lucien Bonaparte, ministre de l'Intérieur.

Another preparatory drawing for the painting is in the Musée des Arts Africains et Océaniens, Paris, and oil sketches for the work are in the Musée du Louvre (Inv. RF. 1983-105; Cuzin in *Age of Revolution*, 1975, no. 201, repr. p. 177), and in the Musée du château de Versailles (Inv. 8464; Constans, 1980, no. 4616, incorrectly described).

In 1810 maréchal Berthier commissioned from Vincent another representation of the *Bataille des Pyramides*; this painting is still at the château de Grosbois. A large preparatory drawing for the second version, signed and dated 1810, is in an American private collection (*Burlington Magazine*, CXXVI, pp. 524–525, fig. 46).

GUILLAUME VOIRIOT ?

Paris 1713 – Paris 1799

322. *Seated Figure in Turkish Costume*

Black chalk, heightened with a little white, on faded gray paper. 55.4 x 42.8 cm. Scattered creases.

Inscribed in black chalk at lower left, *himan de la grande / mosquée M.ͬ Clement.*

PROVENANCE: J.-B. Dumas; Georges Haumont (according to *Barbault*, 1974, p. 30, note 18); François Boucher; purchased in Paris in 1961.

BIBLIOGRAPHY: F. Boucher, *Connoisseur*, CXLVIII, October 1961, pp. 88–91, fig. 5, as Vien; *Annual Report*, 1961–1962, p. 67, as Vien; F. Boucher, *Bulletin de la Société de l'Histoire de l'Art français*, 1962 [1963], pp. 69–76, as Vien; Dayton, Ohio, 1971, no. 13, repr., as Vien; Gillies and Ives, 1972, no. 44, as Vien; Rosenberg, 1972, pp. 219–220, under no. 144, as Vien ?; *Barbault*, 1974, pp. 34, 42, pl. XV, as Voiriot ?; P. L. Near, *Arts in Virginia*, XXIII, 3, 1983, p. 22, fig. 4, as Vien or Voiriot.

Rogers Fund, 1961
61.139

Joseph-Marie Vien, *pensionnaire* at the French Academy in Rome from 1744 to 1750, organized a masquerade, *La caravane du sultan à La Mecque*, for the carnival of 1748 in which his fellow students and friends took part, wearing fancy dress *à la turque*. These costumes were recorded in a series of twenty-nine engravings by Vien, the preparatory drawings for twenty-two of which are preserved in the Petit Palais, Paris. A second series of studies after these costumes, including the present sheet, appeared on the Paris market in 1961; they were attributed to Vien by François Boucher. Since then Thomas Gaethgens, Pierre Rosenberg, and Nathalie Volle have pointed out that the drawings in the second series differ in style and in detail from Vien's drawings at the Petit Palais. They tentatively propose an attribution for the second series to Guillaume Voiriot, who was in Rome at the time of the 1748 *mascarade* (*Barbault*, 1974, pp. 28, 30).

A further complication is the fact that Vien's engraving of the costumed figure in our drawing is entitled *Prestre de la Loy* and not *himan de la grande mosquée*, as here. The identity of the *M.ͬ Clement* who wore the costume is uncertain.

SIMON VOUET

Paris 1590 – Paris 1649

323. *St. Louis in Glory*

Black chalk, heightened with white, on beige paper. Framing lines in pen and brown ink. 39.1 x 28.6 cm. Several small repaired tears.

Inscribed in pen and brown ink at lower right, *Vouet*; numbered in pen and brown ink on verso, *n° 15*; inscribed in pencil, *Simon Vouet.*

PROVENANCE: Andrew Fountaine ?; Fountaine sale, London, Christie's, July 7–10, 1884, possibly no. 829, "Simon Vouet. The Assumption of Saint Louis, in black chalk," no dimensions given; [Baderou]; purchased in Paris in 1961.

BIBLIOGRAPHY: *Annual Report*, 1961–1962, p. 66; Bean, 1962, p. 169, fig. 13; Bean, 1964, no. 53, repr.; Rosenberg, 1966, p. 138, under no. 140; Rosenberg, 1972, p. 224, under no. 150; *Saint-Paul —Saint-Louis*, 1985, p. 38, under no. 30.

Rogers Fund, 1961
61.132

Study for the figure of St. Louis carried to heaven by two angels, a painting executed by Vouet for the second story of the enormous reredos behind the high altar of Saint-Louis, the church of the *maison professe* of the Jesuits in

Paris (for the painting in place see the engraving repr. *Saint-Paul—Saint-Louis*, 1985, p. 35). The reredos was destroyed at the end of the eighteenth century, and the paintings that decorated it have been dispersed; Vouet's *Glorification of St. Louis* is now in the Musée des Beaux-Arts, Rouen (Rosenberg, 1966, no. 140, repr.; *Saint-Paul—Saint-Louis*, 1985, p. 37, repr. in color).

324. *Two Crouching Nude Male Figures*

Black chalk, heightened with white, on beige paper. The two vertical ruled lines in red chalk. 17.4 x 28.3 cm. Crease at lower left; scattered stains. Lined.

Inscribed in pen and brown ink at lower right, *S. Vouet*; numbered in pencil at center of upper margin, ..64[?].

PROVENANCE: [Baderou]; purchased in Paris in 1962.

BIBLIOGRAPHY: *Annual Report*, 1962–1963, p. 63; J. Bean, *Master Drawings*, III, 1, 1965, pp. 50–52, fig. 2 (the engraving), pl. 45 (our drawing); Rosenberg, 1972, p. 224, under no. 150.

Rogers Fund, 1962
62.127.1

These figures appear in reverse, flanking an inscribed tablet, in the engraved frontispiece to a series of six prints reproducing Vouet's now destroyed decoration of the vault of the library of the Hôtel Séguier, Paris (Crelly, 1962, figs. 145–150). The engravings are the work of Vouet's pupil and son-in-law Michel Dorigny, who in the frontispiece copied Vouet's design quite closely, though somewhat ineptly in the case of the raised hand of the figure on the left.

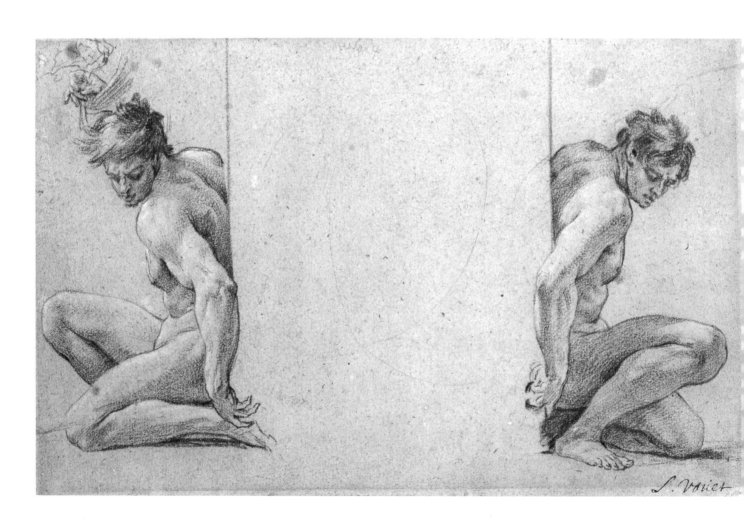

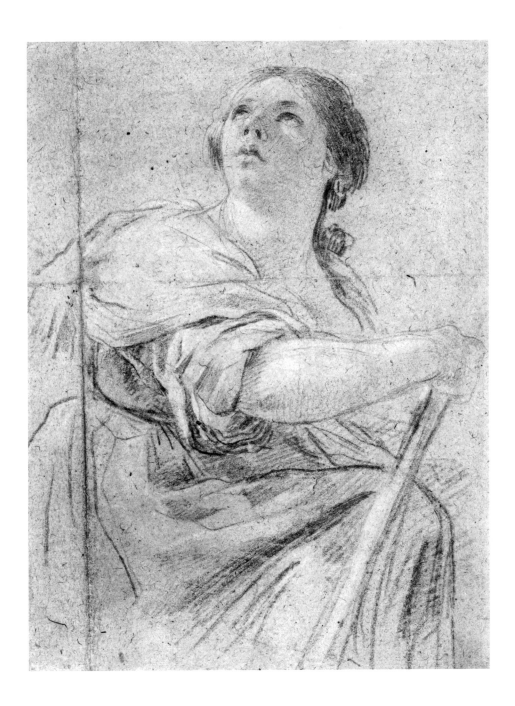

325. *Woman with a Staff Looking Upward*

Black chalk, heightened with a little white, on beige paper. 25.3 x 19.0 cm. Vertical crease at left; horizontal crease above center. Lined.

PROVENANCE: [Colnaghi]; purchased in London in 1964.

BIBLIOGRAPHY: *Annual Report*, 1963–1964, p. 62; Rosenberg, 1972, p. 224, under no. 150.

Rogers Fund, 1964
64.38.10

It has been suggested that the pose of the figure is similar to that of an angel musician in the vault of the Alaleoni chapel in S. Francesco a Ripa, Rome (Crelly, 1962, fig. 16). However, Vouet's Alaleoni chapel decorations are relatively early (1622–1624), while the style of the drawing is that of the artist's later years.

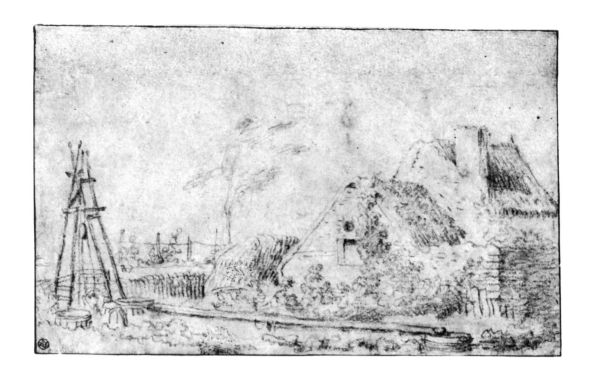

ANTOINE WATTEAU

Valenciennes 1684 – Nogent-sur-Marne 1721

326. *Landscape with a Cottage and Well*

Red chalk. Framing lines in pen and brown ink. 8.7 x 14.2 cm. (overall). A strip of paper 1.1 cm. in height has been added at upper margin.

PROVENANCE: Pierre-Jean Mariette (Lugt 2097); Mariette sale, Paris, 1775–1776, possibly part of no. 1392, "Quatre Études de Paysages, des environs de Paris, à la sanguine"; James Jackson Jarves; Cornelius Vanderbilt.

BIBLIOGRAPHY: *Metropolitan Museum Handbook*, 1895, p. 33, no. 522; Eisler, 1966, pp. 165–176, fig. 8; Eidelberg, 1967, pp. 173–182, pl. 29 (much enlarged, and before restoration); Grasselli and Rosenberg, Washington, 1984, pp. 99–102, under no. 36, fig. 3 (before restoration); Grasselli and Rosenberg, Paris, 1984, pp. 101–104, under no. 36, fig. 4 (before restoration).

Gift of Cornelius Vanderbilt, 1880
80.3.522

Colin Eisler was the first to publish and illustrate this drawing. He pointed out that it is similar in composition to a lost landscape painting by Watteau, *Le marais*, known through an engraving by Louis Jacob, where the design is reversed (Dacier, Hérold, Vuaflart, III, p. 69, no. 136, IV, pl. 136).

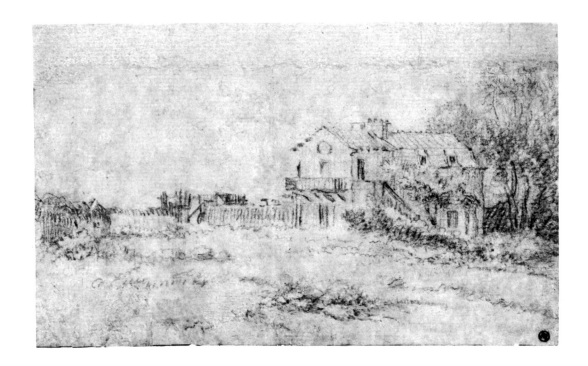

327. *Landscape with a Country House*

Red chalk. 8.5 x 14.3 cm. (overall). A strip of paper 1.2 cm. in height has been added at upper margin. Lined.

PROVENANCE: Pierre-Jean Mariette (Lugt 2097); Mariette sale, Paris, 1775–1776, possibly part of no. 1392, "Quatre Études de Paysages, des environs de Paris, à la sanguine"; James Jackson Jarves; Cornelius Vanderbilt.

BIBLIOGRAPHY: *Metropolitan Museum Handbook*, 1895, p. 33, no. 524; Eisler, 1966, pp. 165–176, fig. 1; Eidelberg, 1967, pp. 173–182, pl. 30 (much enlarged); Grasselli and Rosenberg, Washington, 1984, pp. 99–102, under no. 36, fig. 4; Grasselli and Rosenberg, Paris, 1984, pp. 101–104, under no. 36, fig. 5.

Gift of Cornelius Vanderbilt, 1880
80.3.524

Colin Eisler was the first to publish and illustrate this drawing. He pointed out that it is similar in composition to a lost landscape painting by Watteau, *La breuvoir*, known through an engraving by Louis Jacob, where the design is reversed (Dacier, Hérold, Vuaflart, III, p. 69, no. 137, IV, pl. 137).

328. *Standing Savoyarde with a Marmot Box*

Red and black chalk. 31.2 x 20.3 cm. Horizontal crease below upper margin.

Inscribed in pen and brown ink at lower left, *Watteau*; on the verso, part of the draft of a letter by Watteau addressed to an unknown recipient, *Monsieur / J'ai reçu aujourd'hui vos deux lettres ensemble qui ont / autant donné de peine au facteur pour me les remettre en / main qu'elle m'ont causé de surprise par la qualité / que vous me donnez de peintre de son A. A. Monseignr / Le Duc d'Orléans moy indigne et qui n'a aucun talens / pour y aspirer a moins que d'un miracle. J'ai tant / de foy en vos reliques que je ne doute nullement de son / accomplissement si vous voulez avoir la bontée de joindre vos / prières au désir que j'ai d'acquérir du crédit et de la / faveur mes désirs sont sans bornes quand même.* (See Dacier, Hérold, Vuaflart, I, pp. 156–157).

PROVENANCE: F. Locker Lampson; A. Birrell; [Owen]; Mr. and Mrs. Herbert N. Straus.

BIBLIOGRAPHY: Dacier, Hérold, Vuaflart, I, 1929, pp. 154–157, fig. 62; Parker and Mathey, 1957, I, p. 68, no. 496, repr.; Rotterdam, Paris, New York, 1958–1959, no. 86, pl. 31 (with additional bibliography); Gillies and Ives, 1972, no. 48; *Annual Report*, 1977–1978, p. 36, repr.; *Notable Acquisitions*, 1975–1979, repr. p. 56, p.

ANTOINE WATTEAU (NO. 328)

57; Grasselli and Rosenberg, Washington, 1984, pp. 116–117, 119, no. 51, repr.; Grasselli and Rosenberg, Paris, 1984, pp. 118–119, no. 51, repr.

Bequest of Therese Kuhn Straus, in memory of her husband, Herbert N. Straus, 1977
1978.12.1

The drawing was etched by Caylus, but the print was not included in *Figures de différents caractères*.

329. *Standing Nude Man Holding Bottles*

Black and red chalk, heightened with a little white. 27.7 x 22.6 cm. (overall). A strip of paper 3.3 cm. wide has been added at right margin and the drawing continued in the artist's hand. Lined.

PROVENANCE: Felix Harbord; Mrs. H. D. Gronau (according to Virch); Walter C. Baker.

BIBLIOGRAPHY: Parker and Mathey, 1957, I, p. 74, no. 518, repr.; Rotterdam, Paris, New York, 1958–1959, no. 85, pl. 33; Virch, 1962, no. 73, repr. (with additional bibliography); *Annual Report*,

328

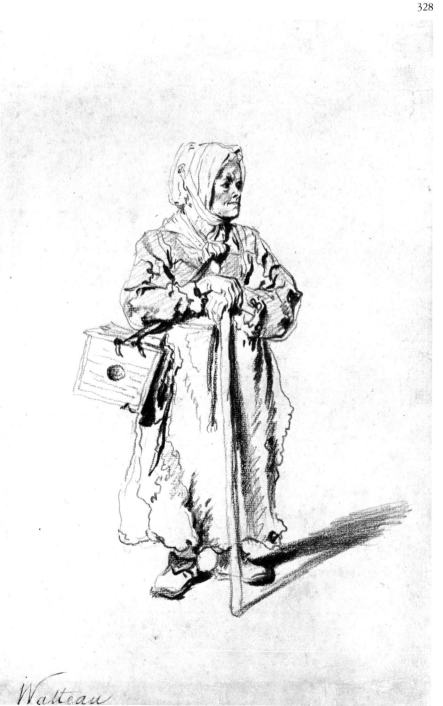

1979–1980, p. 27; *Notable Acquisitions*, 1979–1980, p. 48, repr.; Grasselli and Rosenberg, Washington, 1984, p. 130, under no. 62, p. 132, no. 64, repr. (with additional bibliography); Grasselli and Rosenberg, Paris, 1984, pp. 133–134, under no. 64, p. 135, no. 64, repr.

Bequest of Walter C. Baker, 1971
1972.118.238

329

Study for the satyr who fills Bacchus's cup in the lost *Automne*, one of the four paintings of the Seasons commissioned by Pierre Crozat. A study for the same satyr in the Princes Gate Collection, Courtauld Institute, London, comes closer to the figure in the painting (Parker and Mathey, 1957, I, no. 521, repr.).

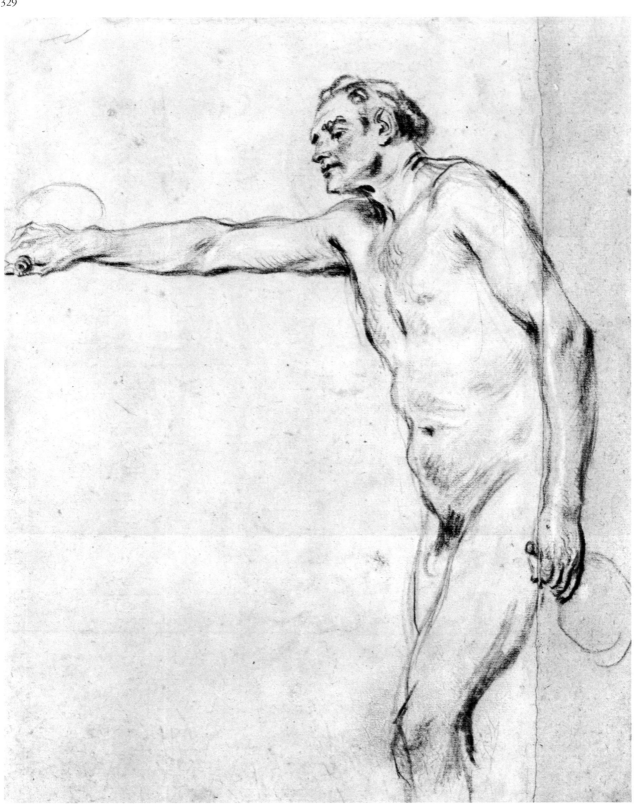

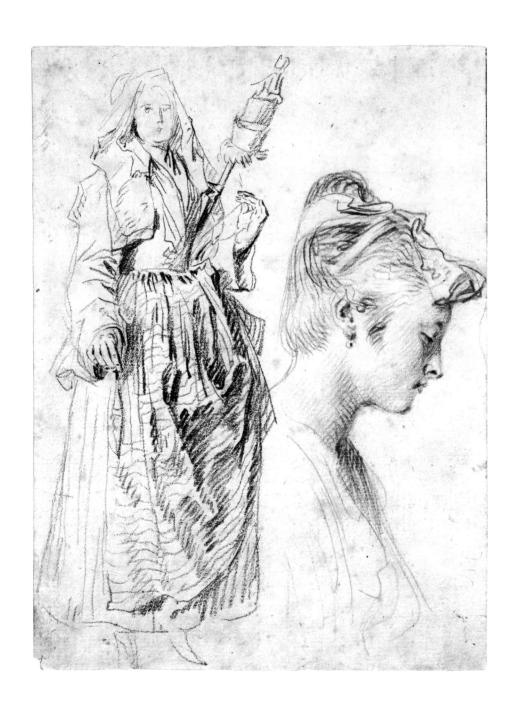

294

330. *Standing Woman Holding a Spindle, and Head of a Woman in Profile to Right*

Each of the two figures drawn in a different shade of red chalk, the woman at left in a brownish-red chalk, the head at right in an orange-red chalk. 16.3 x 12.2 cm.

PROVENANCE: Horace Walpole ? (see Grasselli and Rosenberg, Washington, 1984, p. 93); C. S. Bale; Bale sale, part VI, London, Christie's, June 9–14, no. 2502, "A woman, with a distaff; and a female head . . . From Strawberry Hill"; J. P. Heseltine (Lugt 1507); Anne D. Thomson.

BIBLIOGRAPHY: Heseltine, 1900, pp. 66–67, no. 21, repr.; Guiraud, 1913, no. 101, repr.; Wehle, 1924, p. 64, repr.; Parker and Mathey, 1957, I, no. 500, repr.; Eisler, 1966, pp. 174–175, fig. 12; Jean-Richard, 1978, p. 44, under no. 78; Grasselli and Rosenberg, Washington, 1984, p. 93, no. 30, repr. (with additional bibliography); Grasselli and Rosenberg, Paris, 1984, p. 95, no. 30, repr.

Bequest of Anne D. Thomson, 1923
23.280.5

The woman with the spindle appeared in a lost painting by Watteau, *La fileuse*, known through an engraving by B. Audran (Dacier, Hérold, Vuaflart, IV, 1921, pl. 123). The same figure was etched by François Boucher for *Figures de différents caractères* (Jean-Richard, 1978, no. 78, repr.).

331. *Seated Woman Holding a Fan*

Red and black chalk, heightened with white, on beige paper. Framing lines in pen and black ink. 21.4 x 13.1 cm. Lined.

PROVENANCE: Andrew James; Miss James; sale, London, Christie's, June 22–23, 1891, no. 309; Sir James Knowles; Knowles sale, London, Christie's, May 27–29, 1908, no. 242; George Blumenthal; Ann Payne Blumenthal.

BIBLIOGRAPHY: Goncourt, 1875, p. 243, under no. 367; P. Leroi, *L'Art*, LI, 1891, p. 96, no. 309; Parker, 1931, p. 44, pl. 37; Parker and Mathey, 1957, II, p. 309, no. 546, repr.; *Metropolitan Museum of Art Bulletin*, February 1959, p. 166, repr.; Méjanès, 1973, p. 119, under no. 1; Grasselli and Rosenberg, Washington, 1984, p. 160, fig. 2, p. 302, fig. 6, p. 304; Grasselli and Rosenberg, Paris, 1984, p. 160, fig. 2; p. 303, fig. 9, p. 304.

Gift of Ann Payne Blumenthal, 1943
43.163.23

The figure appears at the left in Watteau's painting *La perspective*, in the Museum of Fine Arts, Boston; the drawing was etched in reverse by Trémolières in *Figures de différents caractères* (Méjanès and Vilain, 1973, pl. VIII).

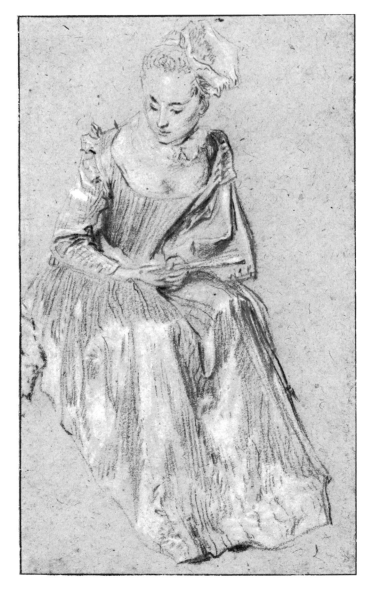

332. *Studies of a Woman Wearing a Cap*

Black and red chalk, heightened with a little white. 18.4 x 20.6 cm. Horizontal crease above lower margin. Lined.

PROVENANCE: Pierre Crozat ? (3273 with the paraph, Lugt 2951); Mrs. B. M. Ferrers; sale, London, Sotheby's, May 13, 1931, no. 84, repr.; Mr. and Mrs. Herbert N. Straus.

BIBLIOGRAPHY: Parker and Mathey, 1957, II, p. 314, no. 597, repr.; Gillies and Ives, 1972, no. 47, repr.; *Annual Report*, 1977–1978, p. 36.

Bequest of Therese Kuhn Straus, in memory of her husband, Herbert N. Straus, 1977
1978.12.3

The figure in profile at the left was engraved by Pierre Filloeul in his *Livre de différents caractères de têtes, inventez par Watteaux* (Goncourt, 1875, p. 318, no. 762).

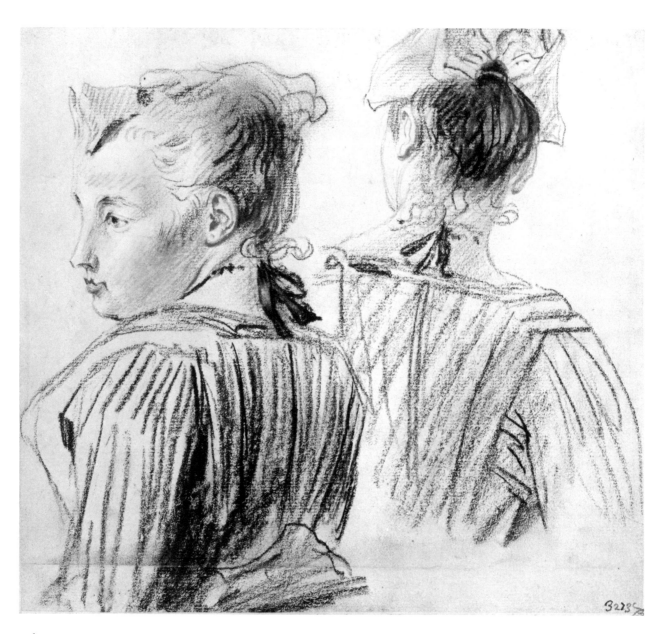

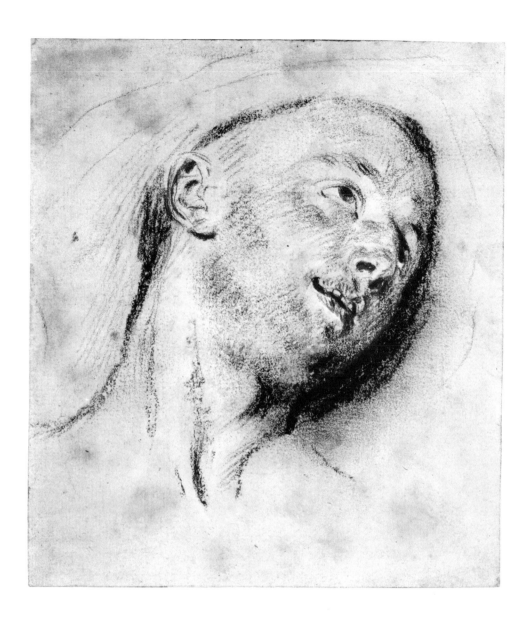

333. *Head of a Man*

Red and black chalk. 14.9 x 13.1 cm. Scattered brown stains.

PROVENANCE: J. Neil (according to Biron sale catalogue); marquis de Biron; Biron sale, Paris, Galerie Georges Petit, June 9–11, 1914, no. 63, repr., bought in; purchased in Geneva in 1937.

BIBLIOGRAPHY: Allen, 1938, pp. 77–78, repr.; Williams, 1939, p. 50, fig. 2, p. 51; Benisovich, 1943, p. 70; *Metropolitan Museum, European Drawings*, 1943, no. 31, repr.; *Metropolitan Museum, European Drawings*, 1944, no. N.S. 36, repr.; Tietze, 1947, no. 83, repr.; Shoolman and Slatkin, 1950, p. 42, pl. 25; *Art Treasures of the Metropolitan*, 1952, p. 69, fig. 62, p. 222, no. 62; Parker and Mathey, 1957, II, no. 726, repr.; *Metropolitan Museum of Art Bulletin*, February 1959, p. 166, repr.; Bean, 1964, no. 56, repr.; Byam Shaw, 1970, p. 257, fig. 21; Metropolitan Museum, 1970, no. 310, repr.; Gillies and Ives, 1972, no. 46; D. Posner, *Antoine Watteau*, London, 1984, pp. 206, 208, p. 225, pl. 49, repr. in color; Grasselli and Rosenberg, Washington, 1984, p. 188, no. 110, repr., p. 364, fig. 8, p. 365 (with additional bibliography); Grasselli and Rosenberg, Paris, 1984, p. 189, no. 110, repr., p. 364, fig. 8, p. 365.

Rogers Fund, 1937
37.165.107

Study for the head of the seated figure of *Mezzetin*, a painting in the Metropolitan Museum.

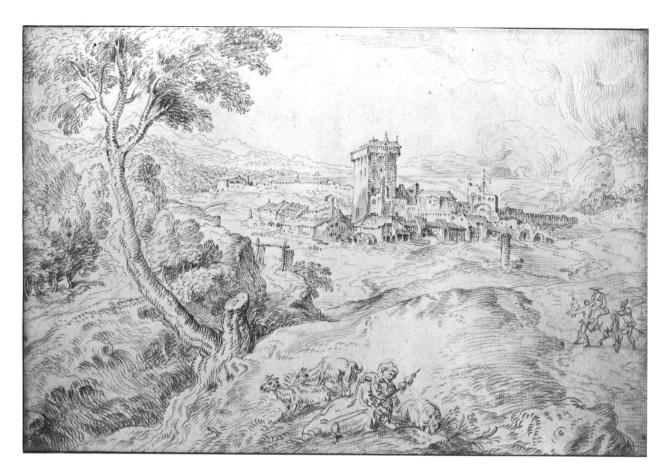

ANTOINE WATTEAU

334. *Landscape with an Old Woman Holding a Spindle, after Domenico Campagnola*

Red chalk. Framing lines in pen and brown ink. 20.6 x 31.9 cm. Lined.

PROVENANCE: André de Hevesy; sale, London, Sotheby's, April 25, 1951, no. 70, bought in by Hevesy; [Komor]; Walter C. Baker.

BIBLIOGRAPHY: K. T. Parker, *Old Master Drawings*, X, June 1935, p. 8, pl. 7; Parker and Mathey, 1957, I, p. 58, no. 439, repr.; Virch, 1962, no. 72, repr.; *Annual Report*, 1979–1980, p. 27; Bean and Turčić, 1982, under no. 40; Grasselli and Rosenberg, Washington, 1984, p. 222, no. 140, repr.; Grasselli and Rosenberg, Paris, 1984, p. 223, no. 140, repr.

Bequest of Walter C. Baker, 1971
1972.118.237

The Campagnola drawing copied by Watteau is probably that now in the Metropolitan Museum (1972.118.243, Bequest of Walter C. Baker, 1971; Bean and Turčić, 1982, no. 40, repr.).

LOUIS-JOSEPH WATTEAU,
called Watteau de Lille

Valenciennes 1731 – Lille 1798

335. *Young Father Distressed by His Growing Family*

Pen and brownish-gray ink, brown wash, over black chalk. 36.5 x 22.6 cm. (overall). A horizontal strip 1.5 cm. in height has been added at lower margin and the drawing continued in the same hand.

Inscribed in pen and brown ink at lower margin, *.e dessin est de Watteau de lille et ma eté donné par le citoyen Momal. professeur de dessin à l'academie de Valencienes*—[sic] *e fachet—capitaine de. . . .*

PROVENANCE: Jacques-François Momal (professor at the École des Beaux-Arts in Valenciennes from 1785 until his death in 1832); E. Fachet; Richard Owen; Edith Sachs.

BIBLIOGRAPHY: *Annual Report*, 1978–1979, p. 24.

Gift of Mrs. Howard J. Sachs and Peter G. Sachs, in memory of Miss Edith L. Sachs, 1978
1978.516.3

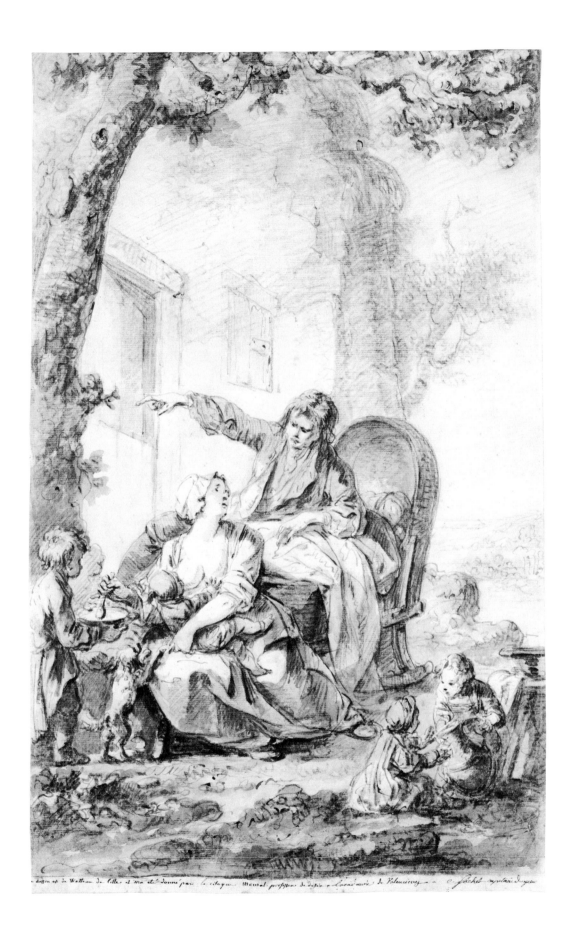

dessin est de Watteau de Lille et m'a été donné par le citoyen Mouret, professeur de dessin à l'académie de Valenciennes — fâché m'y plaise l'ayeu

JOHANN GEORG WILLE

Obermühle im Biebertal 1715 – Paris 1808

336. *Ruins of the Château of Becoiseau, near Mortcerf (Seine-et-Marne)*

Brown chalk, brown wash. Framing lines in pen and brown ink. 25.4 x 34.3 cm. Lined.

Inscribed in pen and brown ink at upper left margin in the artist's hand, *Ruines du chateau de Becoiseau près de Mortcerf en Brie dessinés par J. G. Wille 1784.*

PROVENANCE: Unidentified mark, ARD, stamped blind on mount (Lugt 172); Edith Sachs.

BIBLIOGRAPHY: *Annual Report*, 1978–1979, p. 24.

Gift of Mrs. Howard J. Sachs and Peter G. Sachs, in memory of Miss Edith L. Sachs, 1978
1978.516.2

Wille and three friends set off on a sketching trip to Mortcerf on August 17, 1784, and stayed in considerable discomfort at a local inn for eight days. The excursion is described with good humor by Wille himself in his journal; the party was plagued by bad weather and vile food, and Wille reports that he brought back only five drawings, "dont quatre faits dans les ruines de Becoiseau" (*Mémoires et journal de J.-G. Wille*, Paris, 1857, II, pp. 99–103). The seated draughtsman in the foreground must be one of Wille's traveling companions.

PIERRE-ALEXANDRE WILLE

Paris 1748 – Paris 1837

337. *Two Women in an Elegant Interior: a Singer Accompanied by a Lutenist*

Pen, gray and brown ink, gray and brown wash, yellow and pink watercolor, over traces of black chalk. 24.5 x 19.9 cm.

Signed in pen and brown ink at upper right, *P. A. Wille / filius inv. et del / 1771*.

PROVENANCE: [Light]; purchased in Boston in 1969.

BIBLIOGRAPHY: *Annual Report*, 1969–1970, p. 72, repr.; Bean, 1972, no. 74; Gillies and Ives, 1972, no. 49; K. E. Maison, *Master Drawings*, X, 1, 1972, p. 34; *Notable Acquisitions*, 1965–1975, p. 60, repr.

Rogers Fund, 1969
69.49

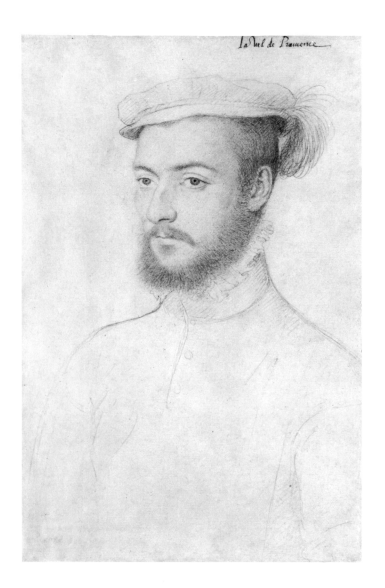

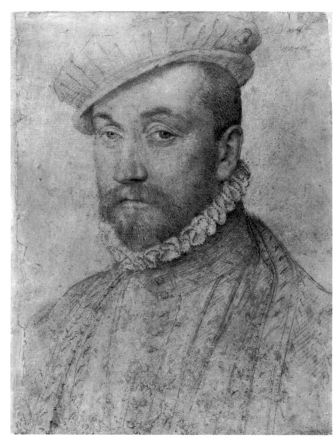

ANONYMOUS ARTIST

16th century ?

338. *Portrait of La Val de Pramence*

Black and red chalk. 32.5 x 21.7 cm.

Inscribed in pen and brown ink at upper right, *La Val de Pramence.*

PROVENANCE: [Wildenstein]; Walter C. Baker.

BIBLIOGRAPHY: Virch, 1962, no. 19, attributed to François Clouet (with previous bibliography); *Annual Report*, 1979–1980, p. 27.

Bequest of Walter C. Baker, 1971
1972.118.201

ANONYMOUS ARTIST

16th century ?

339. *Portrait of a Man*

Black and red chalk, heightened with white. 27.6 x 20.7 cm. Many repaired losses. Lined.

Illegible and largely effaced pen inscription at upper right.

PROVENANCE: Anne D. Thomson.

BIBLIOGRAPHY: Wehle, 1924, p. 64, as François Clouet; Benisovich, 1943, p. 70, p. 72, fig. A; *Metropolitan Museum, European Drawings*, 1943, no. 30, repr., as François Clouet; *Metropolitan Museum, European Drawings*, 1944, no. N.S. 35, repr., as François Clouet.

Bequest of Anne D. Thomson, 1923
23.280.4

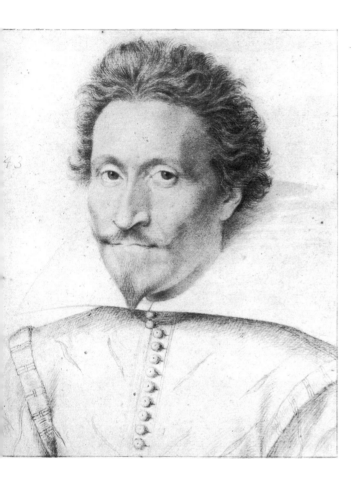

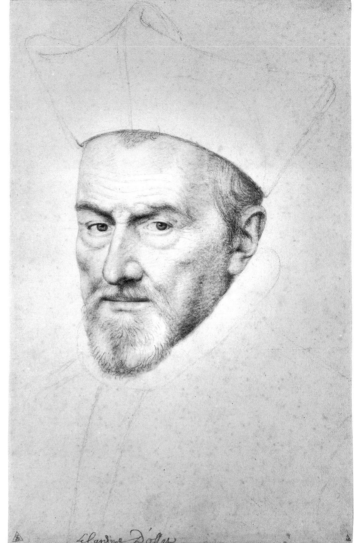

ANONYMOUS ARTIST

16th century ?

340. *Portrait of a Man*

Black and red chalk, heightened with white. 25.2 x 20.1 cm.

Numbered in black chalk at left margin, *43*; faint black chalk inscription on verso, *Pouribus*[?].

PROVENANCE: Jacob de Vos (Lugt 1450); Pieter Langerhuizen (Lugt 2095); Langerhuizen sale, Amsterdam, Frederick Muller, April 29 – May 1, 1919, no. 634, as François Pourbus ?; Edith Sachs.

BIBLIOGRAPHY: *Annual Report*, 1951, p. 32.

Gift of Edith Sachs, 1951
51.76.3

ANONYMOUS ARTIST

16th century ?

341. *Portrait of an Ecclesiastic*

Charcoal, stumped, black and red chalk. 39.8 x 25.7 cm.

Inscribed in pencil at lower margin, *Le Cardinal d'Ollar*.

PROVENANCE: Marquis de Lagoy (Lugt 1710); Henry Danby Seymour (Lugt 176); [J. Seligmann]; Harry Sachs; Edith Sachs.

BIBLIOGRAPHY: *Annual Report*, 1951, p. 32, as Dumoustier; *Metropolitan Museum of Art Bulletin*, February 1959, p. 165, repr., as Pierre Dumoustier.

Gift of Edith Sachs, 1951
51.76.2

ANONYMOUS ARTIST

16th century ?

342. *Portrait of a Man*

Black and red chalk, heightened with white. 34.1 x 23.4 cm. Four repaired losses.

PROVENANCE: Eugène Kraemer; Kraemer sale, Paris, Galerie Georges Petit, June 2–5, 1913, no. 153, as French school, late 16th century, "Portrait de Louis de Lorraine"; Georges Dormeuil (Lugt Supp. 1146a); Dormeuil sale, Paris, Hôtel Drouot, June 17, 1949, no. 3, as French school, 16th century, "Portrait présumé de Louis de Lorraine"; purchased in Paris in 1950.

Rogers Fund, 1950
50.84

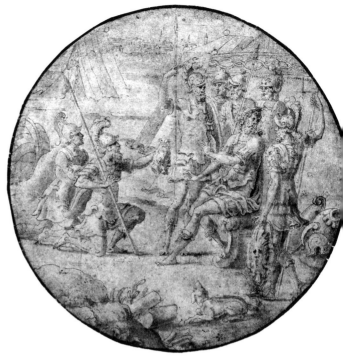

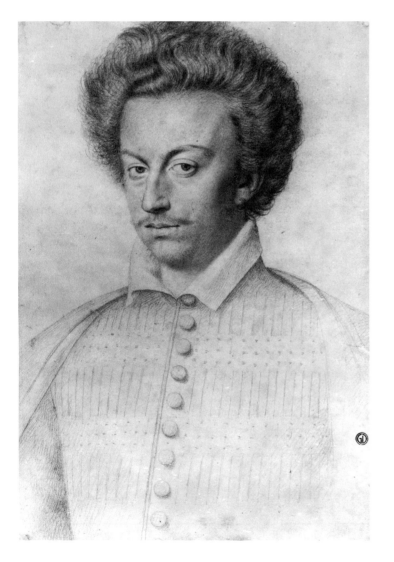

ANONYMOUS ARTIST

second half of the 16th century

343. *The Head of Pompey Presented to Caesar*

Pen and gray ink, pale gray wash. Framing line in dark green wash. Diameter 13.6 cm.

PROVENANCE: Nicholas Lanier (Lugt 2886); Harry G. Sperling.

BIBLIOGRAPHY: *Annual Report*, 1974–1975, p. 50.

Bequest of Harry G. Sperling, 1971
1975.131.106

ANONYMOUS ARTIST

16th century

344. *Portrait of a Man, 1594*

Black and red chalk, heightened with white. 28.5 x 22.0 cm.

Dated in black chalk at upper right corner, *1594*.

PROVENANCE: Mrs. James B. Haggin; Mrs. William M. Haupt.

BIBLIOGRAPHY: *Annual Report*, 1965–1966, p. 74.

Gift of Mrs. William M. Haupt, from the collection of Mrs. James B. Haggin, 1965
65.251.5

ANONYMOUS ARTIST

late 16th – early 17th century ?

345. *Portrait of a Man*

Charcoal, stumped, black and red chalk, some lines reinforced with pen and gray ink. 24.8 x 17.0 cm. Surface abraded; a number of repaired tears and losses.

Inscribed in pen and brown ink on verso, *Fiamingo*; numbered in pen and red ink, 793.

PROVENANCE: Stefano Bardini; Bardini sale, New York, American Art Galleries, April 23–27, 1918, no. 443, as Italian school, sixteenth century; Richard Ederheimer; Ederheimer sale, New York, Anderson Galleries, April 9, 1919, no. 127, as Dumonstier; Harold K. Hochschild.

BIBLIOGRAPHY: H. W. Williams, Jr., *Metropolitan Museum of Art Bulletin*, August 1940, pp. 156–157, attributed to Lagneau; Benisovich, 1943, p. 70, as close to Lagneau.

Gift of Harold K. Hochschild, 1940
40.91.1

ANONYMOUS ARTIST

late 16th – early 17th century ?

346. *Portrait of a Man*

Charcoal, stumped, black and red chalk, a little black crayon. 37.2 x 26.6 cm.

Inscribed in pencil on verso, *Dumoutier Fecit / J.*

PROVENANCE: Marquis de Lagoy (Lugt 1710); Henry Danby Seymour (Lugt 176); [J. Seligmann]; Harry Sachs; Edith Sachs.

BIBLIOGRAPHY: *Annual Report*, 1951, p. 32, as Lagneau.

Gift of Edith Sachs, 1951
51.76.1

ANONYMOUS ARTIST

late 16th – early 17th century ?

347. *Portrait of a Man*

Charcoal, stumped, black and red chalk, a little black crayon. 29.2 x 21.8 cm. Lined.

PROVENANCE: Walter C. Baker.

BIBLIOGRAPHY: Virch, 1962, no. 39, as Lagneau (with additional bibliography); *Annual Report*, 1971–1972, p. 39, as Lagneau.

Bequest of Walter C. Baker, 1971
1972.118.14

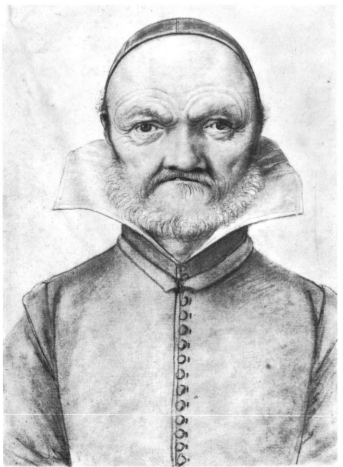

ANONYMOUS ARTIST

17th century ?

348. *Bust of a Man with a Broad Collar*

Graphite on vellum. Framing lines at left and at lower margins in pen and brown ink. 15.8 x 11.4 cm.

Inscribed in pencil on verso, *Coll^n Gigoux.*

PROVENANCE: Jean-François Gigoux (Lugt 1164); Alexandrine Sinsheimer.

BIBLIOGRAPHY: *Annual Report*, 1958–1959, p. 56.

Bequest of Alexandrine Sinsheimer, 1958
59.23.64

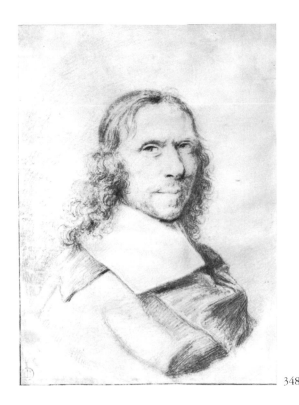

348

ANONYMOUS ARTIST

second half of the 17th century ?

349. *Wooded Landscape with a Tower*

Pen and brown ink, brown wash, over traces of graphite. Framing lines in graphite. 19.6 x 26.7 cm. Lined.

Numbered in pen and dark brown ink at lower right, 6.

PROVENANCE: Gustave Lebel; Jean Dollfus (according to Virch); Walter C. Baker.

BIBLIOGRAPHY: Rotterdam, Paris, New York, 1959, no. 31, pl. 22, as Poussin (with additional bibliography); Virch, 1960, p. 310, fig. 1, p. 315, as Poussin; Virch, 1962, no. 41, repr., attributed to Poussin; Mongan, 1962, no. 656, repr., as Poussin; Friedlaender and Blunt, IV, 1963, p. 62, no. G 27, pl. 237, attributed to Dughet (with additional bibliography); M. Chiarini, *Paragone*, 187, 1965, p. 72, as Poussin; Friedlaender and Blunt, V, 1974, p. 124, as Dughet; *Annual Report*, 1979–1980, p. 27; Wild, 1980, II, p. 256, as Dughet.

Bequest of Walter C. Baker, 1971
1972.118.225

This attractive drawing, very picturesque in effect but not convincingly constructed in spatial terms, has been attributed in turn to Nicolas Poussin, to "The Silver Birch Master," to Giovanni Domenico Desiderii, and to Gaspard Dughet. None of these attributions has met with general agreement, and the drawing seems to us to be the work of an as yet unidentified artist who was strongly influenced by the landscape draughtsmanship of both Poussin and Claude.

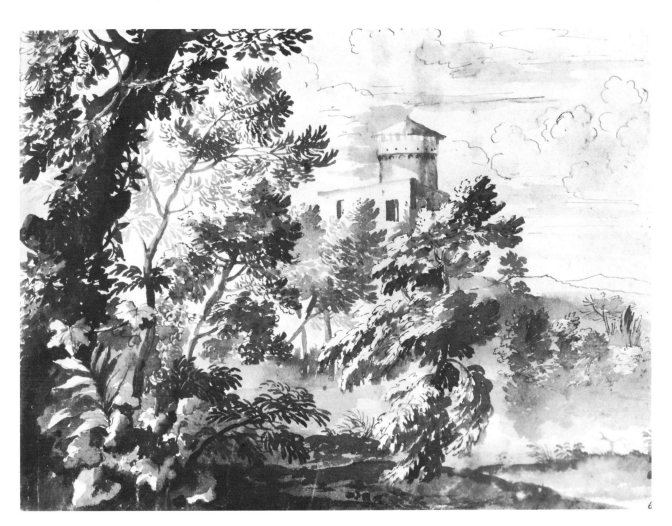

6

ANONYMOUS ARTIST

late 17th century ?

350. *Landscape with Classical Architecture by a Lake*

Pen and brown ink, brown and a little gray wash, over traces of graphite. Corrections in white gouache in foreground figures. 24.8 x 32.7 cm. Vertical crease at center; scattered brown stains.

PROVENANCE: Walter C. Baker.

BIBLIOGRAPHY: Virch, 1962, no. 42, attributed to Jean Lemaire; *Annual Report*, 1971–1972, p. 40, attributed to Jean Lemaire.

Bequest of Walter C. Baker, 1971
1972.118.15

The drawing was apparently acquired by Walter C. Baker as the work of Claude; in cataloguing the sheet Claus Virch tentatively proposed the name of Jean Lemaire.

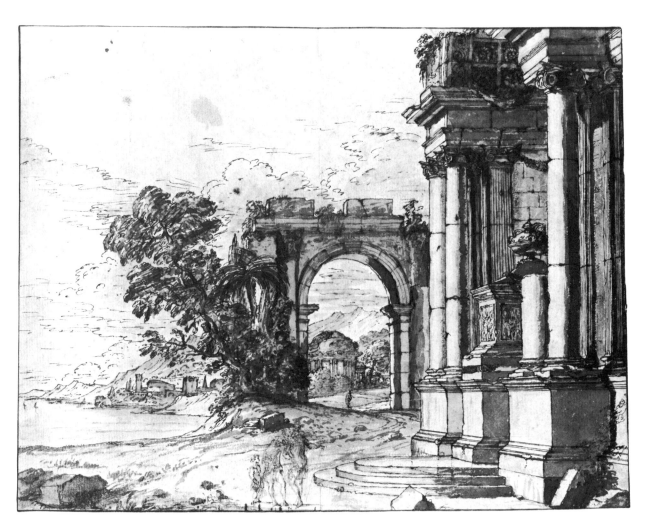

ANONYMOUS ARTIST

second half of the 17th century ?

351. *Ceiling Decoration with the Four Continents and the Signs of the Zodiac*

Pen and dark brown ink, brown, gray, and red wash, heightened with white, over red and black chalk. 39.5 x 53.0 cm. (overall). The sheet is made up of eleven rectangular pieces of paper affixed to a backing.

Inscribed in pencil on verso of old support, *Daniel Marot 1653–1718.*

PROVENANCE: Hippolyte Destailleur; Destailleur sale, Paris, May 19–23, 1896, no. 430, as Le Brun ?; [Baderou]; purchased in Paris in 1965.

BIBLIOGRAPHY: *Annual Report*, 1965–1966, p. 75, as Daniel Marot.

Rogers Fund, 1965
65.207.2

The author of this vigorous and original design has yet to be identified. In the 1896 Destailleur sale it was classed under the name of Charles Le Brun with a question mark. Since then the name of Daniel Marot the elder has been suggested, but the strong angular draughtsmanship seen here is quite unlike Marot's limp and indecisive pen work.

See No. 186 above.

ANONYMOUS ARTIST

second half of the 17th century ?

352. *Neptune and Other Marine Deities Pay Homage to Louis XIV*

Pen, brown and gray ink, gray wash, heightened with a little white, over red chalk. 15.8 x 20.1 cm. Repaired tear at center of right margin. Lined.

Inscribed in graphite at lower right, *Triumph of Louis 14*; in pen and brown ink at lower right margin, *M. corneille.*

PROVENANCE: Janos Scholz; purchased in New York in 1950; transferred from the Department of Prints and Photographs in 1973.

The Elisha Whittelsey Collection,
The Elisha Whittelsey Fund, 1950
1973.306

ANONYMOUS ARTIST

end of the 17th century

353. *Allegory of the League of Augsburg*

Pen and brown ink, brown wash, over black chalk. 43.6 x 55.0 cm. Contours incised for transfer; vertical crease at center.

Inscribed in pen and brown ink throughout the composition from left to right, *D / C / A / B / F / E*; in pencil, *jurieu / Ambition / Le Maître de la Lotterie / perfidie / Saxe / Brandebourg / Lyege /* and *Brandebou . . .* (crossed out).

PROVENANCE: [Baderou]; purchased in Paris in 1961.

BIBLIOGRAPHY: *Annual Report*, 1961–1962, p. 66.

Rogers Fund, 1961
61.136.6

Design for the upper part of a calendar for the year 1692 entitled *La lotterie chimérique d'Augsbourg où chacun met du sien sans proffit*; the engraving reverses the drawing (*Collection Hennin*, II, 1878, p. 283, no. 5,944).

The master of the lottery seated at center is William III of Orange-Nassau, Stadtholder of Holland and king of England. The scribe at left in the broad-brimmed hat is the French Calvinist pastor Pierre Jurieu, a counselor of William III. Allegorical figures of Ambition and Perfidy stand behind William III. The five figures at the right represent Brandenburg, Genoa, Germany, Liège, and England.

The name of the inventor of the design was not supplied in the engraved calendar, but the artist was a vigorous draughtsman. Jennifer Montagu points out certain affinities with the style of Antoine Dieu.

ANONYMOUS ARTIST

second half of the 17th century ?

354. *Cormorants Used for Fishing*

Black chalk. Faint framing lines in red chalk. Some contours incised. 35.4 x 50.7 cm. White pigment stains at lower center and upper right; vertical crease at center.

PROVENANCE: [Prouté]; [Baderou]; purchased in Paris in 1964.

BIBLIOGRAPHY: *Catalogue "Colmar" 1964. Paul Prouté et ses fils*, Paris, 1964, no. 17, repr., attributed to "Louis Elle, le Vieux, dit Ferdinand"; *Annual Report*, 1964–1965, p. 51.

Rogers Fund, 1964
64.196.1

Cormorants fly from their cage above, while in the foreground the birds are forced to disgorge the fish they have captured. The Jesuit Louis Lecomte, sent to China by Louis XIV in 1685, had reported that cormorants were used there on a large scale in commercial fishery. The European costumes of the fishermen suggest that this scene may be a political satire intended as a calendar illustration. The empty cartouche at the upper margin and the fact that many of the contours are intended for transfer would give support to this suggestion.

ANONYMOUS ARTIST

late 17th – early 18th century

355. *The Son of Moses Circumcised*

(Exodus 4:24–26)

Red chalk, red, brown, and gray wash, heightened with white, on beige paper. 23.1 x 28.6 cm. Lined.

PROVENANCE: Earl Spencer (Lugt 1530); sale, New York, Sotheby Parke Bernet, January 20, 1982, no. 36, repr., as Antoine Coypel, Biblical Scene, purchased by the Metropolitan Museum.

BIBLIOGRAPHY: *Annual Report*, 1981–1982, p. 22 (as Antoine Coypel ?).

Harry G. Sperling Fund, 1982
1982.25.2

It is not known under what artist's name this drawing figured in the Spencer collection in the eighteenth century; the attribution to Antoine Coypel seems to be modern and is in any case erroneous. Certain similarities in style, especially the indications of heads and hands, suggest that the drawing might be the work of Guy-Louis Vernansal (1648–1729). For this artist see Nos. 304 and 305 above.

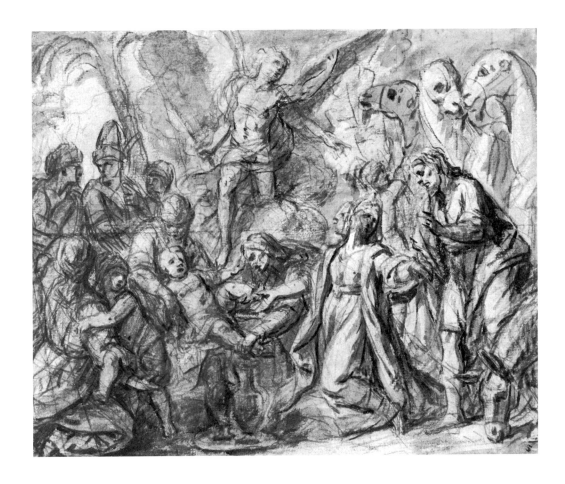

ANONYMOUS ARTIST

first half of the 18th century ?

356. *The Consecration of a Bishop*

Brush and gray wash, heightened with white, over black chalk, on beige paper. Shaped framing lines and ruled vertical and horizontal lines in graphite. 27.4 x 36.0 cm. Scattered brown stains.

PROVENANCE: Marquis de Chennevières (Lugt 2073); [Baderou]; purchased in Paris in 1971.

BIBLIOGRAPHY: *Annual Report*, 1971–1972, p. 40, as Dulin.

The Mr. and Mrs. Henry Ittleson, Jr. Purchase Fund, 1971
1971.238.2

Chennevières's attribution for this drawing is not known. When purchased in 1971, it was tentatively ascribed to Pierre Dulin (1669–1748) and thought to be related to his engravings commemorating the coronation of Louis XV in 1722. However, the drawing is entirely different in style from Dulin's preparatory studies for this project preserved in the Cabinet des Dessins, Musée du Louvre (Guiffrey and Marcel, V, 1910, nos. 3740–3797).

The ceremony represented is clearly the consecration of a bishop, and the drawing may be intended for an illustration in a Pontifical, the liturgical book containing the prayers and ceremonies for rites celebrated by bishops.

The facial types and postures of the elongated figures, as well as the elegance of the composition, remind us of the work of Pierre-Jacques Cazes (1676–1754).

ANONYMOUS ARTIST

early 18th century ?

357. *Allegory of Winter, after Sébastien Leclerc*

Gray wash, over red chalk. Squared in graphite. Framing lines in pen and brown ink. 11.4 x 18.8 cm. Lined.

Numbered in pencil at lower left, *28*.

PROVENANCE: Sir Robert Mond (Lugt Supp. 2813a); [Goldschmidt]; purchased in New York in 1963.

BIBLIOGRAPHY: Borenius and Wittkower, 1937, p. 86, no. 328, 1, as Sébastien Leclerc II; *Annual Report*, 1963–1964, p. 62, as Sébastien Leclerc II.

Rogers Fund, 1963
63.223.1

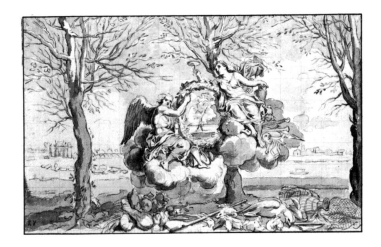

A much reduced copy of Sébastien Leclerc's engraving *L'hiver*, which reproduces in reverse one of the tapestries of *Les saisons*, a Gobelins *tenture* designed by Charles Le Brun (*Inventaire 17ᵉ siècle*, IX, 1980, no. 1596, repr. p. 75).

When in the Mond collection the drawing was attributed, for no apparent reason, to Sébastien Leclerc II.

See No. 358 below.

ANONYMOUS ARTIST

early 18th century ?

358. *Allegory of Spring, after Sébastien Leclerc*

Gray wash, over red chalk. Squared in graphite. Framing lines in pen and brown ink. 11.4 x 18.9 cm. Vertical crease just left of center. Lined.

Numbered in pencil at lower right, *29*.

PROVENANCE: Sir Robert Mond (Lugt Supp. 2813a); [Goldschmidt]; purchased in New York in 1963.

BIBLIOGRAPHY: Borenius and Wittkower, 1937, p. 86, no. 328, 2, as Sébastien Leclerc II; *Annual Report*, 1963–1964, p. 62, as Sébastien Leclerc II.

Rogers Fund, 1963
63.223.2

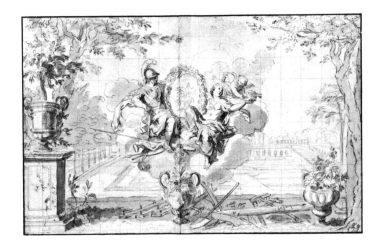

A much reduced copy of Sébastien Leclerc's engraving *Le printemps*, which reproduces in reverse one of the tapestries of *Les saisons*, a Gobelins *tenture* designed by Charles Le Brun (*Inventaire 17ᵉ siècle*, IX, 1980, no. 1593, repr. p. 74).

See No. 357 above.

Index of Former Collections

Destailleur, Hippolyte:
65, 66 (Cochin le jeune), 92 (David), 274,
278 (Gabriel de Saint-Aubin), 351
(Anonymous)

Dollfus, Jean:
349 (Anonymous)

Dormeuil, Georges:
342 (Anonymous)

Doucet, Jacques:
113 (Fragonard), 179, 180 (Lespinasse)

Duits, Clifford:
247 (Pierre)

Dumas, J.-B.:
322 (Voiriot)

Dumon:
257 (Puget)

Duras, Amédée-Bretagne-Malo, duc de:
7 (F.-J. Belanger)

Duval Le Camus, J.-A.:
76 (M. Corneille)

Ederheimer, Richard:
345 (Anonymous)

Ellinckhuysen, J. F.:
79 (Cousin)

Esdaile, William:
138 (La Fage), 159 (C. Le Brun)

Esmerian, Raphael:
219, 220 (J.-B. Oudry)

Fachet, E.:
335 (Watteau de Lille)

Ferrers, Mrs. B. M.:
332 (A. Watteau)

Flameng, François:
32 (F. Boucher)

Flines, Philip de:
58 (Claude)

Fountaine, Andrew:
323 (S. Vouet)

Friedman, Harry G.:
78 (Cousin), 88 (Dassier), 138 (La Fage)

Fries, Augustin:
9 (J. Bernard)

Gallatin, Albert:
56 (Châtelet)

Garnier, Étienne-Barthélemy:
137 (Jouvenet)

Gasc, Charles:
1 (É. Allegrain)

Gault de Saint-Germain, P.-M.:
135 (Jombert)

Gavarni, Paul:
14 (Bouchardon)

Gigoux, Jean-François:
47 (Callot), 348 (Anonymous)

Girardon, François:
181 (Le Sueur)

Goldschmidt-Rothschild, Erich von:
196, 197 (Moreau le jeune)

Goncourt, Edmond and Jules de:
14 (Bouchardon), 122 (Gravelot), 224
(Pajou), 276 (Gabriel de Saint-Aubin),
293 (C. Vanloo)

Graaf, Jan Baptist de:
33 (F. Boucher)

Guéraud, Pierre:
1 (É. Allegrain), 17 (Bouchardon)

Gregory, Peter:
106 (Dugourc)

Gronau, Mrs. H. D.:
329 (A. Watteau)

Groult, Camille:
112 (Fragonard)

Guichardot:
85 (N. Coypel)

Guyot de Villeneuve:
64, 67, 68, 69, 70 (Cochin le jeune)

Haggin, Mrs. James B.:
344 (Anonymous)

Hamal, Henry:
232 (Pécheux)

Harbord, Felix:
329 (A. Watteau)

Haumont, Georges:
218 (J.-B. Oudry), 322 (Voiriot)

Haupt, Mrs. William M.:
344 (Anonymous)

Heseltine, J. P.:
110 (Fouquet), 114 (Fragonard), 234,
235, 236, 237 (Picart), 330 (A. Watteau)

Hesme de Villeneuve:
125 (Greuze)

Hevesy, André de:
334 (A. Watteau)

Heyl zu Herrnsheim, Freiherr M. von:
53 (Challe)

Hochschild, Harold K.:
266 (H. Robert), 345 (Anonymous)

Hoover, Mrs. O'Donnell:
31, 32 (F. Boucher), 152 (Lancret)

Humann, Christian:
26 (F. Boucher), 67, 68, 69, 70 (Cochin le
jeune), 244, 245, 247 (Pierre), 283 (L. de
Silvestre), 302 (L.-C. Vassé)

Hyde, James Hazen:
13 (Bouchardon), 217 (Nicolle), 238
(Picart)

Ingram, Sir Bruce S.:
234, 235, 236, 237 (Picart), 255 (Puget),
281 (I. Silvestre)

James, Andrew
331 (A. Watteau)

James, Miss
331 (A. Watteau)

Jammes, Jean-Camille:
211, 212 (Nicolle)

Jarves, James Jackson:
48 (Callot), 254 (Poussin), 326, 327
(A. Watteau)

Joubert:
165 (F. Lemoine)

Joubert, Joseph:
125 (Greuze)

Julienne, Jean de:
181 (Le Sueur)

Kaïeman:
1 (É. Allegrain)

Kaufman, S.:
133 (Hoüel)

Kavanagh, Mrs. Corina:
200 (Moreau l'aîné)

Komor, Mathias:
205 (Natoire)

Knowles, Sir James:
331 (A. Watteau)

Concordance metropolitan museum of art accession numbers

ACC. NO.	THIS VOLUME	ACC. NO.	THIS VOLUME	ACC. NO.	THIS VOLUME	ACC. NO.	THIS VOLUME
80.3.451	48	51.76.3	340	61.130.3	162	63.223.1	357
80.3.522	326	52.14	115	61.130.5	164	63.223.2	358
80.3.524	327	52.138	209	61.130.19	175	64.3	304
80.3.583	254	53.121	295	61.132	323	64.33	160
87.12.125	291	54.142	279	61.136.3	86	64.38.10	325
06.1042.7	118	55.214	30	61.136.4	64	64.75	199
06.1042.11	171	56.225.4	138	61.136.6	353	64.182.1	192
06.1042.19	47	57.139	39	61.139	322	64.182.2	191
07.282.1	58	59.23.39	28	61.161.1	90	64.182.3	190
07.282.8	228	59.23.40	213	61.161.3	280	64.193.2	100
07.283.11	153	59.23.41	214	61.164	178	64.196.1	354
08.227.8	188	59.23.62	202	61.165.1	25	64.196.2	41
08.227.9	189	59.23.63	203	61.165.2	18	64.244	134
10.45.15	119	59.23.64	348	61.165.3	19	64.253	59
10.45.16	173	59.23.68	267	61.165.4	21	64.281.1	35
10.45.28	222	59.23.71	263	61.165.5	20	64.281.2	36
11.66.15	221	59.23.73	277	61.165.6	24	65.65	208
20.166.4	56	59.104	63	61.166.1	44	65.112.6	3
23.280.4	339	59.205	152	61.170	231	65.125.1	161
23.280.5	330	59.208.91	13	61.234	4	65.125.2	233
36.101.4	151	59.210	217	62.19	84	65.132	206
37.165.103	186	60.53	111	62.124.1	317	65.159	10
37.165.104	224	60.66.2	88	62.124.2	318	65.207.2	351
37.165.106	275	60.142.1	40	62.127.1	324	65.251.5	344
37.165.107	333	60.175.1	29	62.127.2	313	66.54.1	106
40.91.1	345	60.176.1	31	62.130.3	284	66.91	12
40.91.17	266	60.176.2	32	62.238	170	66.106	38
41.190.119	251	61.1.1	125	62.242	195	66.128	116
42.186.3	250	61.1.2	130	62.272	185	66.219	108
43.163.19	5	61.1.3	33	63.1	93	67.39	87
43.163.20	6	61.2.6	205	63.3	229	67.55.17	105
43.163.21	201	61.20.3	258	63.76.5	215	67.55.20	179
43.163.22	166	61.24	79	63.76.6	216	67.55.21	180
43.163.23	331	61.28	42	63.91.1	122	67.95.7	303
47.43.2	183	61.54.2	91	63.92.1	89	67.100.1	241
49.38	110	61.58	145	63.92.2	273	67.100.2	242
49.131.1	127	61.59	61	63.105	168	67.100.3	243
49.131.2	128	61.123.1	252	63.117	78	67.100.4	239
49.131.3	129	61.124.1	211	63.167.1	281	67.100.5	240
49.168	57	61.124.2	212	63.167.2	255	67.116	309
50.84	342	61.125	60	63.167.3	234	67.129	269
51.122	321	61.126	97	63.167.4	236	67.150	289
51.76.1	346	61.127.1	34	63.167.5	235	67.163	172
51.76.2	341	61.127.2	117	63.167.6	237	67.196	9

ACC. NO.	THIS VOLUME	ACC. NO.	THIS VOLUME	ACC. NO.	THIS VOLUME	ACC. NO.	THIS VOLUME
67.275	310	1974.206	238	1979.10.2	23	1983.300	65
68.80.1	37	1974.354	285	1979.10.3	22	1983.301	66
68.80.2	169	1974.356.44	113	1979.10.4	182	1983.302	144
68.105	54	1974.356.46	248	1979.18	94	1983.360	148
69.10	155	1974.356.47	249	1979.64	230	1983.426	135
69.49	337	1974.356.48	196	1979.388	223	1983.427	131
69.122.1	101	1974.356.49	197	1980.13	292	1983.429	308
1970.41.1	142	1974.366	294	1980.321	140	1983.431	156
1970.41.2	72	1975.60	77	1981.15.1	1	1983.432	80
1970.133	218	1975.131.91	43	1981.15.2	14	1984.19	232
1970.242.1	102	1975.131.92	45	1981.15.3	85	1984.51.1	26
1971.206.1	2	1975.131.98	62	1981.15.4	176	1984.51.2	46
1971.238.1	137	1975.131.103	82	1981.15.5	187	1984.78	7
1971.238.2	356	1975.131.106	343	1981.129	103	1984.236	73
1971.280	133	1975.131.107	99	1981.219	246	1984.238	167
1972.118.14	347	1975.131.112	121	1981.220	139	1984.247	74
1972.118.15	350	1975.131.113	120	1981.277	141	1984.248	51
1972.118.197	27	1975.131.118	150	1981.286	104	1984.250	146
1972.118.200	55	1975.131.120	210	1982.25.1	259	1984.268	256
1972.118.201	338	1975.131.132	109	1982.25.2	355	1984.311	261
1972.118.204	92	1975.161	174	1982.61	8	1984.312	227
1972.118.212	114	1975.308	71	1982.62	194	1984.352	107
1972.118.222	200	1975.361	159	1982.63	290	1984.357	95
1972.118.224	253	1975.439	158	1982.93.1	76	1984.381	198
1972.118.225	349	1976.99	219	1982.93.2	123	1984.384	276
1972.118.228	264	1976.188	220	1982.93.3	124	1984.390	271
1972.118.229	265	1976.189	316	1982.93.4	184	1984.391	270
1972.118.230	268	1976.334.1	306	1982.94.1	245	1984.400	305
1972.118.231	262	1976.334.2	307	1982.94.2	302	1984.456	287
1972.118.233	274	1977.130	204	1982.173	283	1985.6.1	311
1972.118.236	320	1977.416a	297	1982.190	244	1985.6.2	315
1972.118.237	334	1977.416b	301	1982.434	52	1985.6.3	136
1972.118.238	329	1977.416c	299	1983.29.1	247	1985.37	143
1972.224.1	81	1977.416d	298	1983.29.2	68	1985.43	53
1972.224.2	83	1977.416e	296	1983.29.3	69	1985.47	98
1972.224.3	126	1977.416f	300	1983.29.4	70	1985.102	288
1972.224.4	149	1978.12.1	328	1983.29.5	67	1985.103	257
1972.224.5	181	1978.12.2	278	1983.66	96	1985.104.3	154
1972.224.6	193	1978.12.3	332	1983.128.1	165	1985.112.1	147
1973.15	75	1978.27	16	1983.128.2	49	1985.112.2	226
1973.113	282	1978.292.1	286	1983.128.3	50	1985.112.3	225
1973.306	352	1978.411.1	11	1983.147	272	1985.115	132
1973.317.1	15	1978.516.1	112	1983.234	177	1985.245.1	260
1973.317.2	314	1978.516.2	336	1983.265	163	1985.245.2	319
1974.46	312	1978.516.3	335	1983.266	207		
1974.106	157	1979.10.1	17	1983.299	293		

Index of Artists